GOODNOUGH

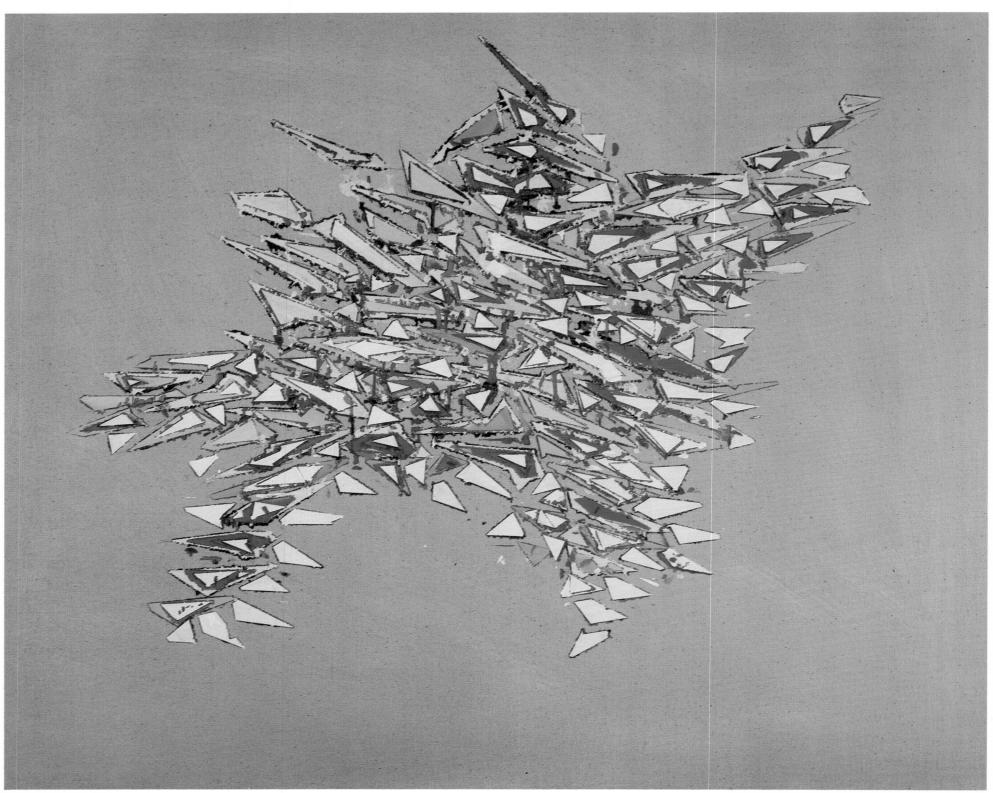

Blue, Gray, White, 1981
(plate 231)

GOODNOUGH

Text and interview by Martin Bush
Director, Edwin A. Ulrich Museum of Art at Wichita State University

Foreword by Clement Greenberg

Notes from a collector by William F. Buckley, Jr.

Abbeville Press • Publishers • New York

Designer: Ulrich Ruchti

Editor: Mark Greenberg

All works reproduced are in private collections unless otherwise specified in the captions.

ISBN: 0-89659-260-X
ISBN: 0-89659-274-X (signed first edition)

Library of Congress catalog card number 81-68051

First edition

CONTENTS

6
Acknowledgments

8
Foreword
 Clement Greenberg

11
Robert Goodnough
 Martin Bush

161
Talking with Robert Goodnough
 Martin Bush

212
The Development of a Pool
 William F. Buckley, Jr.

242
Notes

243
Chronology

244
List of Plates

247
Selected Bibliography

251
Collections and Exhibitions

ACKNOWLEDGMENTS

A manuscript requires the assistance and collaboration of many people, and I have been most fortunate in this respect. Robert Goodnough has been most helpful during the past few months in helping me to gain a clearer insight into his life and work. We have spent many hours together, and it was from conversations with him that I was able to produce much of the material in this book.

Mark Greenberg edited the manuscript and it has been a pleasure to work with him. I would also like to thank Donita Ragan Buck, who struggled through the typing of several drafts of the manuscript, and Debbie Dodge, who helped me with much of the bibliographic material.

Many others have contributed to the project, among them: the late Harry Abrams, Robert Abrams, Frederick R. Brandt, Tibor de Nagy, André Emmerich, Emiko Goodnough, Clem Greenberg, Gary Hood, Sydney and Frances Lewis, Phyllis Linn, Walter K. Long, David Mirvish, and Clint Willour. I am grateful to all of them.

> M. H. B.
> Wichita, Kansas
> July, 1981

FOREWORD

He's one of the better painters of the time—which comes to saying he's one of the best. That this hasn't been driven home yet—for this I blame Goodnough himself in large part. But I blame the art public, too, and in larger part. To appreciate him rightly, you have to like painting as painting, as art. Fewer and fewer presumably cultivated people seem to do that.

For over a decade now, the best pictorial art has turned away from spectacular innovation à la Pollock and radical reversal à la Newman. The best pictorial art has assimilated Pollock and Newman (it wouldn't be the best if it hadn't), but it is no longer forced to look spectacular in innovation. It innovates, but in a different context, one in which spectacular newness has become conventional and official, academic in the perjorative sense. The best pictorial art (and sculptural art, too) now has become an affair of subtleties, shading, inflections. Well, superior art has always been that. It's context alone that makes it look spectacular. And the context for the spectacularly new emerged only in the 1850s (Michelangelo's case as painter to the contrary notwithstanding). Before Manet, the best new art may have surprised, but it didn't astonish or bewilder, not even when it offended.

The *very* best new painting has been abstract for decades now (against my own preference or prejudice). This isn't to say at all that good new painting has been mostly abstract, but just that the *very* best of it has been and still is. Nevertheless, it's only over the last decade or so that abstract painting (abstract sculpture not yet) has, as it were, consolidated itself. By which I mean that it no longer has to be superlative in order to be good. Before, abstract art had to be great in order not to be inferior. Before, painting that was good, and just that, without being great or superlative, was predominantly representational, while most abstract painting—let alone sculpture—was not good, to put it mildly. It's in the new context of an abundance of abstract painting that is good, that is strict, that has level—it's in this context that Goodnough's art stands out.

He was doing good painting thirty years and more ago. His small blackish picture in the Muriel Kallis Steinberg Newman collection is one of the best things in it, and that's saying a lot. The picture is tight, nuanced, and at the same time "violent." Later on, going in a somewhat different direction, Goodnough showed, as he still does, how much life was still left in Analytical Cubism (as Hofmann and Pollock did in their time, and maybe de Kooning, too, before the fifties). But Goodnough's art of the last dozen years is, I feel, his best yet. The paintings are, apparently, too nuanced for current taste. Too what? Tenuous? Here, if ever, the difference between the phenomenal and the intrinsically aesthetic shows itself to the attuned eye. Goodnough's adjustments of color as well as of layout are anything but tenuous. Their intricacies are what I'd call "fibrous"; they convey a wealth of force by slight-seeming means: the placing and proportioning of the clustered leaf-facets in relation to large areas of unmarked canvas; the microscopic spacing of the leaf-facets themselves, their changes of hue and value, their thickened surfaces, which lift from the canvas almost imperceptibly—that's how some of the best art of our time gets itself made.

Current "aware" taste doesn't really keep up with abstract painting or sculpture—even less, maybe, than its equivalent in the 1870s kept up with Manet and the Impressionists. Going taste still can't tell a good from a bad Rothko, let alone a good from a bad Newman or a good from a failed Pollock. It's a grosser taste than that of the 1870s: it goes more by classifications, it discriminates less between one work and another; it knows reputations far more than it knows art. Well, "aware" taste, taste directed to the latest in art, seems to have been declining off and on since the 1850s or 1860s—but only off and on. Periodically till now, the decline seems to have been more or less checked if not reversed. The best new art has always floated to the surface of attention within a decade or two since Manet. Is it taking any longer to do so now? Goodnough is a test case.

But I still want to place some of the responsibility for the

artist's relative lack of recognition on himself. I think it has to do with his diffidence. Goodnough has changed direction more than once, mostly but not always to the advantage of his art. I remember a short succession of Pollock-influenced paintings he did in the early fifties. The influence looked glaring, yet the pictures were perfection. I hadn't learned then that when a work of art is good enough, over the course of time it will soak up its influences to the point where they become, if not obliterated, irrelevant. (Gorky taught me that.) For whatever reason, Goodnough didn't pursue his "Pollock" vein. He went on making good art, but without *emphasis*. That came only with his "facet-leaves." With these he hasn't yet—I dare to say as a presumptuous critic—hit every nail on the head and driven it all the way in.

And still, if he were to leave off painting right now, what Goodnough's already done will amount to a lot; it will stay, it will hang in, as part of what's kept high art going these past thirty-odd years. After all, and no matter what, he remains a master-painter.

<div style="text-align: right">CLEMENT GREENBERG</div>

ROBERT GOODNOUGH

Martin Bush

The façade of an indistinguishable old store stands silently amid the noisy confusion of Barrow Street in the heart of New York's Greenwich Village. Its doors and windows are guarded by forbidding metal grilles that keep out intruders, while half-opened blinds and a large standing screen hide its secrets from prying eyes. People arriving for dinner at One If By Land—Two If By Sea, an exquisite restaurant next door that once was Aaron Burr's carriage house, rarely notice the glow deep within the building's confines. The light always burns late into the night and only rarely does anyone enter or leave the place. Those who are permitted inside, however, are surprised to find bright, warm light flooding over two large and strikingly beautiful canvases by the well-known American artist, Robert Goodnough.

More often than not, the paintings in Goodnough's studio are unfinished, yet there is still a marvelous sense of harmony about them. Pale green, yellow or perhaps blue petal-like clusters appear to soar in close-keyed arrangements on vast delicately hued surfaces that appear to have a personality of their own. In an almost mystical way these canvases glow with an Oriental splendor. "I do not feel that the presence or absence of recognizable themes makes a difference in the power to convey a message," explains the artist, "for the message comes from the ability to build, and it is to this that the observer should react." These are complex paintings, but it is not important for the casual visitor to understand them. Goodnough would prefer instead to have people respond to the work as one might to the song of a bird, to think of the paintings as being simple, quiet, and enriching experiences.

Robert Goodnough is something of an anomaly. Until 1969, he was known as a second-generation Abstract Expressionist, a refiner, not a revolutionary, a technically superb craftsman as well as a conceptually solid artist, whose most cherished gifts—an extraordinary compositional eye, a knowing appreciation for the value of color, and a sophisticated capacity for infusing each painting with his own personal calligraphy—have given him the reputation of

1. Robert Goodnough in his Army Field Artillery uniform, 1945
2. Robert Goodnough at eighteen months
3. Robert Goodnough, 1981
4. Robert Goodnough working on a painting in his Barrow Street studio, 1979

being one of the finest contemporary painters in America. Clement Greenberg, the distinguished art critic and one of the brightest individuals associated with abstract art in the post-World War II years, considered Goodnough to be a solid painter early in his career. "But recently," wrote Greenberg, "Goodnough has become one of the handful on whom the fate of painting as a high art seems to depend."[1]

Although critics ordinarily refer to Goodnough as a second-generation Abstract Expressionist or a Color-field painter, he probably is best described as a maverick who has really never belonged to any school of painting. When Goodnough began to work seriously, he embraced the emotional content of Abstract Expressionism. But in the ensuing years, he channeled this emotion through a multitude of styles closely related to Analytic Cubism and Synthetic Cubism before

2.

1.

3.

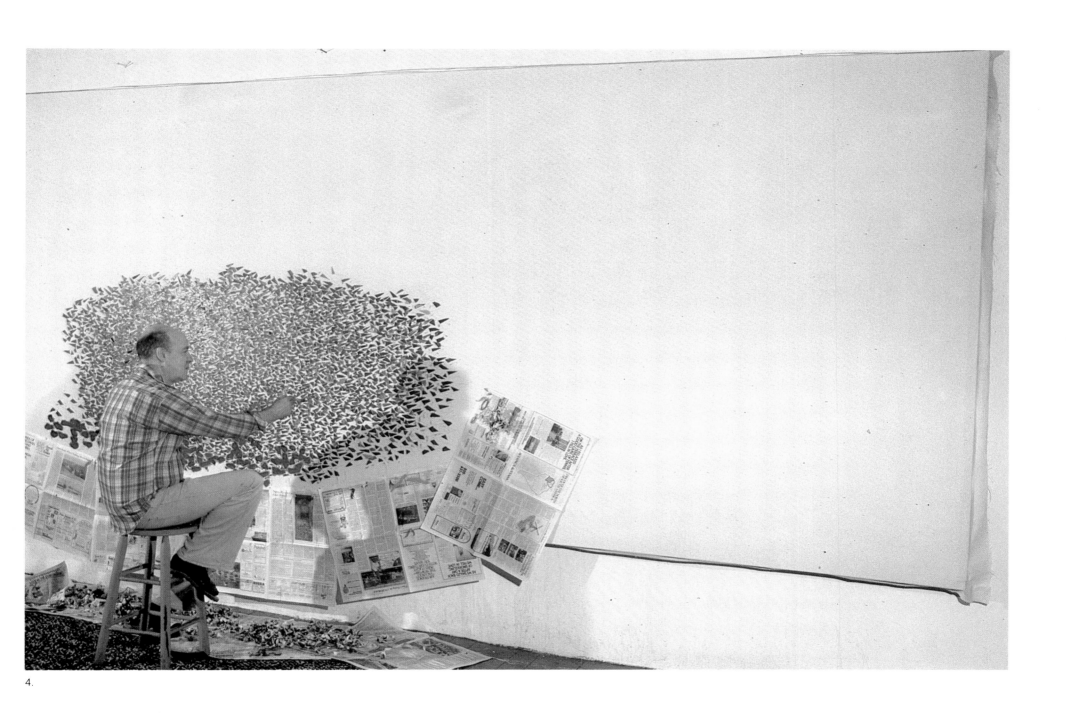

4.

5. *Two Figures,* 1947
Oil on Masonite, 20 x 24"
6. *Provincetown Landscape,* 1947
Watercolor on paper, 14 x 18"
The Snite Museum of Art, University
of Notre Dame, South Bend, Indiana
Gift of Mrs. Theresa Parker
7. *Provincetown Landscape,* 1947
Oil on Masonite, 35½ x 47"

arriving at an abstract painterliness marked by a superb feeling for color and form. It was an agonizing process because he sought to avoid repetition or cliché in his paintings as he moved from the painterly to the geometric, or fluctuated between the figurative and the abstract. Today, however, his elegant and austere abstractions cannot be mistaken for anyone else's work but his own.

Robert Goodnough is one of those proud, complex, and shrewd individuals who defies easy description. At 5 feet 10 inches, he is a solidly built man with thinning light brown hair and hazel eyes. He frequently dresses casually in a plaid sport shirt, sweater, cap, and slacks, hardly looking the part of a successful New York artist. At Sandolino's, a little deli-cafe next to his studio where he occasionally reads *The New York Times* while having some soup, a piece of pecan pie, and a Coke, waitresses think of him as being a conservative college professor. This idea is reinforced by his quiet, almost awkward and self-effacing manner. Yet strangers quickly learn that the man is well-read, knowledgeable about classical music, the theater, and literature; he is an extraordinarily intelligent person. Beneath his gentle, unassertive exterior, are a steely inner strength and a dry and subtle sense of humor that slowly emerge as one gets to know him.

While painting, Goodnough often listens to the music of Stravinsky or Bach, drinking countless cups of fruit juice or decaffeinated coffee. He is a disciplined worker, frequently painting from late in the afternoon until the early hours of the morning. This, of course, leaves little time for socializing, even though he enjoys playing chess and ping pong with friends. His old friend and dealer, Tibor de Nagy, fondly recalled that Goodnough seldom attended openings of his own exhibitions during the 1950s and 1960s. If he did arrive at one, Tibor said, it would be during the final minutes of the reception. His wife Emiko has been a good influence on Goodnough. Now he not only attends his own openings, but he and Emiko are often seen at receptions for Kenneth Noland, Dan Christensen, Michael Steiner, and others, and more and

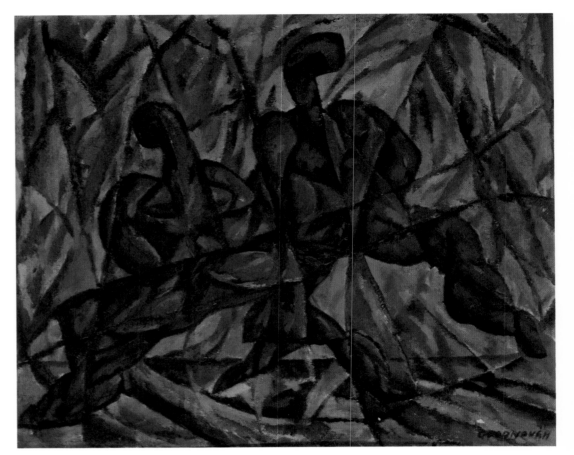

5.

7.

more frequently they appear at parties in the homes of people such as William F. Buckley, Jr., and Dr. Lee Salk. Most of the time Goodnough avoids talking about art because he considers such talk limiting and prefers instead to explore other subjects with friends and new acquaintances.

Robert Goodnough began life in Cortland, New York, the oldest of four children born to Harriet Summers Goodnough and Leo Goodnough. Like most young couples, the Goodnoughs had for years longed to own a home of their own, and the opportunity came when Robert was four years old. Leo took a job as a toolmaker in nearby Moravia, a quiet hamlet in the picturesque Finger Lakes region, where he purchased a home for his family. The house, still known as "the Goodnough place," is situated on Skinner Hill Road, high above the town.

It was ideal for the children: the security of a loving family, friendly neighbors, and all around them the fascinating mysteries of the fields and woods. Bob and his younger brothers, Paul and Phillip, and their sister, Joyce, thrived on country life. "From the hill where we lived we could look down into a long winding valley where fierce Iroquois Indians once lived. Can you imagine," said Goodnough, "how exciting it was for us." Up the road a bit, a stone tablet marked the site of a log cabin where Millard Fillmore, the thirteenth president of the United States, was born. From the stone marker, the children could see the blue haze that marks the surface of Owasco Lake in the distance. The water, of course, was a natural attraction; they liked to wander down to an inlet, exploring the banks and fishing in what appeared to them to be their own private wilderness.

Goodnough remembers fondly the many hours of fun they had with his first BB gun, and later with his most prized possession, a rifle given to him by his parents on his fifteenth birthday. After that, hunting rabbits and woodchucks was a favored pastime. Goodnough's love of art also began in this rustic setting. "I always enjoyed drawing," he said, "even in those days. The first drawing I can remember, done while I was a first grader, was called 'Skunk in Trap.' My

8.

9. Jackson Pollock in his studio, 1950
10. *Clock, Counter Clock*, 1952
Oil on canvas, 51 x 51"
Collection Mr. and Mrs. B. H. Friedman, New York

father told me the only way you could tell what it was was by reading the title. It must have been pretty awful, I guess. Or maybe it was just so abstract that my father couldn't understand it."

There was little original art in the tiny village, but that did not deter young Goodnough, who had developed a keen visual interest. He would seek out art books whenever he could, carefully studying reproductions of work by the old masters, and copying or improvising from them for hours. He dreamed of becoming a great artist. And he worked at it, constantly drawing or painting watercolors and small oils, eventually filling several portfolios, for no reason at all, other than that he enjoyed what he was doing.

The family's Baptist minister, the Reverend George Brow, liked Goodnough's spirit and saw in the youngster an enthusiasm for art that appeared worth nourishing. Brow, something of an amateur painter himself, thought it would be nice if Bob were to drive with him to Auburn (a 17-mile trip) on Saturday mornings, and attend regular art classes at Walter Long's school. "I was thrilled," said Goodnough. "Prof" Long, as he was fondly called by students, was a delightful man: talkative, animated, a born teacher, and truly loved by those around him. A former professor of art at Syracuse University, Walter Long knew raw artistic talent when he saw it, and he saw it—a lot of it—in Robert Goodnough. "He was quiet, very quiet," Long said with a smile. "Bob was a skinny kid who didn't say much. He just worked and listened, but I could tell he was turning everything over in his head, really thinking, and he was a smart one too, eager—and how he could draw."[2]

That same summer, Long and the Reverend Brow, with the cooperation of a sturdy Model T Ford, took Goodnough and two other high school boys to New England for a three-week stay at Gloucester—camping out, swimming in the ocean, painting, and looking at a lot of art. It was an unforgettable experience, and Long made it even more memorable by introducing the group to Grant Wood, George Aarons, Gordon Grant, Anthony Thieme, and other well-known artists who spent their summers by the sea.

18

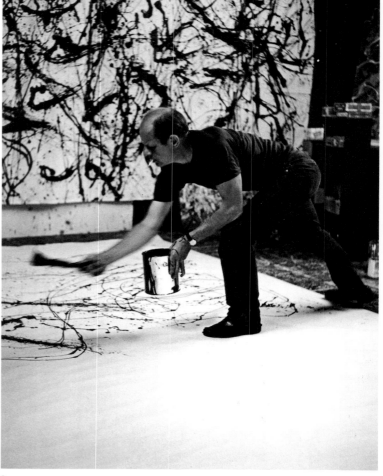

9.

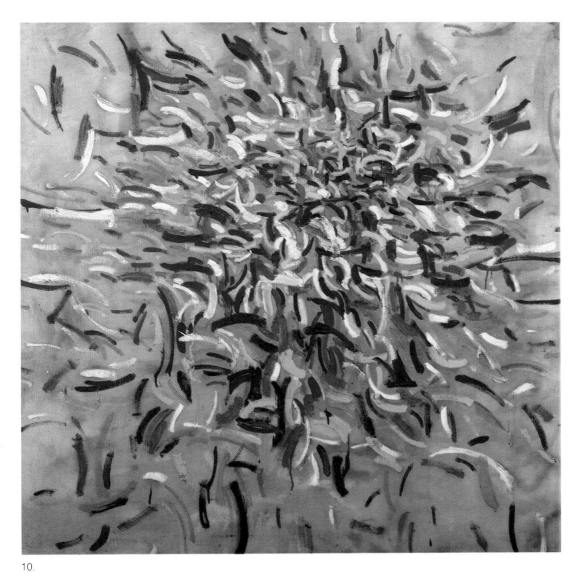

10.

Goodnough had practically no chance of continuing with art after graduating from high school. Since neither he nor his parents had money, college seemed remote. But Walter Long would not hear of giving up. "Apply to Syracuse," he said. "I'll help." Long telephoned former colleagues, sent them Goodnough's work, and persuaded his old friends to offer Goodnough a half-tuition scholarship at Syracuse University.

Money was scarce. The Depression that crippled the nation throughout the 1930s dragged on. Times were hard. Goodnough still had to pay for his own room and board, and he did so with whatever odd jobs were available. Occasionally, he even painted signs in his room for extra spending money. In spite of these financial difficulties, art school went well for Goodnough. He did the usual things: drawing from plaster casts, working from live models, painting portraits. His work attracted the attention of George Hess, an instructor in the art department and a talented local painter as well. "Hess tried to get us to break up our canvas surfaces. No one knew what he was talking about, but there was an atmosphere of experimentation in his classes that made us feel an interest beyond the appearance of the model. He would turn a student's canvas around and draw on the back of it in heavy black lines and quickly paint in empty areas in an almost abstract way, and I envied his freedom," said Goodnough. "Hess would take our drawings home and cut them up and rearrange them in such a way as to make forceful designs. He cared little for surface technique, and there was a certain messiness about things. He seemed to have a sense of the importance of the two-dimensional surface. Now I can appreciate what he was trying to pound into our heads, but then I could understand it only emotionally." This may have been because everything being done at Syracuse was realistic, and there was little or no mention of abstract art. Because Goodnough looked promising, the art faculty allowed him to pursue an independent study program through most of his junior and senior years.

11. *Abstract*, 1951
Acrylic and oil on canvas, 56 x 60"
12. *Collage*, 1953
Canvas on board, 8 x 8"
13. *Abstract*, 1955
Acrylic and oil on canvas, 36 x 42"

11.

By the time Goodnough graduated, war had been raging in Europe for months. Hitler's armies occupied Poland in September 1939, and by April of 1940, German troops occupied Norway and Denmark. Almost without a pause, the Nazi blitzkrieg overran The Netherlands, Belgium, Luxembourg, and France, much to the astonishment of the entire world. Where would Hitler strike next? The world anxiously waited. In the United States people wondered if President Franklin Delano Roosevelt could keep America out of war.

But it was not Hitler who stunned America. On Sunday morning, December 7, 1941, the Japanese launched a devastating air and sea attack on American warships and military installations at Pearl Harbor in the Hawaiian Islands. It was sudden and deadly. The next day Congress declared war and shortly thereafter Goodnough was drafted into the army. "Don't worry. It will be over in six months," his father

12.

20

13.

14.

14. *Standing Figure: Cowboy*, 1954
Oil on canvas, 69 x 59"
Collection Mr. and Mrs. B. H. Friedman, New York
15. *Dinosaurs*, 1953
Paper collage, 25 x 34"
16. *Dinosaur*, 1952
Wood, 18¾" high
Whitney Museum of American Art,
New York
Lawrence A. Bloedel Bequest

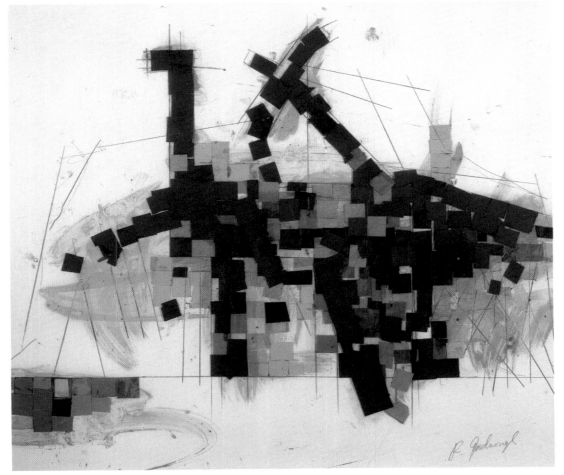

15.

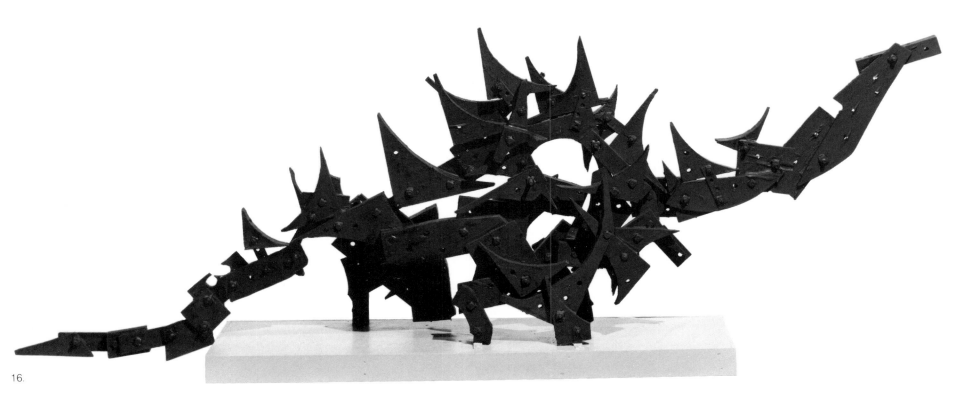

16.

17. *Seated Figure*, 1955
Oil on canvas, 48½ x 48"
North Carolina Museum of Art, Raleigh, North Carolina
Gift of James I. Merrill

said, echoing the sentiments of many Americans. But it wasn't.

The army assigned Goodnough to a field artillery unit at Fort Bragg, North Carolina, and, much to his surprise, the officers greeted him with warm enthusiasm because he was an artist. They loved having their portraits painted and took great delight in ordering murals to brighten up the stark temporary buildings. Goodnough did this for three years, becoming increasingly dissatisfied. It appeared that he would never leave the United States or see any action. Nonetheless, Goodnough got a lot of work experience doing the thing he loved—painting. He painted portraits of the base commander ("I made him stand up," he said), the regimental commander's father, and the governor of North Carolina, J. Melville Broughton. The portraits were, on the whole, much better than the rather stiff imagery of the murals. The army "brass" liked their quiet painter and promoted him to radio sergeant before many months had passed.

Early in 1944, Goodnough's outfit was ordered to the South Pacific—apparently he would not miss the fighting after all. But he soon learned artists were also in demand in the South Pacific. Before long, he was working on a mural of Neptune in the officers' mess aboard an LST headed for the invasion of New Guinea in the Dutch East Indies and Luzon in the Philippines. Had fate sidestepped him again? Would he miss the fighting once more? He wondered, but not for long. Within days, Goodnough got his first terrifying look at the madness of war.

The fighting seemed unreal—the steaming jungle, the dead and dying everywhere. It was almost more than a man could bear. And yet, rather strangely, Goodnough was moved to describe through poetry the nightmarish scenes he had witnessed.

Closely I saw the enemy, touched the hardened forms,
Grinning in a ditch, where they had fallen.
Above and beyond there were the trees and the rubble,
The road pulsating with vehicles and lonely walking men

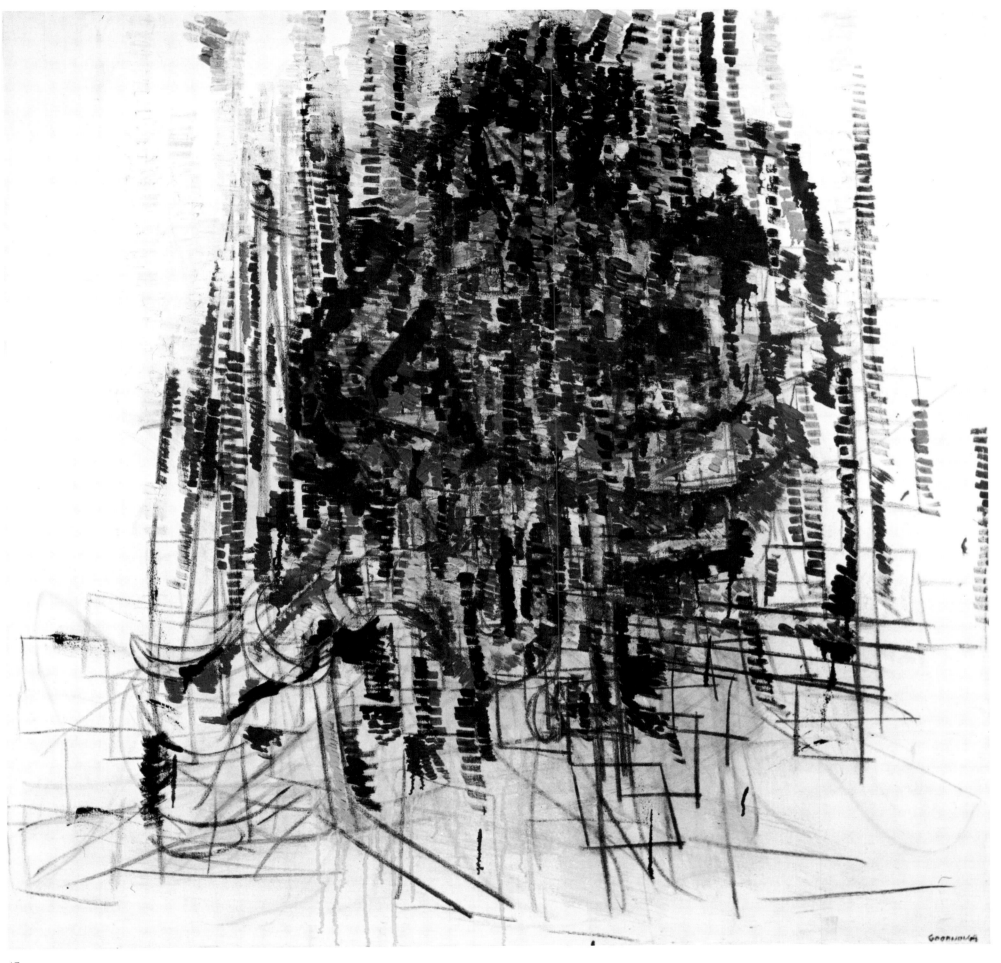

17.

18. *Composition*, 1955
Oil on canvas, 42 x 52"
Newark Museum, Newark,
New Jersey
Gift of Paul Ganz

As the battle moved
In a great kaleidoscopic pattern.
How is it that here all is stopped?
The weight of this inertia
Clutches to question the great surge of victory
And condemn or condone
A system which man has called civilization.
The mangled bodies, cursed, kicked, spat at,
As pulp and stringy flesh
From which jagged bones protrude,
Are the enemy,
Blasted by unsensing guns.
Under steel helmets the minds
That direct triggers must steel themselves.
Or is it nature's will
That flesh should harden and ring as steel?
For when the man no longer moves
He no longer is the enemy,
But a wasted spirit.
By these forms lying limpid in a ditch
Man learns of himself.[3]

The fighting on New Guinea eventually subsided, and the army assigned Goodnough to an information and education unit that was part of the occupation force. There was not much to keep him busy, except a little art work for several hastily published training manuals and pamphlets and for the daily island newssheet that was popularly referred to by American troops as the "Cebu News." The work was easy; there was plenty of time to relax, even in a place so recently ravaged by the fury of war. It was a time for waiting, a time for rest, a time for thinking. Discarded magazines were everywhere, and Goodnough spent hour after hour browsing. This is how he made what was for him a most startling discovery, something destined to influence his life more than he then imagined. For the first time, he saw reproductions in *Time* magazine of abstract work by Henri Matisse, Piet Mondrian, and Pablo Picasso. "It was a shock," he said.

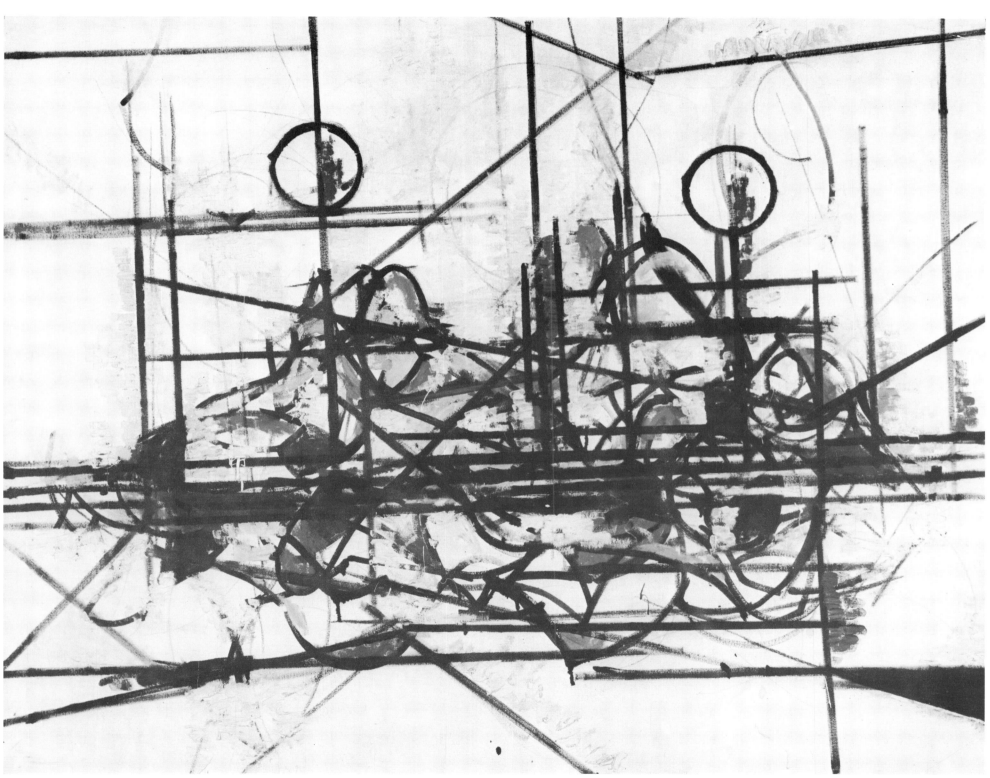

18.

19. *Five Greek Figures*, 1956
Oil on canvas, 60 x 85"
20. *Bird*, 1956
Steel and plaster, 8" high

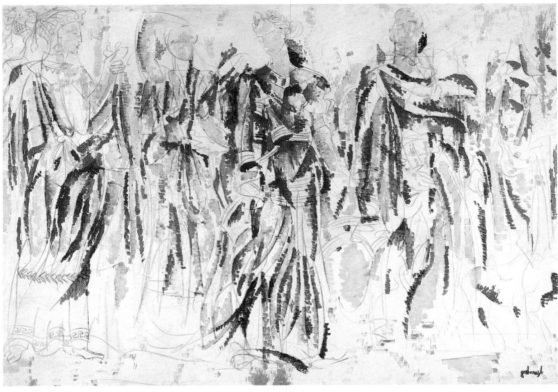

19.

"What I had been doing was mundane. But their paintings were alive, daring, free." What a challenge it would be to paint like that, he thought. He was "tired of painting people who looked like people, with their eyes, noses, and mouths in just the right places. This looked like the time to make some changes and free up a bit."

The time was soon right. The war ended. Goodnough, having been among the first draftees to enter the service, became one of the first to be discharged. Four years had gone by and he was home in Moravia at last. But he had experienced too much of life. The rustic village, though still dear to him, was no place to live now, not if he were to be an artist. He had no future in Moravia; staying was unthinkable. He said hello, then goodbye, and left for New York City, the very soul of the art world—the only place for an artist to live.

"I had always wanted to come to New York," he said. "I wanted to 'make it' as an artist. I had longed to experience the excitement, the beauty, and the passion of the City." And the City did not disappoint him. What a show: the streets and subways, the stores and restaurants—every-

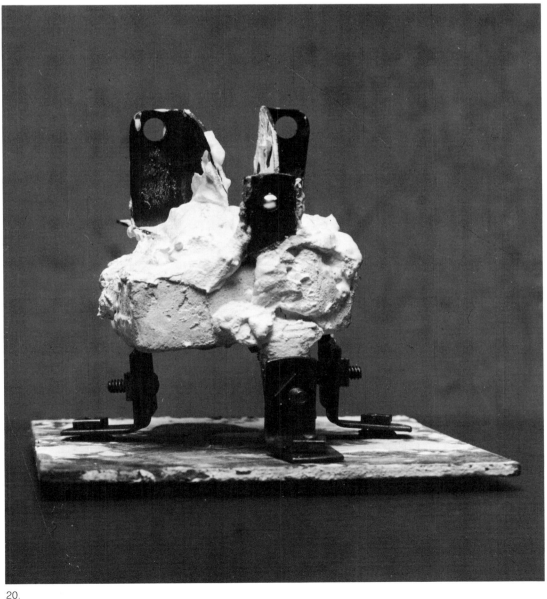

thing—night or day, the curtain never came down. Nowhere else in America could a person find a place so richly endowed with life, so brilliant, yet so mindless.

Sloan House, the YMCA on West 34th Street, became home for a while. It was crowded, impersonal, and cheap, and there were hundreds of other ex-G.I.'s like him—just out of the service, hanging around, wasting time, waiting for something to happen. Waiting for what? Not many knew. It was easy living, though. There were always the $20 veterans' benefit checks each week. Sure, thought Goodnough, I'll find work—soon, well, after a while—after a while. He was no different from most others. It was fun at first, the galleries, the museums, the newness of it all; but a nagging hollowness began to trouble him as the weeks turned into months. It was time to work on his dream.

But how did one get started as an artist in New York? Where did a person go? How did a stranger "make it?" These were troublesome questions. And nothing happened —nothing. Goodnough grew more and more impatient, until one day he met Hy Koppleman, a fellow artist. Hy was frustrated, too. "Let's do something," he said. "Let's enroll in The Ozenfant School of Fine Arts on the G.I. Bill (a law that provided educational subsidies for veterans of World War II). I hear it's pretty good. At least we'll have something to do, someplace to go. Besides, the government will be paying for it," said Koppleman. It sounded good. "Why not," said Goodnough. They caught a taxi and headed for Ozenfant's.

Amédée Ozenfant had been a founder of the French Purist movement and the editor, in 1931, of a highly regarded anthology entitled *Foundations of Modern Art*. He believed a basic understanding of past traditions could point the way toward future growth and a newer set of traditions. Thus, *Foundations of Modern Art* stressed the necessity of recognizing the complementary interrelationships that exist between art, literature, science, technology, and religion, and it emphasized the importance of respecting the classical tradition in each of these areas.

21. *Seated Figure with Gray*, 1956–
57
Oil on canvas, 57 x 52"
Whitney Museum of American Art,
New York
22. *Reclining Nude*, 1957
Oil on canvas, 8 x 10"

Art students stood in awe of Ozenfant. He had an international following and knew, or appeared to have known, almost everyone of significance in Paris before the war. No one had better credentials than Ozenfant. Picasso, Mondrian, Le Corbusier, André Gide, Matisse, Georges Braque, and other celebrated intellectuals were his friends. Thus, it was no surprise to Goodnough or the class when Ozenfant would bring one of them in for a brief visit. This is how Goodnough met Joan Miró, the great Spanish painter. Ozenfant was a good teacher, somewhat authoritarian, and always stressed the precise use of line, the use of a hard pencil with no erasing, and the need for three coats of paint. Moreover, he emphasized the importance of maintaining at all times calm control and discipline in one's work. In short, the old Frenchman believed in discipline, precision, and care. "He was an ego," said Goodnough. "We were always painting to a fine edge—and painting with three coats at that. Yet Ozenfant inspired us to work; he was an important influence on our lives."

Occasionally, Goodnough wandered over to Hans Hofmann's art classes on 8th Street, which balanced the strict training that Ozenfant had impressed upon his students. The main activity at Hofmann's was drawing from a live model or a still life. Hofmann insisted that students approach subject matter in a manner that differed from that of artists of the past. "At the time of making a picture," he said, "I want not to know what I'm doing; a picture should be made with feeling, not with knowing. The possibilities of the medium must be sensed."[4] Hofmann had lived in Paris for a decade, beginning in 1904, and had been friends with the Fauve and Cubist innovators. Goodnough really liked the old man because he was warm, expansive, and assured. Maybe, he thought, it would be rewarding to study with Hofmann in Provincetown, Massachusetts, that summer.

Don Haagen and Sam Prager, friends who had shared with Goodnough the Ozenfant experience, liked the idea and agreed that it would be great fun to spend a summer on Cape Cod. So, in late May, 1947, they rented a quaint old cottage on a dock a few steps off Commercial Street.

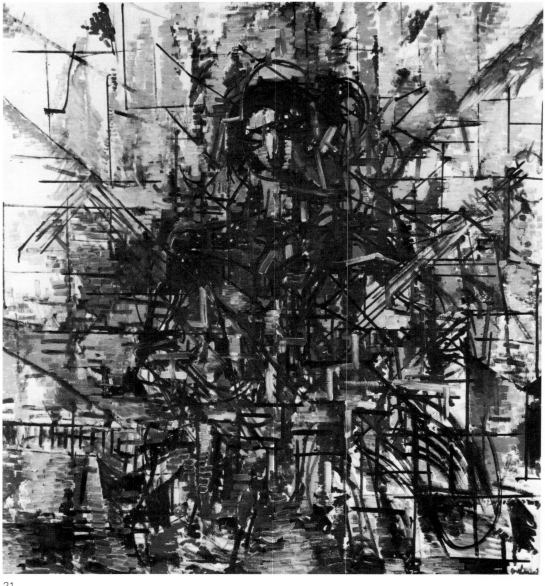

21.

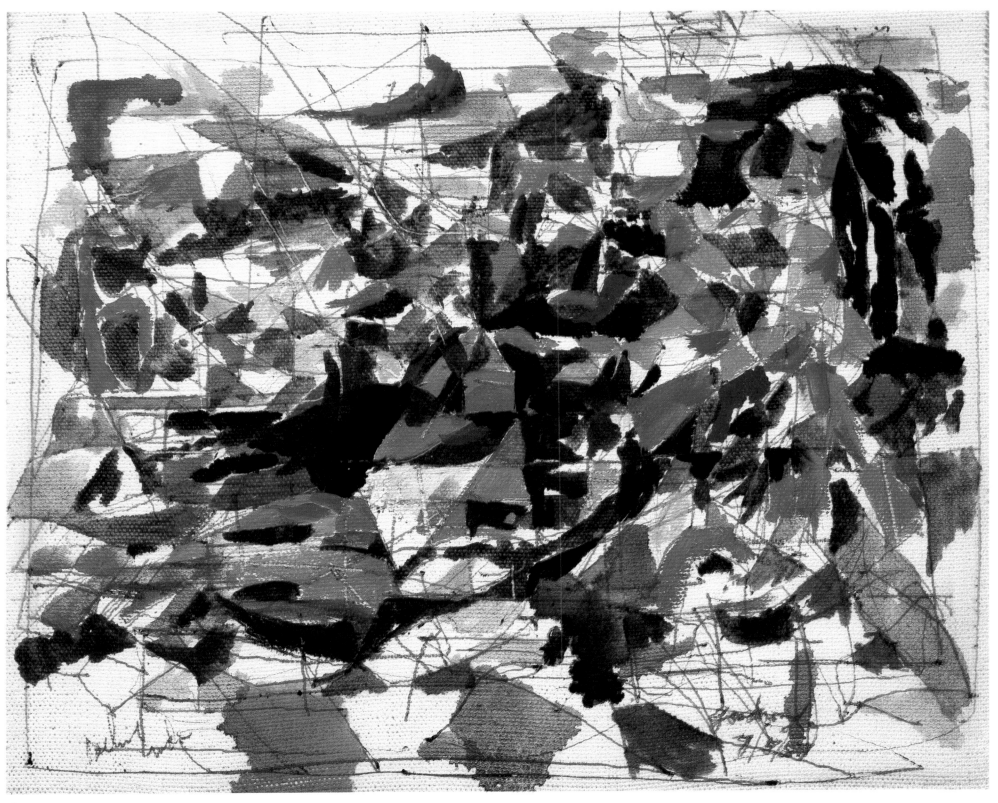

22.

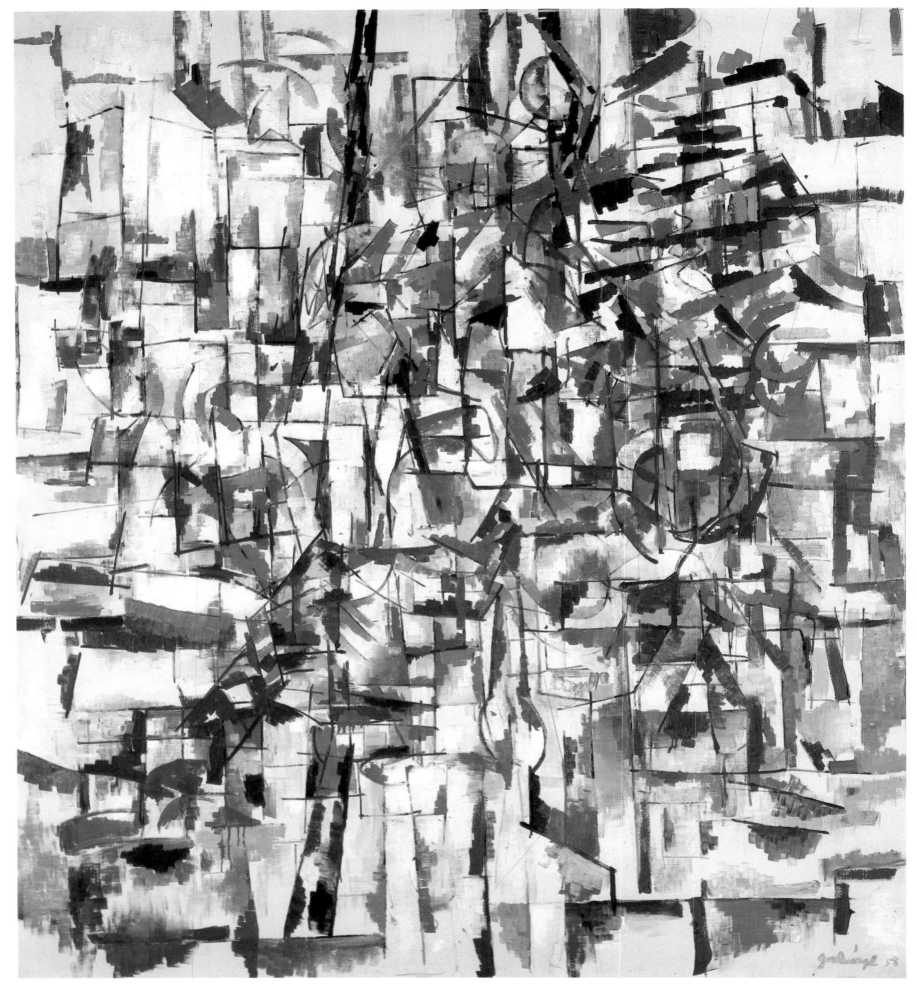

23.

23. *The Frontiersman*, 1958
Oil on canvas, 68 x 60½"
Sydney and Frances Lewis Collection, Richmond, Virginia
24. *Girl in Red*, 1958
Oil on canvas, 36 x 46"
Hirshhorn Museum and Sculpture Garden, Smithsonian Institution, Washington, D.C.
25. *The Flood*, 1958
Oil on canvas, 61 x 69"
Oklahoma Art Center, Oklahoma City, Oklahoma
Gift of James I. Merrill

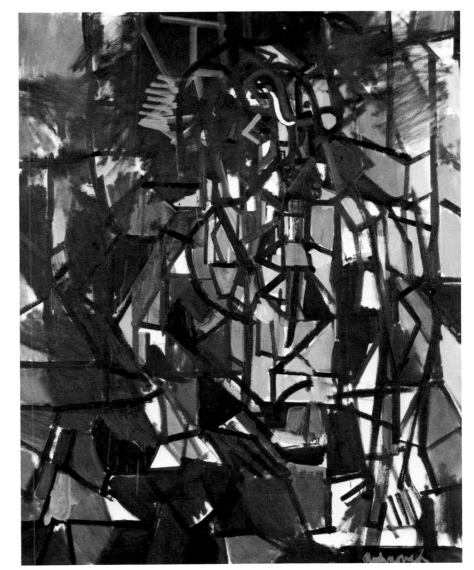

24.

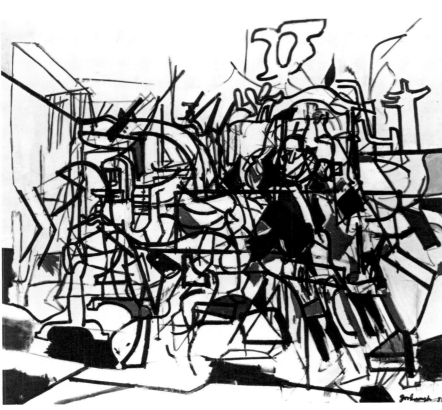

25.

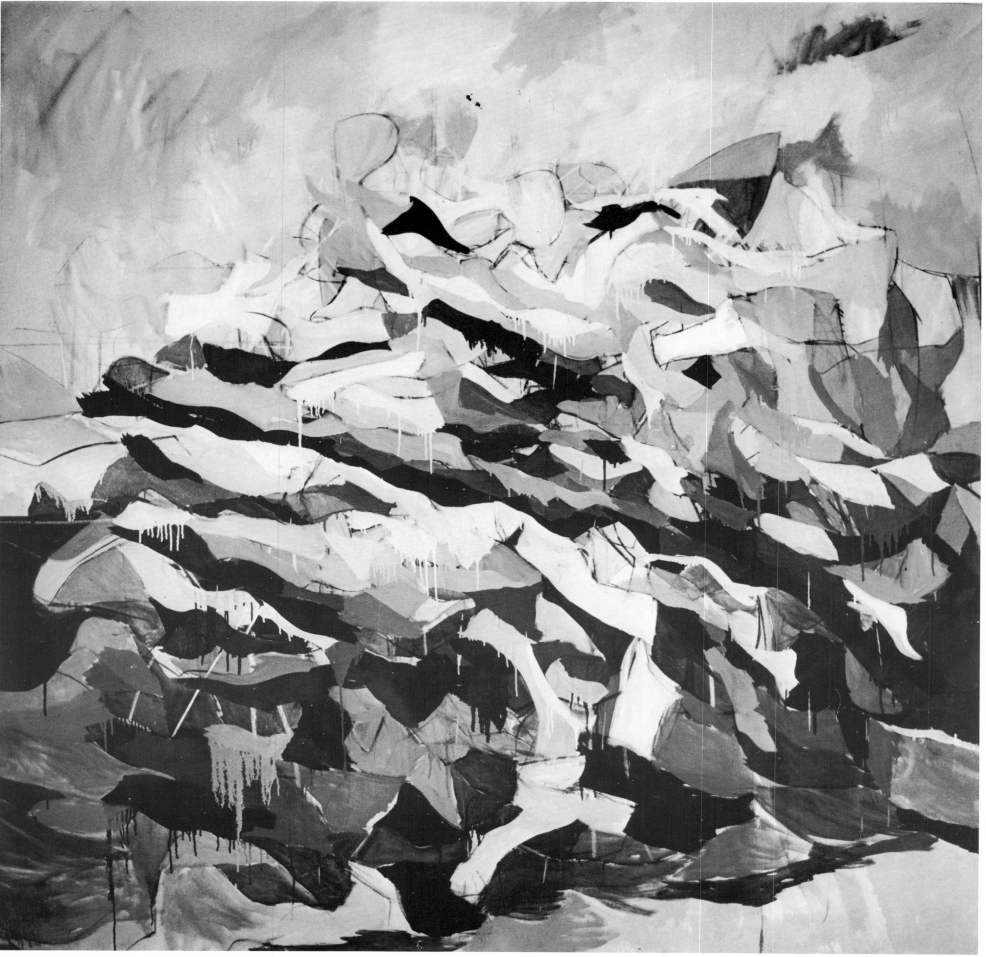

26.

"I see you're already an experienced painter," Hofmann said, the first time he addressed Goodnough about his work, speaking with a paternal respect and warmth Goodnough had not found in Ozenfant. Other students also responded to Hofmann's engaging personality, and a closeness quickly developed between Hofmann and the class. The feeling carried over into relationships among the students themselves. They were colleagues—students and teacher alike. This sense of camaraderie brought about friendships for Goodnough with Larry Rivers, Al Leslie, Paul Georges, Wolf Kahn, and the man destined to become the most influential art critic of his time—Clement Greenberg.

Hofmann was demanding. No one denied that. Even in his harshest moments, however, he acted with an honest intensity. While moving about the class, he would see something he didn't like, stop suddenly, wipe it out, redraw it with rapid strokes, or even tear it in half, all the while shifting one part against the other to illustrate ways of creating movement where none had existed before. Students referred to this Hofmann ritual as the "push-and-pull" method.

Despite Hofmann's gruff manner, students realized that he used his enthusiasm to draw them out, to awaken them to possibilities that lay hidden before them. They thought of him as a friend. It was a rewarding experience. "I felt myself freeing up," said Goodnough. "The summer was good for me."

Robert Goodnough was fortunate to have studied with two unusually gifted and different painters. Ozenfant and Hofmann stressed opposite points in most important artistic issues, yet neither did so to the exclusion of all else.

Goodnough returned to New York in the autumn of 1947 with renewed enthusiasm. He and Don Haagen rented a six-room cold-water flat at 639½ Hudson Street in downtown Manhattan, and Goodnough immediately turned a rear room into a studio, his first in New York. Things were looking up a bit, except for money. It was the same old story, and the G.I. Bill was again the answer. It meant more schooling,

27. *Centaur*, 1958
Oil on canvas, 58 x 64"
28. *Laocoon*, 1958
Oil and charcoal on canvas, 66⅜ x 54⅛"
The Museum of Modern Art, New York

27.

or the $75 monthly check would no longer be in the mail, so Goodnough enrolled in the graduate art education program at New York University.

It was a time of change—surprising change. World War II had isolated American artists from the School of Paris, whose leaders had long influenced and dominated painting in the United States. But American artists were luckier than most of them realized. Having been cut off from European trends, and wishing to avoid the staleness of American Social Realism or the Regionalism of Thomas Hart Benton, Grant Wood, and John Steuart Curry, several New Yorkers ventured into a radical style of art that critics conveniently labeled Abstract Expressionism, or the New York School. It was a dynamic swing away from tradition. "We see about us evidences of the struggle toward the realization of a new

28.

29.

29. *Abstract*, 1959
Oil on canvas, 78 x 78"
30. *Ulysses Abstract*, 1959
Acrylic and oil on canvas, 68 x 68"

30

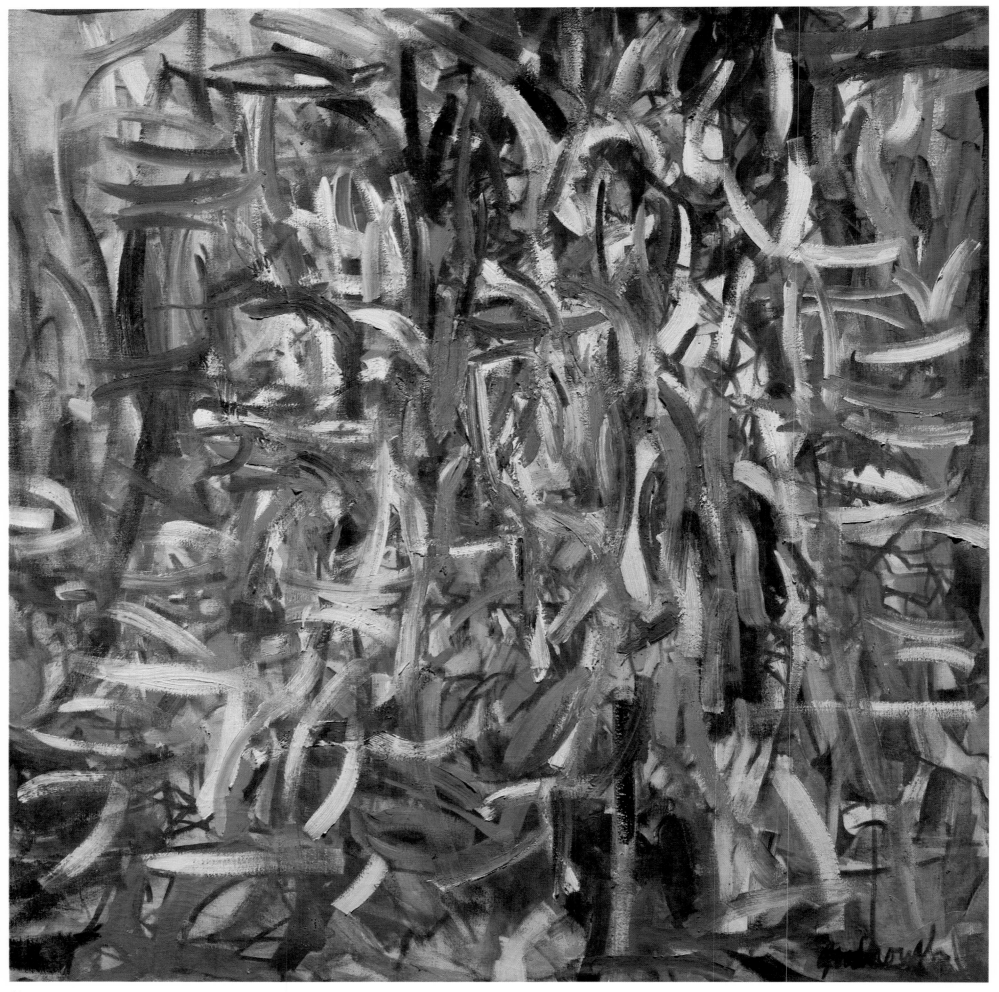

language," wrote Goodnough, "at times insecure and hesi-
tant but slowly developing into a form that may, sooner than
we expect, be generally recognized as contemporary."[5]

The Abstract Expressionists had achieved a major break-
through in art by severing links with the past and by drawing
upon their own humanity for subjects and themes, each
relying on his or her own expressive power. Jackson Pol-
lock, Willem de Kooning, Hans Hofmann, Adolph Gottlieb,
Franz Kline, and Robert Motherwell, along with Lee Krasner,
William Baziotes, Mark Rothko, Philip Guston, Barnett New-
man, Ad Reinhardt, Theodoros Stamos, Clyfford Still, Bradley
Walker Tomlin, Richard Pousette-Dart, and James Brooks
were the chief innovators.

Between 1947 and 1951, these painters brought about
the first artistic revolution America had ever witnessed. They
did not believe art should be purely nationalistic, nor did
they feel that it should reflect the glories of European cul-
ture. They felt that art should have a universal language, one
that could have meaning anywhere. And they did not aban-
don subject matter as so many of their detractors claimed. It
was the source of the subject that was important to them.
Landscape and figurative painting had become so repeti-
tious over the years that it no longer appealed to many
contemporary artists. Consequently, they began to experi-
ment with new techniques and new subjects, turning to the
subconscious mind for ideas and inspiration.

Although the Abstract Expressionists had a passionate
commitment to their art, they were, nevertheless, the butt
of a great deal of ridicule from more traditional artists and
from the public as well. How, critics asked, can one paint
experiences from the subconscious mind? What is "gesture
painting" anyway? Why is "painterliness" suddenly so im-
portant? And who do they think they are fooling with their
so-called "action painting?"

Abstract Expressionism was undoubtedly too cerebral for
most people. Courageous as they were, most of the Ab-
stract Expressionist painters found it more than a little trying
to reveal their innermost feelings in the face of such hostility.

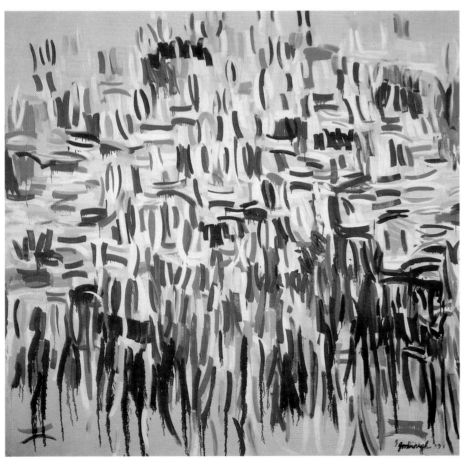

32.

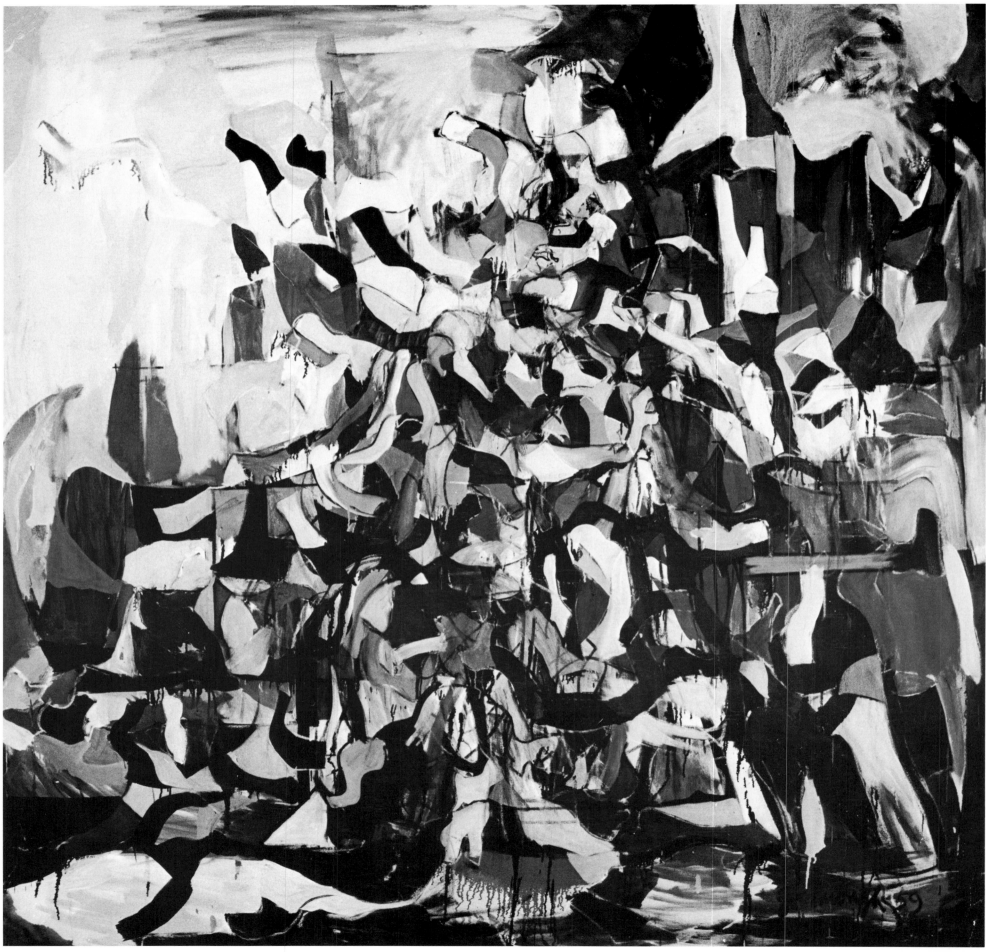

33.

33. *Laocoon II.* 1959
Oil on canvas, 84 x 84"
34. *Summer.* 1959–60
Oil on canvas, 78 x 130"

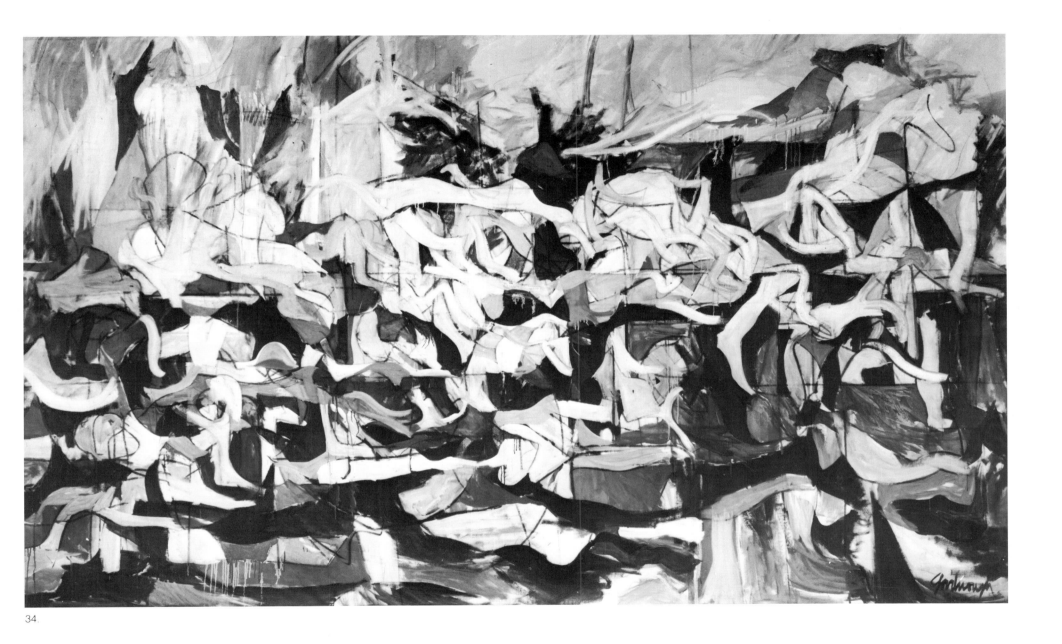

34.

35. *Carnival II*, 1960
Oil on canvas, 58 x 68"
Collection Henrik Krogius
36. *Figure*, 1960
Oil on canvas, 34 x 26"

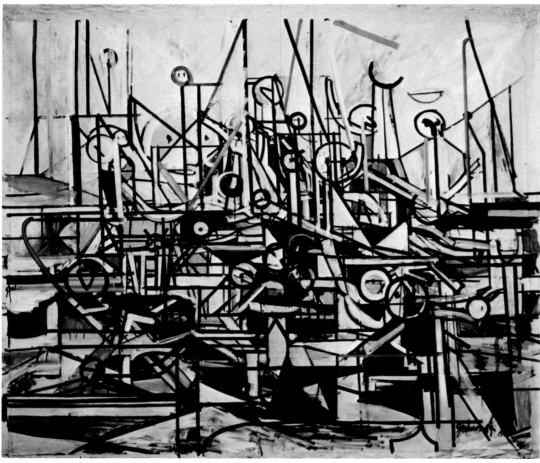

35.

They needed assurances, understanding, and support.
They wanted to discuss their insecurities, to exchange
ideas, to defend and promote their intensely held beliefs in
the company of open-minded and responsive people. This
need led to the creation of forums where artists could ad-
dress sympathetic audiences composed mainly of them-
selves, their advanced students, and friends. Motherwell,
Baziotes, Rothko, and the abstract sculptor David Hare
established the first of these Abstract Expressionist forums
in 1948, calling it the Subjects of the Artist School. Barnett
Newman became part of it soon thereafter. The loft at 35
East 8th Street was for almost nine months the focal point
of Abstract Expressionism in New York City, a place where
those interested in abstract art could gather informally, talk
and exchange ideas, in a friendly social atmosphere. On
many Friday evenings, nearly 150 people would jam the

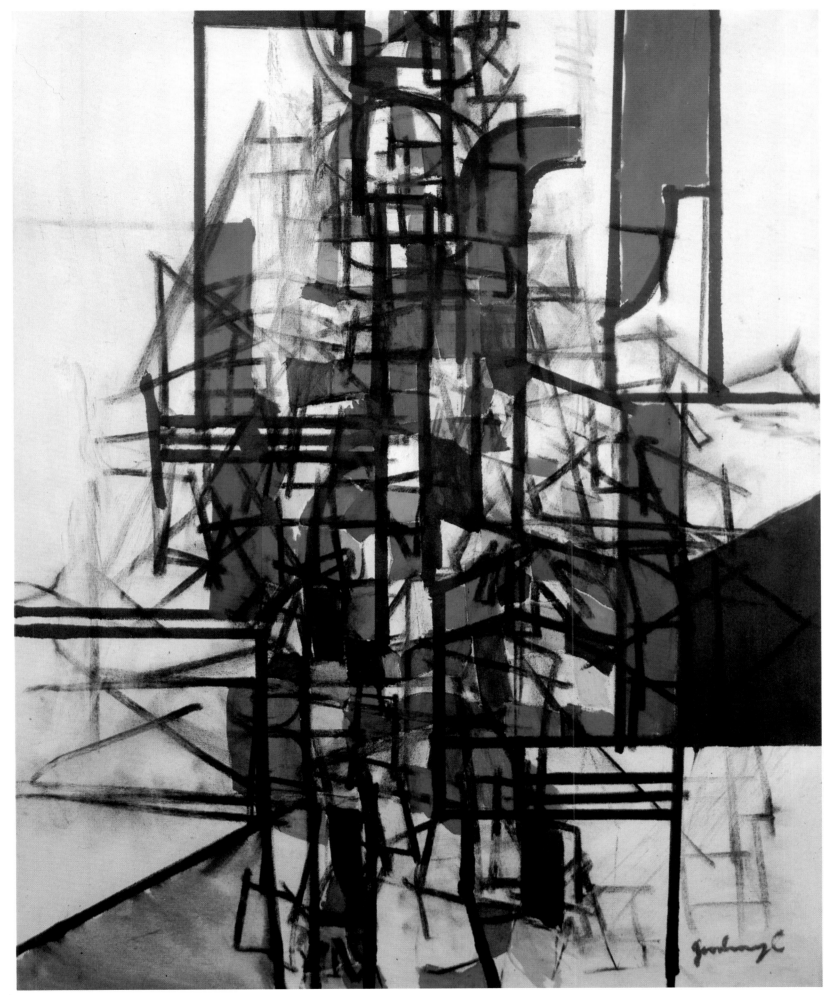

37. *Dinosaur*, 1960
Painted plaster, 12" long
38. *Vertical*, 1960
Acrylic and oil on canvas, 80 x 18"
39. *Motorcycle*, 1959
Oil on canvas, 8 x 10"

space to overflowing, providing the artists with a small yet intensely responsive crowd. Goodnough attended most of these meetings and occasionally recorded something of what was said there.

Motherwell insisted, according to Goodnough's notes, that a "good painter knows painting and its development and is therefore able to see his work in relation to what has already been done."[6] Motherwell was more interested in the city street than he was in nature because the city was a better mirror of contemporary life. The excitement, the hardness and the flatness of the streets and sidewalks contributed more to the lives of most Americans than the countryside, Motherwell said. He saw greater understanding in what man had made than in what had always existed in nature. What is more, Motherwell was optimistic about the new American art, although he admitted that no American had yet achieved the stature of the more established Europeans. He saw tremendous promise in the Abstract Expressionist movement, however, because its members were not afraid to paint as they felt. There was no hint of manufacturing what the public wanted. "Each seeks his own identity," said Motherwell, "and there is a feeling of full steam ahead.

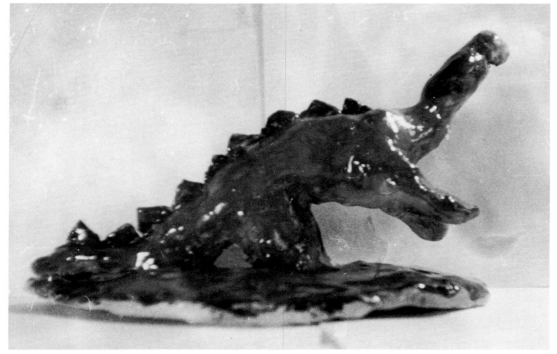

37.

38.

39.

40.

40. *Picnic,* 1960
Oil on canvas. 84 x 76"
Collection Robert Sturz, New York

The Abstract Expressionists are independent, but know the importance of the art of Europe and the potential of America."[7]

Although few of the Abstract Expressionists were able to make a living selling their own work, most were so absorbed by what they were doing that they continued to work despite their personal difficulties. Motherwell emphasized the high degree of intelligence among these artists: they talked intelligently, they wrote well about what they were doing, and still they possessed humility in their attitudes toward the never-ending criticism directed at them. "Some people might see the Abstract Expressionists as a group of fanatics," Motherwell said, "but that, too, is good." For this reason, he predicted, the Abstract Expressionists would eventually succeed.[8]

As the weeks went by, the questions, the answers, and the speakers themselves became redundant. Interest lagged, attendance dropped, and in May 1949 the school itself closed—but not for long. It was revived almost immediately by Robert Iglehart, Hale Woodruff, and Tony Smith, teachers in New York University's Department of Art Education. They rented the loft in a private gesture to get more work space for several students, particularly Goodnough, Al Leslie, and Larry Rivers. The loft was renamed Studio 35. Of the three instructors, Tony Smith played the most significant role in his students' lives. "Tony used to visit me quite a bit," said Goodnough, "and we would talk about art. He was the philosopher of art, I think. Tony had a great deal of influence on my work because he took such an interest in me, and I think he helped me to go into abstract art by giving me ideas. Once we went together to visit Jackson Pollock on Long Island, and that was quite an impressive experience for me." Pollock helped Goodnough understand that painting should not be thought of as precious. "The important thing is the idea . . ." said Goodnough. "When we went into Pollock's studio that day, he had a painting lying on the floor, and somebody stepped on the edge of it. The person immediately started to apologize. 'That's all right,' Pollock

41. *The Bather*. 1960
Oil on canvas. 84 x 76"
42. *Collage*. 1960
Paper collage. 14 x 12"
43. *Figure Group: Abduction*. 1960
Oil on canvas. 68 x 68¼"
The Corcoran Gallery of Art, Washington. D.C.
Gift of the Ford Foundation

41.

said, 'step on it.' He didn't think of his work in a precious way. And I think that was a good lesson for me.''

Generally speaking, Studio 35 invited a cross-section of intellectuals to lecture about new trends in modern art. Among the better-known guests were Jean Arp, Baziotes, the avant-garde composer John Cage, the poet and critic Nicolas Calas, Joseph Cornell (who showed his superb collection of early films), Jimmy Ernst, Herbert Ferber, Fritz Glarner, the one-time Dadaist Richard Hulsenbeck, Reinhardt, the poet and critic Harold Rosenberg, and Rothko. But these meetings declined into tedium, much like those of

43.

44. *The Beach*, 1961
Oil on board, 13 x 20½"
45. *Country Dance*, 1960–61
Oil on canvas, 54 x 54"
Sydney and Frances Lewis Collection, Richmond, Virginia

44.

45.

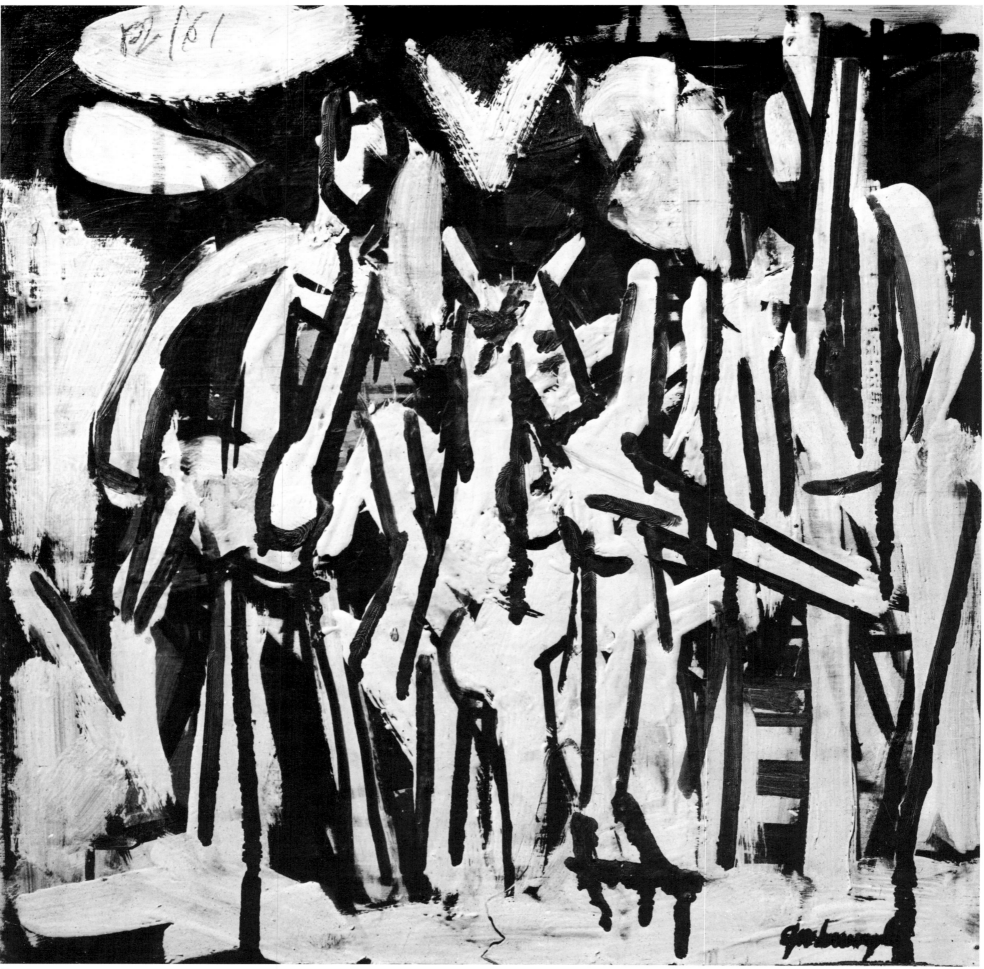

46.

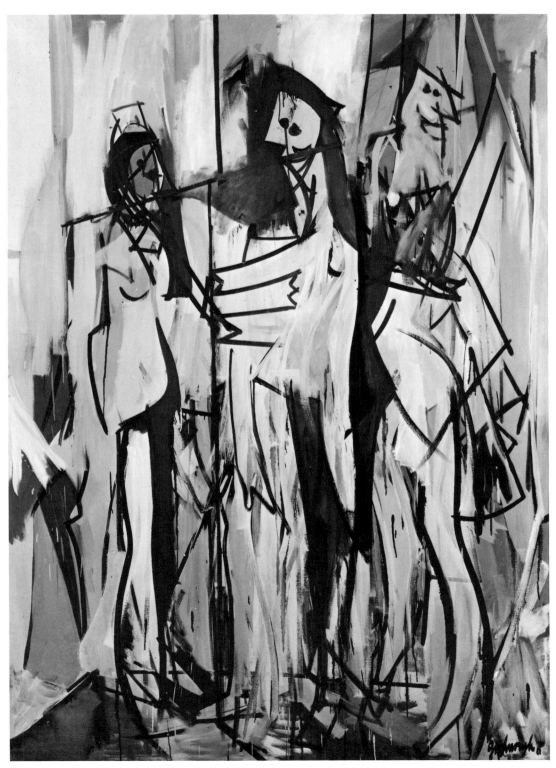

47.

the Subjects of the Artist School, and Studio 35 ceased to exist in April 1950. Before the last meeting, however, Goodnough proposed a three-day summing-up in closed session, where participants could review what had occurred during the season past. Most of his friends found it an appealing idea, and the last conference took place on the weekend of April 21, 1950, with only the artists present. Later, Goodnough, whose task it had been to record the dialogue of the final meeting, edited the material (with Motherwell and Reinhardt) for publication in 1952 under the title of *Modern Artists in America*.

The forums were rewarding for Goodnough. "I liked what the Abstract Expressionists were doing," he said. "I liked the freedom of the work. They had gotten away from just looking at a model, copying one, and went off in a completely different direction. . . . The first generation of Abstract Expressionist painters were the ones who influenced my direction. . . . I think it was the freedom of the way they . . . worked."

It was natural, given the circumstances, that Goodnough would be drawn to the expressive power, the freshness, and the audacity of the Abstract Expressionists. They had achieved an artistic breakthrough of monumental proportions and Goodnough had been lucky enough to share some of the excitement with them. He made good use of the opportunities these acquaintances provided, visiting studios, taking notes, and interviewing in depth ten of the most important practitioners of the Abstract Expressionist school. In doing so, he accumulated a wealth of original source material for use in his masters thesis at N.Y.U., entitled *Subject Matter of the Artists*, which he completed in the spring of 1950.

Many of the statements made by the pioneer Abstract Expressionists were confusing and at times ambiguous. Despite these inconsistencies, they reveal some fascinating early insights into the feelings and the thoughts of the leaders of Abstract Expressionism in New York. Baziotes, Motherwell, Gottlieb, and de Kooning generally represented

48.

48. *Seven*, 1961
Ink on paper, 10 x 10″
49. *One*, 1961
Ink on paper, 4 x 8″

49.

50. *Abstraction*, 1961–62
Acrylic and oil on canvas, 60 x 68"
51. *Collage*, 1960
Paper collage, 8 x 10"

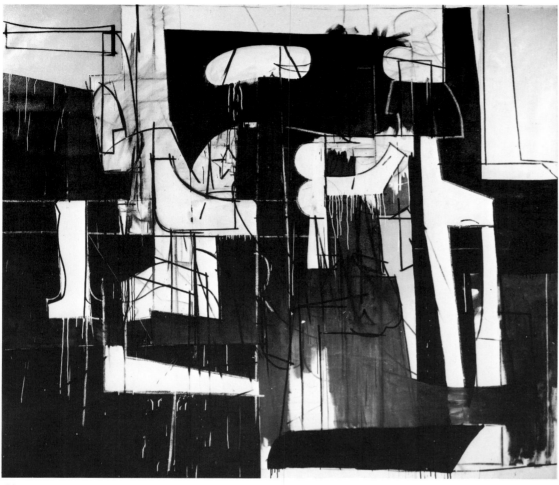

50.

the traditional thinking of the group, while Newman, Rothko, and Pollock were more antitraditional in their orientation. William Baziotes said that by dealing with poetic emotions, he sought a response "outside the prosaic or banal experience of daily life. . . . There is nothing mystical in contemporary painting," he said. "By viewing painting from Paul Cézanne to the present we find a gradual development toward abstraction or toward what might more nearly be termed a broader view of content. There is then no break with tradition, but only the logical development of paintings which is in keeping with the times."[9]

Because Robert Motherwell had participated in long discussions at the Subjects of the Artist School, Goodnough was not surprised to learn that Motherwell thought it odd for an artist to draw from nature. "His painting comes from imagination and memory," Goodnough wrote of Motherwell,

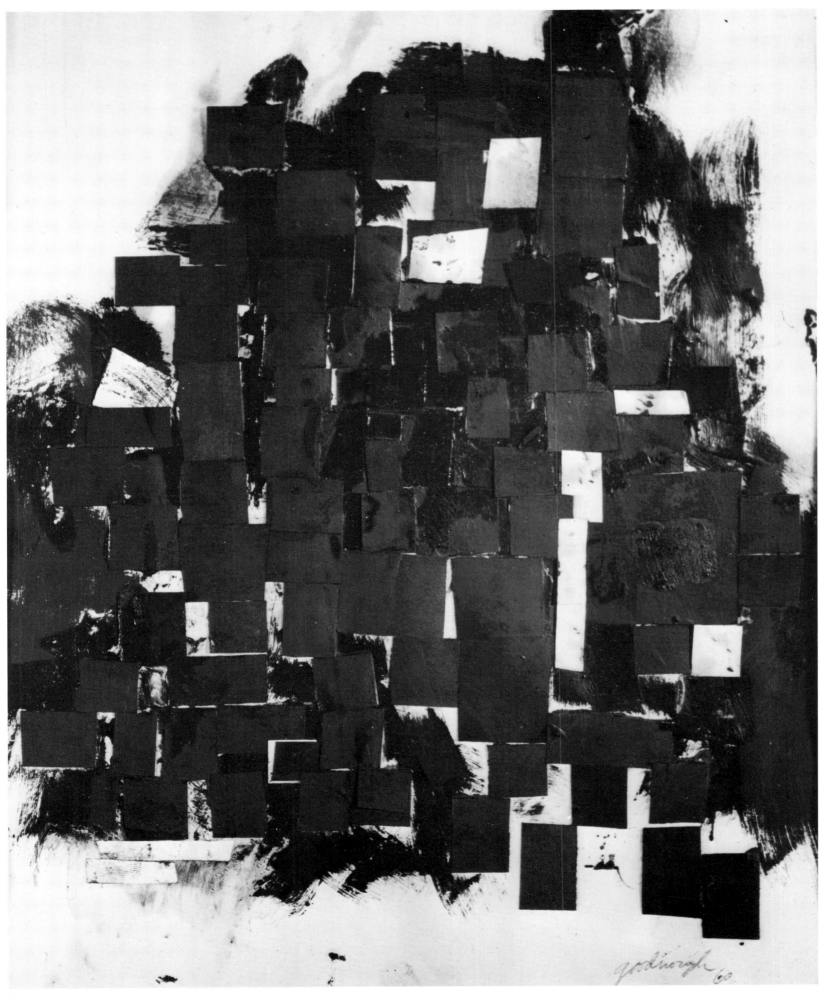

51.

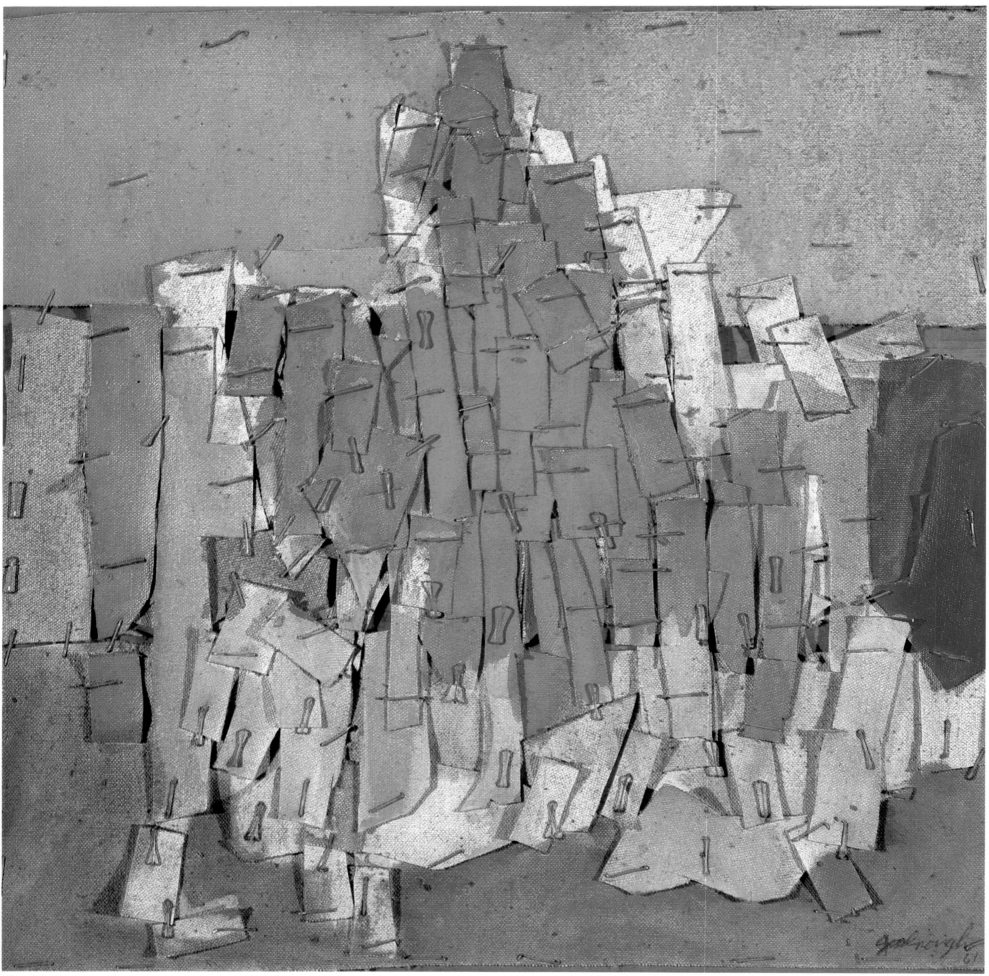

52.

who had never spent hours copying models and still-life groups in art classes as others had done. Motherwell honestly believed that the idea of representation that sometimes hindered artists had nothing to do with him. More importantly, perhaps, Goodnough was impressed by the intensity of Motherwell's beliefs. "Only to the degree that one is fanatical about an idea is he successful with it, and only the fanatic accomplishes work of value," said Motherwell. "There must be total indifference to how far behind the public is, and there must be no concessions."[10]

Unlike Motherwell, Adolph Gottlieb had worked from models for years. In the late 1940s, however, he also discovered that he could paint more effectively by relying upon his own imagination and memory and by using something that did not originate with a model or in nature. "This was a deliberate act on his part to satisfy an unconscious need. Gottlieb decided to use rectangular compartments on his canvases in order to project different images on a single surface," wrote Goodnough. "At first he thought he was selecting significant parts of objects to evoke images, those having emotional meaning to him, but later he found he was using images not as parts of existing objects, but as coming from a subconscious source, and he felt it was inevitable that he should use them."[11]

Gottlieb told Goodnough he would like to paint something he was not sure would be art in the accepted sense. "When you do not depend on tradition," said Gottlieb, "you must develop a new kind of assurance which depends upon your own capacities." According to Gottlieb, so-called academic art originated in and had stagnated from the lack of this kind of security.[12]

"It is usually a mistake," said Gottlieb, "to try to follow the non-objective trend." Association of ideas had to be a part of all painting. The *kind* of association is important, and he emphasized the word *kind*. Artists should be aware of this. There may be an association in terms of inward experience as well as associations outside of human beings, he said. The Abstract Expressionist painters were not eliminating

53. *Landscape with Figures*, 1961
Oil on canvas, 24 x 36"
Herbert F. Johnson Museum of Art,
Cornell University, Ithaca, New York
Gift of Dr. and Mrs. Aaron H. Esman
in memory of Edith and Maurice
Mencher
54. *Seated Horse*, 1961
Oil on canvas, 54 x 54"

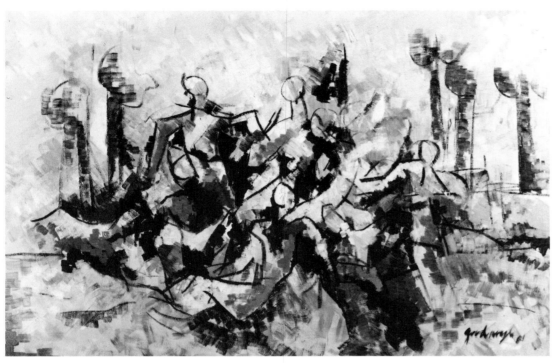

53.

subject matter, they were dealing with it in a manner never used before. Free assocation, said Gottlieb, is a way of going to an "inner nature" that may not be visual but which is, nevertheless, part of experience.[13]

Willem de Kooning was considered by most younger artists to be one of the most inspirational figures in the Abstract Expressionist movement, a man who was always accessible to young artists, and a person genuinely admired as a painter because he constantly ventured beyond the boundaries of the already known. Goodnough was surprised to learn de Kooning did not think of himself as an innovator, or even of innovation as being valid in 1949. "This is the end of a period in painting," de Kooning said, "but within this period are the beginnings of a new one."[14]

De Kooning saw artists in an extremely fortunate position as America entered the second half of the twentieth century. "There is no one to limit his freedom," said de Kooning, "because few people understand the frontiers where the artist walks." "De Kooning tries to express those values most meaningful to himself," wrote Goodnough, "and to satisfy himself only. Somewhere, de Kooning feels, there will

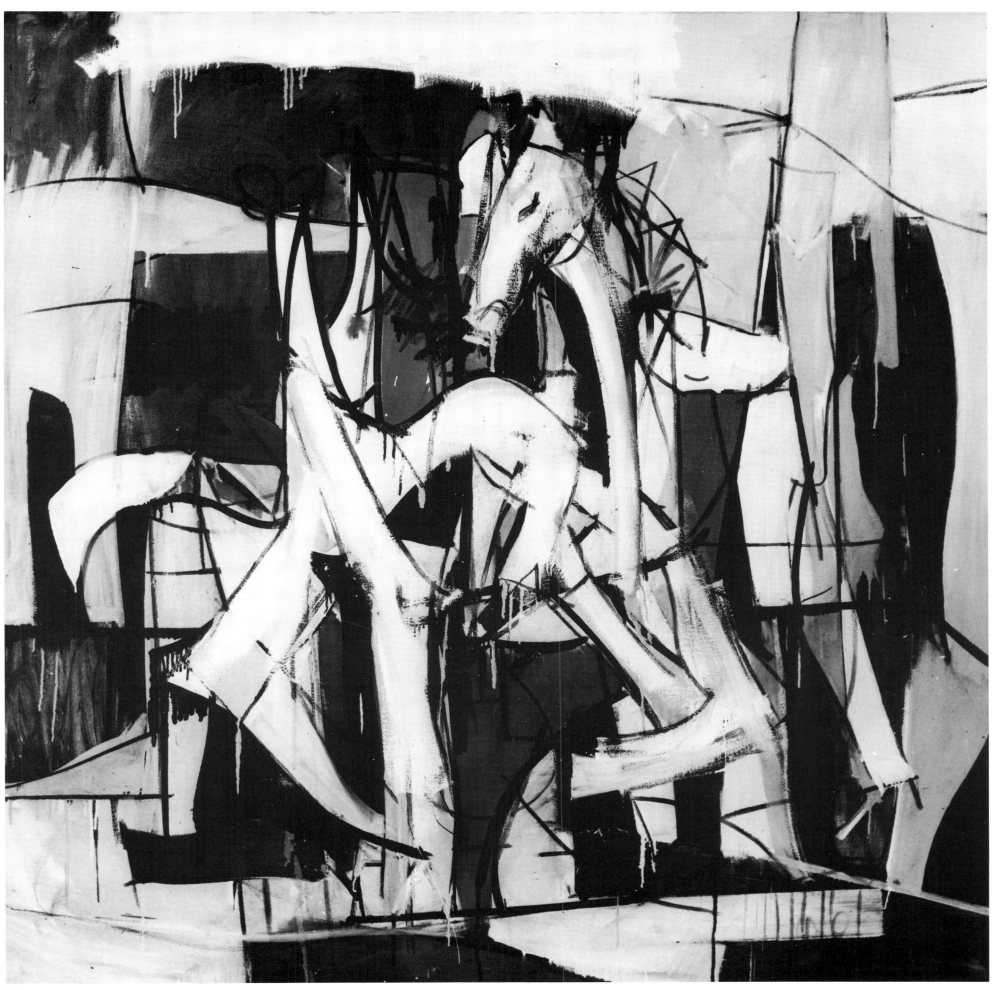

54.

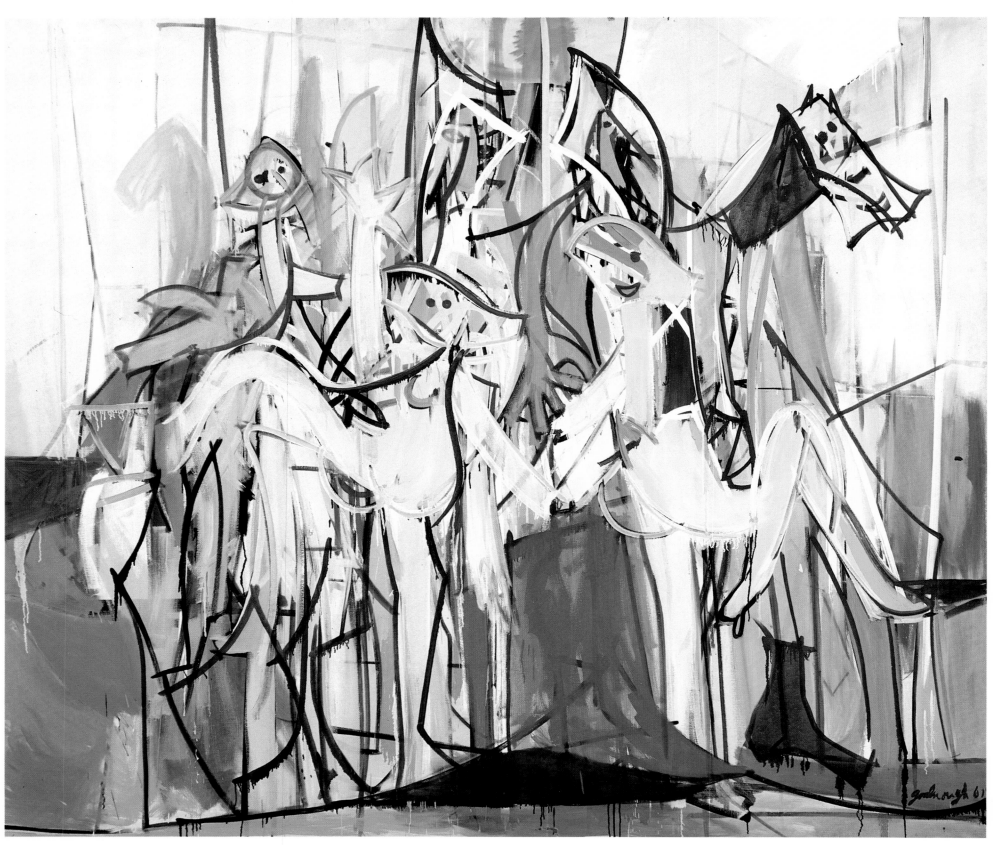

55.

55. *Abduction XI,* 1961
Oil on canvas, 72¼ x 84⅜″
National Museum of American Art,
Smithsonian Institution, Washington, D.C.
Gift of S. C. Johnson & Son, Inc.

be those who will react to his paintings, but he must not be concerned with that."[15]

Barnett Newman, one of the most extreme antitraditionalists in the group, described himself to Goodnough as a person in exile. "I believe in exile," he said, "a self-imposed exile. As I, as an artist, am separate from the world, so a picture is separate from the world of things." Newman liked to compare himself with a composer who makes diagrams for other musicians to interpret and play, yet Newman viewed his own work as being far more difficult than a composer's. "A painter like me has to make the instrument and, while making it, play it at the same time."[16]

To Newman, the act of painting and the bringing into existence of a work of art were the same process. Newman "has to take a brush and 'fight it out,'" wrote Goodnough, "and he is about the only one left who has to work while composing and acting at the same time."[17] A person who had never encountered a Newman painting might have expected, after listening to Newman, to see a wildly busy surface, something of a gestural battlefield. Instead, Newman's canvases of that period were usually of a single color with a shiny line of the same color painted down the middle. His was a starkly simplified expression.

Mark Rothko mentioned the composer Wolfgang Amadeus Mozart as the finest example of a person employing the clarity of an idea in his work. The great Austrian's ideas were so pure, said Rothko, that his compositions contained no feeling of nostalgia or reference to previous experiences. To Rothko, clarity in painting also depended upon the elimination of anything dealing with an association or any reminder of previous attachments. References to outside experiences interfered with Rothko's complete involvement with the particular problem at hand. Rothko said he desired to create paintings that "achieve complete clarity of idea, in which there can be no doubt as to my intention. . . . Any reference to an illusion of space had to be eliminated."[18]

Jackson Pollock was the most publicized and controversial of the Abstract Expressionists and perhaps best sym-

56. *Ulysses*, 1961–62
Oil on canvas, 78 x 78"
57. *OGO*, 1962
Oil on canvas, 108 x 108"

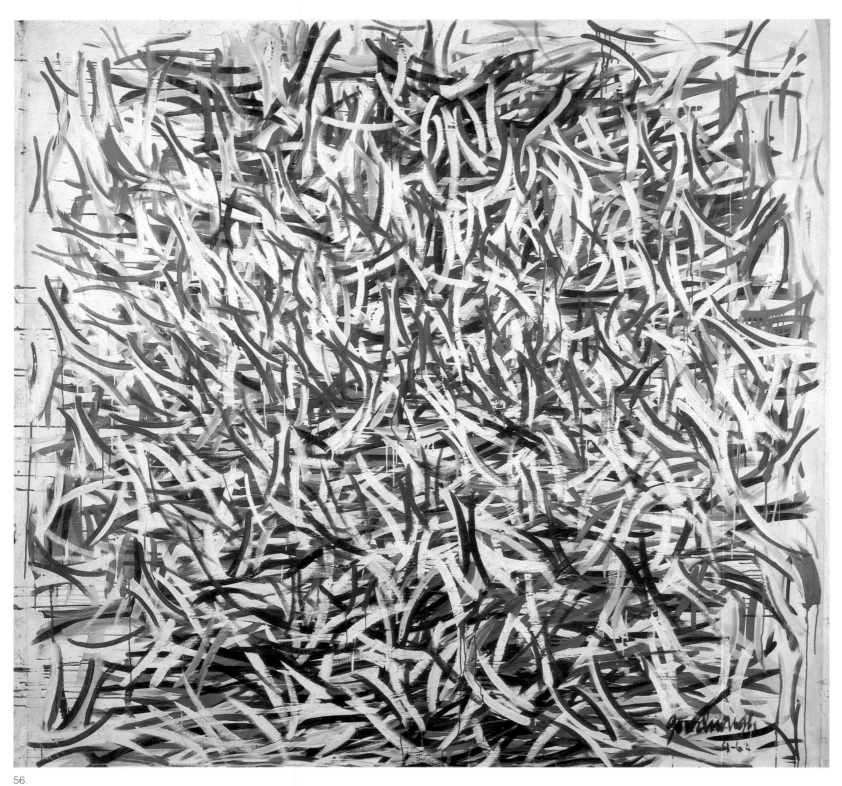

56.

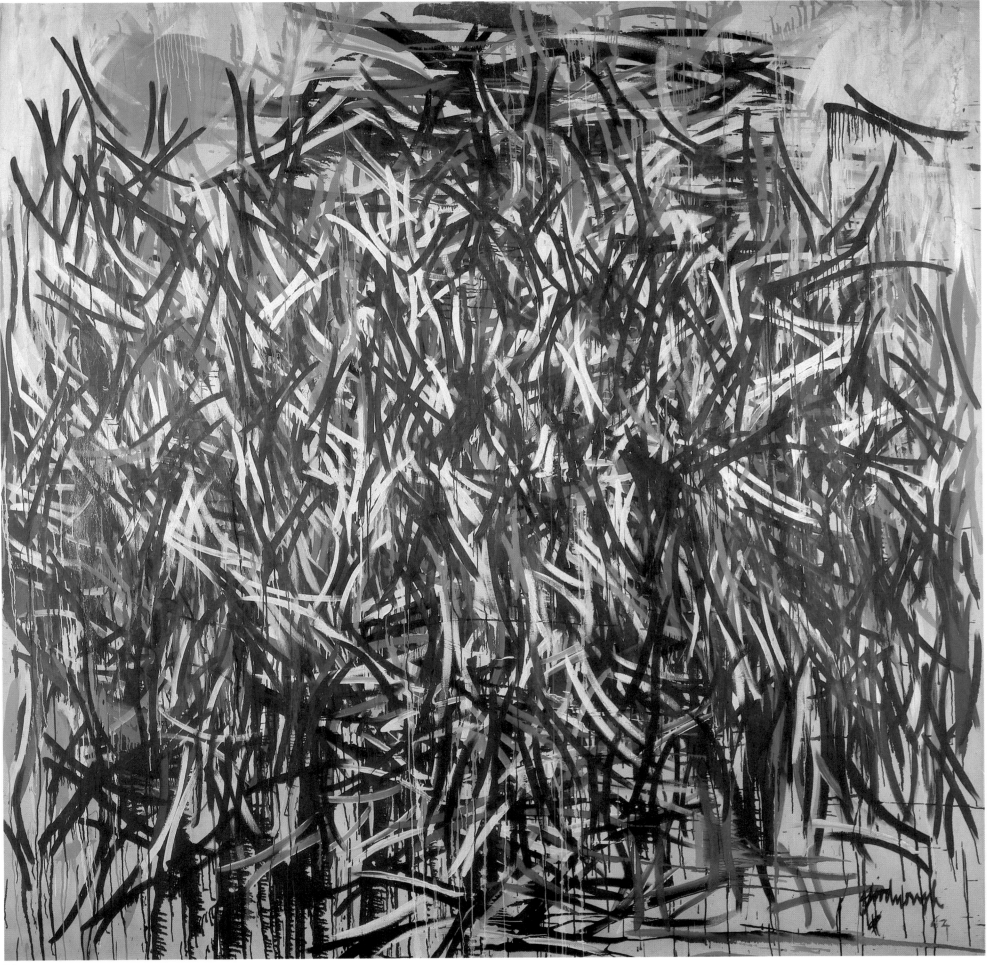

57.

58.

bolized the group's feeling of liberation and passionate commitment to the new art. Goodnough recalled Pollock as being quiet, not too talkative, and extremely polite and thoughtful. "He gave the impression of being a very strong person—a big physique, big strong hands, you know, he was really a rough kind of person, in a way, but still a very gentle personality. What impressed me most about Pollock," said Goodnough, "was the freedom with which he approached what he was doing. He hadn't always worked that way." Pollock believed it was unnecessary for a painter to verbalize about his work. "It is important to keep working," said Pollock, because "what I paint will tell in the long run, not what I say about what I do."[19]

Pollock had gallon cans of paint, usually enamel, scattered throughout his studio. He would study a canvas for a while before beginning, smoke a cigarette, then take a big, stubby brush or stick, dip it in the color nearest at hand and, with a rapid movement of his wrist, arm, and body, allow the paint to fall in a variety of rhythms over the surface of the canvas lying on the floor. "Pollock depends on the intensity of the moment of starting to paint to determine the release of his emotions and the direction the picture will take," wrote Goodnough. "No sketches are used." Pollock would then stop to consider what had been accomplished. The paint was allowed to dry, and Pollock would nail the painting to the wall. Weeks might pass before Pollock again felt close enough to the picture to continue with it. This long period of study, according to Goodnough, was a time for "getting acquainted" with the canvas. The process would then be repeated, after which several more weeks would pass before the painting was given renewed attention. It was then time to decide whether to go "back into it," or decide that it was finished. Pollock's paintings were never painted from beginning to end, they were the result of a long laborious process. Pollock believed a painting had to become "concrete"; it had to exist on its own before it could be considered finished. "He does not know beforehand how a particular work of his will end," wrote Goodnough. "He is

59. *Abstraction X*, 1963
Oil on canvas, 84 x 84"
Whitney Museum of American Art,
New York
60. *Figure Abstraction*, 1963
Oil on canvas, 82 x 110"

impelled to work by the urge to create and this urge and what it produces are forever unknowable."[20]

The people at N.Y.U. liked Goodnough and hired him to teach painting—mostly portraiture—after graduation. Life appeared not to have changed much, and the sense of artistic community among the painters remained about the same. De Kooning, Kline, Reinhardt, and several others organized yet another club, this time at 39 East 8th Street, and referred to it as simply "The Club," or "The Eighth Street Club," or sometimes "The Artists Club." It again provided a forum where artists could share and support each other, but it was larger than the previous groups and Goodnough thought relationships had become more social than aesthetic. "There was just too much talk and not enough painting in my life in those days," he said. Somehow, with teaching and the need to paint, the newest club seemed unrewarding and time consuming, and Goodnough tired of it.

These were the years he also reviewed exhibitions for *Art*

59.

60.

61.

61. *The Boat Trip*, 1962
Oil on canvas, 79⅞ x 90⅛"
The Solomon R. Guggenheim Museum, New York
62. *Moonlight Sail*, 1962
Acrylic and oil on canvas, 36" diameter

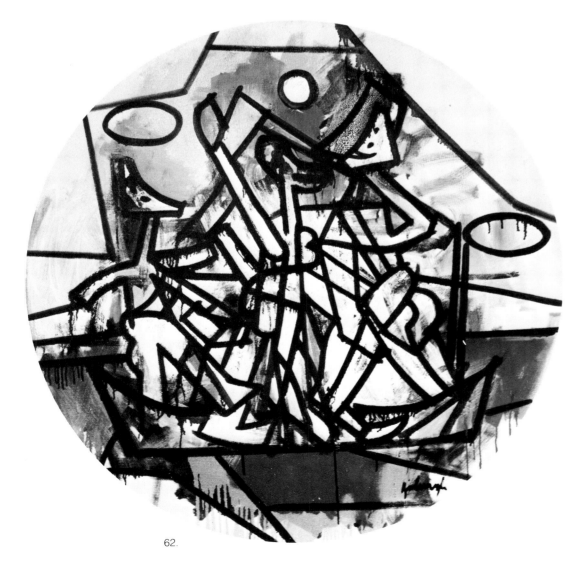

62.

News, a job he gave up because, as he explained: "You see so much painting, you begin to wonder why anyone should paint anymore. Aren't there too many already?" Happily, though, seeing a really outstanding work tended to cheer and encourage him. "I must paint good work!" he would promise himself; then it was back to the studio to paint.

Goodnough still felt the need for more freedom to paint, so he left N.Y.U. in 1953, and took a part-time job at the Fieldston School teaching art and shop—mostly shop. During the years that followed, Goodnough ran a newsstand with George Franklin, a young playwright, operated a soda fountain with several other friends, took odd carpentry jobs, and did everything possible to keep painting, until 1960, when he was finally able to support himself through the sale of his work.

The now famous "New Talent" exhibition at the Kootz Gallery in the spring of 1950 provided Goodnough an opportunity to show work with an impressive group of artists whom Sam Kootz was introducing for the first time. The exhibition, organized by Clement Greenberg and well-known art historian Meyer Schapiro, included paintings by Franz Kline, Alfred Leslie, Esteban Vicente, Grace Hartigan, and Larry Rivers. That same year, in October, Goodnough had a small one-person exhibition in a little room at George Wittenborn's art bookstore.

Although the Wittenborn exhibition went almost unnoticed, those who did see it were pleasantly surprised. Abstract images had been created almost entirely through the spontaneous use of the material itself. Goodnough had made imaginative compositions by taking advantage of the accidental surface movement of ink splotches on paper that had been crumpled, blotted, and reworked into pleasing though wrinkled surfaces. By adding washes of deep ultramarine and light gray to the strange texture, he captured a delicate mood reminiscent of slowly moving clouds or the mystery of disappearing smoke. Goodnough also presented a series of brilliantly colored tempera sketches in which flat forms had been divided by crisp, diagrammatic, crisscrossing lines to

63. *Circle in Reds*, 1962
Oil on canvas, 58" diameter
64. Robert Goodnough, 1962
65. *Running Horses*, 1963
Oil on canvas, 32 x 40"

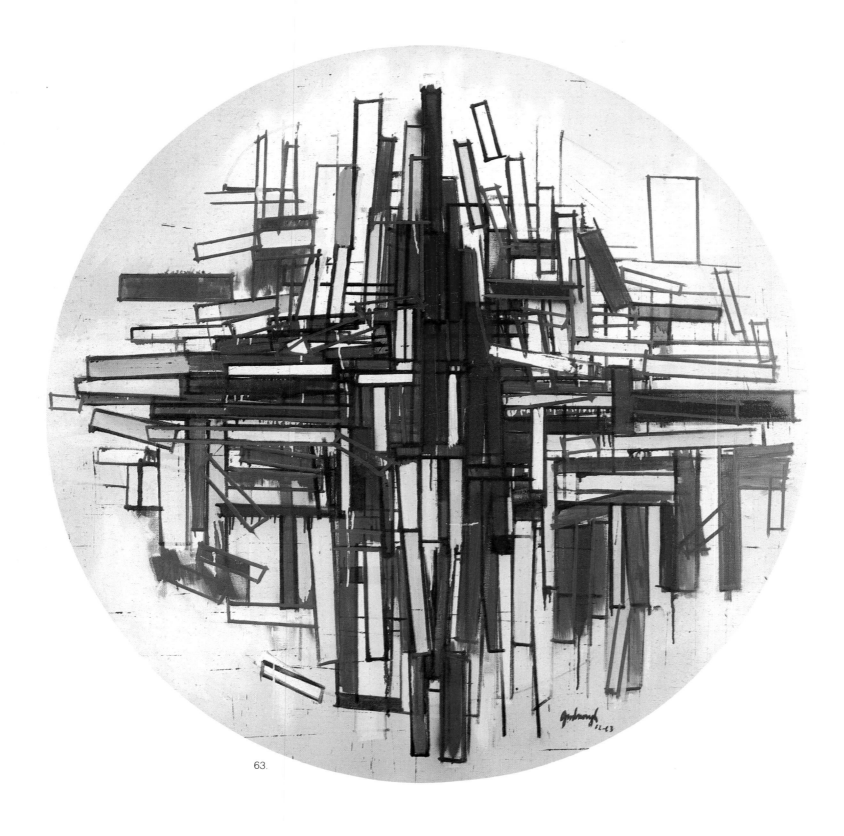

63.

64.

produce carefully calculated patterns. This modest exhibition showed great promise, indeed.

Tibor de Nagy opened a new gallery in December 1950, with John B. Myers as its director. Myers had been editor of *View*, a Surrealist magazine; he had run a puppet theater; and was known as an enthusiastic supporter of everything experimental in the arts. Among friends, he was referred to as an impresario for the avant-garde, "a sort of young American Diaghilev."[21] Myers turned to Lee Krasner, Pollock, Clement Greenberg, and Tony Smith for advice because most of the major American abstract artists were already represented by Betty Parsons, Charles Egan, and Sam Kootz. Greenberg and Smith recommended Goodnough, as well as Frankenthaler, Rivers, Leslie, Grace Hartigan, Robert de Niro, and Leatrice Rose. There were of course others who exhibited at the de Nagy Gallery during the fifties, such as Elaine de Kooning, Friedel Dzubas, Kenneth Noland, and Fairfield Porter, and, in time, the new gallery developed a strong following.

Two years later, Goodnough made an outstanding debut

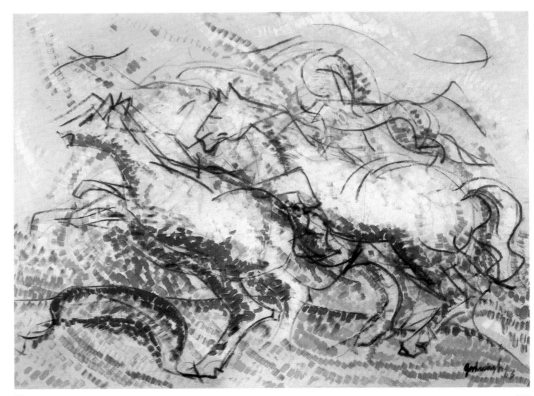

65.

66. *Abstraction*, 1962–63
Acrylic and oil on canvas, 90 x 138"
67. *Battle of the Sexes*, 1963
Oil on canvas, 108 x 216"
The Lannan Foundation, Palm
Beach, Florida

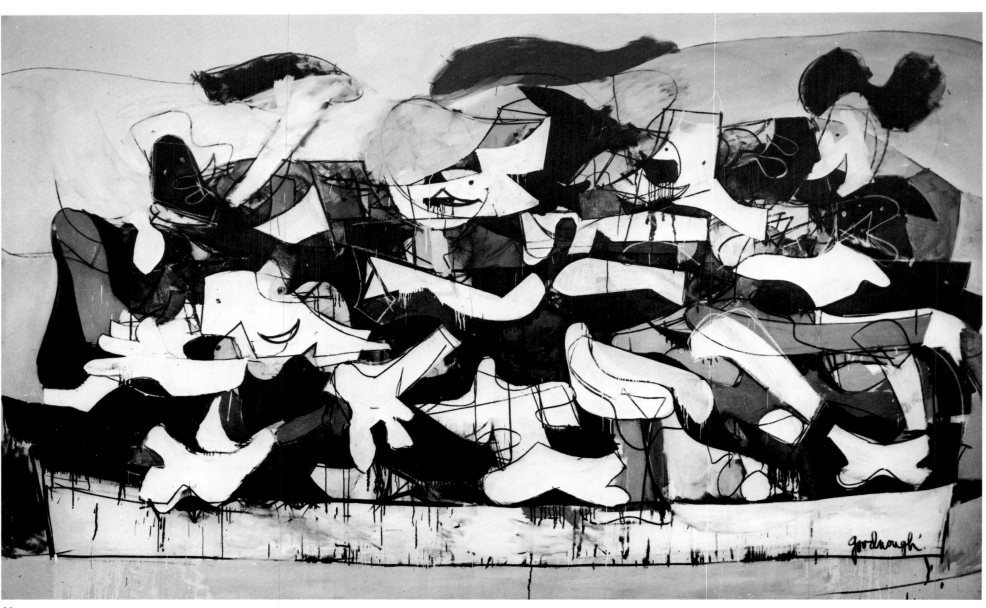

66.

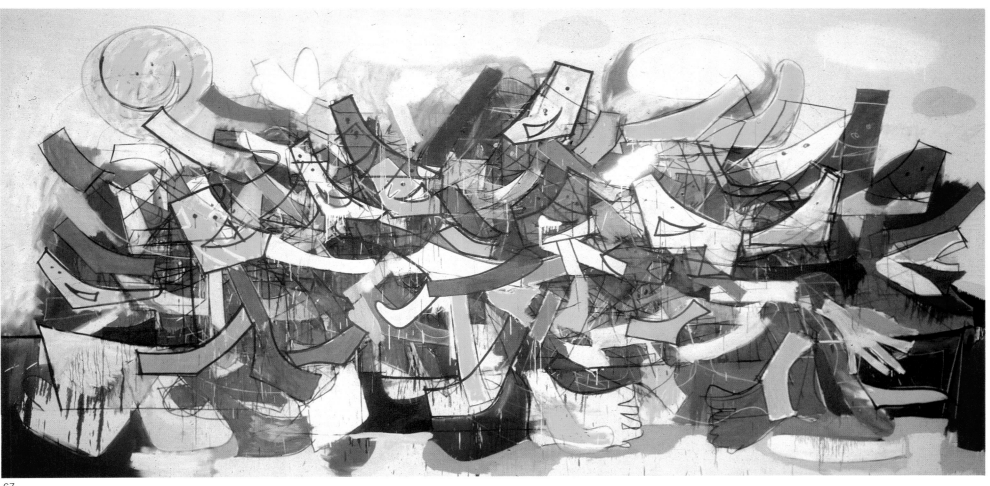

67.

at the Tibor de Nagy Gallery with his first major one-person exhibition in New York, a selection of intriguing Abstract Expressionist paintings featuring a wide diversity of expression. These powerful abstractions appealed to critic Fairfield Porter, who reviewed the exhibition for the February 1952 issue of *Art News*. Porter, an artist himself, liked what he saw but realized the work might confuse others. Therefore, he asked his readers not to be too hasty in judging the paintings, suggesting instead that they draw upon their own imaginations when looking at the show. There are many ways of interpreting forms, he reminded them, just as two people might draw different conclusions upon seeing patterns of footprints in the snow, or listening to sad or happy music. Much of the feeling derived from such an experience depends on an individual's intimate emotions. "Goodnough's work," wrote Porter, "will strike you the same way."

The real strength of the early paintings came from the brilliance of Goodnough's palette. Most of the canvases were filled with whirlwinds of short, intense, colorful strokes that converged toward a seemingly immense galaxy somewhere out in the universe. To produce this effect, Goodnough had left untouched large areas of raw canvas around the edges in a daring attempt to create impressions of formations spinning freely through space—something most Abstract Expressionists had hesitated to do. And it worked! What is more important, the unfinished canvas did not reduce the overall surface tension, an element crucial to gestural painting. There were many good works in the show, but *Number 4*, also called *Pegasus*, was probably the best. One could see in it vestiges of a writhing winged horse lying almost hidden beneath a network of baroque curves that possessed much of the same rich quality found in the work of the Italian master Gianlorenzo Bernini.

The most recently completed picture in the de Nagy show —*Number 8*—indicated that Goodnough had slowly begun to shift away from Abstract Expressionism. Tiny curved strokes, a little like Matisse cutouts, pulled and pushed and

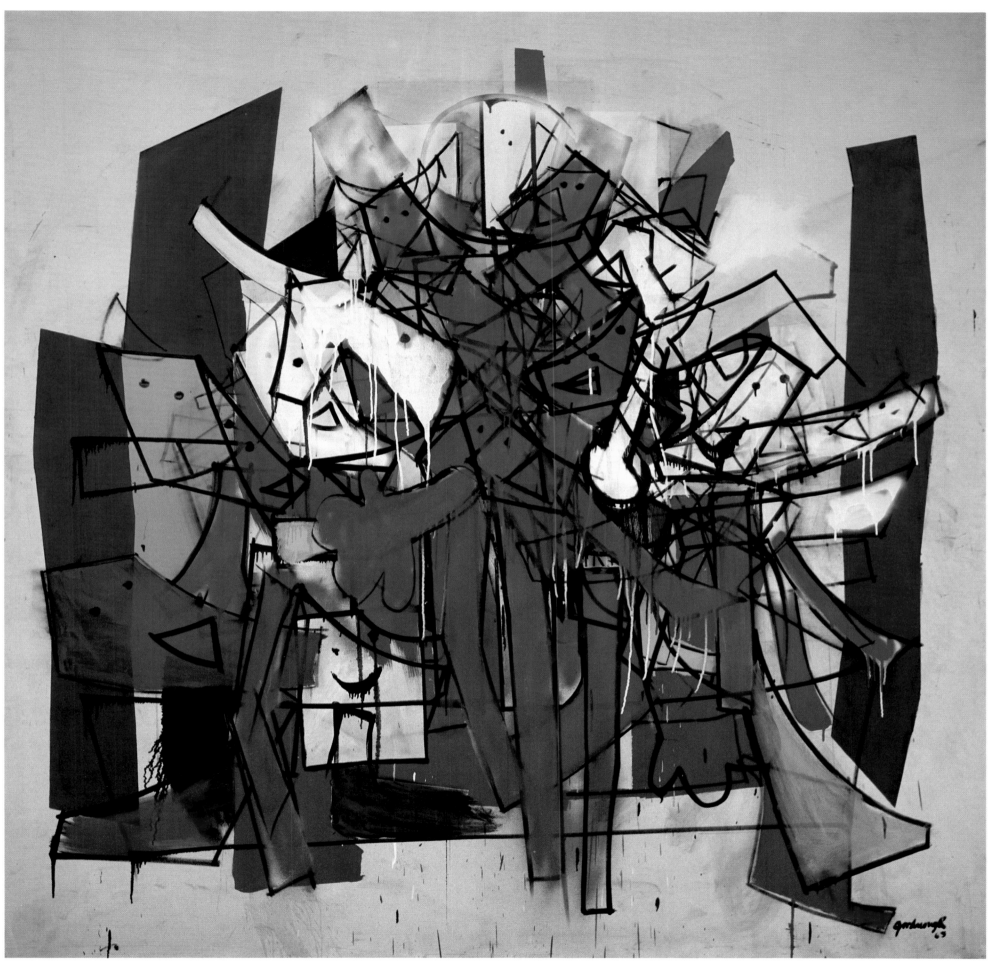

68.

69. *Circle P*, 1963
Oil on canvas, 38" diameter
70. *Circle in Gray*, 1963
Oil on canvas, 78" diameter

spread against the nervous rhythm of a blue-black field, almost as if the surface were a little map of heretofore unknown continents on the ocean's floor. In this curious piece of cartography the land and sea were interchangeable to the eye.

Several other ideas dominated Goodnough's thinking in the summer of 1952. He became more and more intrigued with the possibilities inherent in small collages and geometric shapes. "Collages had a lot of influence on my painting," he said. "By cutting out shapes and gluing them down, you get a certain clarity. Each shape has to be complete in itself when you cut it out of paper. I think it served to clarify my thinking and helped me a lot in developing my painting." The soft-hued paper, when placed on a neutral ground, suggested the kind of surface patterns one might see on the quiet, wind-stirred waters of a secluded pond, or the sensitive, changing designs of a slowly moving kaleidoscope. In the autumn of 1952, the products of these new interests vied for attention with the artist's more familiar calligraphy in his second show in six months at Tibor's gallery.

What had inspired Goodnough's interest in collage? Did the collages merely represent another of his many experiments? Or had some unexpected event triggered his imagination? The answer is simple enough: the forms owed their existence to a reconstructed skeleton of an ancient brontosaurus Goodnough saw while visiting New York's Museum of Natural History. Goodnough was enthralled by the long-extinct brute's elemental energy, perhaps because it seemed to symbolize, in many ways, much of what he had been seeking in his own work. The dinosaur became something of an obsession with him. He loved its primitive form, its massive strength,and the mystery surrounding its disappearance from earth.

Unlike those who accepted popular myths about the dinosaur being stupid, slow, or ill-adapted to its environment, Goodnough learned that it was really an efficient vegetarian, neither sluggish nor stupid, but quick-moving, agile, cunning, and ferocious, with a brain adequate for its needs. This

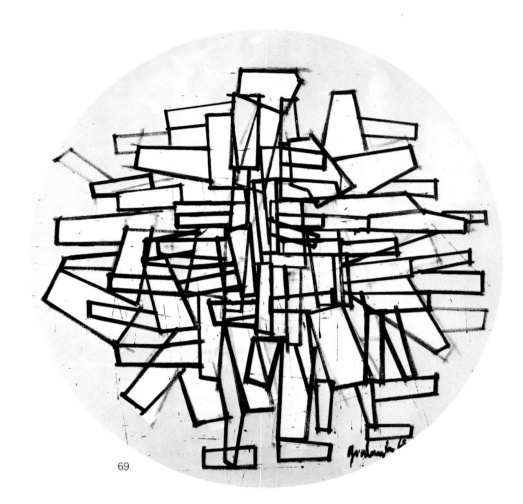

69.

70.

extraordinary beast had ruled the earth for more than 140 million years, longer than any mammal alive today, only to become extinct through some random ecological accident. Respect for this once powerful reptile fired Goodnough's imagination, and he set to work gluing small square strips of paper on a flat surface, selecting and accepting only those aesthetic elements most essential to his concepts. When changes were necessary, more paper segments were added, creating a slight relief effect. Some parts were left smudged or unfinished and without embellishment to add a sense of history to the work. By the time he had finished, most visible signs of the dinosaur had all but vanished, leaving only traces of its origin in the collage to be rediscovered, just as indications of its earlier presence on earth keep reappearing in nature.

In an almost simultaneous experiment, Goodnough drew upon the collage technique to construct several sculptures of dinosaurs in metal and cardboard. He also constructed human figures from lead and bolts and, later, created birds from plaster and scraps of steel. These were pleasing experiments, but nothing more. The collages, however, were tremendously fulfilling because, in Goodnough's hands, they evolved as a pictorial method in the tradition of the formal collagists who consider collage to be painting of a high order.

Because of the collages, his large canvases changed too. The whirlwind formations gave way to thickly brushed impasto surfaces massed rather heavily at the center and flaring outward toward the edges. Several of these paintings suggested the spirit of Chaim Soutine's late windswept landscapes; others were reminiscent of the deep furrowed fields and the troubled skies in many of Vincent van Gogh's paintings. By laying the paint on with short, functional brush strokes, Goodnough had begun to employ the expressive elements of Cubism, even though these paintings were not constructed cubistically.

Although the canvases were highly successful, Goodnough was unhappy with them. In his mind, they failed to

represent the direction he wished to take. Tony Smith dis-
agreed. Smith argued that the paintings were among the
strongest being created anywhere, and he tried to convince
Goodnough of this. Only Jackson Pollock appeared to have
developed more intensely in an area of painting where the
artist had to rely almost entirely on the "unknown." Smith
urged Goodnough to continue because he thought his talent
could "bear the shock." But Goodnough would not listen; he
chose instead to explore painting with a self-conscious and
critical deliberation that would not force him to rely so com-
pletely on an empirical approach.

At about the same time, Harold Rosenberg's historic es-
say, "The American Action Painters," appeared in *Art News*
(December, 1952), providing an aesthetic rationale for the
mystique of Abstract Expressionism then sweeping the
country. What the action painter put on his canvas, ex-
plained Rosenberg, was not just a picture, but a significant
event or act; indeed, he asserted, the act of painting "is the
same metaphysical substance as the artist's existence."

But Goodnough was not inclined to become an artistic
actor seeking, through the act of painting, to make an auto-
biographical confession on canvas as some "existential
matador" might do. He wanted to remove all evidence of his
own personality from the canvas so the viewer could con-
centrate on the work, not the artist.

It is possible that Goodnough also felt the need to be
released from newly imposed conventions that were being
formalized by first generation Abstract Expressionists. He
preferred to be free of so-called "crisis content" gestural
painting, with its apparent carelessness and violence, minor
accidents, painterliness, and the dragging of the brush. He
did not want his canvases to become an arena of gesture
and emotion where the "act" of painting became an event,
an event supposedly inseparable from the biography of the
artist himself. To take such an independent stand against
Abstract Expressionism was to go against the growing tide
of dominant taste in New York's art world. Yet Goodnough
did not hesitate to choose what he referred to as "ideas"

71.

72. *Abstraction*, 1963–64
Acrylic and oil on canvas, 60 x 120"
73. *Adventure II*. 1963
Acrylic and oil on canvas, 68 x 80"

72.

73.

74. *Excursion*, 1963–64
Oil on canvas, 96 x 216"
Syracuse University Art Collections,
Syracuse, New York
75. *Abstraction*, 1964
Oil on canvas, 108 x 312

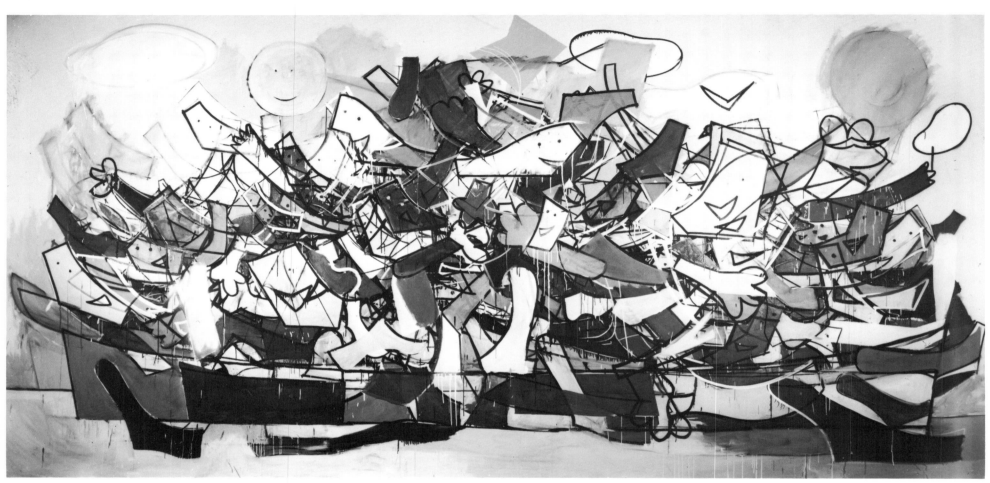

74.

over "crisis content," because "ideas," accomplishments, and the accumulated knowledge of the past were most important to him. "It isn't just a matter of what you want to do yourself," he wrote, "but what you *must* do . . . that's what painting has become. As I see it," he explained, "the past provides . . . examples of high accomplishment, but not models to copy. I look at much art of the past; all kinds, mostly in the form of reproductions, yet I never actually copy."[22]

Goodnough eagerly sought to absorb the lessons of the great painters, past and present, and to assimilate the knowledge into a painterly style of his own. Picasso's canvases inspired him because he liked the Spaniard's inventiveness and free use of form. But Picasso was not the only one. Henri Matisse was another, although Matisse did not have Picasso's dynamic, almost brutal approach, which Goodnough preferred. Goodnough was also strongly attracted to the astonishing vitality of Peter Paul Rubens, and to the powerful images of Rembrandt van Rijn, whose enduring works still rank among the most magnificent ever created by man.

Tradition was obviously important to Goodnough. His

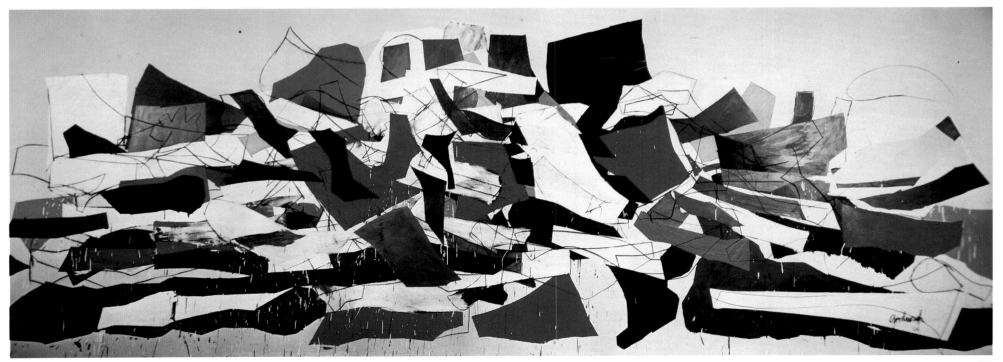

75.

76.

76. *Fragment II*, 1964
Oil on canvas, 10 x 14″
77. *Fragment I*, 1964
Oil on canvas, 12 x 12″
78. Robert Goodnough's Bleeker Street studio, 1964

work showed an intelligent, conscious use of tradition, proving that if an artist submitted to older disciplines, he could expand their scope and shape them into his own personal creative expression. This was apparent from the many phases through which Goodnough's work passed— often simultaneously—while he appeared to be involved with the basic principles of Cubism. True to the tradition he had established for himself, Goodnough kept moving ahead, studying and experimenting.

It soon became obvious that Goodnough's most intense interest lay in solving problems created by a painting's two-dimensional plane and the effect of depth—that illusory third dimension. In the tradition of the Cubists, Goodnough wanted to represent solidity and volume on a two-dimensional plane without converting the two-dimensional canvas illusionistically into a three-dimensional picture-space. He viewed color, as the Cubists did, merely as an exercise in form. Of his Cubist-influenced style, he said: "I try to uncube the 'cube,' to create a space which is neither recessive nor advancing, but just special relationships on a single plane."[23]

As time went on, one sensed a steady trend toward a somewhat tighter abstract vocabulary as he began to fill canvases with overt or underlying geometrical forms set amid a framework of black lines. He never painted out or hid the simple image he had started with even when the image had almost vanished. Viewers could frequently see a lurking dinosaur or a teeming city street lying within or just beyond

77.

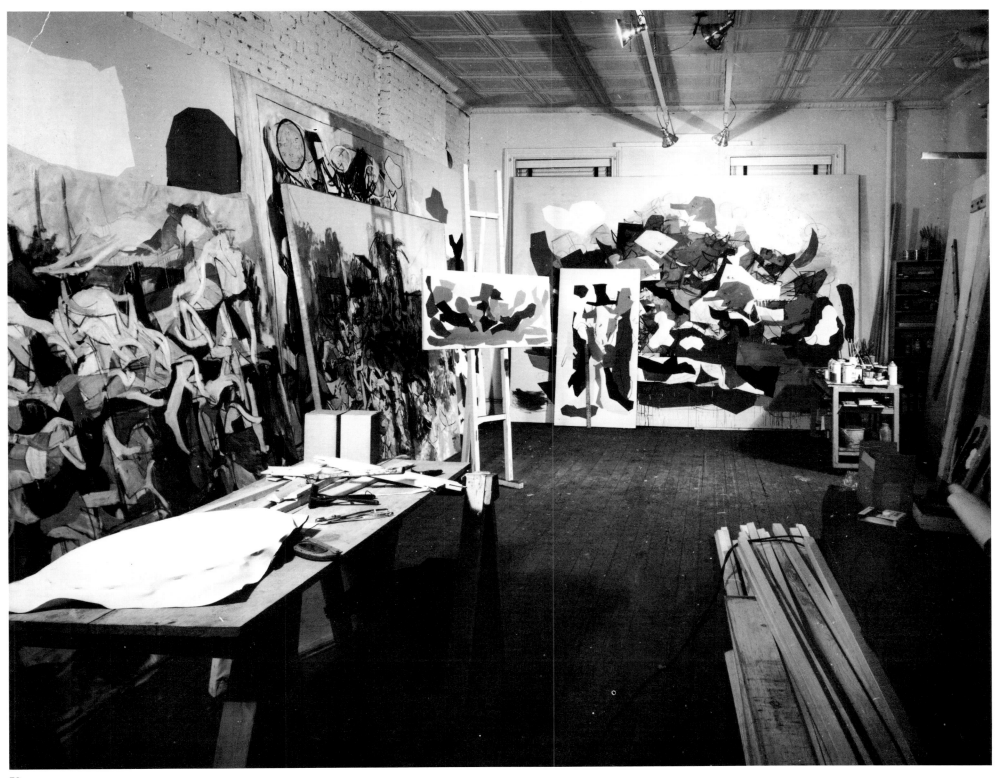

78.

79. *Rectangles II*, 1964
Oil on canvas, 60 x 60"
Collection Weatherspoon Art Gallery, University of North Carolina, Greensboro, North Carolina
80. *Rectangles III*, 1964
Acrylic, oil, and charcoal on canvas, 51 x 51"
Collection Martin H. Bush, Wichita, Kansas

79.

the intricate gridlike systems. Other things were apparent, too. In one picture, for example, a swastikalike construction in black, red, and white could be read into it, reminding many people of an image most had chosen to forget.

The field in some pictures came so far forward that it seemed barely dependent on the canvas itself. Several canvases were composed of circles that appeared to rest on tall thin legs. Although Goodnough did not intend for them to be fanciful, each of the circle and leg images appeared nonetheless to possess elements of a private fantasy. In *Toy Fair*, another large painting, lines and circles seemed to form figures joined in provocative relationships, when nothing like this had been intended, according to the painter.

80.

Frank O'Hara of *Art News* (March, 1954) saw in these paintings a witty seriousness and an individuality that was, at least to O'Hara, slightly "eccentric." Goodnough's work was much more than "witty" or "eccentric"—if anything, it showed a flair for the experimental. Indeed, as we have seen, he painted in several styles at once. "You have a feeling about Goodnough," wrote Lawrence Campbell of *Art News* (May 1955), "that fantasy could lead him in almost any direction." And that is exactly what Goodnough was attempting to do. "I was trying to experience the variety of approaches that different artists had used and I was trying to do it within my own feeling about art and my own interpretation of it by seeing how other artists approached problems," he said. "I tried some relationships with Mondrian, Picasso, and Pollock. I wanted to experience all of the different ways other artists had dealt with problems of painting. I felt that out of the experience would come my own style. It's kind of a process of growth. First you have to learn from other people."

Historian and art critic Irving Sandler summarized Goodnough's accomplishments in a book entitled *The New York School: The Painters and Sculptors*. "Following the examples of de Kooning and, to a lesser degree, Pollock," wrote Sandler, "Goodnough took as his points of departure the painterly, open scaffolds of Analytic Cubism and the tight compositions of the cleanly edged flat forms of the Synthetic phase which he loosened and opened up. Goodnough appeared to believe, as Greenberg later remarked, that the great achievement of the first generation was the 'grafting of painterliness on a Cubist infra-structure.' His aim was to further that achievement."[24]

Although Goodnough's canvases continued to show a remarkable variety of expression, as one can see in *Pan*, where no linear tracery exists, he was more concerned, as Sandler suggests, with achieving a sense of body and volume in his work. Cubist facets were used to produce the spirited percussive rhythms of *Seated Figure With Gray*, completed in 1957, and now in the collection of the Whitney

81. *Figure with a Green Hat*, 1964
Oil on canvas, 16 x 8"
The Snite Museum of Art, University
of Notre Dame, South Bend, Indiana
82. Robert Goodnough in his studio,
1964
83. *Man with a Hat*, 1964
Acrylic on canvas, 30 x 30"

82.

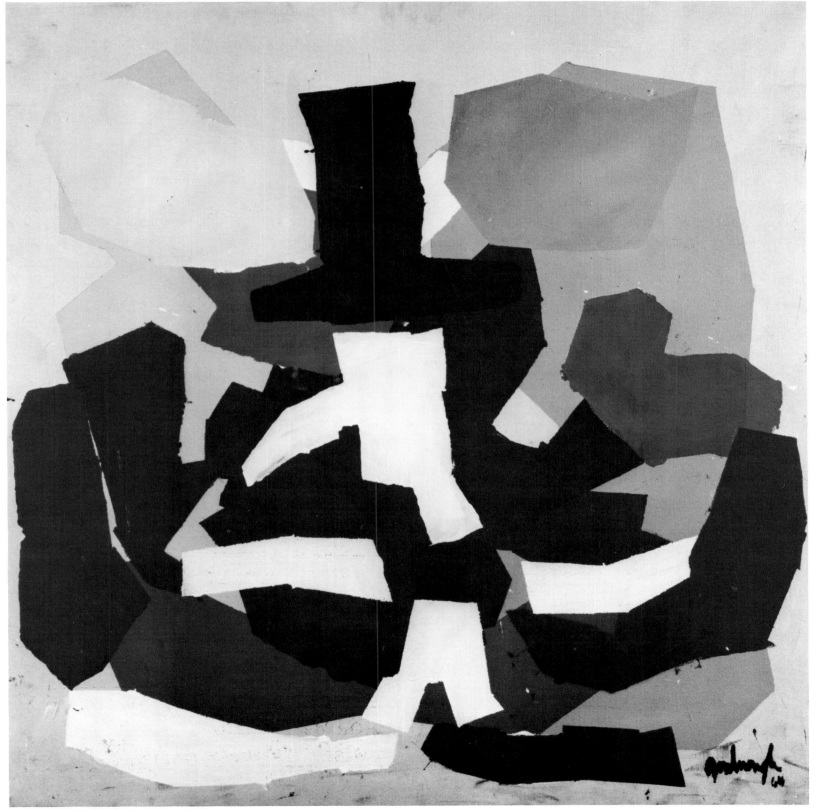

83.

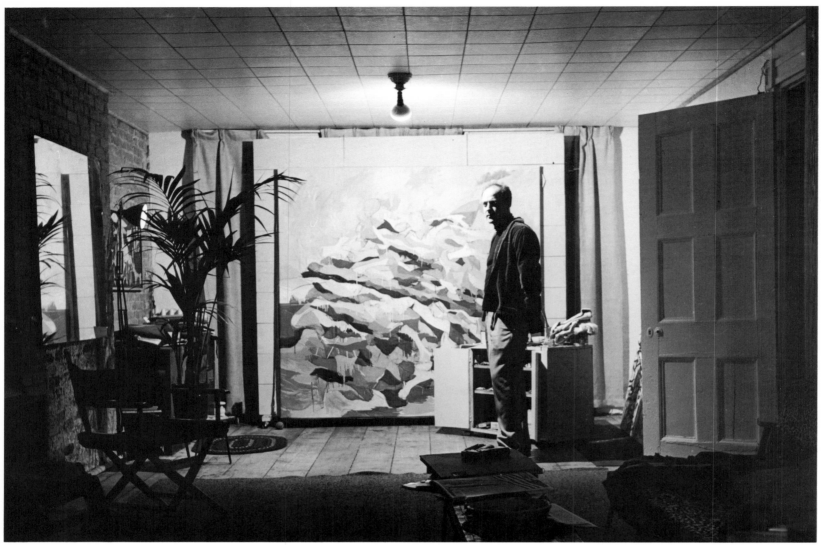

84.

Museum of American Art in New York. Goodnough started
with a sketch of a figure, flattened it (instead of going into
the distance beyond it) to make the sketch part of the whole
painting, and in so doing the figure ceased to have an inde-
pendent existence of its own. *Laocoon*, created the follow-
ing year in the manner of Synthetic Cubism, is a much more
brushy and extravagant work. Its pyramidal composition is
really a painted assemblage of expertly controlled colors
given greater solidity and strength by a strong supporting
drawing beneath; but the drawing does not compete with or
detract from the surface.

Goodnough was virtually abolishing traditional distinc-
tions between "abstract" and "figurative" painting by em-
ploying the figure as the source of his abstract forms. At
times his subjects were romantic individuals from out of the
old American West—Calamity Jane, a marksman, a bandit,
a cowboy; while on other occasions themes came from the
classics, such as Odysseus and Laocoon. There were addi-
tional sources, too: paintings by Leonardo da Vinci, Peter

84. Robert Goodnough in his West
4th Street studio, 1965
85. *Fragment IV*, 1964
Oil on canvas, 8 x 8"
86. *Abstraction*, 1964
Acrylic and oil on canvas, 28 x 66"

85.

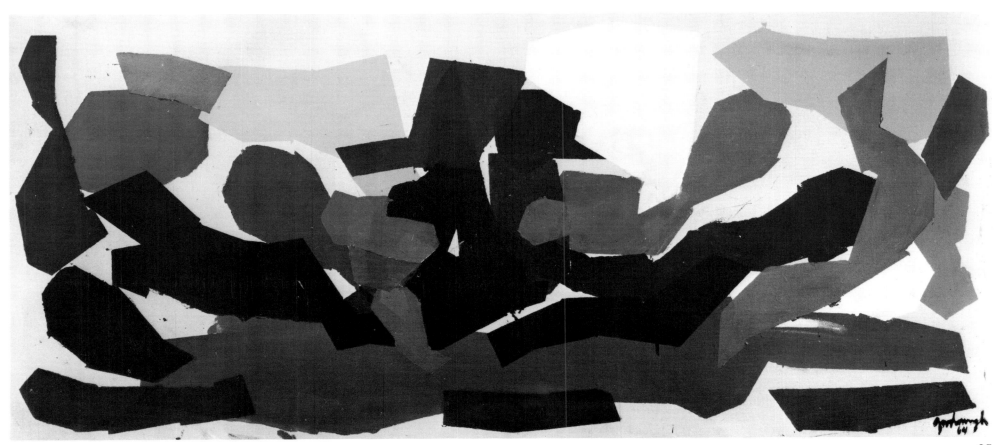

86.

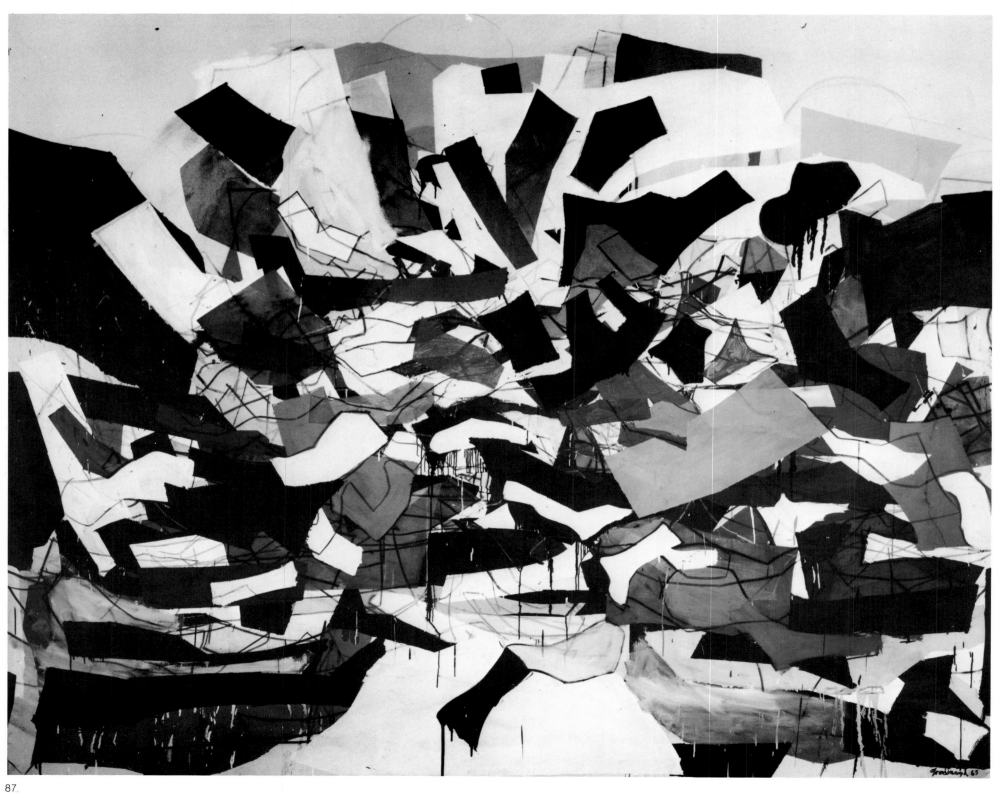

87.

87. *Bomb II*, 1965
Acrylic and oil on canvas, 84 x 108"
88. *Abstract Colors*, 1965
Acrylic and oil on canvas, 72 x 120"

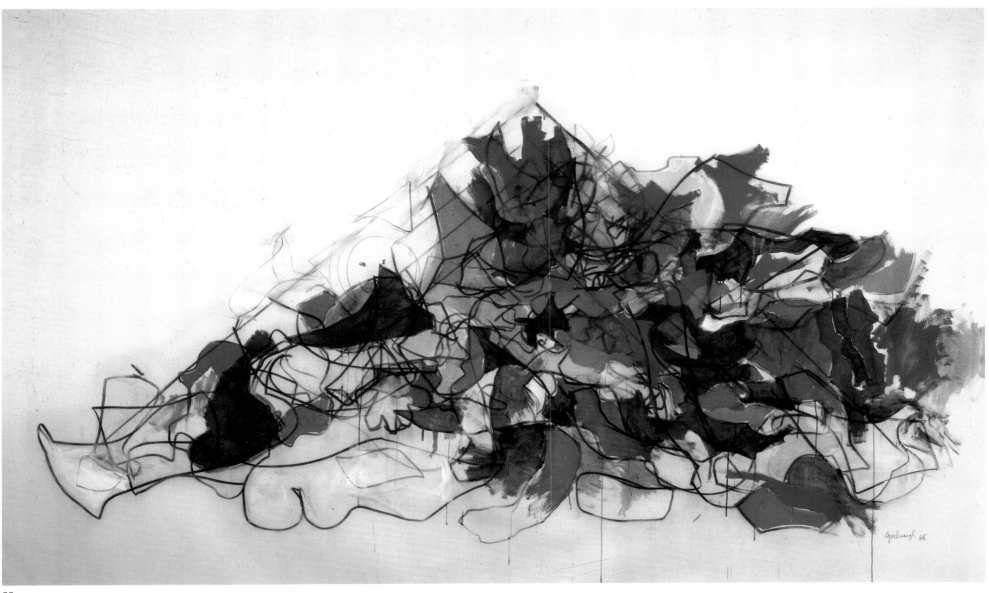

88.

Paul Rubens, Paul Cézanne, Georges Braque, and Pablo Picasso.

"There is a feeling in the best work of American painters of the 'wild' which has been the heritage of this country," wrote Goodnough. "The covered wagons, the Indians, the rolling prairies, the immense forests and mountains are part of one's memory. Thoreau's belief that dullness and tameness are the same, that it is the wild that attracts us in literature, seems also to apply to painting."[25] *The Frontiersman*, a painting Goodnough worked on for nearly a year, is a perfect example of a theme drawn from the romantic legends of the American West. The open linear grids spotted with color are reminiscent of Picasso's *Ma Jolie* (1911–12), but somewhat more rectilinear and suggestive of a Mondrian façade. It is a comprehensive version of Analytic Cubism, in which motion is imparted by the compression rather than the expansion of the theme.

In a more emotional style, Goodnough explored the use of tortuous, undulating strokes to create organic forms possessing calligraphic excitement and an aggressive sense of movement, something like the motion of water or flames. *Summer III*, dated 1959, is an example of this closely woven, loosely worked technique where multicolored strokes and forms flow and dart across the canvas. The shapes are merely areas of color because Goodnough saw color and form as the same thing. In fact, he coined the expression "color-shape" to describe some of the elements of his paintings. *Picnic* is closely related to *Summer III*. It is airy and gay and expresses the joy and happiness of life often associated with summer in the country. Both originated from an inner conflict that troubled Goodnough at the time; he loved rural life, particularly in the summer, but was unwilling to leave the city. "I would like to live in the country in the day," he said, "and the city at night." These paintings illustrate the various degrees of abstraction and representation found in Goodnough's work during the period. And with a little imagination, one can find the shape of an abstract tree against the sky, or other forms that suggest an arm, a leg, or a head.

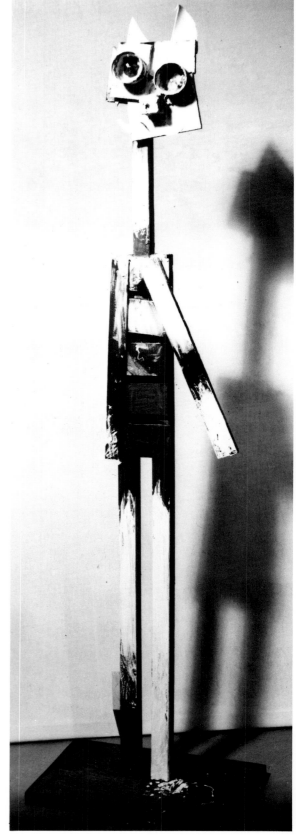

89. *Devil*, 1964–65
Oil on wood, 68" high
90. *Red, Blue, and Gray*, 1965
Acrylic on canvas, 96 x 120"

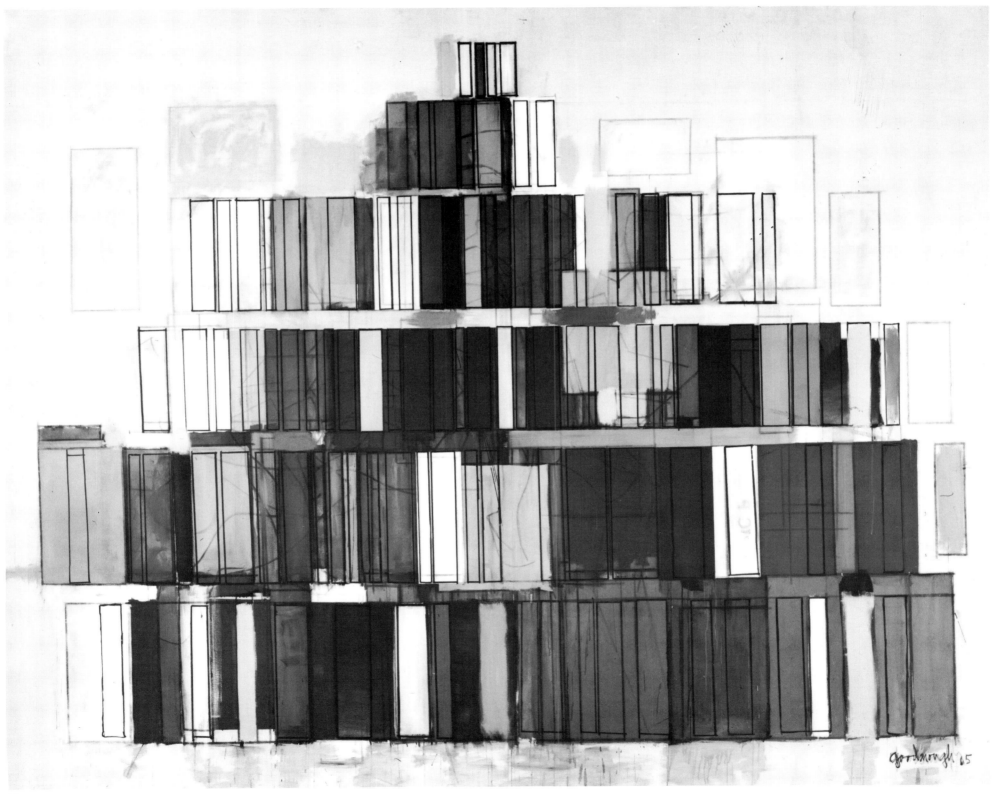

90.

91. *Tattered and Torn*, 1965
Oil on canvas, 29¾ x 36"
Sydney and Frances Lewis Collection, Richmond, Virginia
92. *Untitled*, 1965
Stained glass window, 59 x 35"
Tibor de Nagy Gallery, New York

In the January 1960 issue of *Art News*, Hugo Munsterberg praised what he saw at the Tibor de Nagy Gallery. "In all of these works," he wrote, "one feels the force of a lively intelligence, and a sure and joyous mastery of the medium, which communicates both human and immediate experience." A few months later, the magazine listed the show as one of the ten best one-person exhibitions held in New York during the year.

Goodnough was always seeking new ways to express himself with references to the past. Of course, he did not want to eliminate what had happened before and appeared more intent on bringing history up to date. Thus, *The Bather* owed something to Rubens because Goodnough studied the composition of a Rubens painting and produced an abstract design from the underlying structure, while ignoring the realistic figures of the original. The concept of showing energy was basic to Goodnough's work, as one can

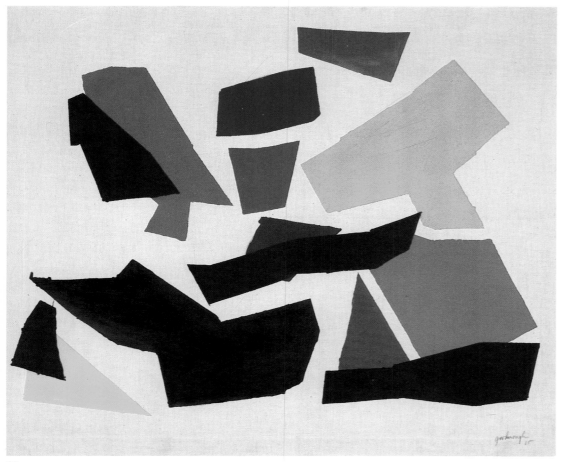

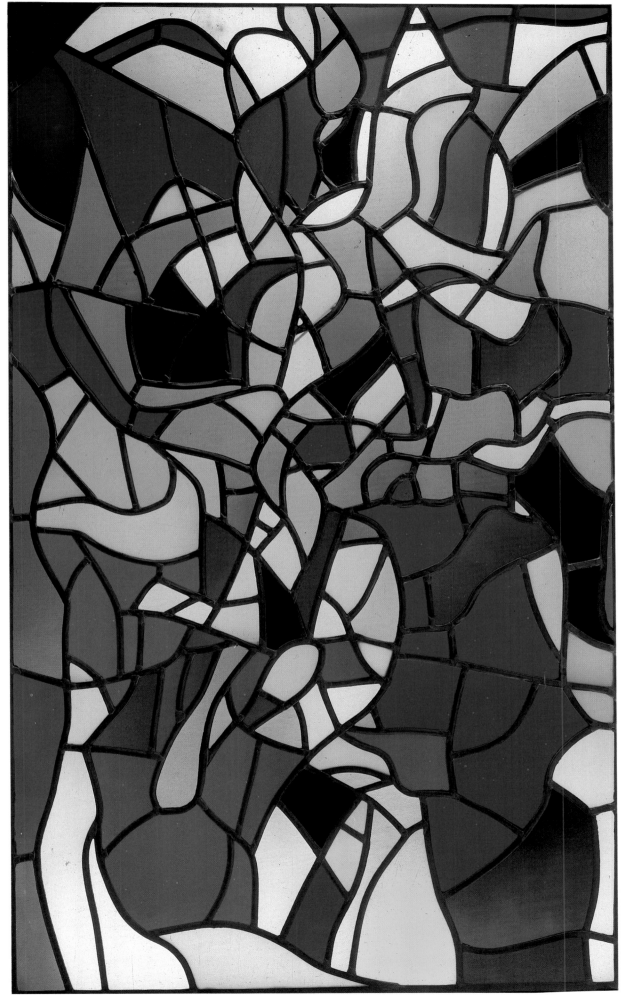

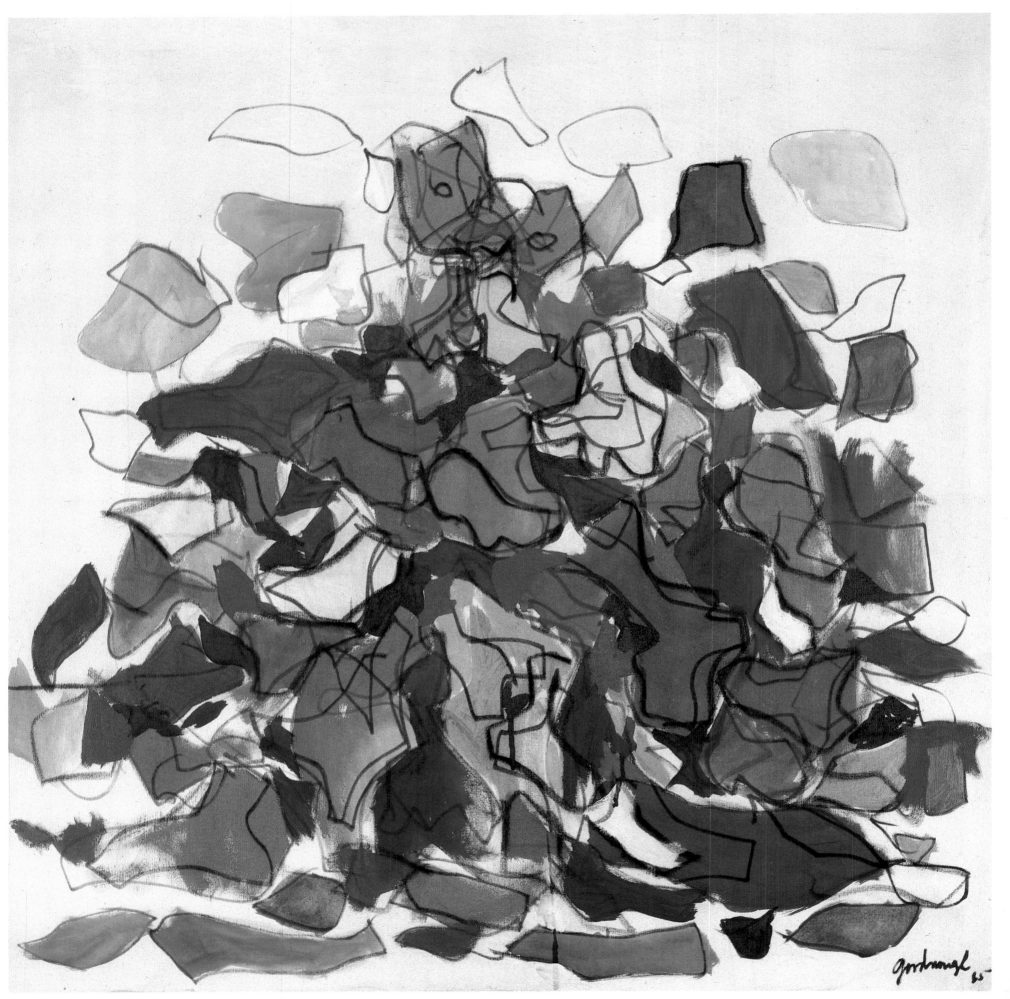

93.

93. *Standing Figure*, 1965
Acrylic and oil on canvas, 36 x 36"
Sydney and Frances Lewis Collec-
tion, Richmond, Virginia
94. *Black Herring Bone*, 1965
Acrylic on canvas, 30 x 48"

94.

see in *Movement of Horses B*. Emotionally charged rhythms of cool and warm colors push against one another to create the energy of the prance and the thrust characteristic of horses. The painting was inspired by Rubens's copy of Leonardo's *Battle of Anghiari*, and when Goodnough was asked what there was about it that intrigued him, he replied: "Rubens created great force and energy in the work through the choice of his subject, much as the Abstract Expressionists did, in a way, through the application of paint. So I guess I was trying to combine the two."

Many people have wondered why Goodnough leaves drips and smudges in most of his pictures. Why, they also ask, does he leave some areas undeveloped? The answer is quite simple: he does not look for purity as Mondrian did. The canvas should not be precious, too finished or slick looking. The drips are integral to the creative act, and the canvas could lose its vitality if the drips and smudges were purposely hidden. To paint over a line or a drip because it happens to be there, would be inconsistent—an afterthought. "Once you've gotten down the idea of the energy and the emotional feeling you're after," said Goodnough, "that's the point to leave it. Why try to polish it too much?" That nothing is ever allowed to be too exact, too rigid, is almost always a characteristic of his work.

Seated Horse had nothing to do with the old masters. It was an attempt at humor because Goodnough felt that much of the painting being done in those years was far too serious and depressing. Artists were using too much black and deep somber colors, so he thought it would be nice to introduce a little humor into his own work. Humor in art is always a risk, yet it appeared to work for Goodnough. *Abstract Horse* is similar to *Seated Horse* although it is not so light-hearted. Goodnough arranged a conflict in the imagery of the painting between the three-dimensional figure and the two-dimensional canvas. The result was figurative, but the figure gradually disappeared into the abstraction.

A Rubens masterpiece, *Rape of the Daughters of Leucippus*, inspired an important series of Goodnough paintings

95. *Red, Black, Blue*, 1965
Acrylic and oil on canvas, 18 x 19″
96. *Floating Verticals*, 1965
Acrylic and oil on canvas, 96 x 24″
97. *Chevrons*, 1965
Acrylic on canvas, 96 x 24″

95.

96.

97.

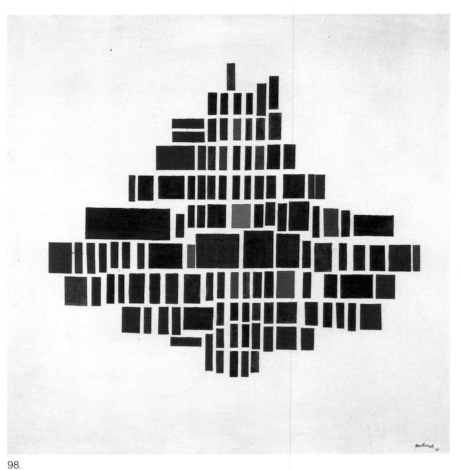

98.

98. *Rectangular 3*, 1965
Acrylic and oil on canvas, 60 x 60"
Sydney and Frances Lewis Collection, Richmond, Virginia
99. *Blue Stairs*, 1965
Acrylic and oil on canvas, 20 x 24"
100. *V-Shapes*, 1965
Acrylic on canvas, 82 x 82"
Wichita State University Art Collection, Wichita, Kansas

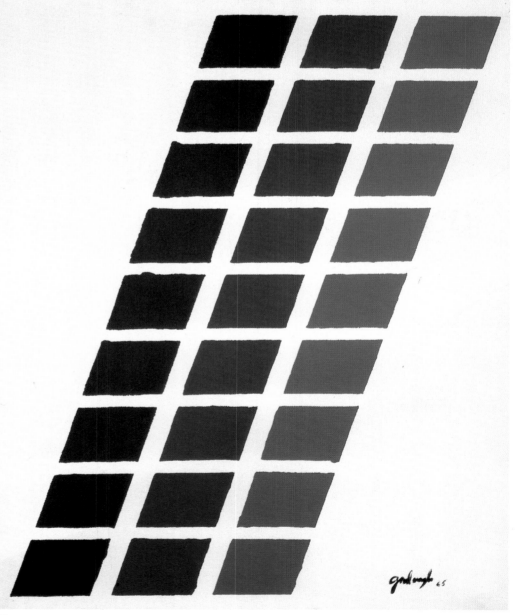

99.

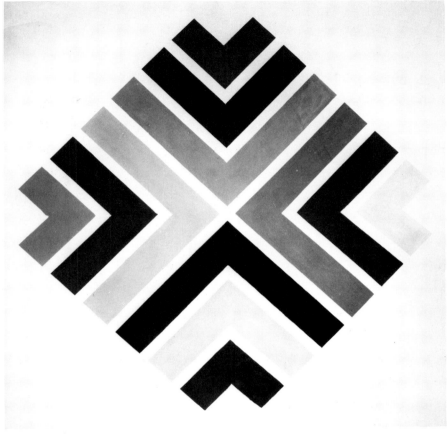

100.

that culminated in the witty *Abduction XI*, exhibited at the Tibor de Nagy Gallery in March 1962. The happy shapes in these works are comparable to those of Miró and once again reveal Goodnough's versatility. "In this picture," wrote critic G. R. Swenson of *Art News* (March 1962), "Goodnough has created a comic masterpiece." The abduction theme was merely a device for organizing an essentially abstract composition into a pleasing picture. In the picture, fresh, expertly painted shapes are set in teeming confusion by the marvelous juxtapositioning of solid-colored geometric forms. The result is a vivid glimpse of the human condition in an extraordinarily poetic expression even though no obvious anecdotal element is present.

Newsweek proclaimed in a March 1962 article, "Goodnough has arrived" and went on to say, "Most painters find one congenial style and stick to it; many painters progress from one style to another; but one of Robert Goodnough's distinctions is that he always works in two or three styles at once."

Katherine Anne Porter's best-selling novel *Ship of Fools* became the catalyst for a new form of comic painting based on figures in a boat. Porter's novel was not all that humorous, of course, but Goodnough sensed the possibilities of drawing upon her theme for a group of richly imaginative and changing canvases. *The Boat Trip* of 1962 differed from his earlier abduction concept in that it was more emotional and less analytical. The obvious physical force of the abduction paintings had been turned into a light-hearted comedy, based on the pleasure of making new friends and discovering new experiences during a boat trip. The humor of *The Boat Trip* had a pulsating energy, but later paintings in the series changed rapidly, growing more serious and evolving into something of a tragicomedy. The 1963 painting entitled *The Battle of the Sexes* marked the transition between the humorous boat paintings and the later more serious ones. This was not meant to suggest that sex is humorous, it was merely Goodnough's way of contrasting in

101. *Triangle*, 1966
Acrylic and oil on canvas, 96" high
102. *Red, Blue Curves*, 1966
Acrylic and oil on canvas, 80 x 80"

a single complex canvas a somewhat tragic attitude with a happier light-hearted feeling.

The transition was due in part to the violence brought home to Americans by events in Vietnam, the Bay of Pigs fiasco, and the tensions of the Cold War that helped precipitate the Cuban Missile Crisis of 1962. The boats became satirical comments on the abandon and indifference that appeared to prevail throughout the world despite the growing possibility of a catastrophe. But the violence of war assumed increasingly greater prominence in paintings such as *Vietnam, Bay of Pigs*, and *Devils in a Boat*, where the boat could still be seen even though it was beginning to disappear from the work. "Goodnough is a versatile, knowledgeable and painterly" artist, wrote Irving Sandler of *Art News* (April 1963). "By emphasizing one or more of the elements that make up his works, he is able to create richly varied and inventive pictures. Together they look like a group show, yet all have his personal stamp." Most observers were astonished by Goodnough's versatility. Would he ever settle into one general style? Goodnough ignored the comments, perhaps because energy, work, and tradition were crucial to his artistic philosophy. This should not be surprising in a nation that cherishes hard work, that considers too much leisure to be suspect, and that, by and large, refuses to acknowledge the real value of the art being created in its midst. Goodnough, like so many other struggling artists, may have grown up with a subconscious belief that he must somehow justify his painting by the expenditure of much time and energy. He must prove himself by hard work.

The variety continued with *A Man with a Hat*, a combination of linear movement, drips, and flat geometric shapes, and with *Rectangles II*, with its implications of Mondrian and the problems of dynamic equilibrium. Although the latter work had a rectangular lined webbing strikingly accented with color and enhanced by a complicated Cézannesque brush stroke, it was started with a different goal in mind. "I tried to get the three-dimensional feeling you get from na-

101.

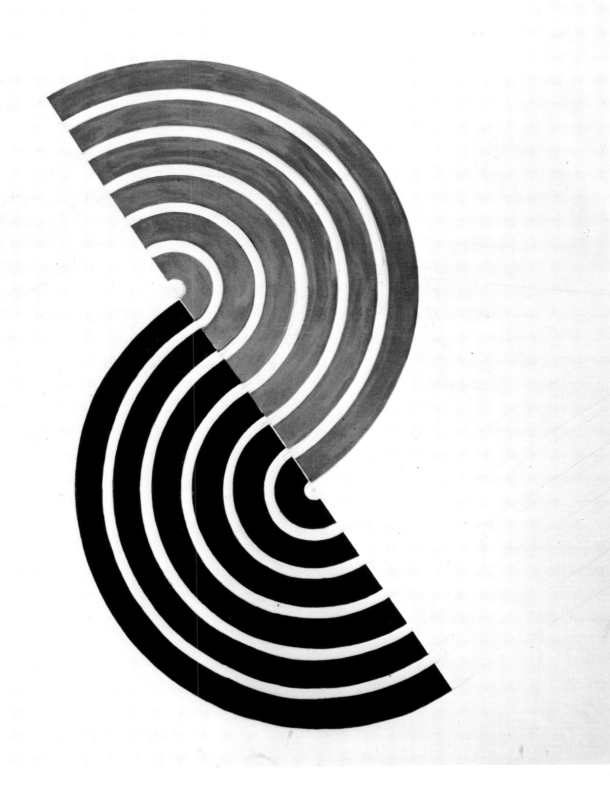

103. *Wood Construction*, 1965
Painted wood, 60" high
104. *Color Wheel*, 1965
Acrylic and oil on canvas, 78 x 78"

ture, or from figures," said Goodnough, "then I started thinking of it as being completely abstract, developed to a point of not having any third dimension. I've heard people say they see this three-dimensionality—I don't. I think of the images as just shapes on canvas." *Bomb II* was part of the Vietnam series. An extremely large painting, it, too, came out of an awareness of the *bomb* with all of its connotations —the readjustment of moral values, the alienation of America's youth, and the wars of mass destruction. "Sometimes a concept may occur through the emotions involved in this awareness," wrote Goodnough, "or in a reaction against these feelings, or in an attempt to use these feelings in a more formal way; but the awareness is there with the artist as with everyone. Who can say what it has had to do with the many searing directions artists have explored in recent years."[26]

Several little-known paintings, such as *Black Herring Bone, Chevrons, Blue Stairs*, and *V-Shapes*, completed in 1965, indicate that Goodnough even dabbled in a style many people spoke of as "masking-tape abstraction," a reference to a technique some artists employed in separating one band of hard-edged color from another. But he quickly and wisely turned away from these "hard" form aberrations with their no-hands look, and returned to his own more familiar arena of painting.

By 1967, there were fewer images and simpler and more purely abstract forms on Goodnough's canvases as he moved toward an economy of means and the elimination of all traces of Abstract Expressionist handling. In *Form in Motion*, an outstanding painting commissioned for the Manufacturers Hanover Trust office on Fifth Avenue at 57th Street in New York, he achieved a sense of vitality and excitement by creating tension through the interplay of strong primary colors against quieter and more restful areas. In this work, big, flat, brightly colored, energized shapes float freely across a gleaming whitish-gray canvas in rhythmical interlocking alignments which are united only by their own magnetism. These patches of color sometimes

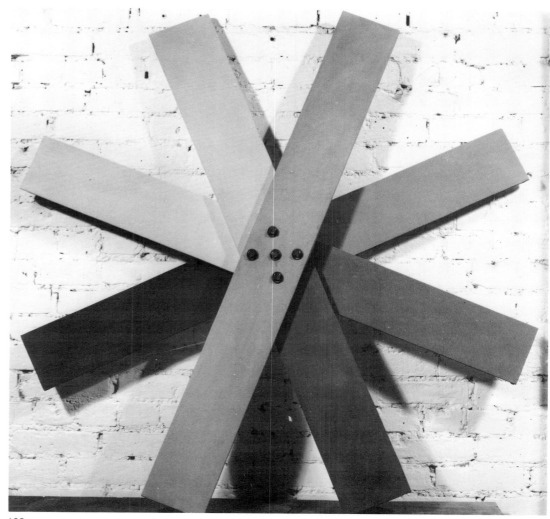

103.

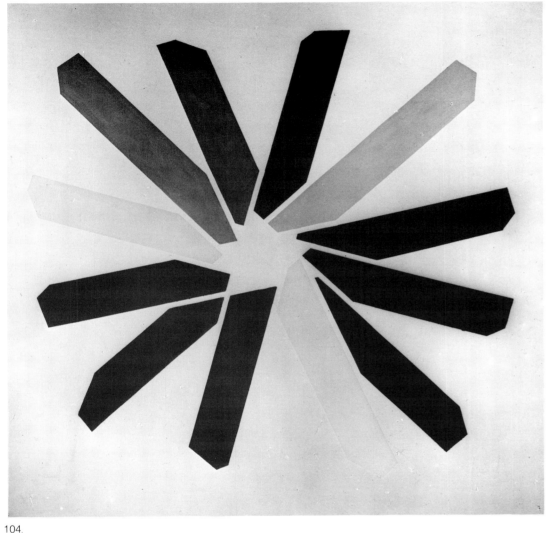

104.

push and flow over each other, a few overlap, and several seem recessive; yet on the whole they have a subtle buoyancy and forceful dynamism that combine to make *Form in Motion* the last great painting of the period.

In 1968, while making dinosaur collages with overlapping shapes, Goodnough placed some pieces of paper on the floor to get a better perspective before gluing them. A few shapes accidentally scattered, and while gazing at them, he realized the separated shapes might create less intense and more romantic arrangements than he had previously been employing.

This unexpected occurrence extended the expressive range of possibilities for his work, and he began to create large shapes (almost 12 to 18 inches across) in strong colors, working on several canvases at the same time. Some had only a single color, a few had three primary colors, while another, *Black Shapes* of 1969, simply utilized large black forms. Several others had either large brown, green, or blue shapes. The theme was transitory, changing quickly into quieter compositions, as muted colors replaced the strong reds, blues, and greens. Goodnough reduced the shapes and nearly abandoned color altogether by introducing paintings whose fields appeared unsized, although they were actually sized with a transparent acrylic. The delicate shapes in these pictures resembled the color of the canvas itself, sometimes being all white, as in *White on White*, completed in 1970, or *White*, created the following year. These astonishingly beautiful works became known as Goodnough's white-on-white paintings.

They were more personal and less like those being done by other artists or schools of painting and marked a major alteration in his point of view. He had arrived at a mature style that was truly his own. The years of ceaseless experimentation were about to end. Most critics called them his best paintings yet. "Like all of Goodnough's works," wrote Lawrence Campbell of *Art News* (April 1970), "they are thoughtful, sensitive and poetic." Perhaps even more importantly, Goodnough had embodied a painterly approach

105. *Motion Form,* 1966
Acrylic and oil on canvas, 36 x 126"
106. *Blue and Brown Collage,* 1966
Collage and watercolor, 7¾ x 6½"
Virginia Museum of Fine Arts, Richmond, Virginia

105.

that seemed to express his mature personality and, in so doing, satisfied his instinctive desire for classic harmony. In these paintings and the pastel canvases that followed, Goodnough relied on a basic simplicity, limiting himself to subdued off-white or silvery gray forms drifting across the veil-like transparency of large raw canvases. The average person often found the white-on-white canvases to be slightly bland at first, but after a while their subtle fluidity and grace became remarkably engaging.

Grace Glueck of *Art in America* (January–February 1972) called Goodnough "one of the most interesting painters around. . . ." To her, Goodnough's imagery suggested: "drifts of leaves, birds in flight, [or] a scatter of moonlight floating on a pond."

It was Hilton Kramer of *The New York Times* (February 5, 1972) who best summarized Goodnough's accomplishments up to that date. "It has been fascinating over the years to watch this veteran abstract painter slowly and painstakingly dissolve the cubist substructure of his pictorial imagery in an effort to enlarge and release a more expressive two-dimensionality," wrote Kramer. "In his new work, [Goodnough] has arrived at his purest statement of this two-

113

107. *Prisms II*, 1966
Oil on canvas, 24 x 24"
Wichita State University Art Collection, Wichita, Kansas
108. *Prometheus*, 1966
Acrylic and oil on canvas, 84 x 84"

107.

dimensionality and in the process has produced his most elegant paintings. Gone is the vivid Mondrianesque color that once dominated his art and in its place is a palette of silver grays and pastel tints that is quite stunning."

Despite excellent reviews, Goodnough's color-field abstractions of the 1970s were sometimes criticized as being too impersonal, too mechanical, and lacking in subject matter. Others said they were so highly intellectualized they failed to communicate with people. "In a way, I liked the idea of my work being impersonal," Goodnough said. "The paintings were not intended to be what I would call romantic, in the sense of portraying a strong mood. They were much more subtle . . . I still like a certain quality of

114

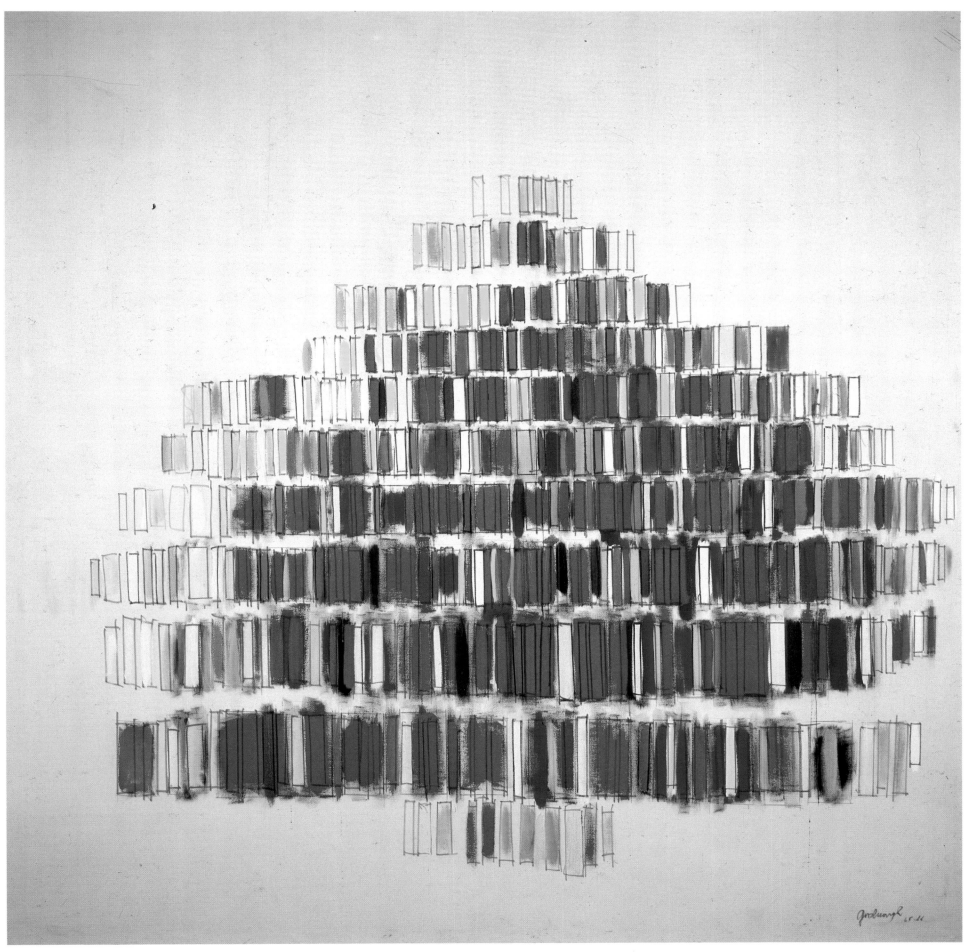

108.

109. *Abstract Development*, 1966
Acrylic and oil on canvas, 84 x 180″
110. *Eleven*, 1966
Watercolor, 5 x 5″
Virginia Museum of Fine Arts, Richmond, Virginia
111. *Struggle*, 1966–67
Acrylic and oil on canvas, 105 x 262″
Governor Nelson A. Rockefeller Empire State Plaza Art Collection, Albany, New York

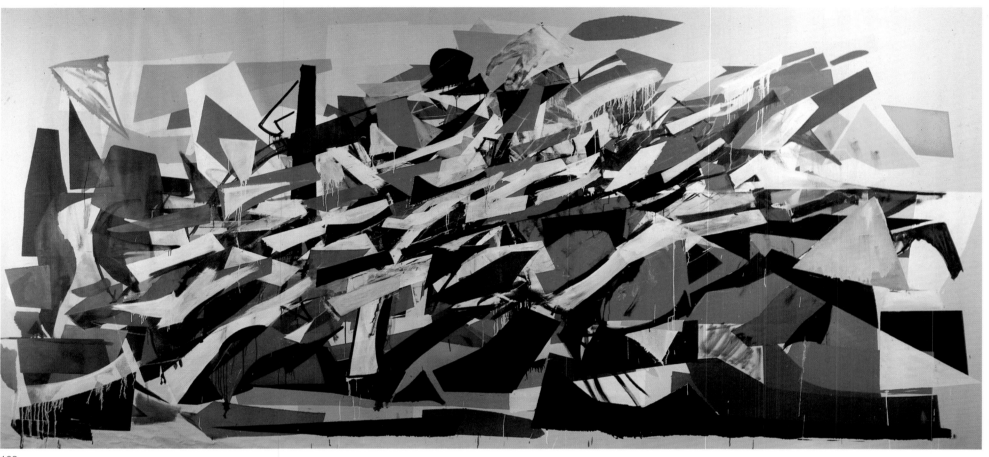

109.

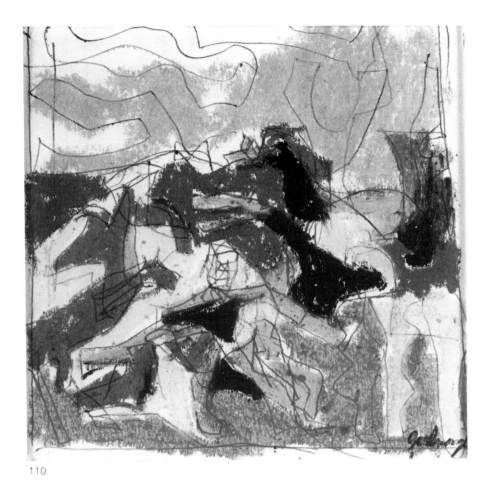

110.

impersonality in art." For an explanation through analogy, Goodnough draws upon the work of Johann Wolfgang von Goethe, the German poet and dramatist: "Goethe's earlier work was very romantic. Later he became more of a classicist. . . . Goethe believed that the romantic idea was not as good as the classic idea, and I believe that art has a higher quality, higher than just emotional expression." Goodnough compared Goethe's philosophy with his own feelings about his earlier work. "In Abstract Expressionism," said Goodnough, "you get too much emotion and I guess one might say that emotion is personal. As you get away from expressing strong emotion, you become more impersonal, or it may seem that way, but at the same time I believe you are speaking to other people on a higher level."

It is important to learn how and why he painted these new pictures to better understand their development and significance. To begin with, "there is no such thing as a good painting about nothing." Goodnough's paintings are projections of his inner feelings about a subject rather than a recreation of how the subject might actually appear. The paintings were born in the depths of the artist's mind and grew from the general realm of his subconscious feelings and emotions; because of this, they symbolize a profound

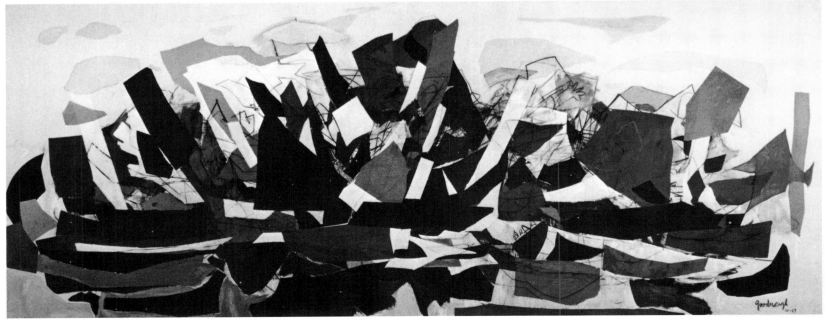

111.

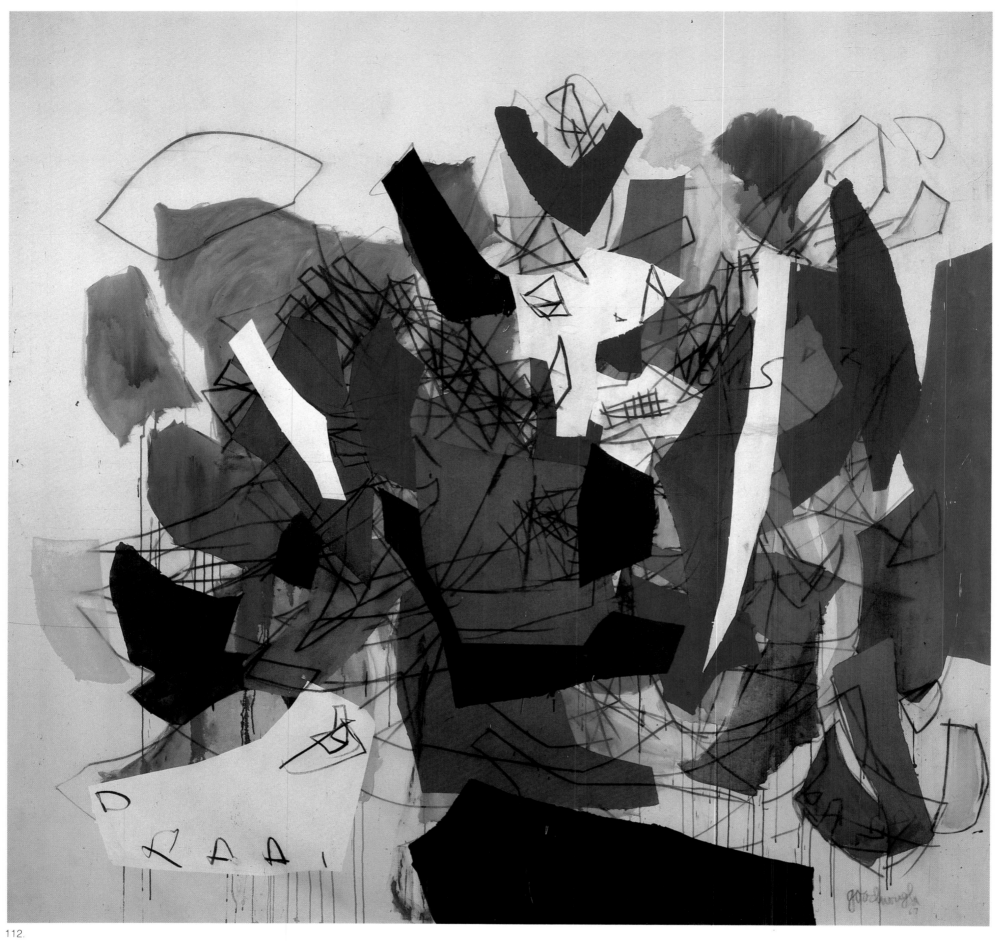

112.

112. *Bright Colors*, 1967
Acrylic and oil on canvas, 106 x 106"
113. Robert Goodnough in his Christopher Street studio, 1967
114. *Vietnam*, 1967
Acrylic and oil on canvas, 84 x 180"

113.

engagement of the self in his work. Like Barnett Newman, Mark Rothko, and Clyfford Still, whose paintings are also immense impressions of color, Goodnough has created form by painting an experience on large, wall-size canvases that literally occupy space and force the viewer into an immediate confrontation. The direct impact of the scale and the painterliness of his pictures from the 1970s, plus their overriding emphasis on color, compel people to react visually, a reaction the artist hopes will be an enjoyable one.

Most of Goodnough's paintings begin as eight-foot squares of raw, white canvas. He likes them bigger than life and taller than he is, believing that large paintings tend to be seen and felt with more effectiveness and provide a clearer awareness of the work as a whole. Great size also gives the viewer a freer sense of feeling about the artist's work and tends to affect perception because it occupies a large physical space.

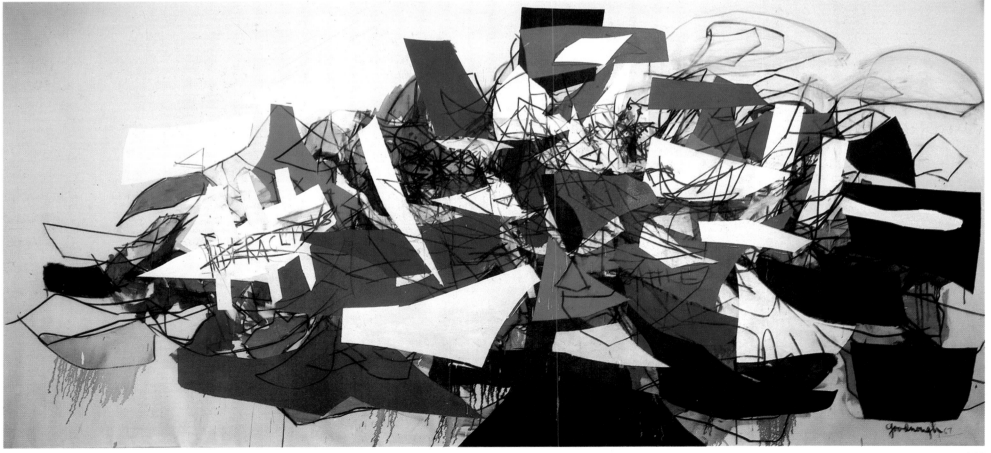

114.

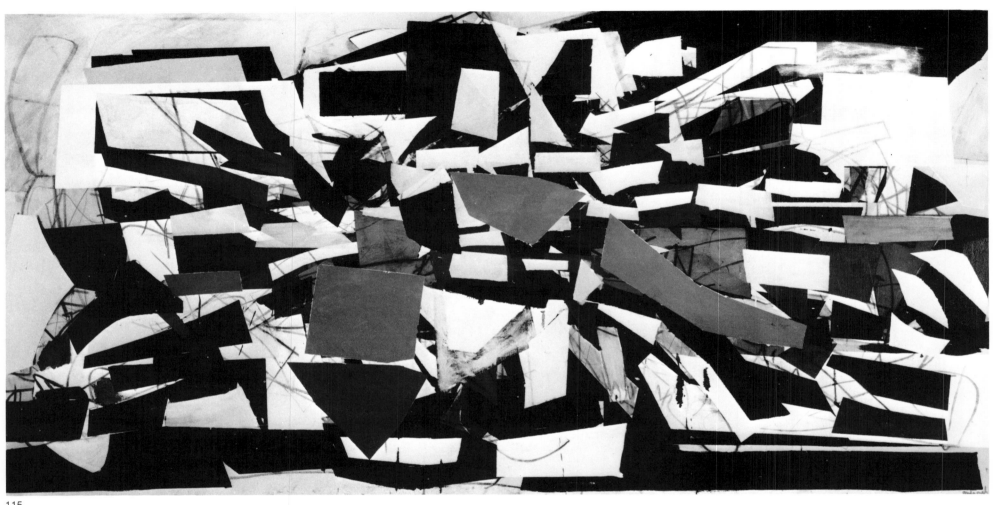

115.

116. *Red and Blue Movement*, 1968
Acrylic and oil on canvas, 68 x 204"
117. *One Two Three: A Homage to Pablo Casals*, 1968
One of a series of 12 serigraphs issued in limited editions of 150. Printed by Gerald Marks and published by the Tibor de Nagy Gallery, New York. 22 x 30"

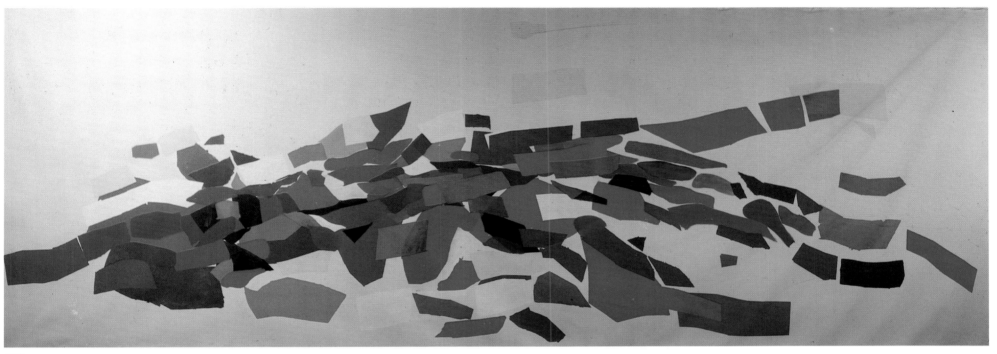

116.

117.

Facing a bare, white canvas can be a moment of considerable anxiety for many artists, but not for Robert Goodnough. He merely seeks to give form to what is in front of him. Often, much like a gambler, he takes a chance by attempting something different, hoping to be successful. If it doesn't work, the canvas is discarded in favor of another. Because of this empirical trial-and-error method, it is not surprising to learn that he destroys many of his paintings before they are finished.

Goodnough does not limit himself to a preconceived plan, nor does he use preliminary sketches. His images are controlled through a highly developed sense of color and form because painting for him is self-discovery, and he arrives at an image through the act of painting itself. Usually he works on several canvases at a time, bringing them along slowly so no particular painting will grow too rapidly. Years of experience have taught him that new thoughts occur as pictures develop, and he realizes that these thoughts might be lost by painting too hurriedly. Therefore, one painting is put aside for awhile, and another brought out, in a constant effort to keep an open mind toward them. "I don't know what I'm going to do next," he admits; "the painting develops as I

continued on p. 130

118. *Form in Motion*, in progress
119. Robert Goodnough and assistant working on *Form in Motion*
120. *Form in Motion*, installed

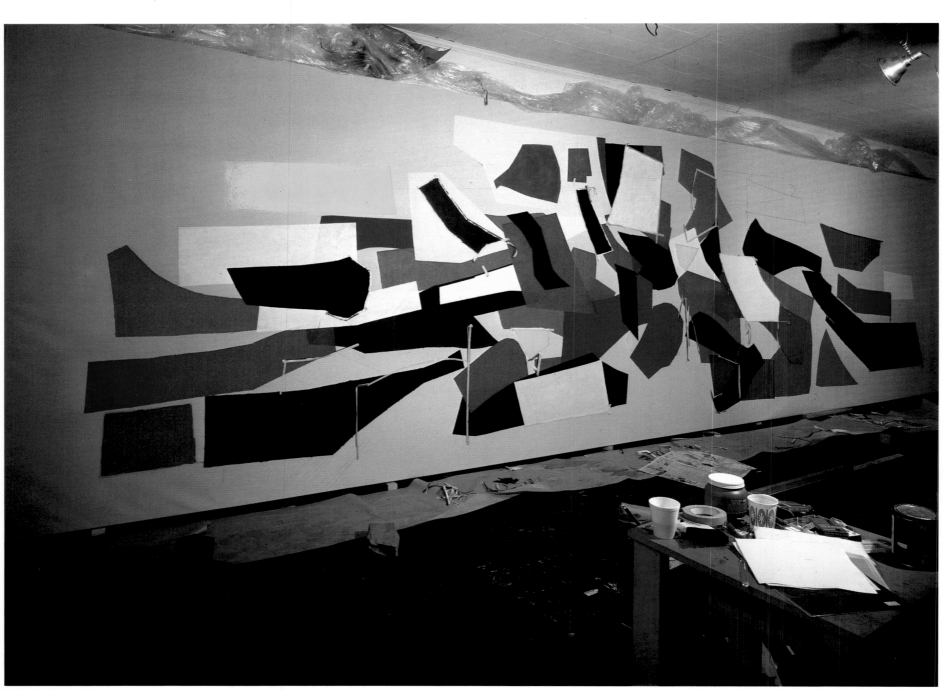

118.

FORM IN MOTION

In the painting *Form in Motion* my intention was to achieve a feeling of vitality through the tension and interplay of strong primary colors and quieter rest areas. At the same time, I tried to give a feeling of lightness somewhat as though the forms were floating or in a state of suspension. This, it seemed to me, would create interest in relation to the large black granite wall on which it hangs. A challenge was presented since the painting would be viewed from nearby and also from the street, and I kept this in mind during the painting process. Though the painting was done for this particular space, it is considered to be a thing in itself and is not thought of as a mural. Forms and colors in dynamic relationship are the subject of the painting, and it is therefore meant to be seen in terms of its formal development.

Robert Goodnough

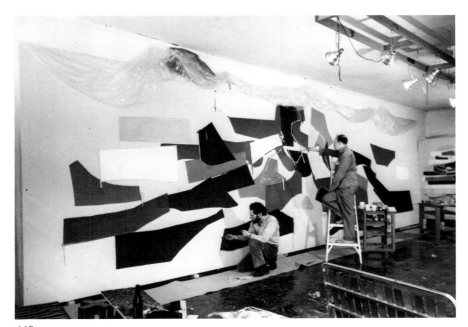

119.

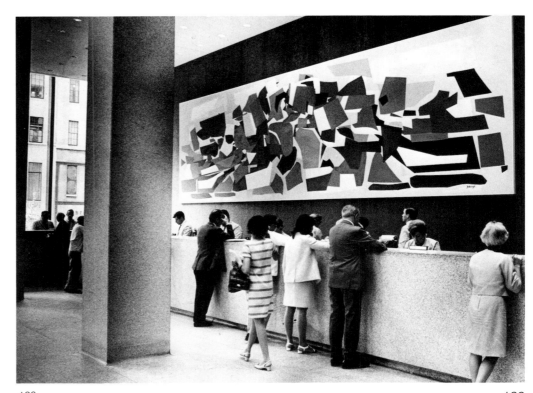

120.

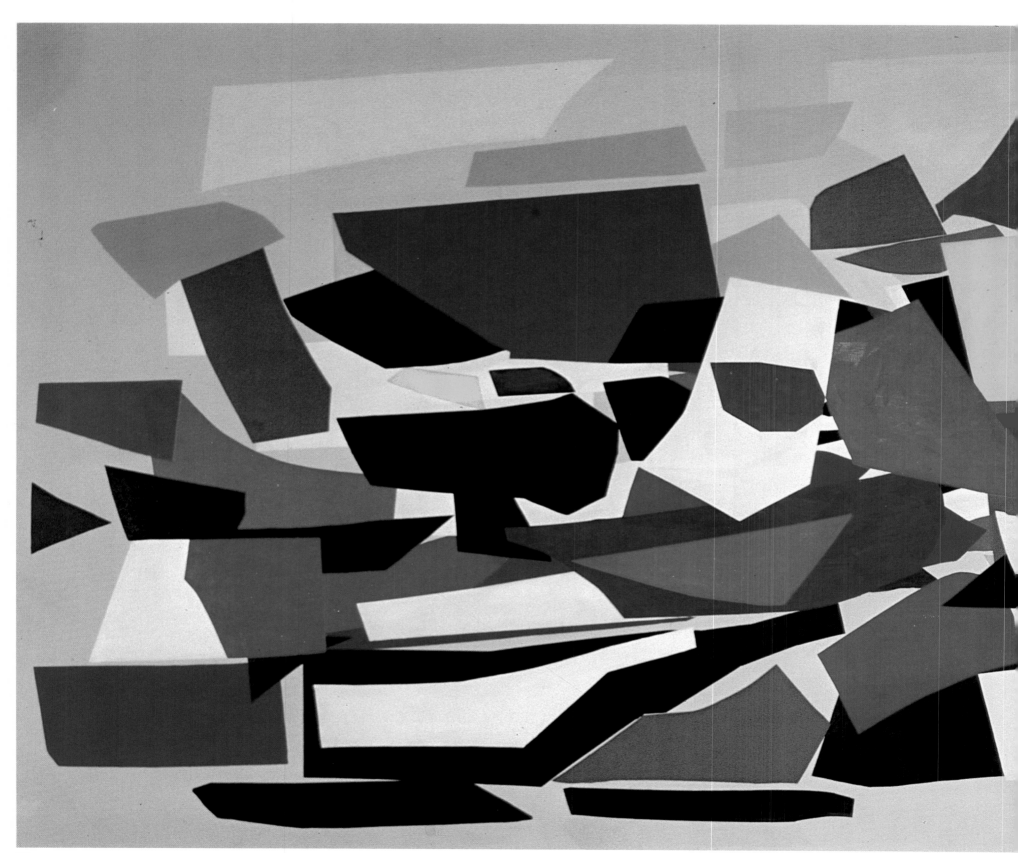

121. *Form in Motion*, 1967
Acrylic and oil on canvas, 108 x 384″
Manufacturers Hanover Trust Company, New York

121.

122. *Color Development.* 1968
Acrylic and oil on canvas. 60 x 180"
Collection The Central Bank. Jefferson City. Missouri
123. *III C.* 1968
Acrylic and oil on canvas. 72 x 192"
124. *Anghiari II,* 1968
Oil on canvas, 60 x 114"
The Museum of Fine Arts, Houston, Texas

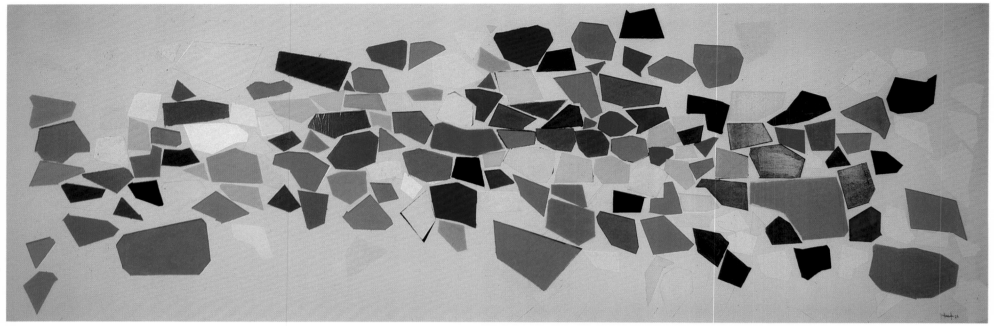

122.

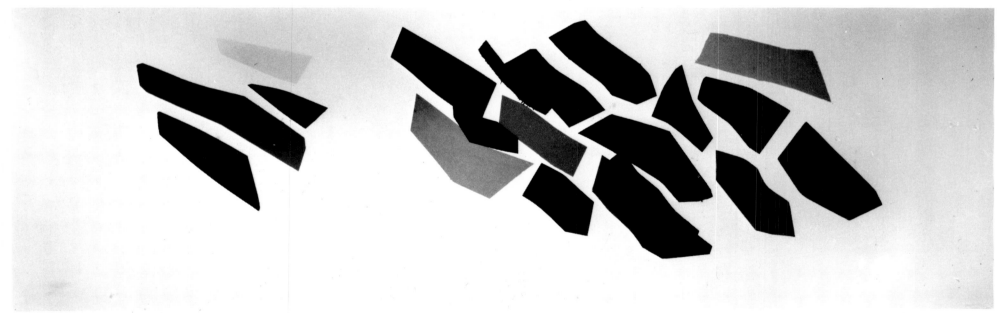

123.

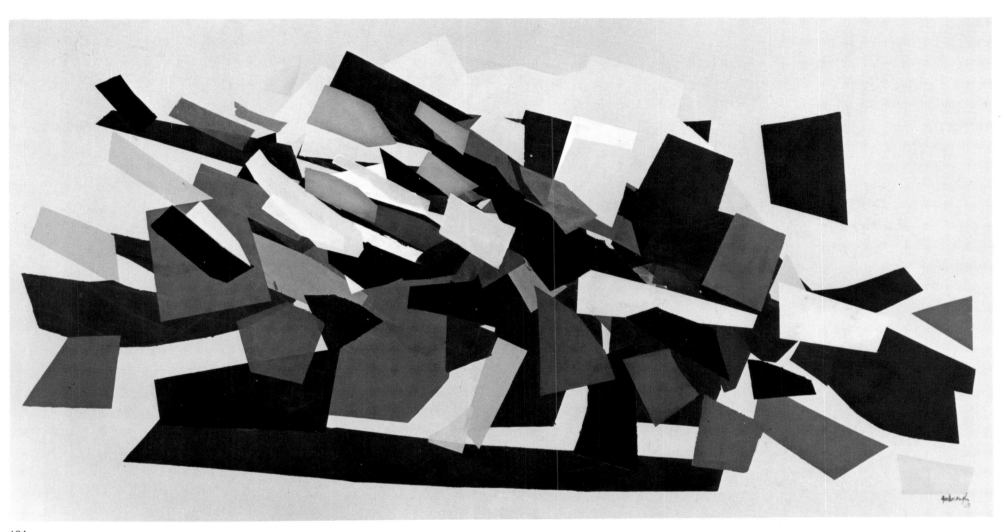

124.

125. *IXL*, 1969
Acrylic on canvas, 40 x 144"
126. *Bird*, 1969
Aluminum, 12" high

continued from p.121

work on it." Yet he works with the tenacious purpose of satisfying himself, for a painting must be good in his own judgment before he is willing to force his artistic attitude upon the world.

The large canvases he faced in 1969 and 1970 had a color—off-white—and Goodnough utilized the off-white color of the raw canvas in his white-on-white paintings. As the years passed, he sought a different field or ground on which to work and turned to pale colors—some of them more intense than others. The more intense the colors, the more difficult it was to make them work; but Goodnough believed that almost any color would work well if used correctly. He sometimes preferred shapes in colors that were somewhat lighter than the canvas itself. *Gray Color Statement* typifies this belief. In it, Goodnough brushed a stain of gray over the canvas's entire surface to create a texture imbued with power and solidity, which in turn transformed the gray into a rich optical color. Then, drawing upon his marvelous sensitivity for shades of gray, warm versus cool colors, and dark and light tones, he deftly placed clusters of rhythmic forms that linger ever so lightly across the gray canvas field.

After considering various color possibilities for a painting, he often selects something entirely new, perhaps a pale yellow or pink, or a particular hue that seemed appealing several days earlier. Before actually beginning, however, red or green paint (together with white) is sometimes added to the paint to change the color just a little, preferably to a slightly lighter shade. Whether those delicate colors are

125.

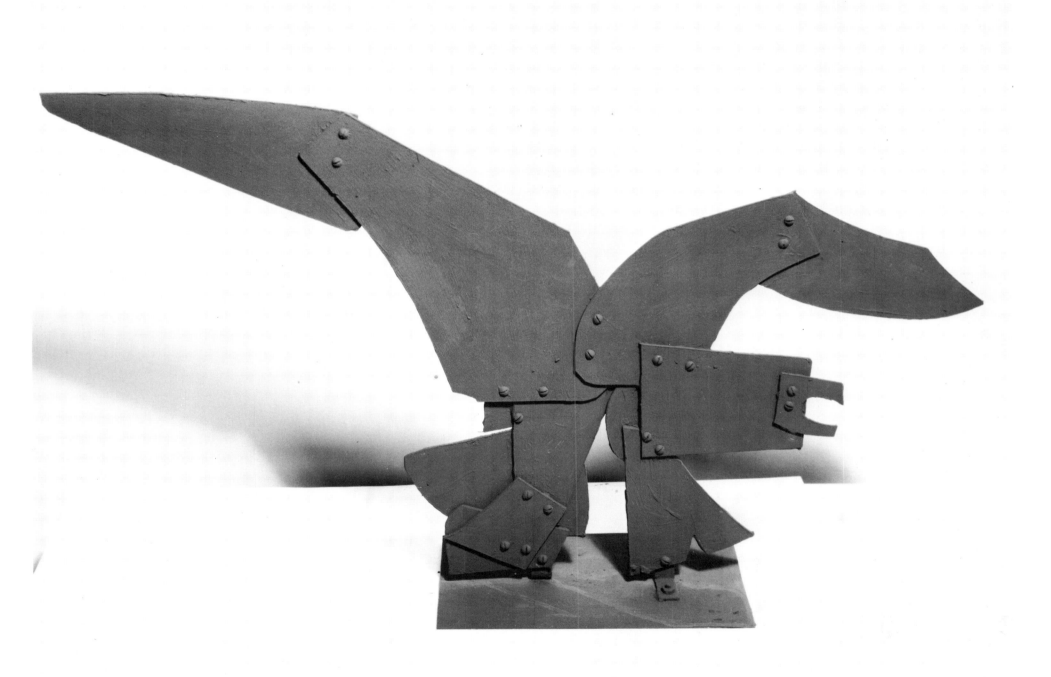

126.

127. *Collage Red, Blue,* 1969
Paper collage, 10 x 10″
Collection Kathleen Goodnough
128. Robert Goodnough in his Christopher Street studio, 1969
129. *Dinosaurs* under construction in Robert Goodnough's Christopher Street studio, 1969

127.

128.

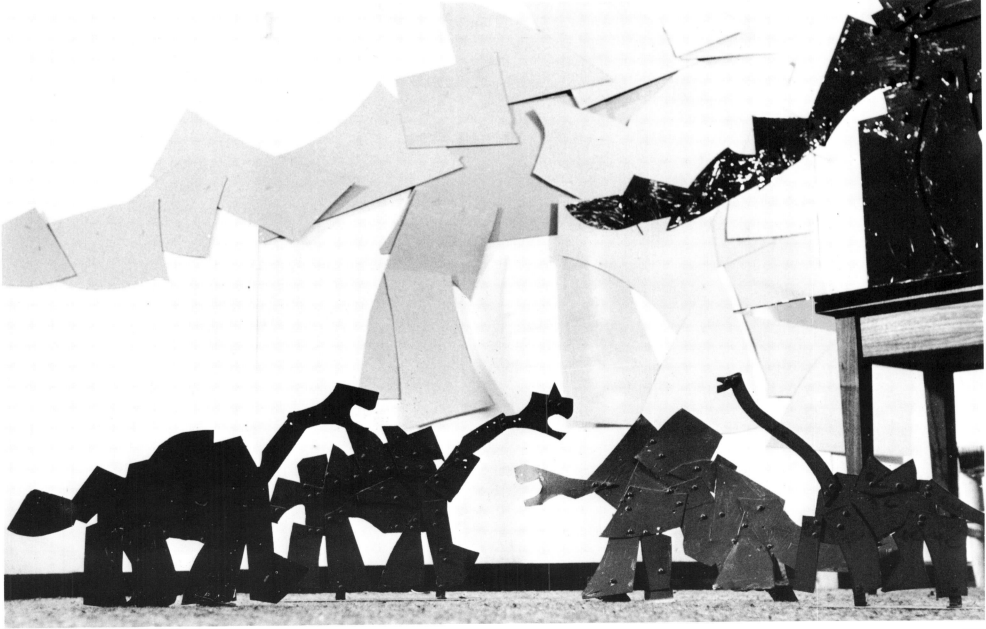

130. *Horizontal Development*, 1969
Paper collage on cardboard, 28 x 60"
131. *Victory of Anghiari*, 1969
Oil and liquitex on canvas
The Metropolitan Museum of Art
Anonymous Gift, 1969

130.

based on yellow ochre, orange, raw umber, or pink, they help to create a feeling of expansiveness or openness on the flat surfaces. If they are really effective, the vast color of the canvas appears to radiate light.

To obtain the much sought after qualities of purity, economy, lightness, and weightlessness artists frequently strive for, Goodnough uses a four-inch brush and crisscross strokes to gain a two-dimensional sense of flatness, while simultaneously infusing the surface with energy and vitality, without which the paint quality would be meaningless. Sometimes the result is not satisfactory, so more color is added even before the first coat has dried; or color may be added hours later. Goodnough's approach at this point is mostly experimental, and if the color still does not work, he discards the canvas.

At first glance the placing of images (shapes) on these

131.

132. *Theme Variations (Blue)*, 1969–70
Acrylic and oil on canvas, 30 x 30"
133. *Red and Blue Abstraction*, 1970
Handwoven wool, cotton, and linen tapestry, 77 x 103"
A Gloria F. Ross Tapestry

132.

large "environmental" paintings is seemingly simple, yet it is really a complex procedure. The shapes are controlled by the artist's highly developed sense of space and form. As he paints them, Goodnough is literally almost in the painting himself since it is impossible to see the entire picture at once while working so close to it. Typically, the shapes are grouped away from center, and an open area of canvas is preserved to enable the eye to interact with the space while the mind unconsciously shifts the areas of color about. But these shapes are unimportant in themselves; they are used merely as a means of enhancing the color fields or as a way of giving life to the canvas.

In *Variations: Medium*, a distinctively Western painting with Oriental overtones, Goodnough placed most of the

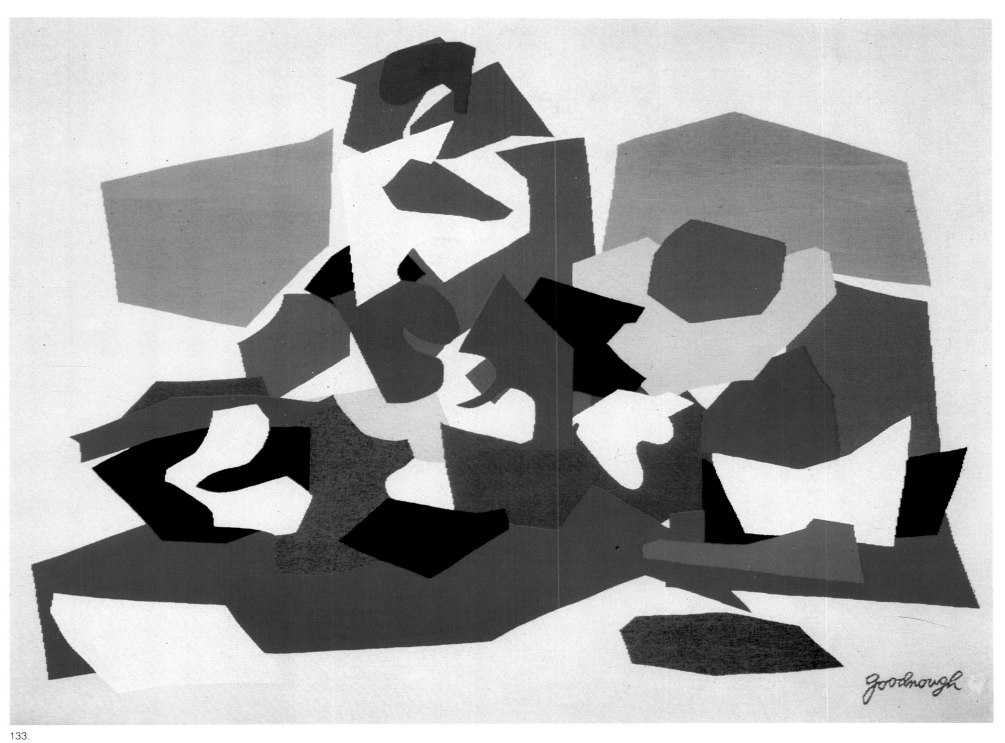

133.

134. *Sculpture Blue*, 1970
Painted aluminum, 7" high
135. *Green Gray*, 1969–70
Acrylic and oil on canvas, 78 x 78"
136. *Collage on Gray, I*, 1971
Paper collage, 4 x 12"

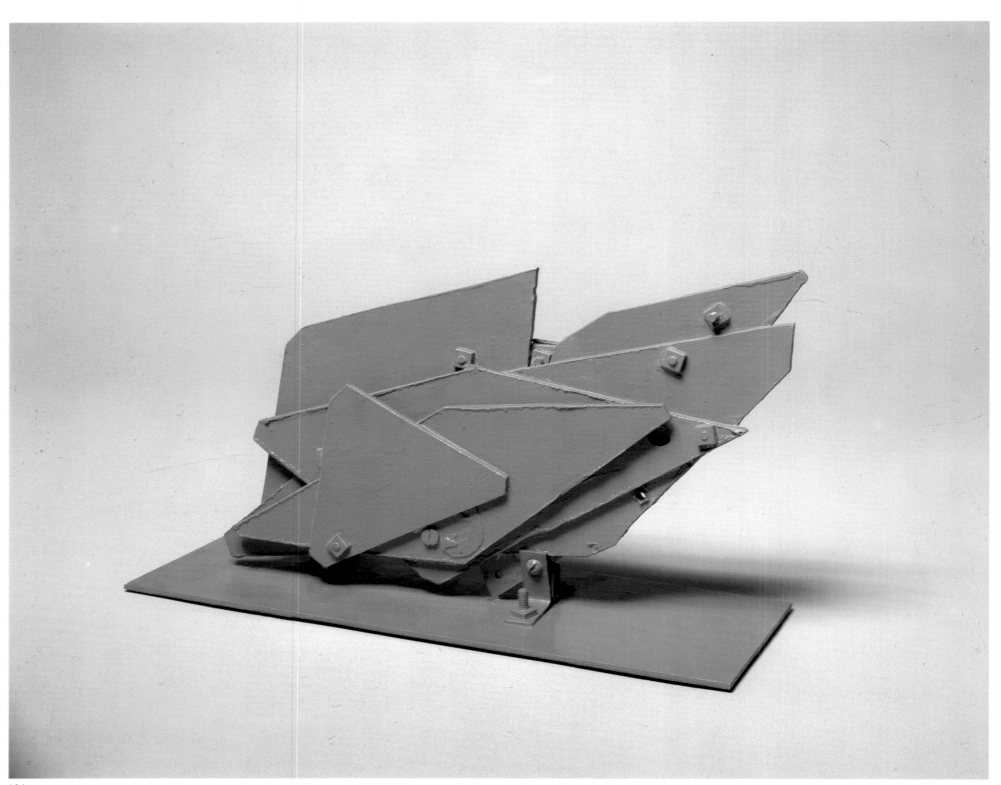

134.

135.

136.

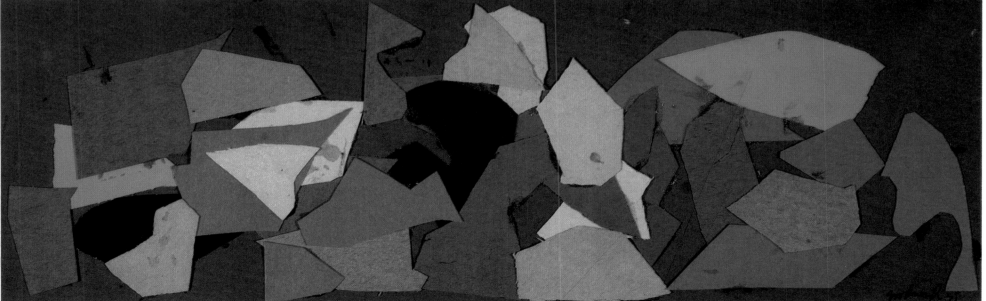

larger shapes at the upper right of the canvas, while letting other more delicate shapes drift gently across the center toward the opposite corners. This gives the painting an enhanced sense of space and time, a freshness of color, and an originality of image, which he likes to call "etherealization." As a result, the viewer is not overly conscious of the forms as shapes since they do not interfere with the viewing of the picture. Moreover, they are not thought of as shapes, or even as having to do with a third dimension; instead there is a clear awareness of the painting as a two-dimensional, self-contained flat surface, whose fragile images glide in a subtle, understated contrast across large areas of empty canvas.

There are no rules, no limits—any color can be used if it works. Goodnough often introduces intense color, yet not so intense that it will dominate the canvas or interfere with the total surface. The entire process is a reversal of traditional figure painting where the figures are dominant. In *Red, Blue, Ochre*, for example, spatial relationships and the totality of the entire painting are most important. Ochre shapes are clustered in a dense islandlike formation slightly to the upper-left of the center, a grouping of blue shapes is near the center, and a third cluster of red shapes is slightly to the lower-right of center. None of the clusters is dominant; instead, the transparent color of the field that first covered the large square surface is still paramount. Ideally, though, nothing in the painting dominates. There is no center of interest; and the entire surface appears to glow warmly with that airy lightness and luminous atmosphere that has come to be associated with the artist's work.

Goodnough allows himself to be guided by the shapes at their moment of birth; he has confidence in himself; he does not reflect. Drawing with a lead pencil or sometimes with a ballpoint pen, he quickly and deliberately creates straight hard-edged shapes on the already painted surface. With the aid of a ruler he draws very lightly, experiments, erases, draws over, occasionally using a pen to accent something or to sharpen and clarify a form. At a certain

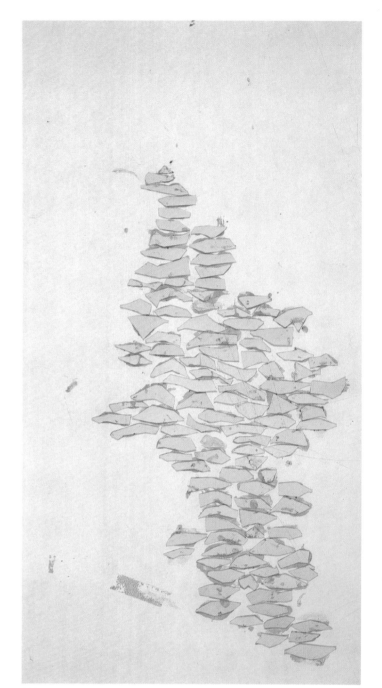

137.

137. *Collage Study*, 1971
Study for serigraph for Lincoln Center poster
138. *Green Color Statement*, 1971
Acrylic and oil on canvas, 54 x 60″
Collection Beverly Sturz, New York

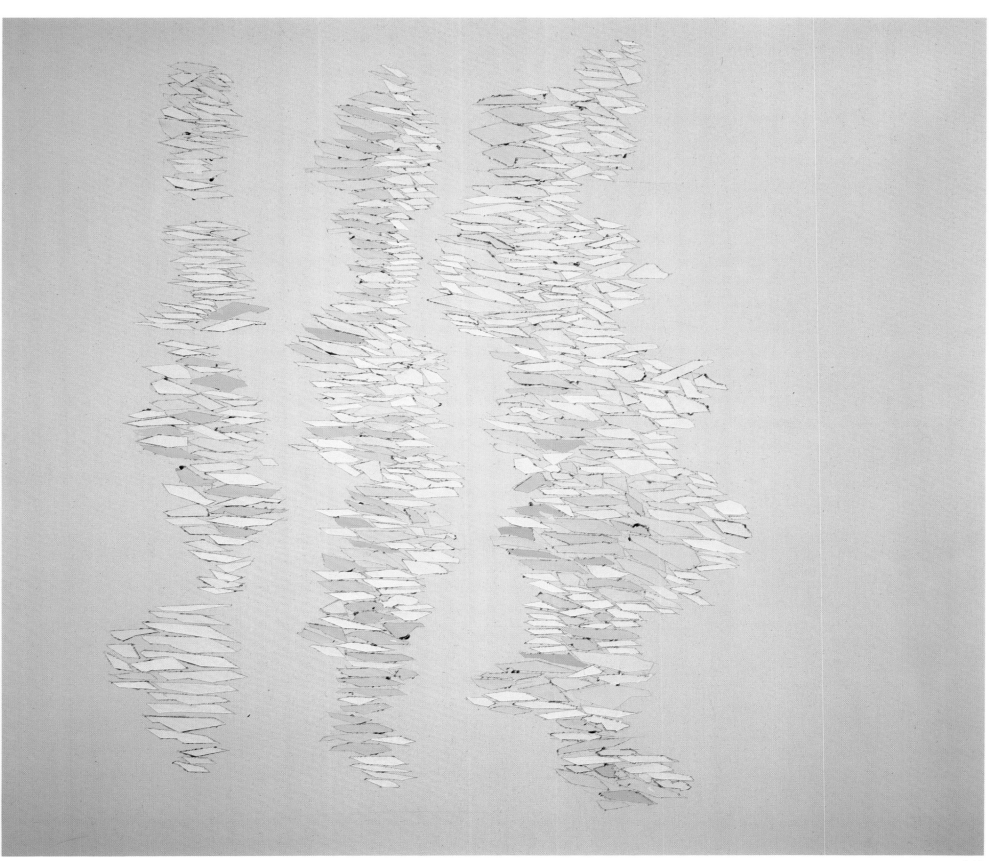

138.

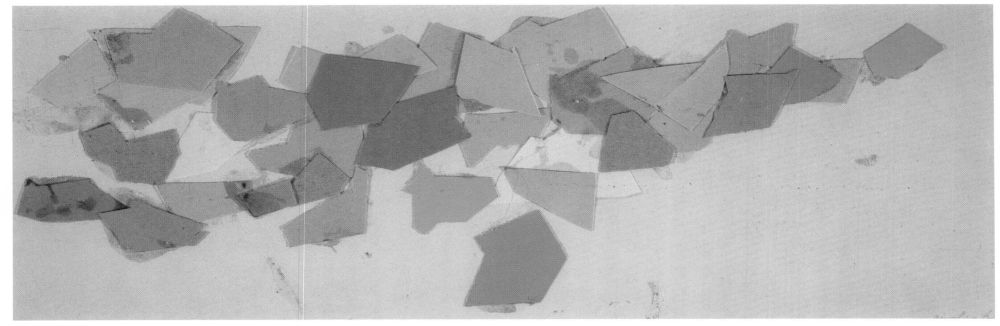

139.

point, intuition becomes operative as well. It seems that Goodnough must only coordinate his hands and eyes for new shapes to be born. Chance guides his fingers. Pure forms, selected intuitively, seem to spring from a profound source of inner spirit, which then imparts a graceful life to the picture itself.

Relationships are quickly established with shapes of similar size and form; a rhythm starts; the shapes appear more quickly now, sometimes in spurts; questions arise and must be answered. How do they relate to each other? What do they do to the area around them? The artist backs away—looks, considers, decides, and returns to the work. The "ghosts" of forms continue to come, pleasing or strange, equal but different; inexplicably, some appear to move forward while others seem to recede; suddenly it is apparent that the area left without shapes is just as important as the space with them. With determination, Goodnough adds image after image until he is satisfied that the painting has achieved its final form.

After the forms have been drawn on the painted surface of the canvas, tape is added around the outside edge of the pencil lines. Goodnough then selects a nuance of color similar to the one which already covers the entire surface of the

139. *Color Collage,* 1971
Paper collage, 4 x 12"
140. *Color Collage on Gray,* II, 1971
Paper collage, 5 x 12"

painting. This first coat of paint for the shapes, an acrylic, usually spreads or oozes under the tape, so no more leakage occurs. Although this second coat is often thicker than the first, it is usually necessary to apply a third and sometimes a fourth coat of paint. By then, the shapes have flattened and their raggedness and thickness give them an element of relief, a kind of collage effect in a noncollage context. This tendency strips the shapes of their individuality, a technique that owes much to Goodnough's earlier involvement with collage. It was through collage that he established the working method that has remained the basis of his art.

When the acrylic has dried—usually in about an hour—Goodnough completes the shapes with a final application of flat oil paint. Sometimes the colored shapes simply will not work. Certain colors tend to push forward, or perhaps flutter, while others tend to recede and, in so doing, become distracting. Frequently the completed image is unsatisfactory to the artist for some other reason. When this happens, everything is left as it is and taping begins anew—on a larger scale this time. Another underpainting of acrylic is usually necessary as the shapes grow larger, perhaps the

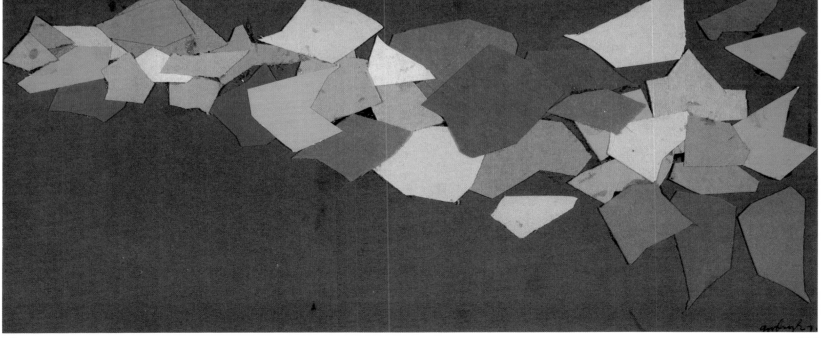

140.

141. *Colors*, 1971
Paper collage, 4 x 12″
142. *Pastel Collage*, 1971
Paper collage, 15 x 7½″
Collection Hans Noë, New York

141.

paint is even darkened a little. Yet, as often as not, the canvas still does not work. Finally, in a last desperate attempt to save the painting, the ground or vast color-field may be repainted in a slightly different value. This is a trying time, for a great deal of effort has gone into the painting— sometimes many days. But when it is clear that it cannot be saved, the canvas is destroyed. There can be no other choice.

Sometimes the destruction of a painting is a moment of relief for Goodnough. No longer must he worry about solving the particular problem that has frustrated him. He feels a certain sense of failure in not having made the idea work; yet he knows that destroying it was the best choice and begins again.

Goodnough constantly seeks to rework his canvas as he paints, to analyze its progress and, ideally, to express an actual or imagined quality. He has suggested that viewers consider how they might feel after a day at the beach or after reading a book. How would one express such emotions? Indeed, is such a thing possible? Goodnough thinks so. But to reach this goal, an artist must visually express an experience that is general rather than specific. Therefore he

143.

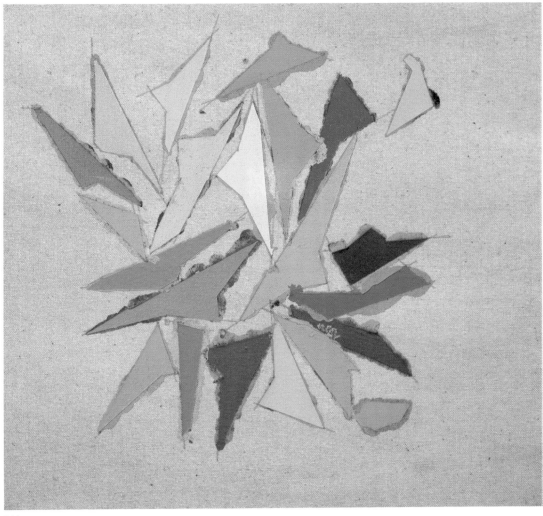

144.

thinks in terms of purely visual effects and relations, and any verbal equivalent to a recognizable image is something that does not concern him.

Even after a canvas seems to have been completed, it may not be exciting enough for him. Perhaps, he reasons, it might look better as a totality when set in space if it were a smaller square, or another painting, such as *Yellow, Green, Gray*, might be stronger as a vertical rectangle. Decisions on such things are usually intuitive or arbitrary, worked out in Goodnough's subconscious, and the large canvas may be cropped to a six-foot square. But some paintings are so good when completed that he would never consider changing their shape or size. This technique of cropping paintings is important since any decision to alter a canvas is also creative and serves to produce an interesting variety of shapes and sizes.

The element of change should never be overlooked in Goodnough's work. It is always there, even though his themes have generally remained the same. This nuance of change is apparent, for example, in a 1979 painting entitled *Blue Mass*, in which he introduced the "wet look," a "look" that originated when he painted various layers of shapes with a thinner paint than he had ever used before. The result was an inordinate number of drips that appear to vibrate as the viewer gazes at an otherwise serene canvas.

A large horizontal picture entitled *Double Group* is representative of the kind of variation Goodnough introduces in his work from time to time. Clusters of dark blue and black shapes play against bright red shapes on a tan-gray canvas, each spreading across the surface. One group of shapes closely follows the top edge of the picture while the other hugs the bottom edge. The title reflects the visual impact or the general effect of the painting. This is characteristic of Goodnough's titles. They are like catalog numbers, with no meaning other than the mention of a dominant color or a dominant group of shapes. Nor does Goodnough now sign or date his canvases. A signature, in his opinion, causes a distraction for the viewer by pulling the eye toward

145. *Development with Red*, 1972
Acrylic and oil on canvas, 30 x 36"
146. *Colors with Tan*, 1972
Acrylic and oil on canvas, 84 x 84"
Collection Mr. and Mrs. Henry Sha-
piro, Chicago, Illinois

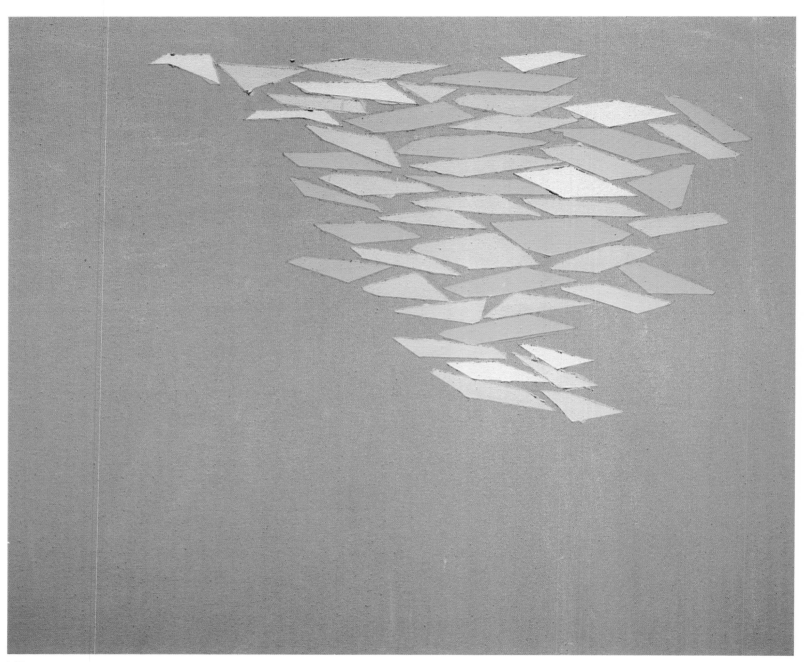

145.

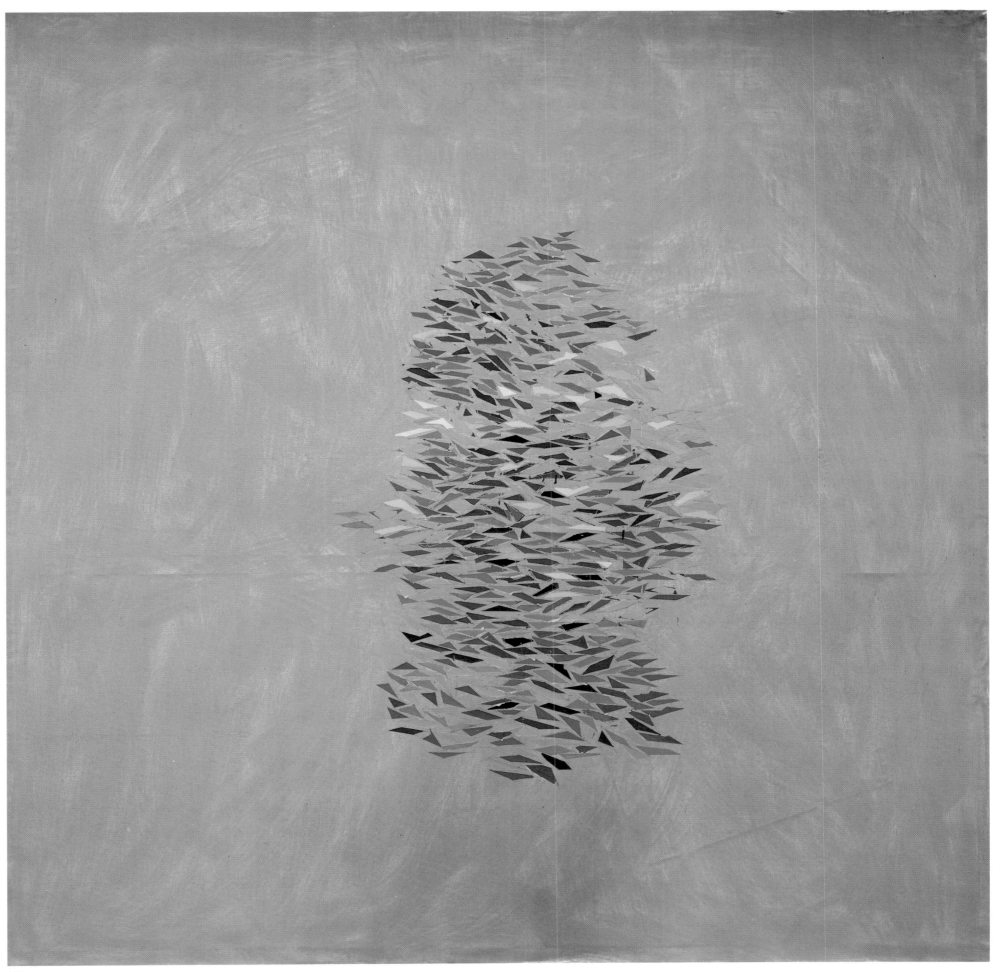

146.

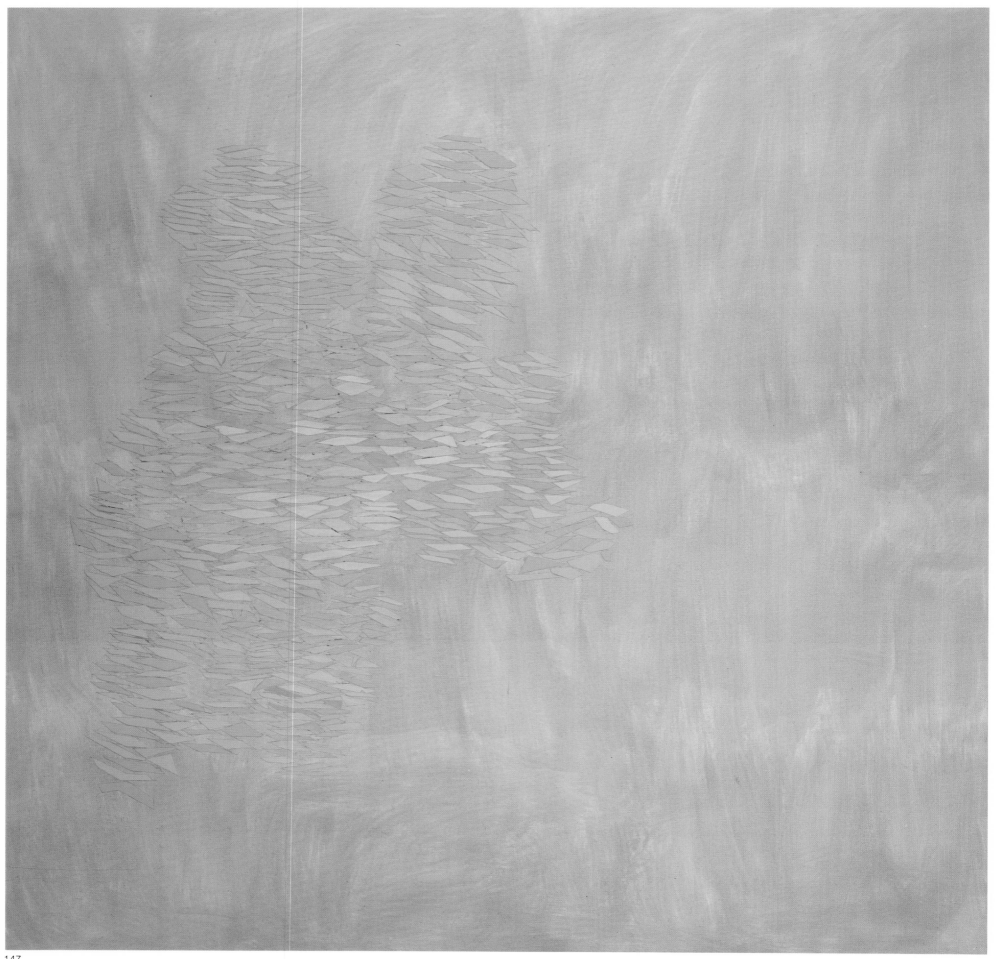

147.

147. *Slate Gray Statement*, 1972
Acrylic and oil on canvas, 110 x 110"
Museum of Fine Arts, Boston, Massachusetts
The Hayden Collection
148. *Quiet Development*, 1972
Acrylic and oil on canvas, 42 x 64"
149. *Yellow with Dark Blue*, 1972
Acrylic and oil on canvas, 78 x 78"

one corner or the other of the painting. But even if it is unsigned, there is no mistaking a Goodnough painting because his style is unique.

Color Shapes on Gray is a little more lyrical and no color is dominant. In this picture a large vertical cluster of color-shapes—red, orange, yellow, green, blue-violet, and black—is situated near the center of a canvas that has been sharply cropped to enhance the power of the cluster itself. The effect is stunning. In *Collage with Red*, a 1980 work that could correctly be described as a reverse painting, pieces of canvas were cut out—and sometimes painted and stapled on a surface of wood, then painted again. The collage began as a blue picture, shifted to black, and ended as a red image because the red shapes are dominant. It was all unplanned. Obviously, the collage continues even now to be of great importance to Goodnough. This is why he keeps returning to it: to get away from pure painting while looking for new ideas. "I start with something familiar," he said, "but deal with it in a vastly different way. It is a little like playing a

148.

149.

150.

150. *Collage with Black*, 1972
Paper on canvas, 12 x 12"
151. *Gray Statement*, 1972
Acrylic and oil on canvas, 74 x 74"
152. *Brick Red with Yellow*, 1972
Acrylic and oil on canvas, 92 x 92"
Shawmut Bank of Boston Collection,
Boston, Massachusetts

piano; the notes are the same but the music is different."

Goodnough's work is almost always acclaimed by critics whenever it is exhibited. Gordon Muck of the *Syracuse Post-Standard* (December 23, 1974) described Goodnough's paintings at the Everson Museum of Art in Syracuse, New York, as "abstract, poetic, atmospheric delights with a spontaneous (real or planned) freshness that should make any spectator a happy participant. To me," wrote Muck, "there is an inner joy and totality of matter, form and content of such incredible subtlety and beauty as to be always remembered and treasured." Ann Hartranft of the *Syracuse Herald-Journal* (January 12, 1975) was no less enthusiastic. "For one artist to fill the Everson's four upper galleries is in itself an accomplishment of some magnitude," she wrote, "but to do it with such beauty, sensitivity of color and consistency of statement is all the more remarkable." These same feelings have been echoed from coast to coast and from Europe, too. A review in *Artequia* (March–April 1975), a magazine published in Madrid, Spain, proclaimed that Goodnough's works at Galerie André Emmerich in Zurich, Switzerland, "triumph brilliantly." André Emmerich himself was delighted. "You don't know," he said, "how pleased I

151.

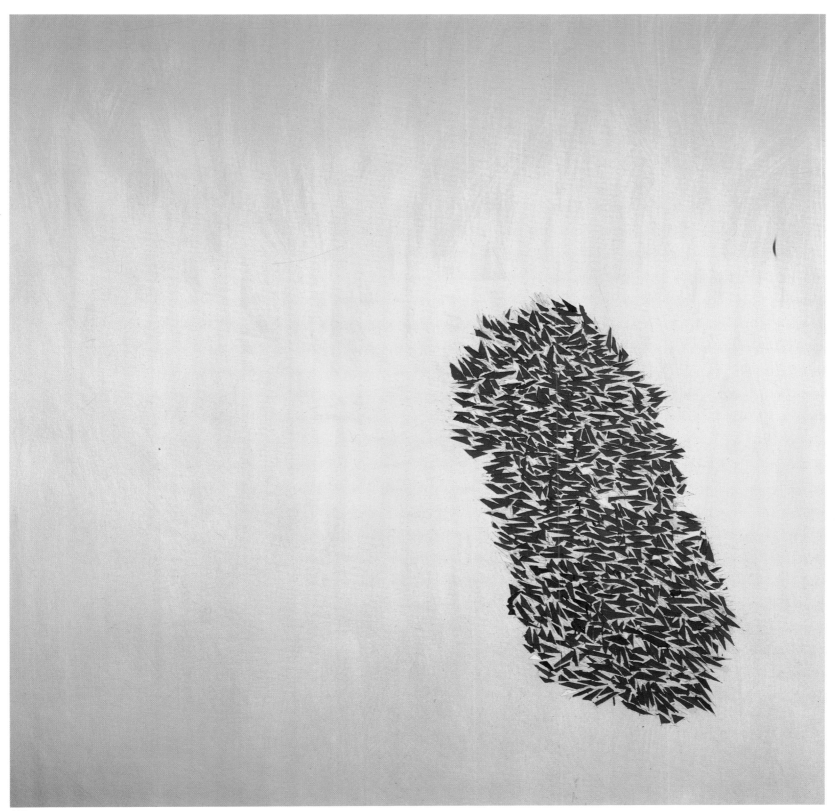

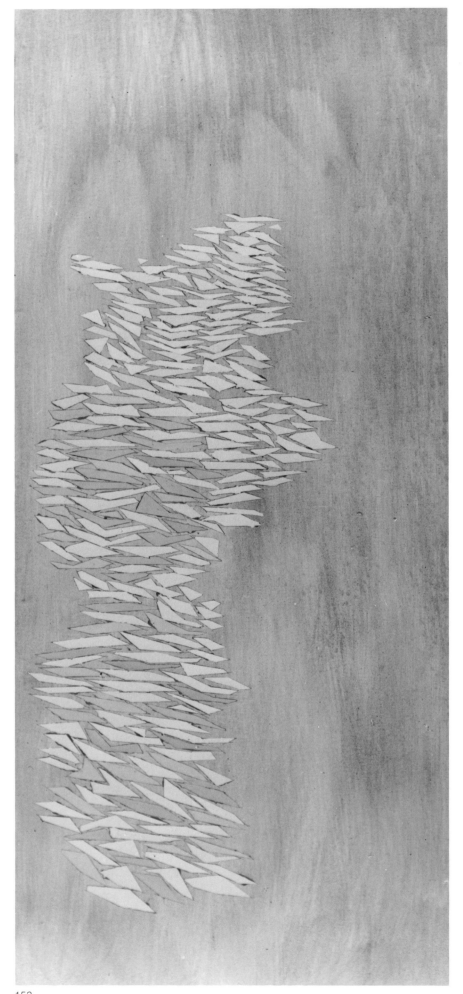

153.

153. *Yellow, Green, Gray*, 1972
Acrylic and oil on canvas, 84 x 36"
154. *White Reach*, 1972
Acrylic and oil on canvas, 12 x 12"

am to have an artist of Bob's caliber back in my gallery. He fits in well with the many outstanding painters and sculptors we show here." And more recently, John Bernard Myers told critic Alexandra Anderson (in the October 1980 issue of *Artforum*) that he considered Robert Goodnough to be "far more important than Robert Motherwell, Mark Rothko, and above all, Barnett Newman."

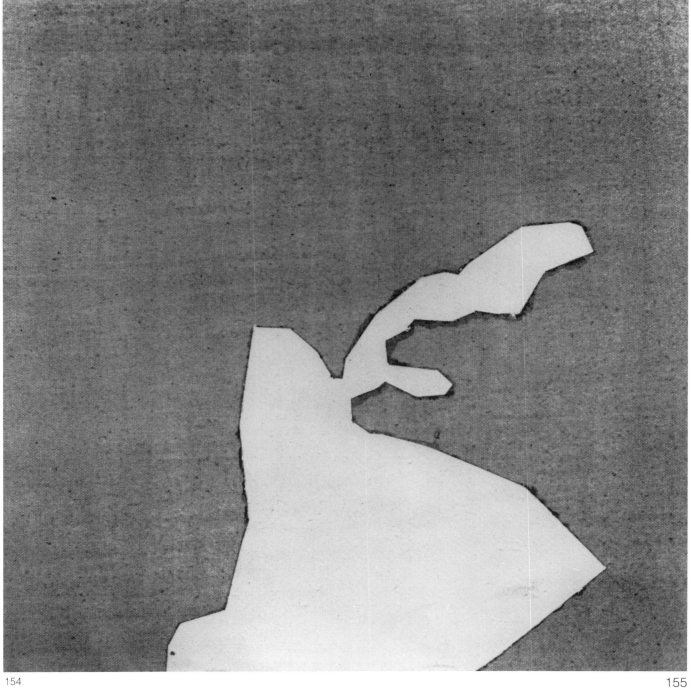

154.

155. *Abstract*, 1972–73
Acrylic and oil on canvas, 38 x 64"
156. *Red, Yellow, Green, Gray*, 1973
Acrylic on canvas, 78 x 78"

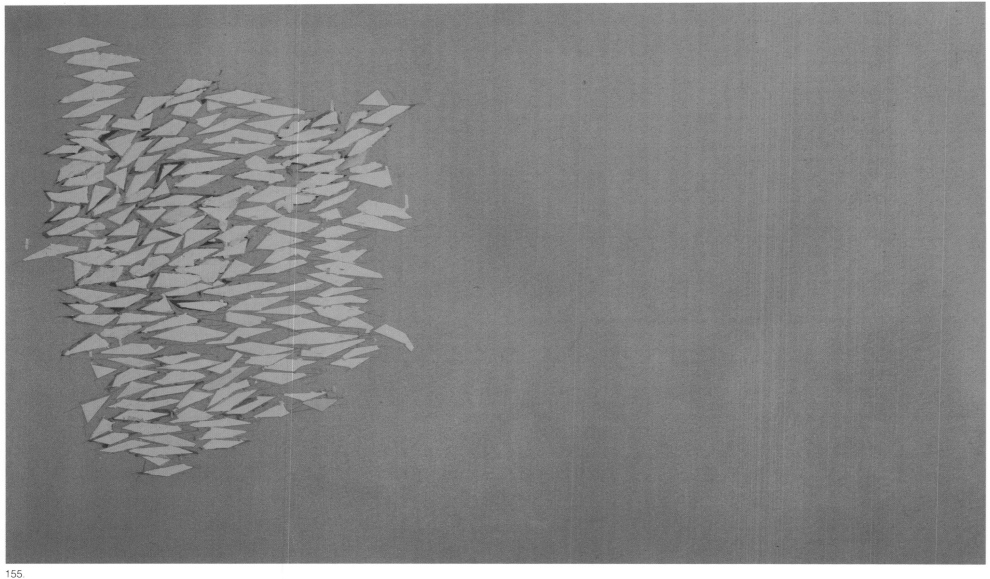

155.

Goodnough's is a lyric not an epic art. The successful Goodnough painting is a quiet, gentle canvas on which form complements form and color meets color in a simple poetry of balance. The imagery in these works is so spare that most of them are virtually monochromes of color whose strength lies in the harmony established between the clusters of shapes and the colors of the canvases themselves. There is a splendid pictorial quality about these rich canvases, and in an almost mystical way, their vast surfaces resonate with an Oriental splendor as they transfer pleasure to the beholder.

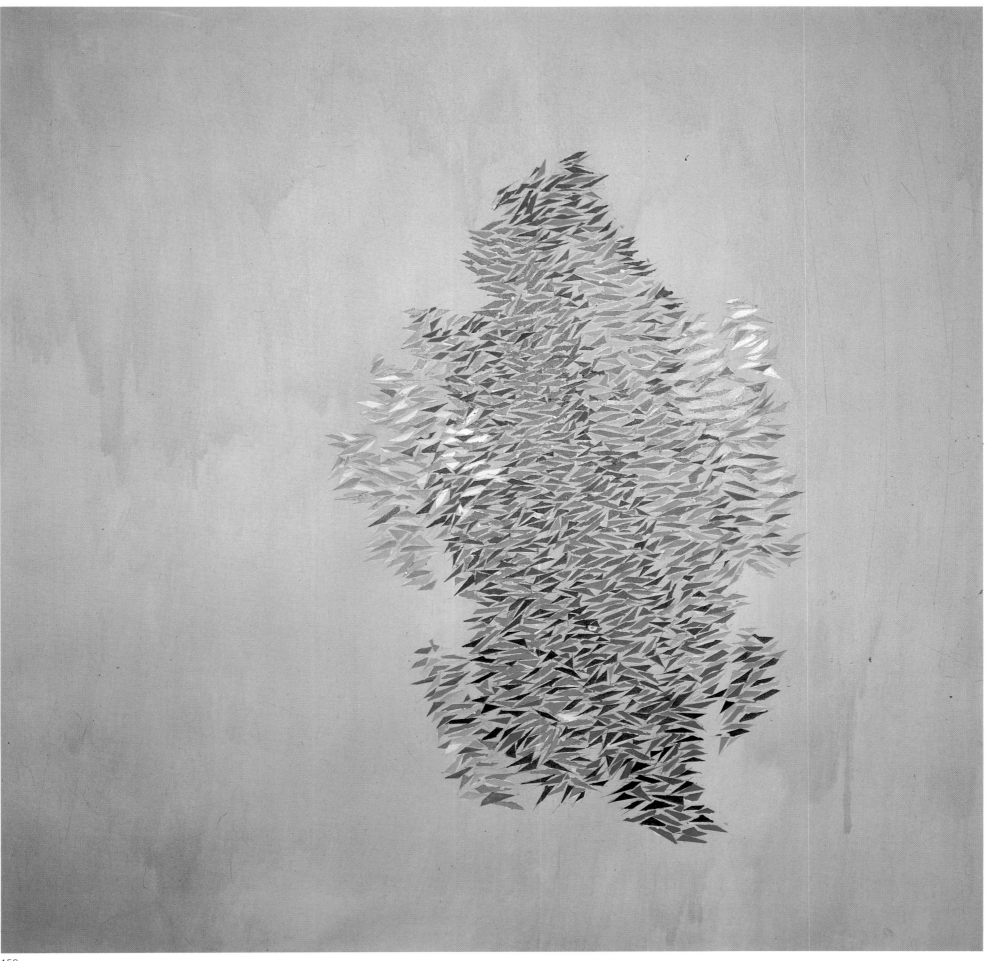

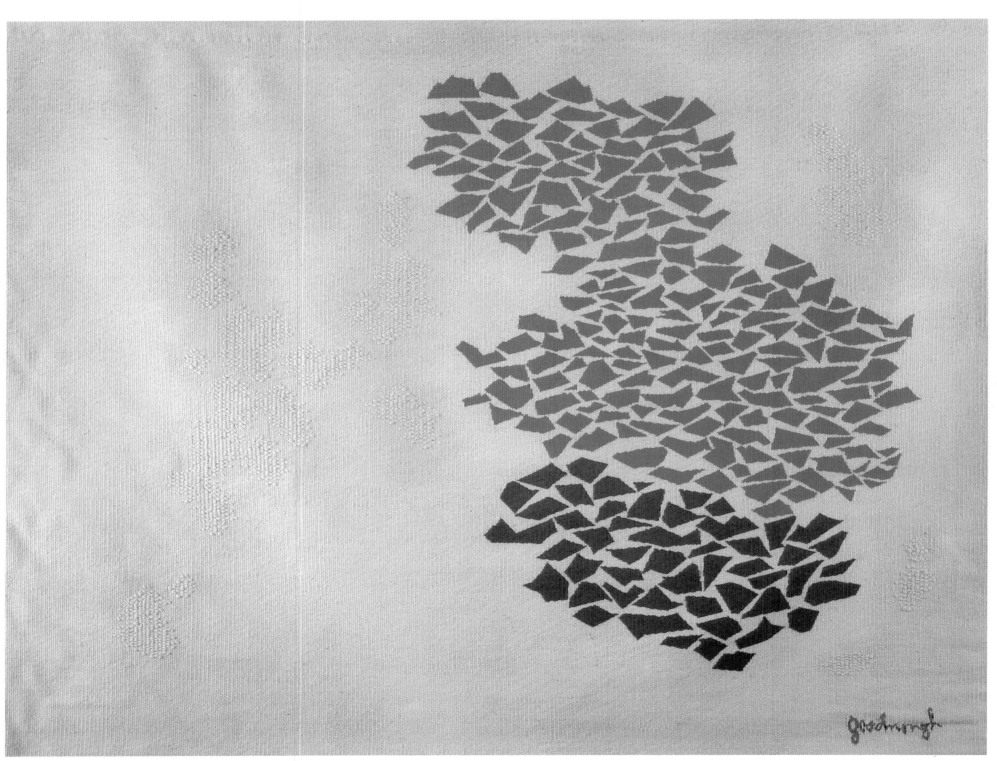

157.

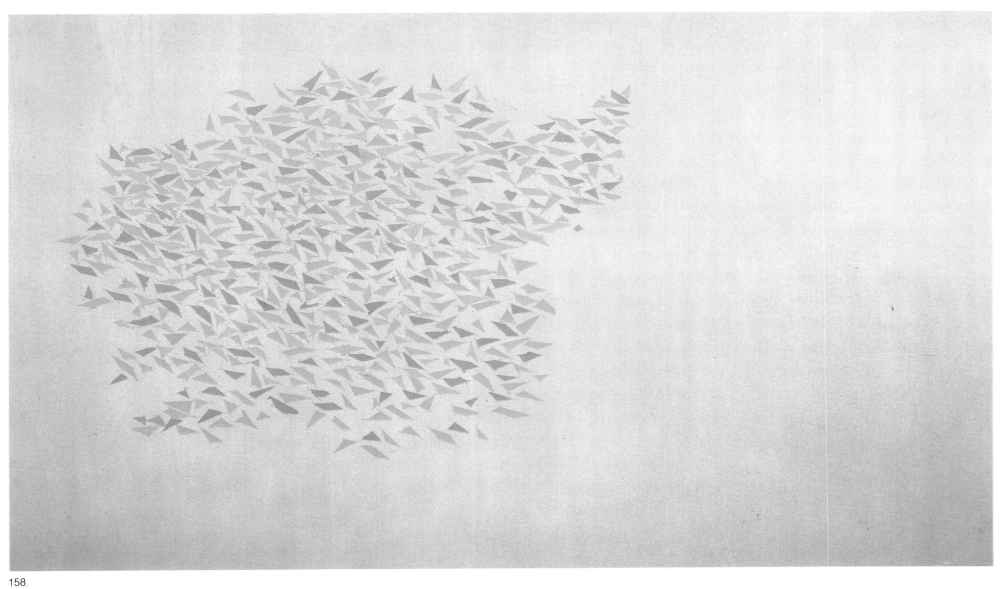

158.

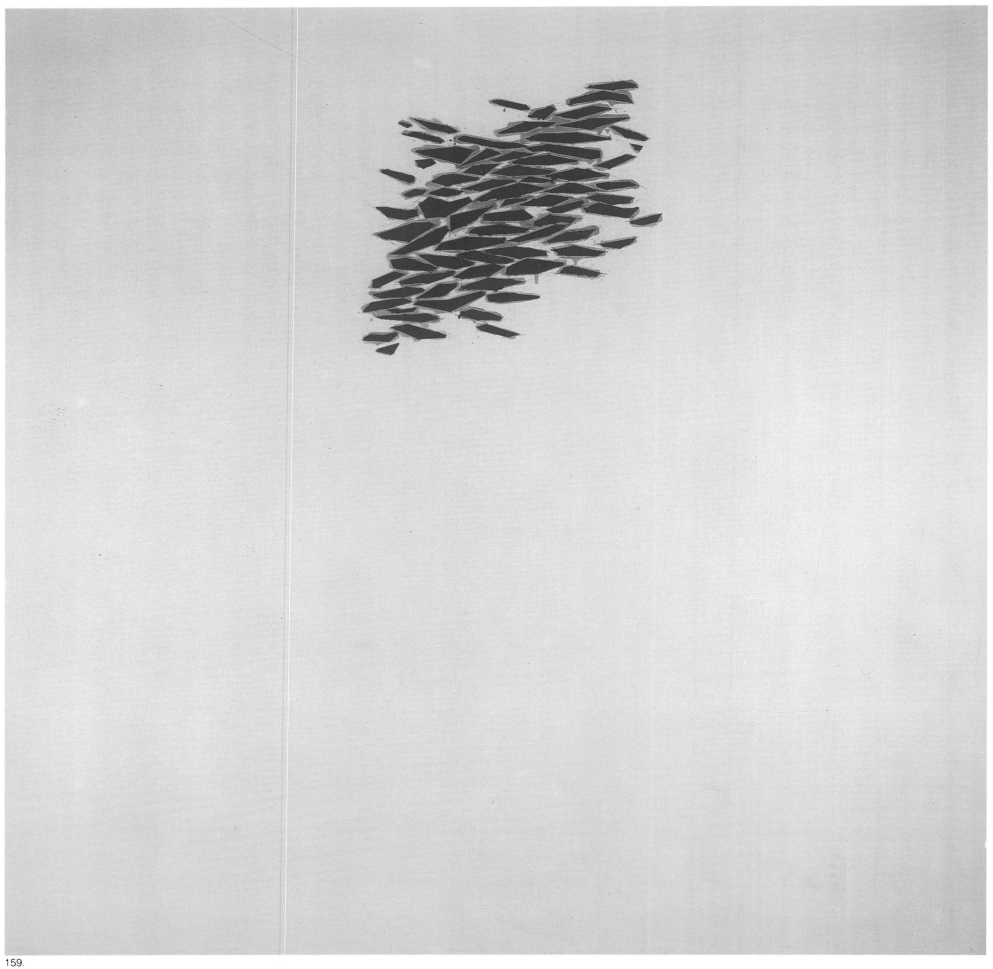

159.

159. *Blue Lift,* 1973
Acrylic and oil on canvas, 78 x 78"
160. *Orange,* 1973
Acrylic and oil on canvas, 38 x 38"

TALKING WITH
ROBERT GOODNOUGH

May 27, 1981

Bush: When you moved to New York more than twenty-five years ago, Bob, to pursue a career as a professional artist, the city must have appeared formidable to you. What was the art world like then? How much has it changed?

Goodnough: You're right, it was formidable. But it was also challenging and exciting because there was a certain electricity in the air. Everybody, it seems, had become enthusiastic about painting—much more so than now, or at least that's the way it appeared to me. Franz Kline, Jackson Pollock, Willem de Kooning, and a number of other painters were going strong. They had freed themselves from Europe, and Americans were gradually beginning to dominate art, especially in the abstract field.

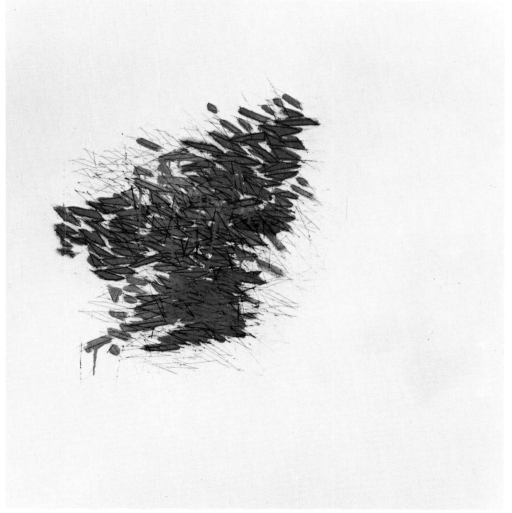

160.

161. *Colors on Pink*, 1973
Acrylic on canvas, 34 x 48″
Collection Mr. and Mrs. David Mir-
vish, Toronto, Canada
162. *Colors on Green*, 1973
Acrylic and oil on canvas, 36 x 36″

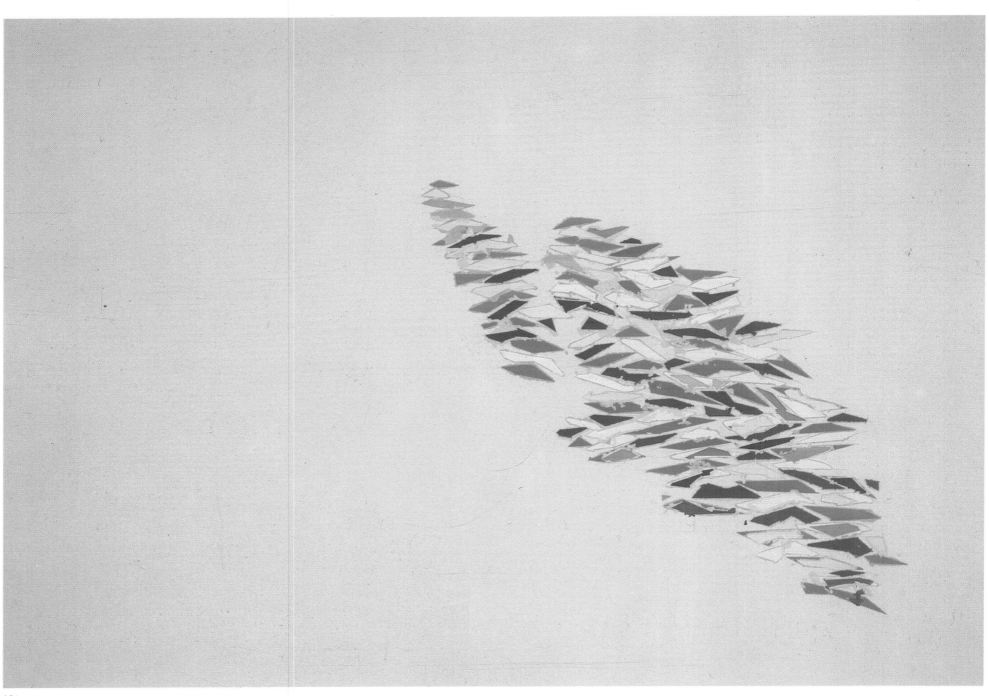

161.

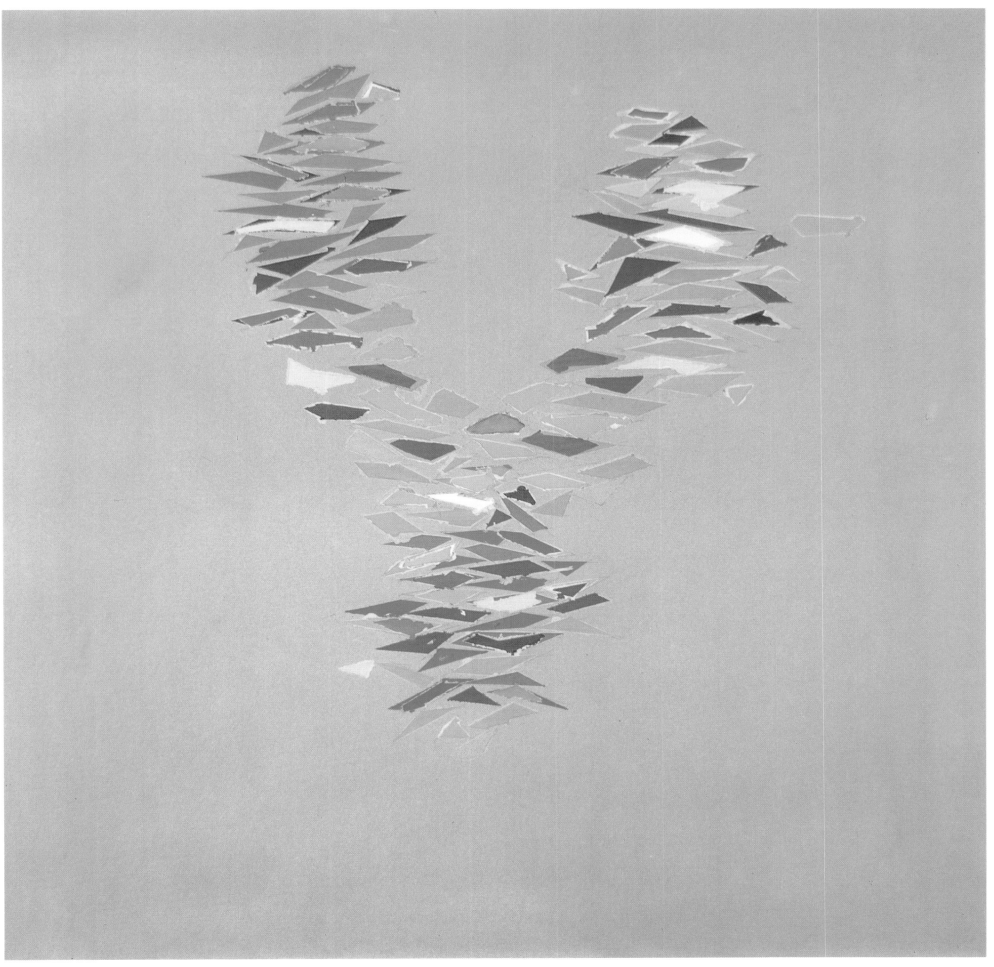

162.

163. *Collage Study*, 1974
Paper collage, 12 x 24″
164. *Red on Gray*, 1973–74
Acrylic and oil on canvas, 36 x 36″
Collection Zapata Corporation,
Houston, Texas

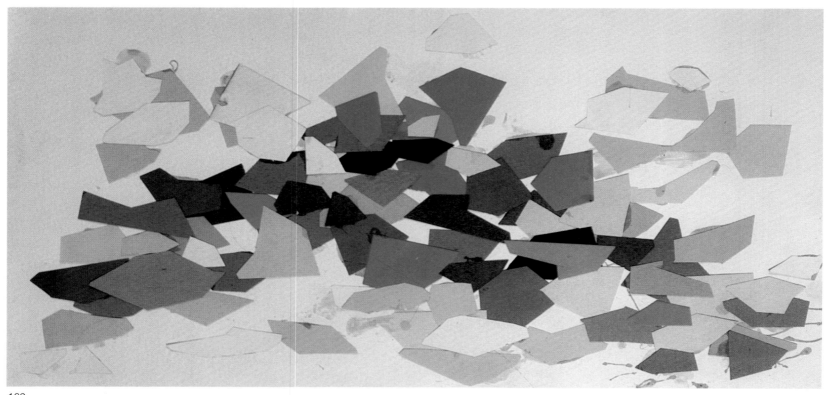

163.

B: When you arrived, though, were the so-called Abstract Expressionists really going strong? Were they the real super-stars?

G: Well, the best-known painters in those days were Picasso and Matisse in Europe. But in this country, the first artists I can recall hearing about were de Kooning, Pollock, Kline, Mark Rothko, Clyfford Still, Robert Motherwell, and people like that. They were the ones I found challenging.

B: Why? What made them so interesting?

G: Because I had started my studies of art at Syracuse University in life drawing and portrait painting—the tradi-tional kind of art that was popular in those days. In time, however, just painting someone's portrait or figure became a little dull. But de Kooning and the others were really caus-ing some excitement. They were taking a lot of liberties with the figure. They were doing other things, too, almost elimi-nating the figure altogether. Finally, you could forget about a model and use your imagination. That was what was so challenging to me. Copying a model had become awfully boring.

164

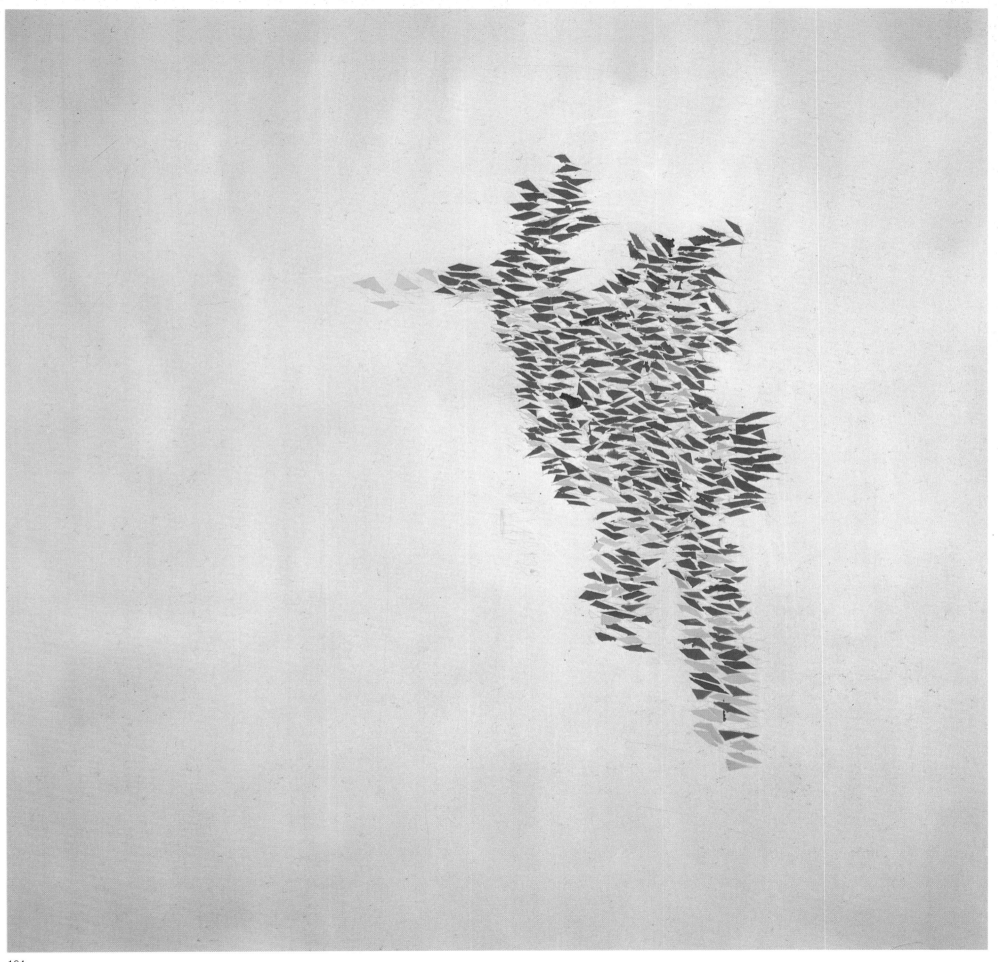

165. *Gray Edge,* 1974
Acrylic and oil on canvas, 66 x 108"
Collection Dr. Lee Salk, New York

B: You've often mentioned that your own paintings were influenced by the Abstract Expressionist movement because it was so refreshing and new.

G: Yes. I gradually worked into it. I still liked to use a figure, but slowly I began to abstract it more and more, and yet, some semblance of the figure remained in the work for a long time. You can actually pick out a figure in most of my early abstract work.

B: What were the critics saying about the New York School painters? Did they accept them, that is to say, in the late 1940s?

G: The only ones I knew about were Clem Greenberg and Harold Rosenberg. They were excited about the trend and encouraged them. But most people couldn't see any future in what was going on.

B: Was it fashionable to criticize the Abstract Expressionists?

G: Oh yes, a lot of people thought they were a joke. I suppose they looked upon the Abstract Expressionists as a bunch of crazies. But there was also a small group who supported them—students, critics, museum curators, gallery owners, and others who thought something exciting was happening, and the Abstract Expressionists soon began to make their presence felt throughout the art world.

B: How well were they living? Were they struggling financially, or were they making a lot of money and getting along well?

G: They were struggling. In fact, I had heard at one time that de Kooning had to stop painting because he couldn't afford to buy paint. Many artists were having a difficult time. If a painting did sell, the price was very low. Pollock was selling his paintings for about $300 at the time, I believe. Yes, they had a hard time.

B: You met and became acquainted with many of them, didn't you?

G: I met most of the artists who eventually became known as the Abstract Expressionists while I was attending New York University. You see, I interviewed several of them while doing research on my masters thesis and got to know them.

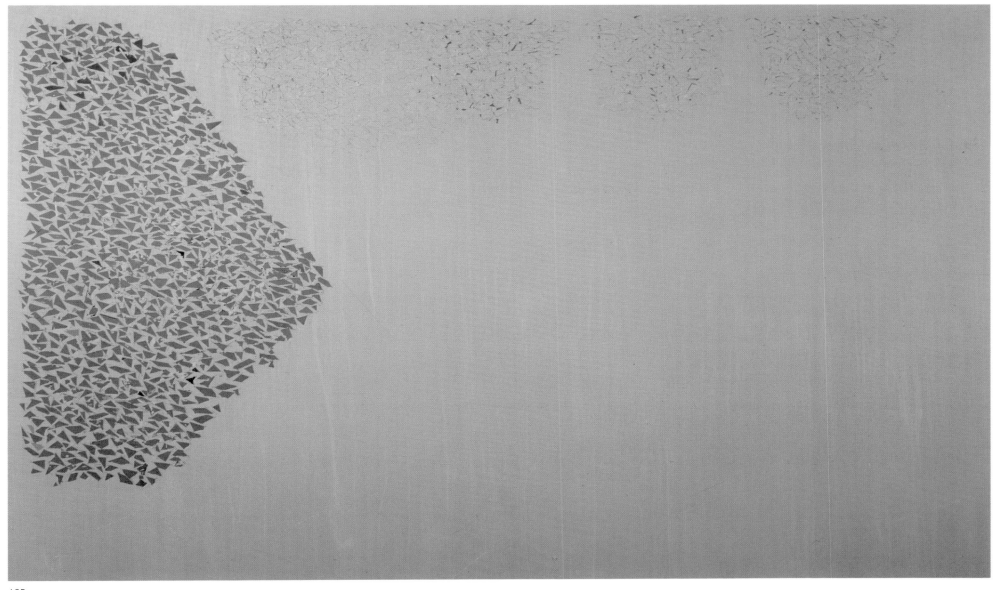

165.

166. *Development with Colors*, 1974
Acrylic and oil on canvas, 36 x 48"
167. *Brown and Gray*, 1974
Acrylic and oil on canvas, 73 x 60"
Collection Hanford Yang, New York

Eventually about thirty or forty of us got together at the 8th Street Club where we had symposiums, and I acted as secretary for the group. That gave an inside view of what was going on at the time. It was all new and stimulating.

B: You really believed in them, didn't you?

G: Very much.

B: How much did they influence your own work?

G: They had a great deal of influence on my work. At first, I think Picasso had the most influence on me; later I began to see that these people were going beyond Picasso. He would abstract a figure and you could still recognize it, but the New York School painters went beyond that, and that's the kind of thing I began to do in my own work.

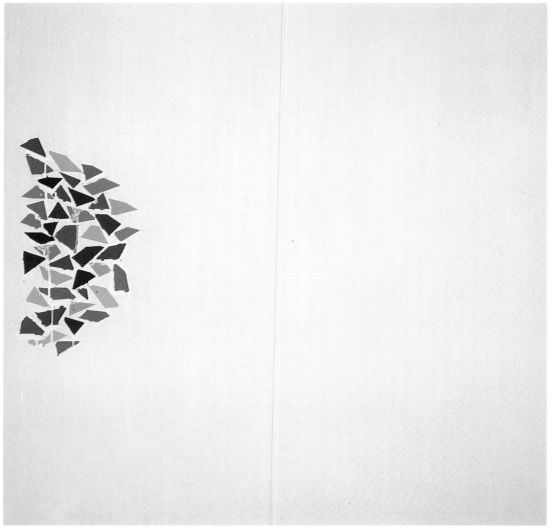

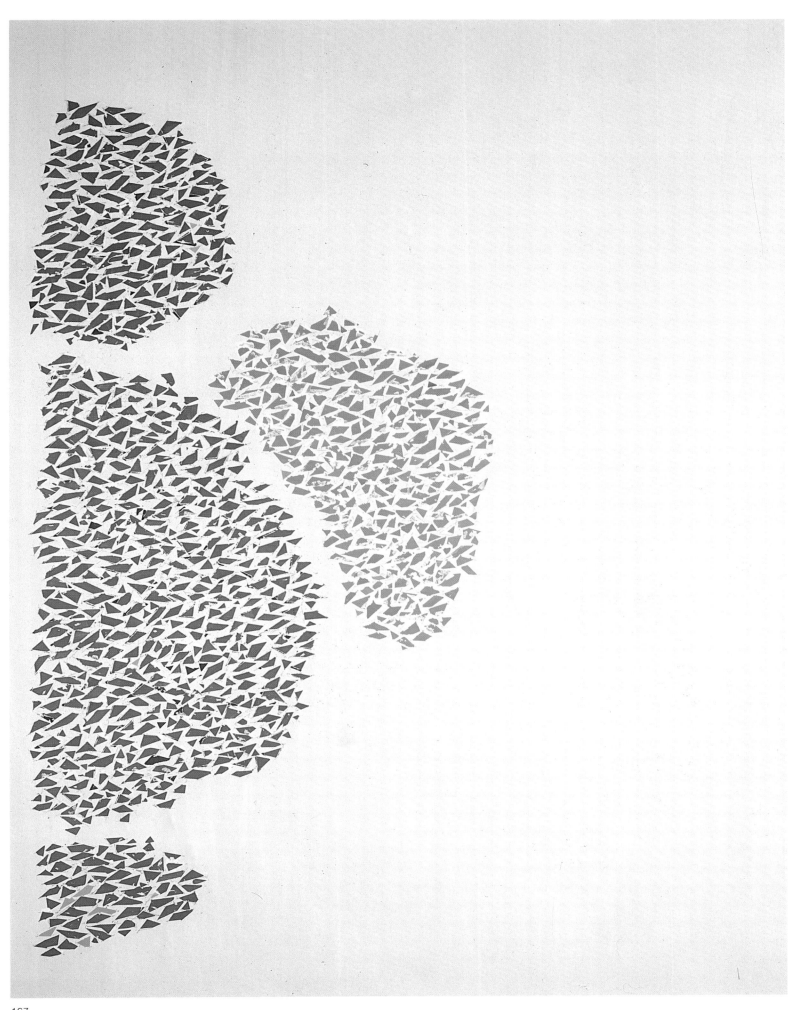

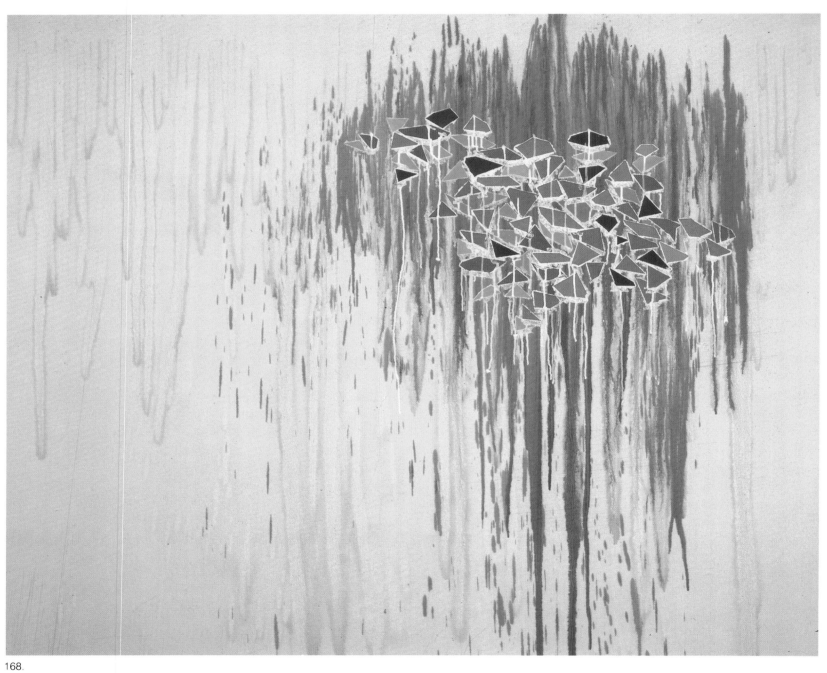

168.

168. *Colors on Green and Orange,*
1975
Acrylic and oil on canvas, 58 x 72"
169. *Abstraction,* 1975
Acrylic and oil on canvas, 44 x 58"

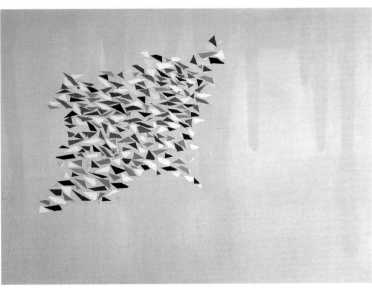

169.

B: You mentioned thirty or forty artists as being in the group. Who were the most influential ones? Were there factions? Who were the artists the younger painters tended to look up to?

G: Most of the people who were interested in the movement were a little overwhelmed by Pollock because he was the big name then. When the Forum was being organized, letters were mailed in which the well-known artists were asked to attend. Pollock sent a note saying he couldn't come because he was home painting! He was somewhat a mystery figure. You didn't see him very often, although he would occasionally drop in at the bar.

B: What about de Kooning? Some people say de Kooning had quite an influence on the younger painters.

G: He did. But Pollock, Clyfford Still, Rothko, and Barney Newman were the ones who had the most influence on the abstract movement. At least that is what I believe.

B: Did you find them to be helpful and pleasant?

G: Pollock was extremely nice, although he was hard to talk to. He never talked much. But he was a warm, friendly person. De Kooning was much more talkative, good natured, easy to talk to. I didn't know Rothko that well. Clyfford Still was just a little bit distant and Barney Newman was very articulate. Barney and Tony Smith were good friends and they used to get together quite often to discuss art trends and other things. We used to sit around and listen to them the way students probably did in the days of Socrates and Plato.

B: Would Pollock respond to questions about his art?

G: Not in any definitive manner, only in a rather vague kind of way.

B: Was he in any way defensive about his paintings?

G: No, not at all. I don't think he liked to talk about his work, though, and I don't believe he considered that his job. He thought it was *his* job to paint and it was the *critics'* job to discuss what he painted.

B: That's true of many artists. I've visited Joan Miró several times, and Miró won't discuss his work either. He merely

170. *Red, Blue, Pale Yellow*, 1975
Acrylic and oil on canvas, 36 x 42"
171. *Colors on Gold-Tan*, 1975
Acrylic and oil on canvas, 48 x 62"

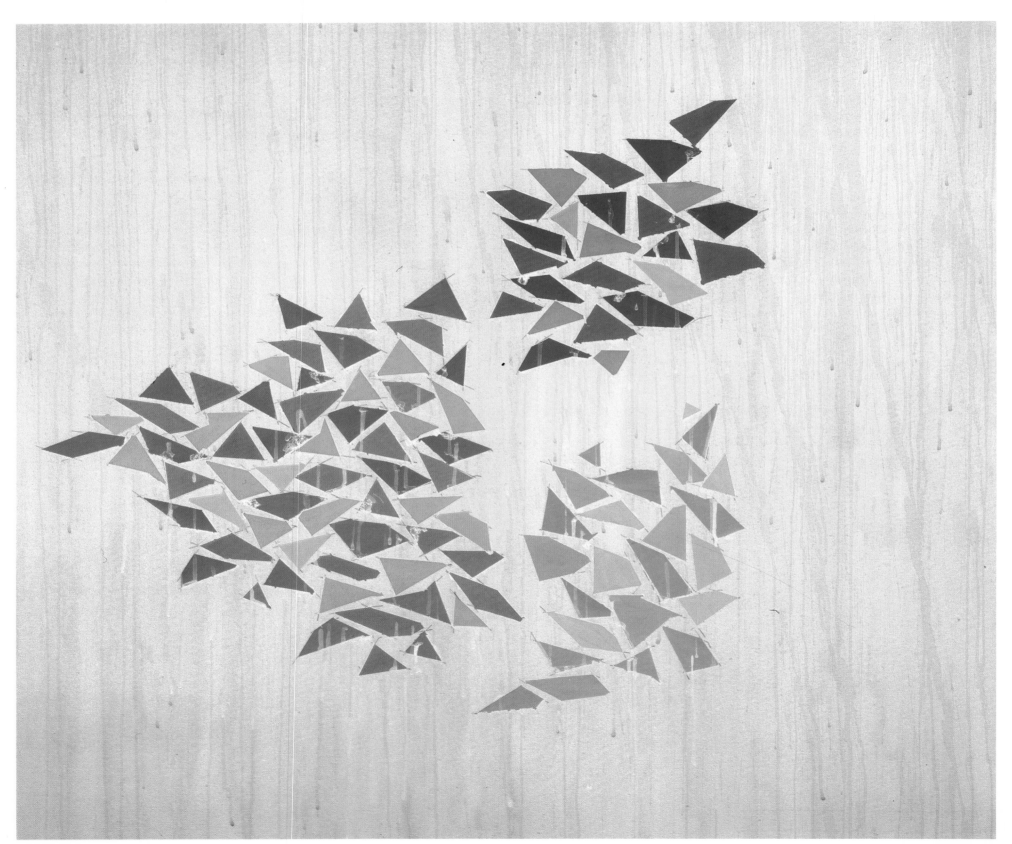

170.

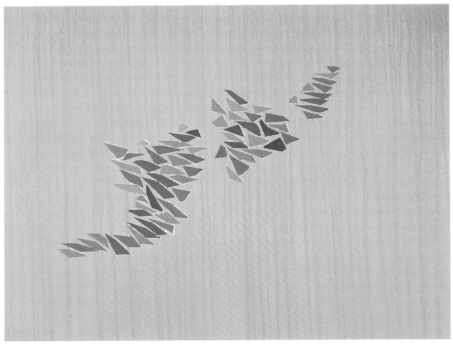

says, "It's whatever you think it is." He just won't comment. Apparently, Pollock was much like that?

G: Yes. I think he felt, as I do, that if you say something about your work, people might tend to read things into it, instead of seeing it with their own eyes in their own way.

B: We know in retrospect that American art was coming of age in the post-war years. And we also know now that Abstract Expressionism was to become the first major art movement of international importance to have originated in the United States. Did you have any idea that that was happening at the time?

G: It was in the air and everybody thought "this is it." But, you know, it may have started in Europe.

B: That's a curious statement for you to make. Why do you say that?

G: Piet Mondrian, of course, was working here, but he had worked in Europe first. And Kandinsky and others had been doing abstract work in Europe for years before it ever started here. But somehow, that early abstract work didn't have the power generated by the Abstract Expressionist painters.

B: Don't you think World War II had a significant impact on the development of Abstract Expressionism? After all, the United States was cut off from the rest of the world and numerous European artists were painting here.

G: Yes. But I think it was just in the cards. The scene had to shift, you know. All the energy was here. This is where the new ideas were being generated; somehow, the New York School just took over. You sensed it. This wasn't something that you looked back upon and said, "This is what happened." You felt it at the time. Most of the artists then were certain that something important was happening.

B: By the late 1950s, Abstract Expressionism was pretty well accepted, wouldn't you say?

G: In the late 1950s? Yes.

B: Or, at least, it was well on its way to being accepted. People all over the world were interested in it. What was the general feeling about the New York School then? Had the Abstract Expressionist movement run its course?

172. *Colors on Pink*, 1975
Acrylic and oil on canvas, 62 x 72″
Wichita Art Museum, Wichita, Kansas
173. *Colors on Tan-Gray*, 1975
Acrylic and oil on canvas, 40 x 46″
Collection Uriel Adar, Scarsdale, New York

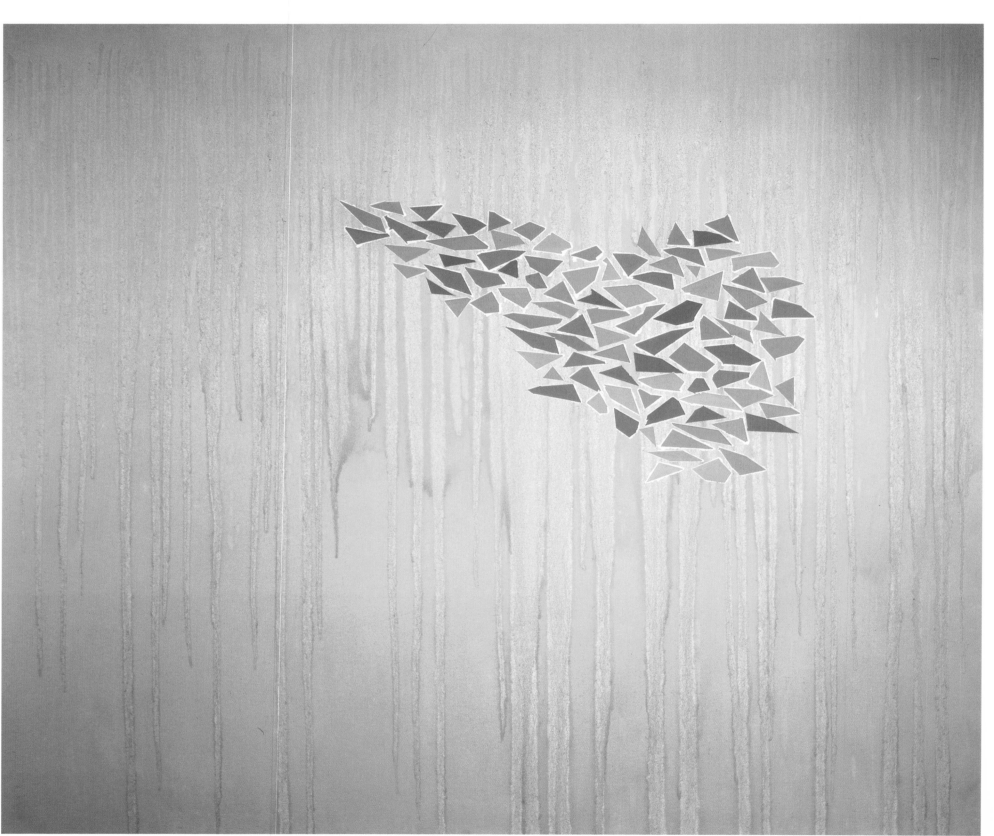

172.

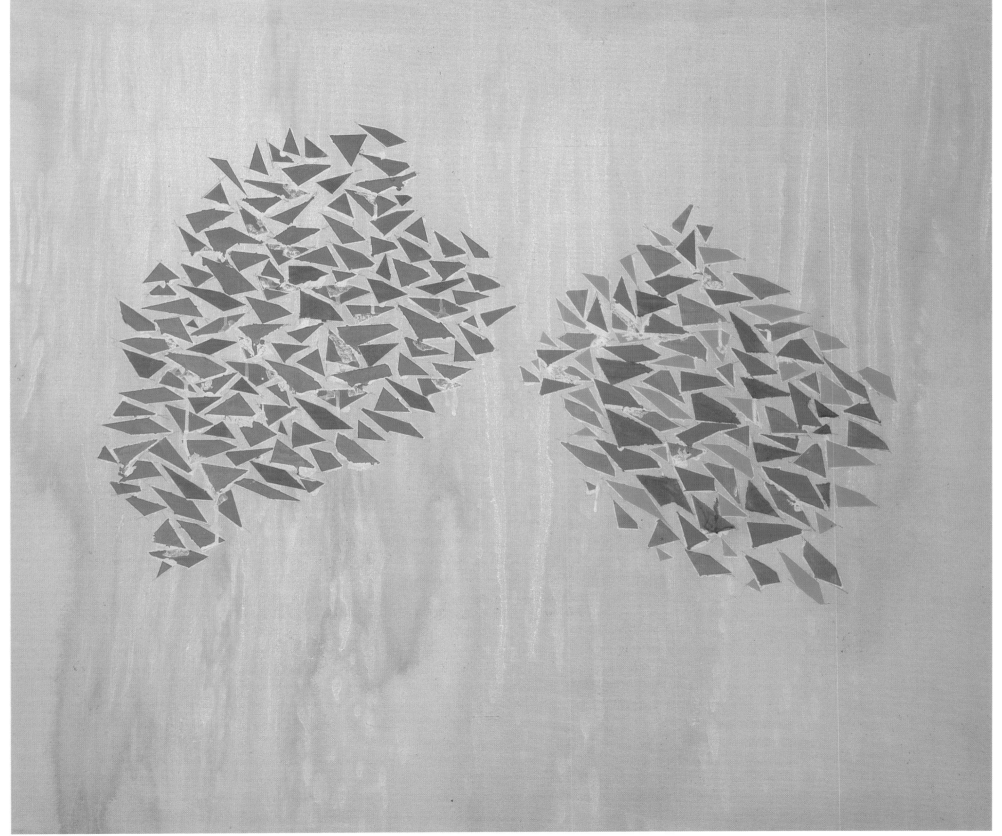

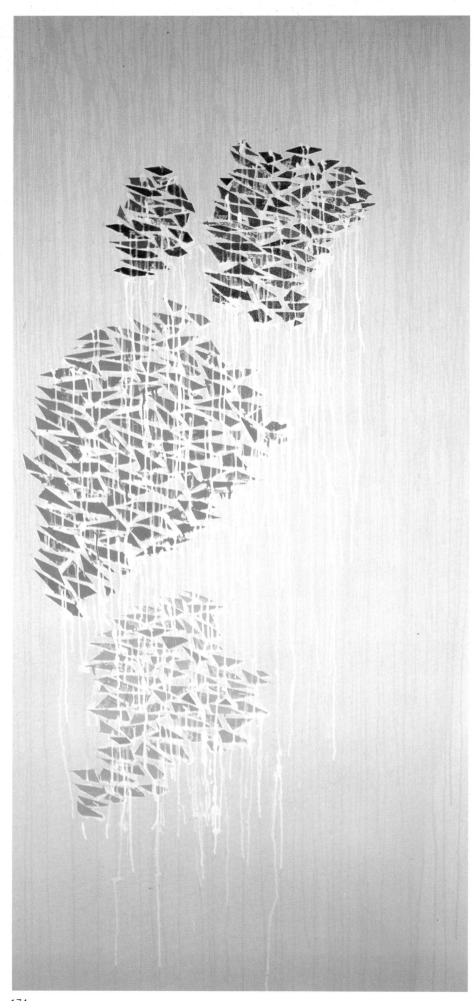

174.

174. *Blue*, 1975
Acrylic and oil on canvas, 84 x 40"
175. A workman putting the finishing touches on Robert Goodnough's large (approximately 110' long) untitled Cor-ten steel and stone mural at the Shawmut Bank of Boston, Boston, Massachusetts, in 1975
176 and 177. Robert Goodnough's Cor-ten steel and stone mural at the Shawmut Bank of Boston, installed by William Soghor

175.

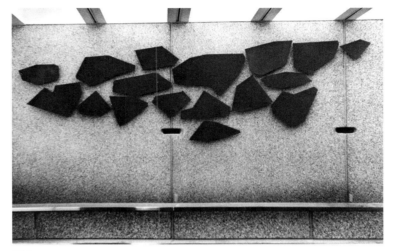

176.

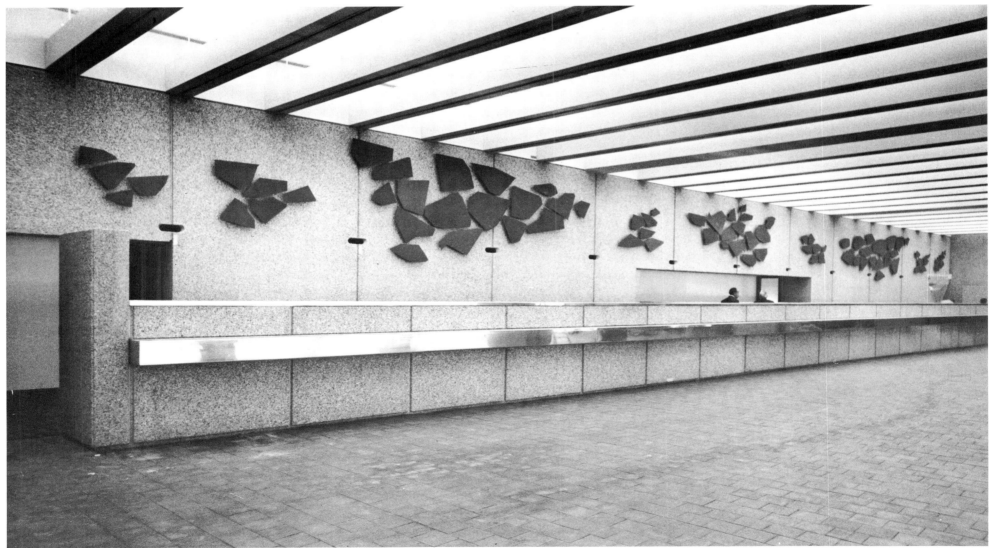

178. *Blue Expansion*, 1975–76
Acrylic and oil on canvas, 72⅛ x 131⅞"
Hirshhorn Museum and Sculpture Garden, Smithsonian Institution, Washington, D.C.
179. *Color Gray*, 1976
Acrylic and oil on canvas, 55 x 116"
Collection Colonial American National Bank, Roanoke, Virginia

178.

G: Well, by the late 1950s the intensity of Abstract Expressionism was diminishing. The artists had settled down to an almost "academic" kind of . . .

B: You don't mean that abstract art had become so established that people were beginning to think of it as "academic"?

G: You're right. I shouldn't say "academic." It was more "classical." It didn't depend on a lot of activity anymore; activity wasn't a part of it. The paintings were less hectic. I think Barney Newman had a lot to do with that because his paintings were rather calm. They didn't have the excitement that Pollock's had. And "color field" painting had begun to evolve from the movement. Greenberg called it a large, bland Apollonian art. And I guess you could say that it was a kind of move from Dionysian to Apollonian art.

B: There was also a fragmentation of art in the 1960s. Each week and each month, or so it seemed, something new and different happened. It was an era of experimentation, perhaps an artist had to be new and different because that's what the media and public expected. Did you have that feeling?

G: Do you mean different movements like the ''Pop Art,'' things like that? I never was too concerned about those kinds of movements—things like conceptual art, minimal art, op art, and other styles. I always felt that they were not necessarily part of the mainstream of art. The idea of ''movement'' for its own sake is not that meaningful to me. In my opinion, art has a historical direction that it takes and no one can really force it to change its course. A lot of that was forced.

B: Do you see yourself as being in the mainstream of contemporary art?

G: That's where I see myself. I hope I'm right. It seems to me that art has gone abstract: the gradual elimination of subject matter (realistic matter) in a kind of painting in which abstract qualities rather than subject matter are dominant. And this, to me, has been the main direction of art during the past fifty years. What's going to happen in the future? I don't know.

B: Many people say art began to go ''big time'' in 1963 or 1964, and the artist suddenly became a celebrity. Works of art were being purchased by important collectors at sums of money that were often astounding. And prices have continued to rise rapidly, particularly during the 1970s. How did you view the gallery situation prior to 1964? And how did you view it after that date? I suppose a third question would be, what are your feelings about ''big time'' art and the large sums that are being paid for paintings? This has seldom occurred in the past, at least during the lifetime of most artists.

G: At first, I believe that people thought of the artist as someone who lived in a garret. . . . They would talk about the ''starving artist.'' But this changed to just the opposite kind of situation.

B: The affluent artist?

G: Yes. I don't think it is important for an artist to starve and struggle in order to do good work. That image has pretty much disappeared.

B: It's been discredited, without a doubt.

G: If some artists can get fabulous prices for their work, I

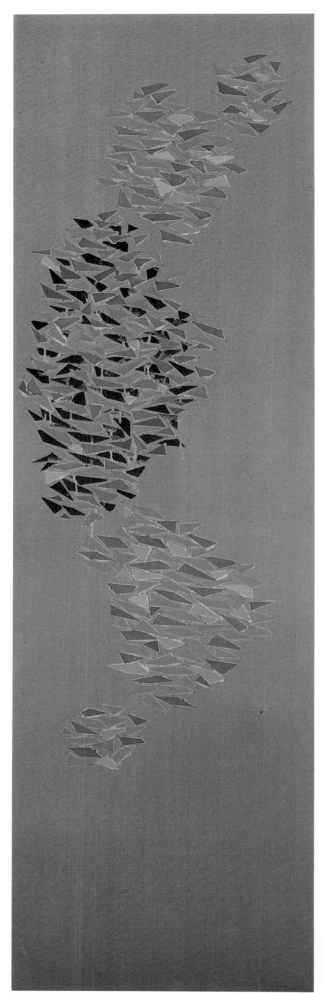

180. *Colors on Gray*, 1976
Acrylic and oil on canvas, 72 x 20"
181. *Mostly Mozart Festival*, 1976
Poster, 40 x 71"
Commissioned by Lincoln Center/
List Fine Art Poster Program, New
York

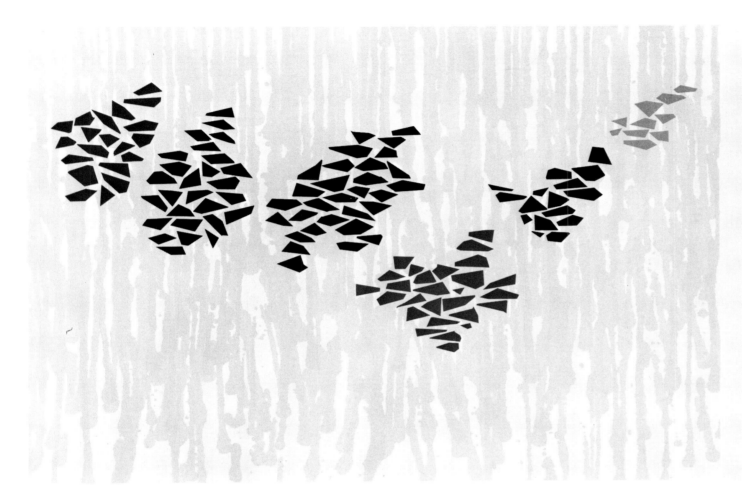

181.

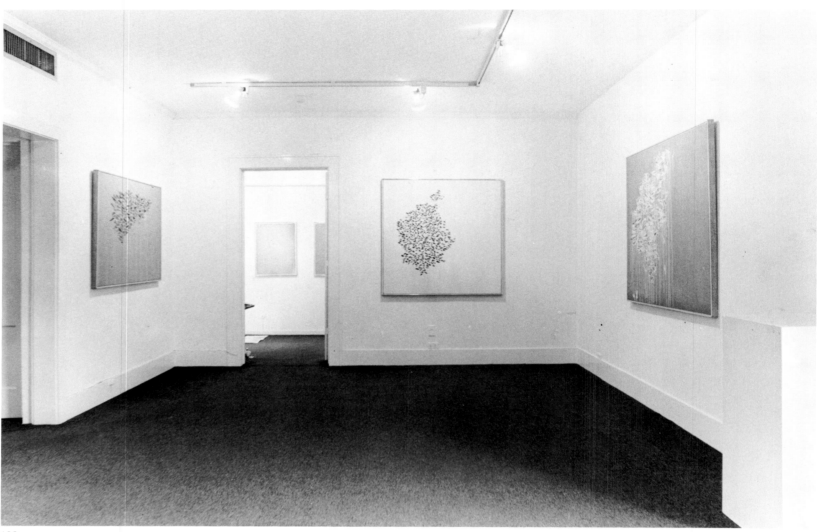

182.

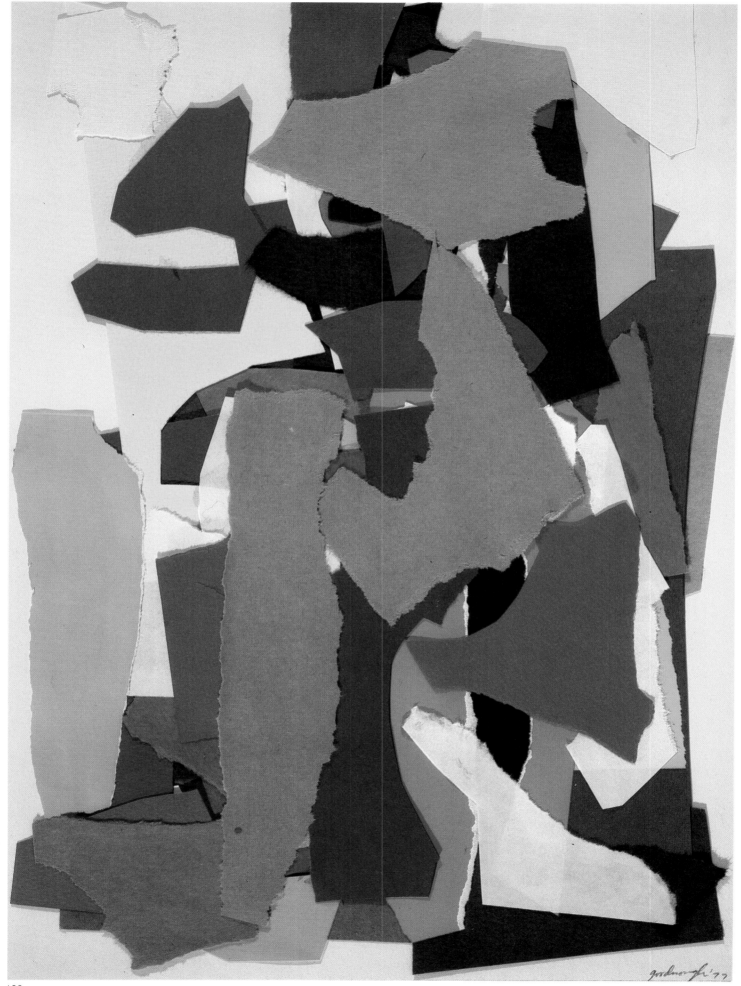

184. *Colors on Maroon*, 1977
Acrylic and oil on canvas, 30 x 48"
185. *Cluster Variables*, 1978
Acrylic and oil on canvas, 40 x 68"
186. *Colors on Purple-Red*, 1977
Acrylic and oil on canvas, 42 x 60"

think that's great! It is like anything else. You have to consider yourself lucky. But if an artist were to paint just for the purpose of getting high prices, that, in my opinion, could be very detrimental to his work.

B: So you would never think in terms of painting in a certain manner to get better prices for your pictures?

G: No. But I'm no different than most people. I certainly have no objection to getting higher prices for my paintings; however, that is not in my mind while I am working. The first thing to do is paint a good canvas and let the rest take care of itself. Price depends to a great extent on the kind of image that is created about an artist's work in the art world. I don't know how it happens. Prices vary so much from artist to artist.

B: Do you feel that art is more of a national thing now than it was in the past? Are more people collecting, for example, in Los Angeles, Detroit, Boston, and elsewhere throughout the nation, whereas, perhaps, in the past, art was basically collected in New York, Paris, London, and other rather sophisticated centers of the Western world?

G: Yes. Even businesses and large corporations are now buying art.

B: You're referring to the Chase Manhattan Collection, the PepsiCo Collections, the Sydney and Frances Lewis Foundation Collection, and the many others that have been put together during the past fifteen years or so.

G: Yes. They have helped the artist and the public because

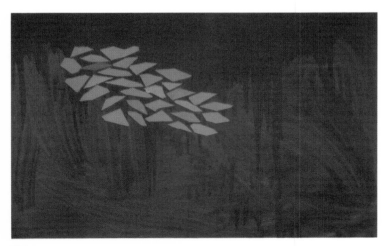

184.

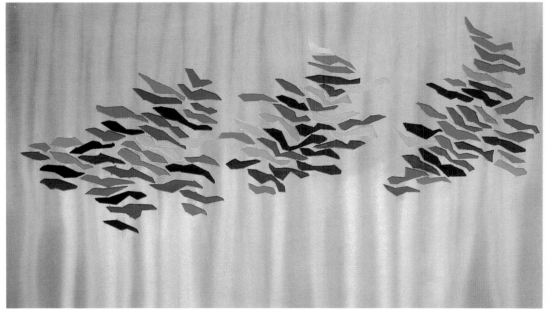

185.

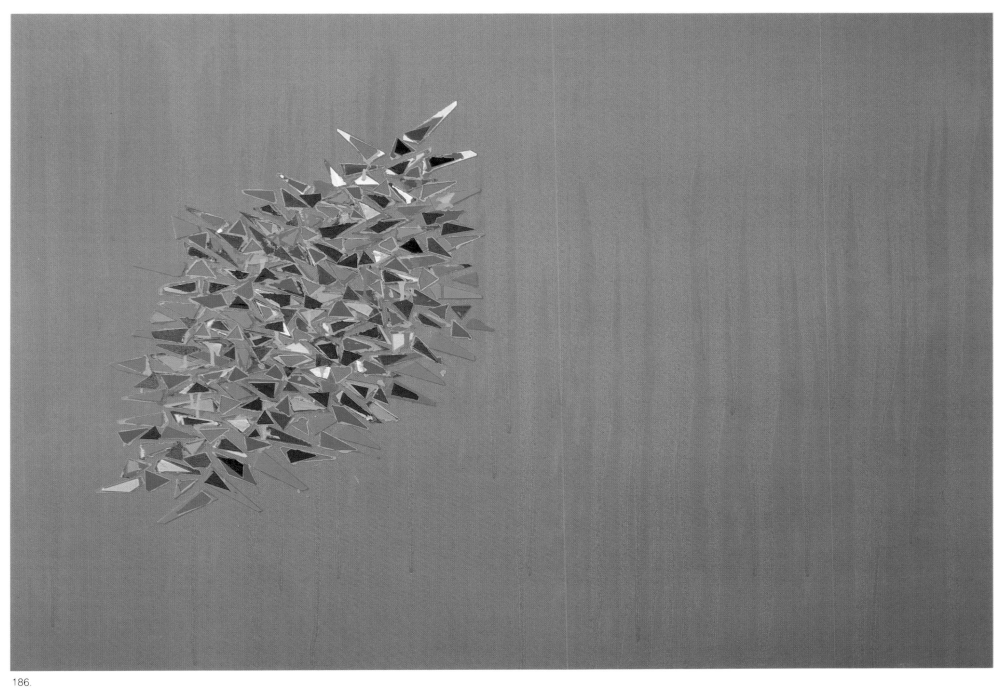

186.

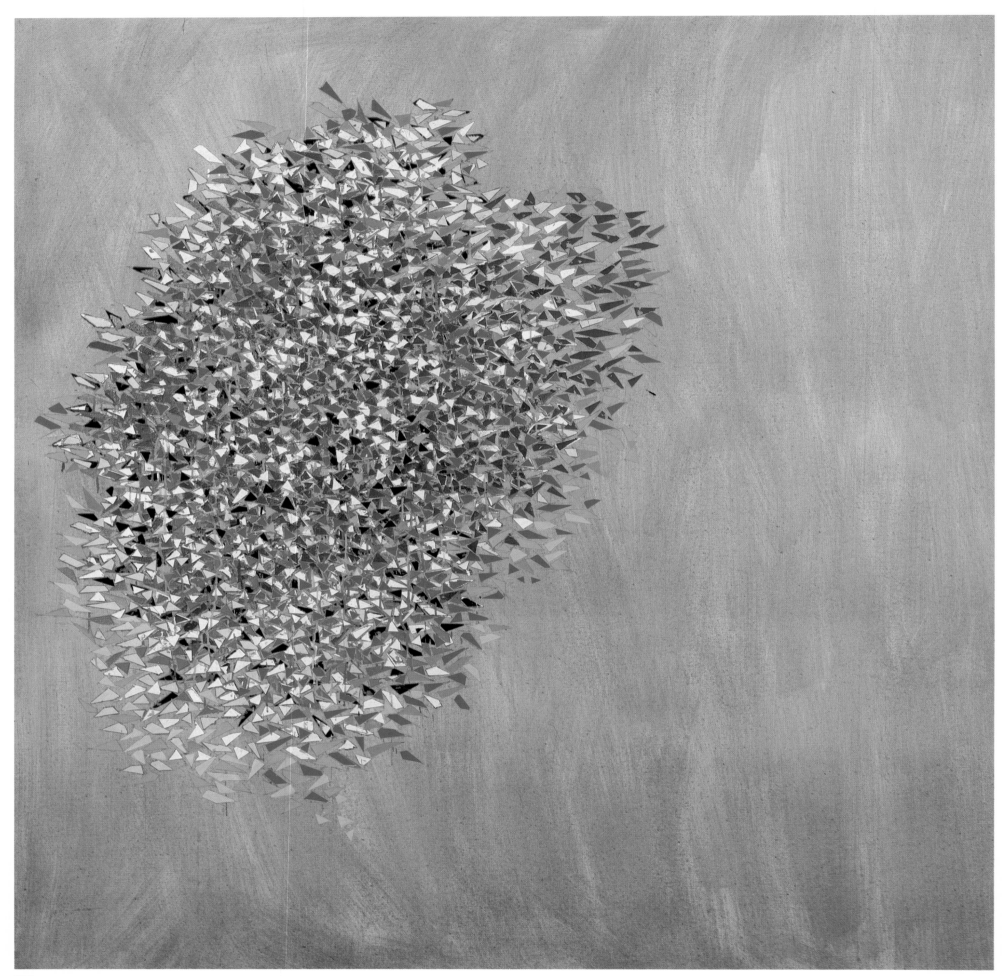

187.

wider groups of people have gotten to see work they wouldn't otherwise have had an opportunity to see.

B: There is another facet we have not mentioned. I am thinking about the contribution the late Harry Abrams made to our culture when he made art available to the general public with his magnificent art books. How do you view that?

G: He was one of those rare individuals who had the courage and foresight to produce quality work. Harry appreciated and understood quality in art and tried to do something about it in the art-publishing field. A few people like that have had a great influence on art in this country. If it were not for Harry Abrams, art would still not enjoy the prestige and popularity that it does today.

B: Harry, as we both know, was also a great collector. But I agree with you, probably the most important thing he ever did was to produce those beautiful art books and thus make all kinds of art—literally the work of hundreds of different artists—readily accessible to the public. The books were printed of good quality, with excellent color, in large "coffee-table sizes," and they are in libraries across the United States and Europe. This has been tremendously important to the artists and public alike.

G: Harry had a great positive influence on mass culture, and I'm sure that his son, Bob, will continue the tradition. Without people like that, art would have a hard time.

B: What about the gallery situation? How did you view the gallery situation when you first showed your work with Tibor de Nagy in the early 1950s? Has it changed much? In other words, how did the way the galleries handled an artist's work then differ from the way they are doing it now? You started with Tibor and stayed with him for many years; now you are with André Emmerich. Would you describe the changes you have seen?

G: I wouldn't say that it has changed all that much. If anything, many of the galleries have developed more respect for the artist. It's like any business: the businessman is the one who has the say, you know. Yet, to a certain extent, you can't always do that with an artist. You have to respect his

188. *Blue*, 1978
Acrylic and oil on canvas, 12 x 12"
189. *Bright Variables*, 1978
Acrylic and oil on canvas, 52 x 70"
Collection Mr. and Mrs. Perry O. Barber, Jr., Houston, Texas

opinions and allow him some say about the way he is represented, and I think that many of the galleries have accepted that.

B: So you see it as something of a symbiotic relationship, in which one party relies upon the other for support and understanding.

G: Yes. André Emmerich said to me once, "I want my artists to be happy."

B: I guess André keeps his artists pretty happy because he's had quite a few outstanding people with him for many, many years.

G: Well, the artist has to be treated as an important person, not only by the gallery, but by the general public as well. He

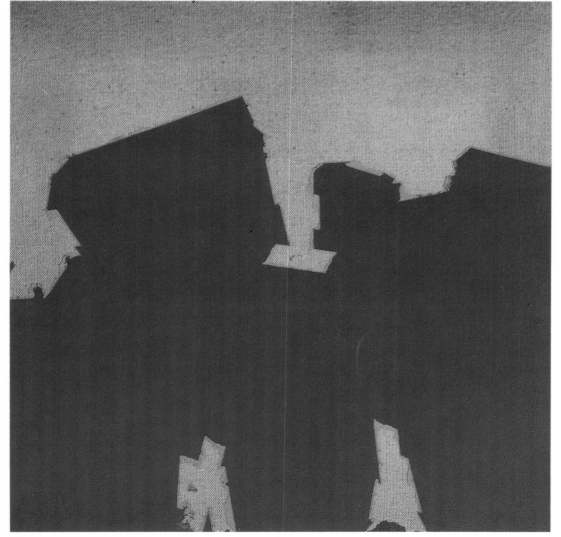

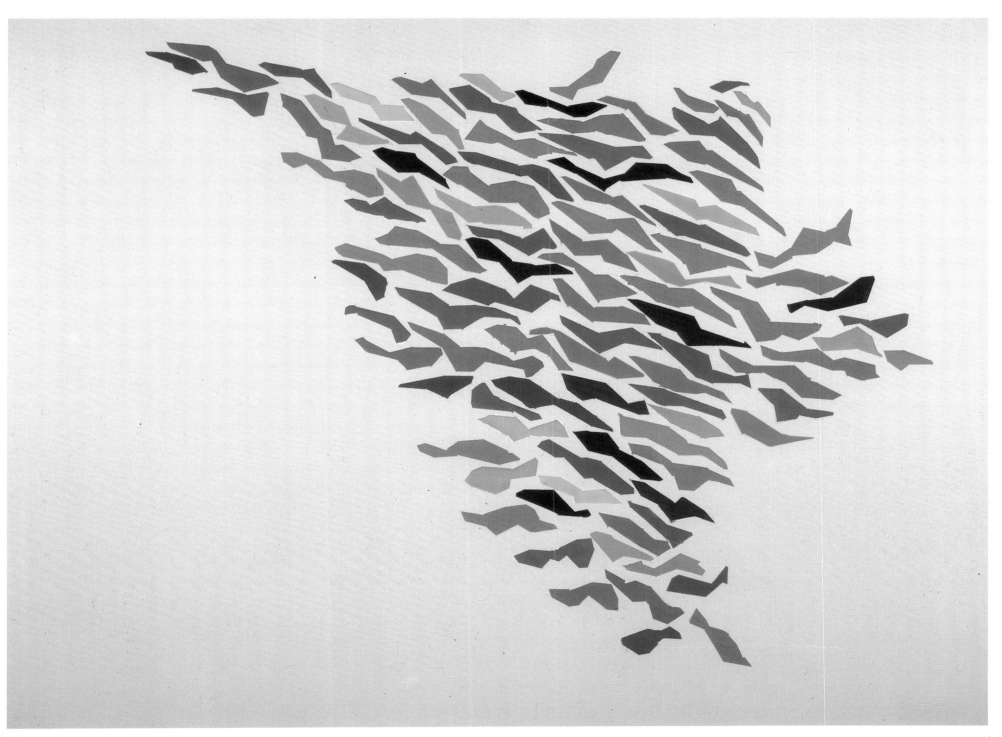

189.

190. *Bright Colors on Blue-Gray,* 1978
Acrylic and oil on canvas, 36 x 52"
191. *Color Shapes,* 1978
Acrylic and oil on canvas, 20 x 36"
Collection Paul and Eileen Good-
nough, Rochester, New York

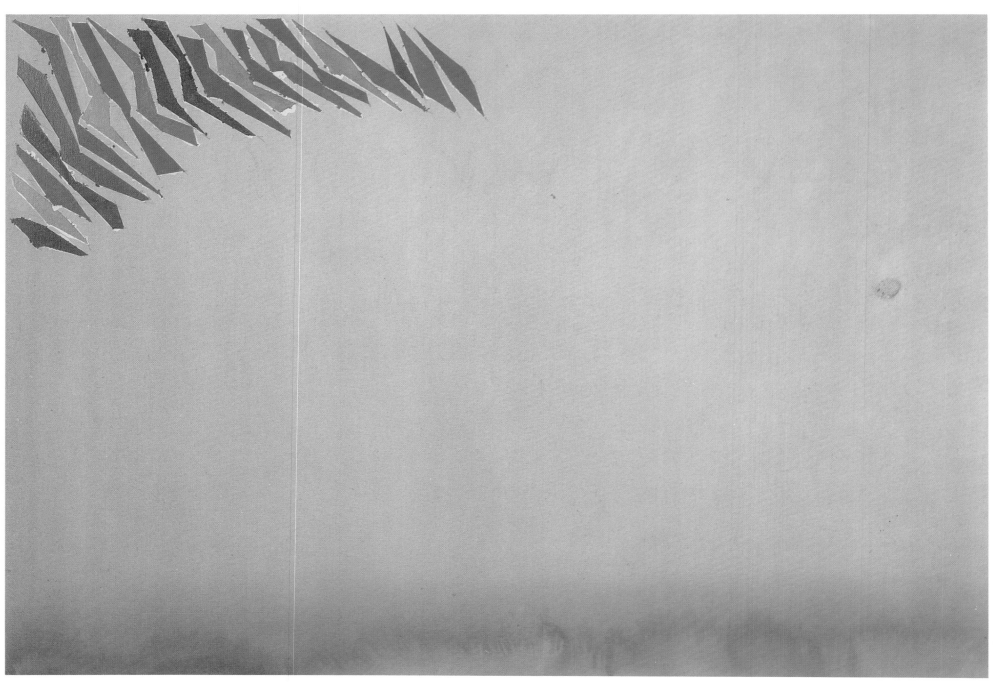

190.

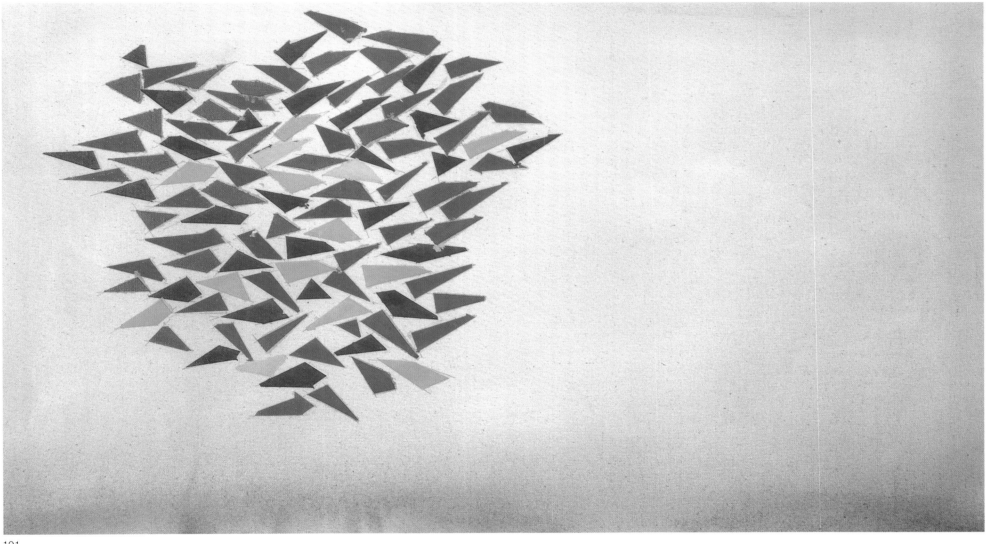

191.

needs to think of himself in the same way, too. I don't believe the artist is as prominent in the world right now as he was a few years ago. The historic changes that took place in the 1950s brought a lot of names into prominence, but things have quieted down since then.

B: When you say a few years ago, what years are you referring to? Do you mean just the 1950s?

G: I'm referring to Pollock's years, the years when the abstract movement really got going strong. I don't believe there is quite as much electricity in the air now as there was then. That doesn't mean that the work is not as good today. Some very good work is being produced now and, in terms of its quality, it may take the passing of time to sort it out to learn

192. *Red, Blue, White*, 1978
Acrylic and oil on canvas, 56 x 70″
193. *Pastel Shapes*, 1978
Acrylic and oil on canvas, 36 x 36″
Collection Mr. and Mrs. T. Rose, New
York

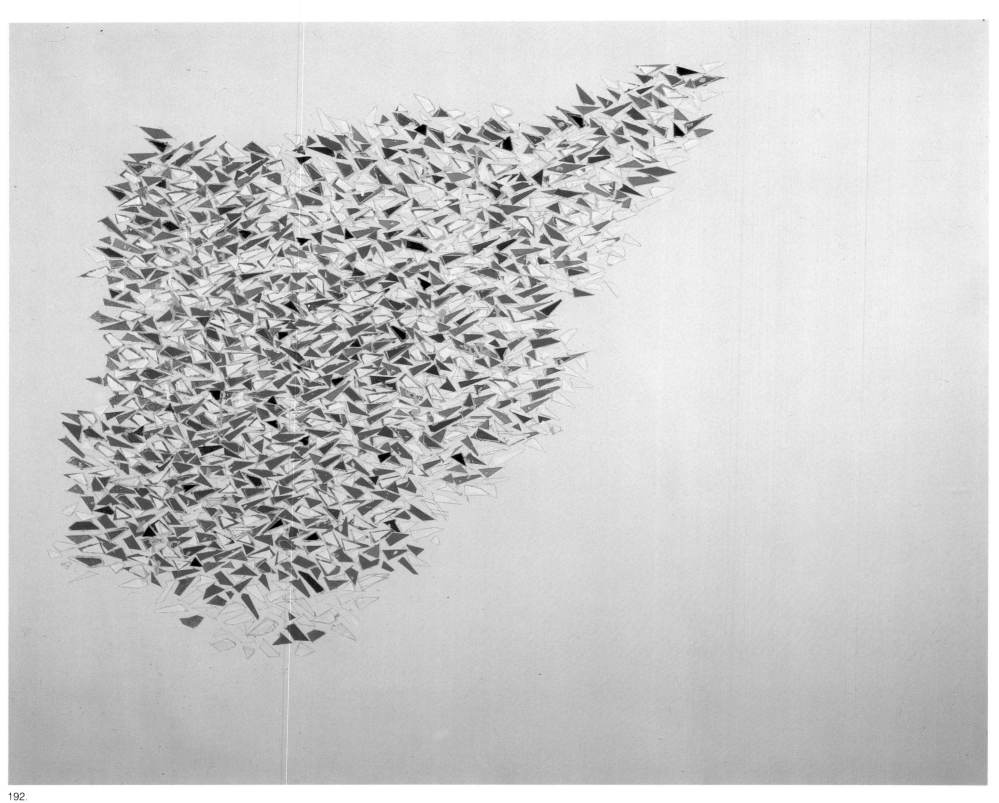

192.

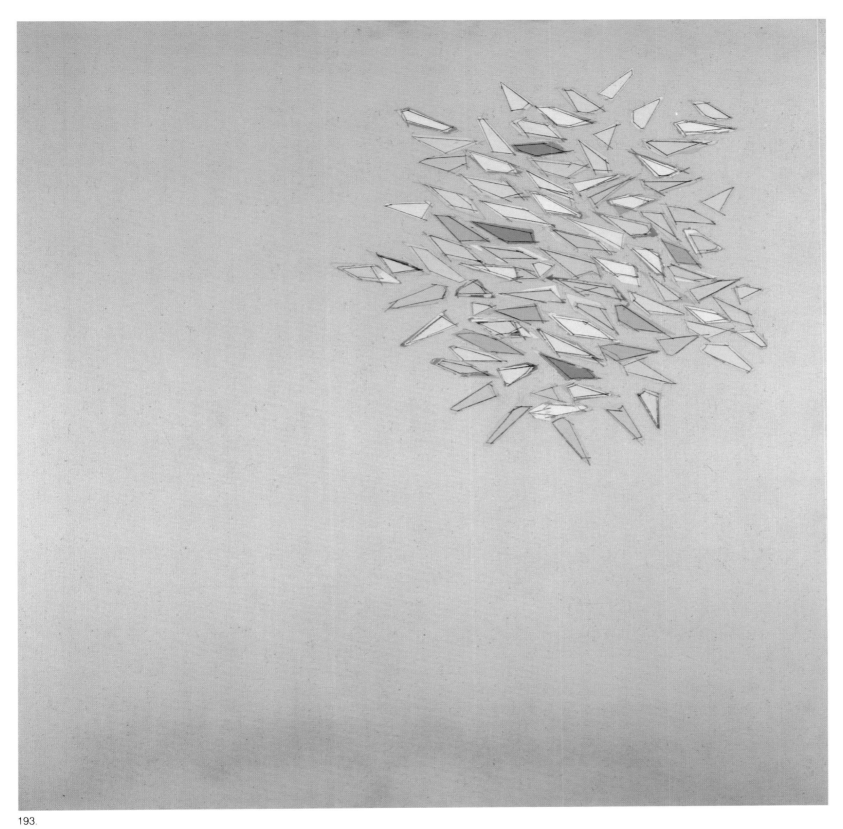

193.

194. *Color Variables*, 1978
Acrylic and oil on canvas, 46 x 58"
195. *Black, White, Red, Gray*, 1978
Acrylic and oil on canvas, 72 x 72"
Collection Mr. and Mrs. Irving Gordon, Houston, Texas
196 and 197. An installation view of Robert Goodnough's exhibition at the Edwin A. Ulrich Museum of Art, Wichita State University, Wichita, Kansas, November 1978

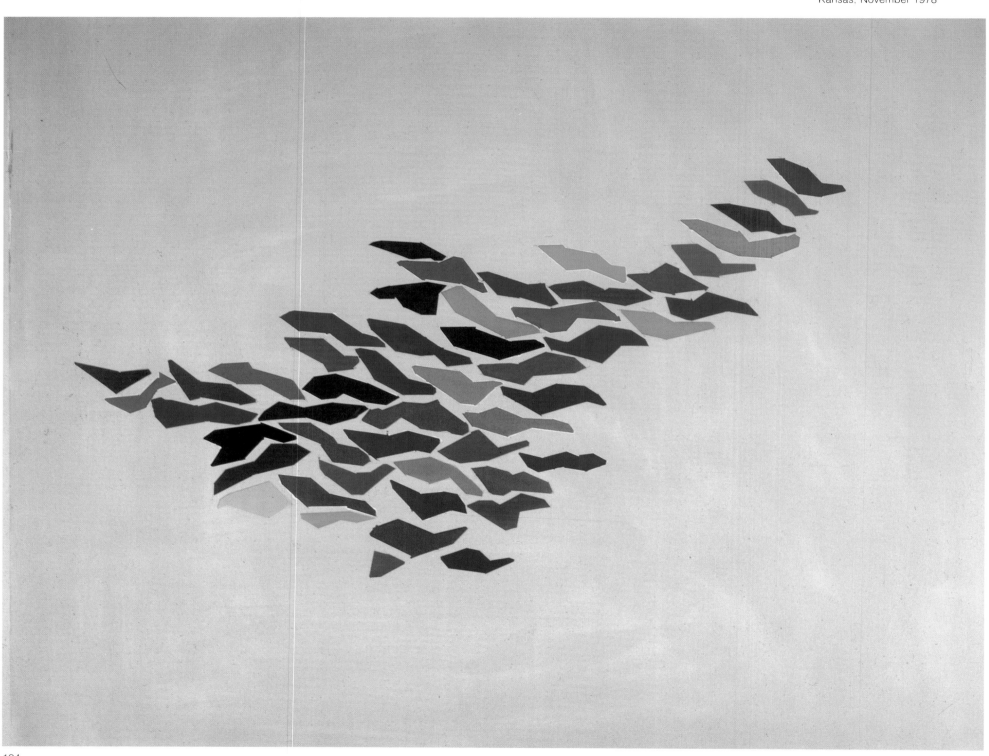

194.

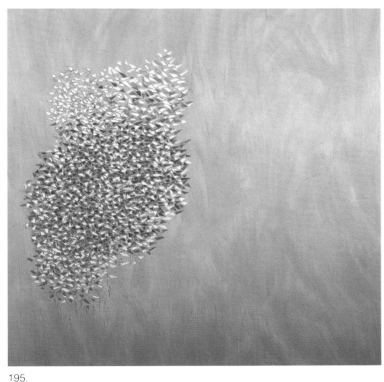

195.

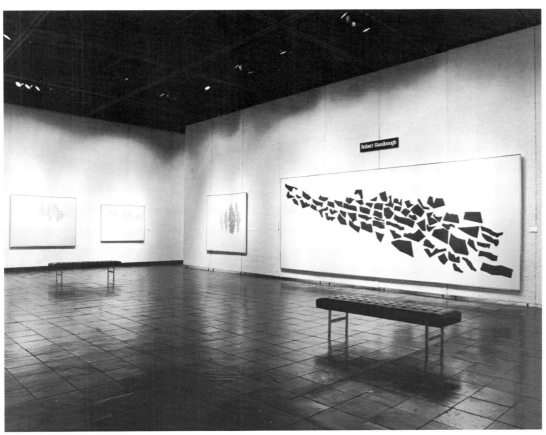

196.

what is really good. Really good work *is* being done. I guess what I'm trying to say is that painting doesn't have the drama attached to it that it did in the 1950s.

B: And yet, the good artists are, in their own way, important, very important in the art world, and they are considered important by at least the most sophisticated part of the general public. I am thinking of Joan Miró, Henry Moore, and Marc Chagall in Europe; Louise Nevelson, Georgia O'Keeffe, Andy Warhol, and others in the United States. People like you, Bob, and Robert Motherwell, to name only a few, are highly respected and well known. Artists may not be more dramatic, as you say, yet there is a great deal of respect for their professionalism in American society.

G: Yes, I think so. You could also mention people like Kenneth Noland and Jules Olitski. It's a calmer approach to innovation; it's not as hectic, and I think people take their time when they buy and when they look. They are all more apt to evaluate art with quality in mind.

B: How have you supported yourself over the years? In recent years, your paintings have sold well and you haven't had to worry about other kinds of income. But early in your career you had to concern yourself with making a living as well as having enough freedom to paint. What was the process you went through? What did you do when you came to New York?

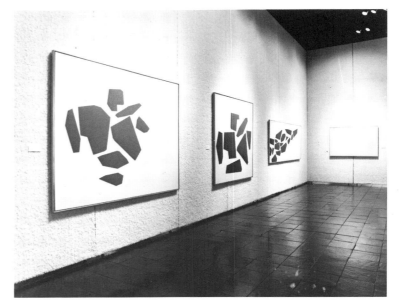

197.

195

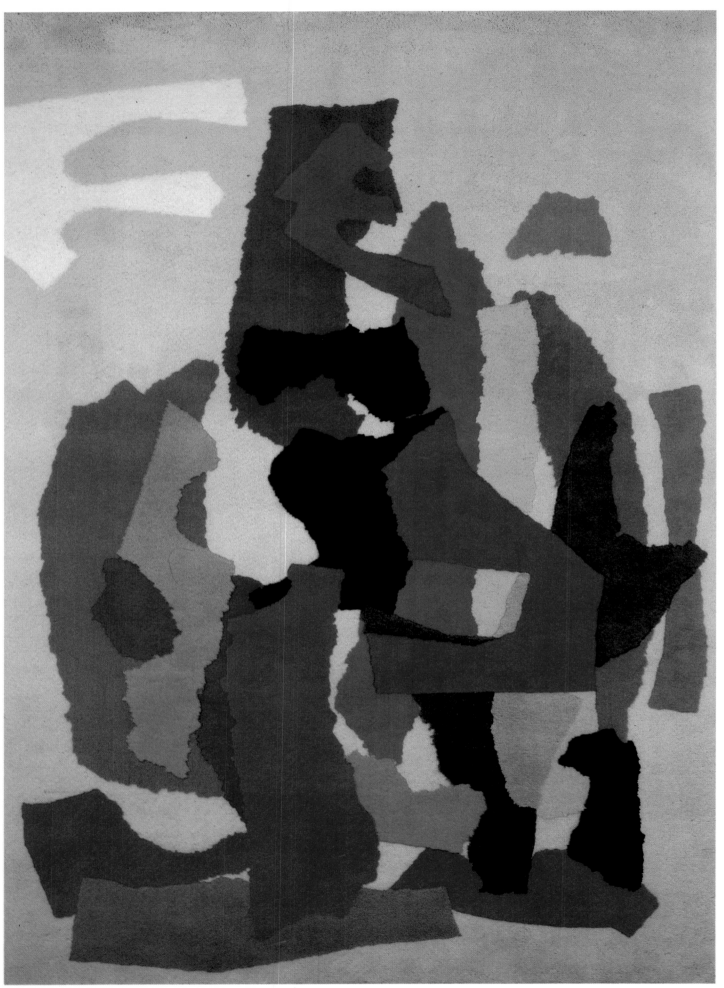

198. *Collage Tapestry I*, 1978–79
Handwoven wool tapestry, 60 x 84"
A Modern Master Tapestry
199. *Collage Tapestry II*, 1978–79
Handwoven wool tapestry, 60 x 84"
A Modern Master Tapestry

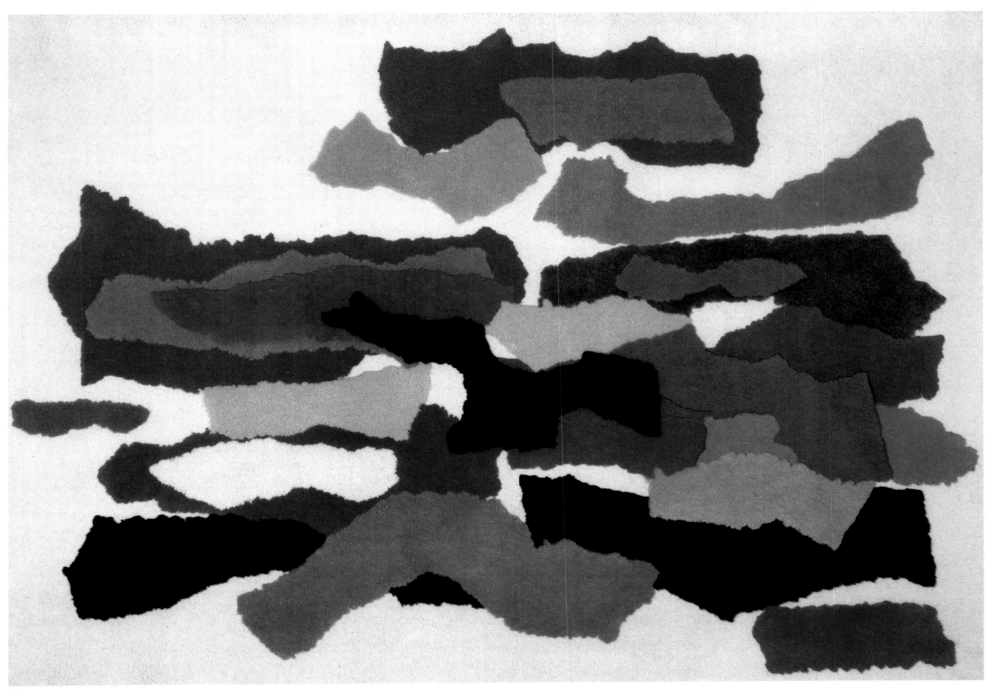

199.

200. *Blue Mass*, 1978–79
Acrylic and oil on canvas, 84 x 84"
Collection Mrs. Robert Goodnough

G: When I came to New York, the first job I had was at the YMCA. I was a night switchboard operator and I worked part-time and on weekends. Shortly after that I got the GI Bill and went to New York University to study painting. I had graduated from Syracuse University before going into the army. The GI Bill paid for part of my expenses, the work at the YMCA helped, and then, a short time later, I got a job teaching arts and crafts—woodworking, mainly—at the Fieldston School in Riverdale, New York. I worked there part-time for about seven or eight years. Then I did some carpentry work.

B: You also ran a newsstand, didn't you?

G: Yes, with a friend, George Franklin. He was a writer. We thought that we were going to make things easier for ourselves. We bought a little newsstand and opened a little counter so we could also sell ice cream and soda pop.

B: It was hard work, wasn't it?

G: The hours were long. We had to start about seven o'clock in the morning. One person would work maybe a half-day, then the other would take over. At the end of one year, we figured out our profits and learned that we had made about 75 cents an hour. So we sold the booth.

B: You also reviewed art exhibitions and wrote articles for *Art News*, didn't you?

G: Yes. I got a job writing reviews for *Art News*. First, I went around to galleries reviewing shows—just short reviews, maybe ten or twenty lines.

B: Was it an all-day situation? How much time did you actually spend on the job?

G: The work I did was part-time. I could paint in-between. But seeing so many shows got a little depressing, and sometimes it made me feel that it was no use painting more pictures when there were so many around, although that was not exactly the right way to look at it. Seeing a good show would do a lot for me, but seeing a lot of bad paintings was awfully depressing.

B: When you say "bad shows," do you mean mediocre?

G: Oh, I think so. Generally speaking, you would see one or

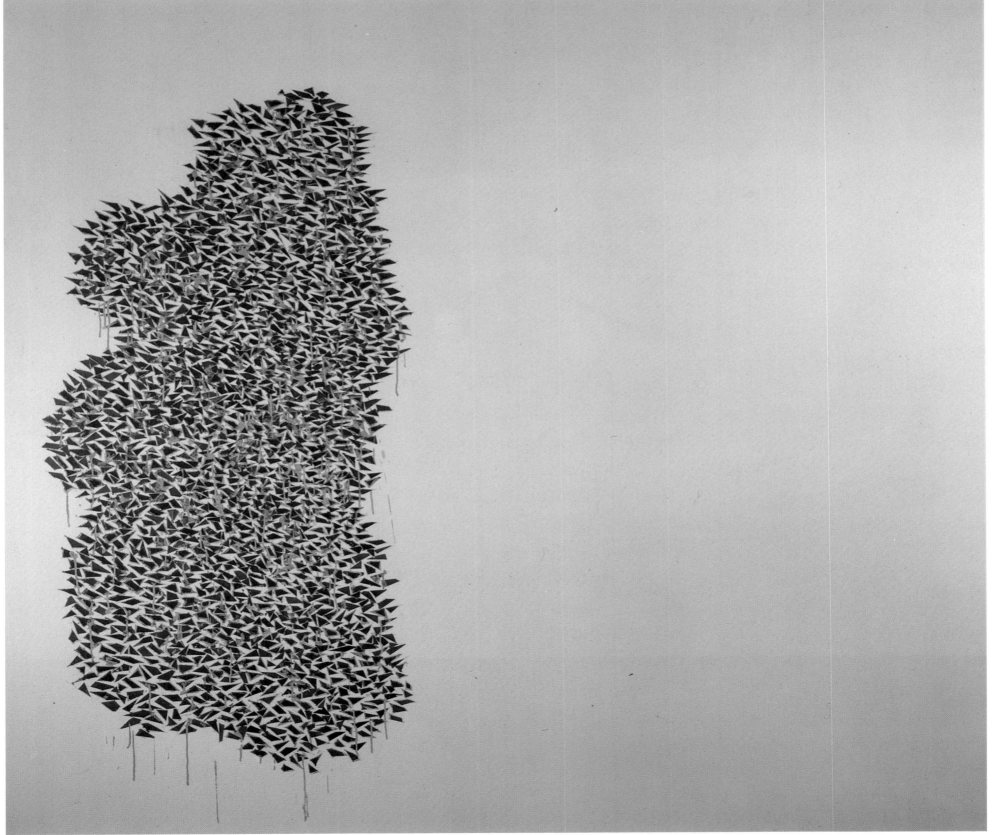

201. *Color Mass on Gray*, 1979
Acrylic and oil on canvas, 48 x 52″
Collection Helvetica Press, New
York
202. *Color Shapes on Gray*, 1979
Acrylic and oil on canvas, 48 x 60″
Collection Uriel Adar, Scarsdale,
New York

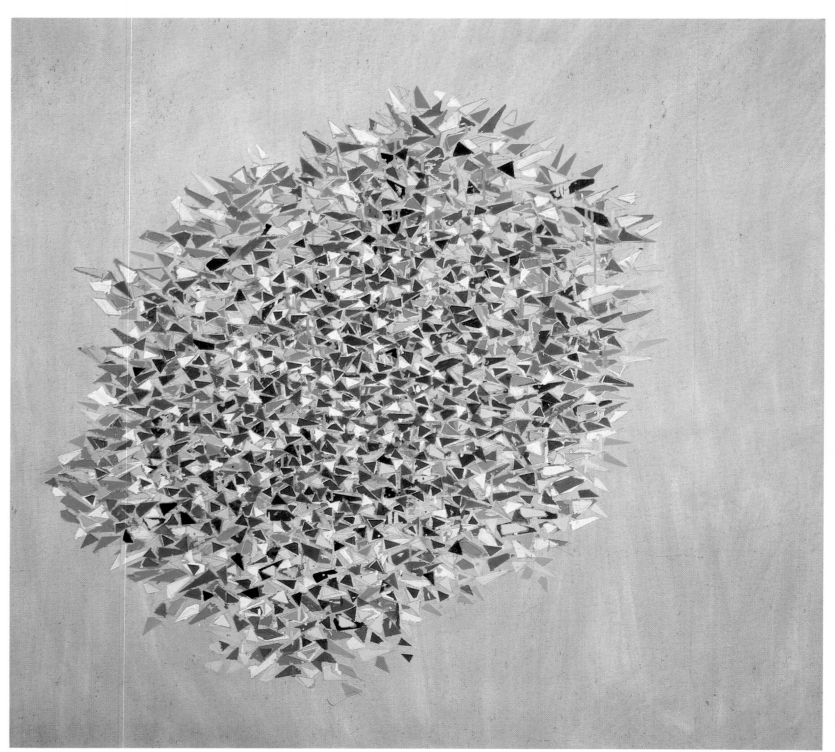

201.

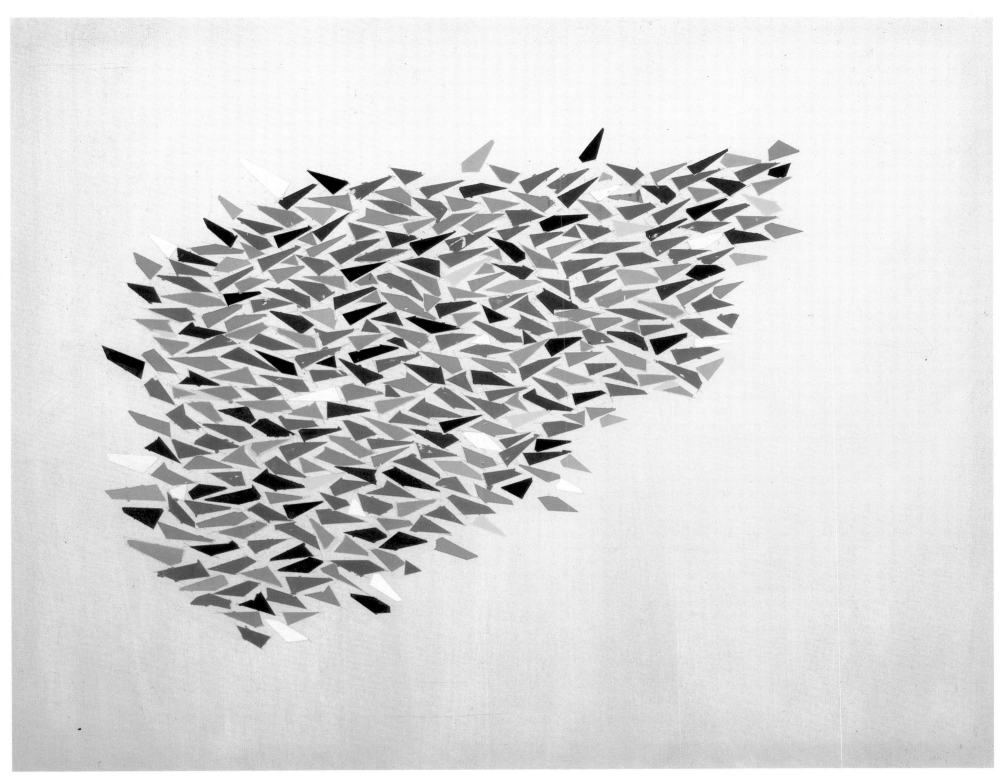

202.

203. *Color Mass on Blue*, 1979
Acrylic and oil on canvas, 52 x 68"
204. Professor Walter K. Long, Robert Goodnough's first art instructor

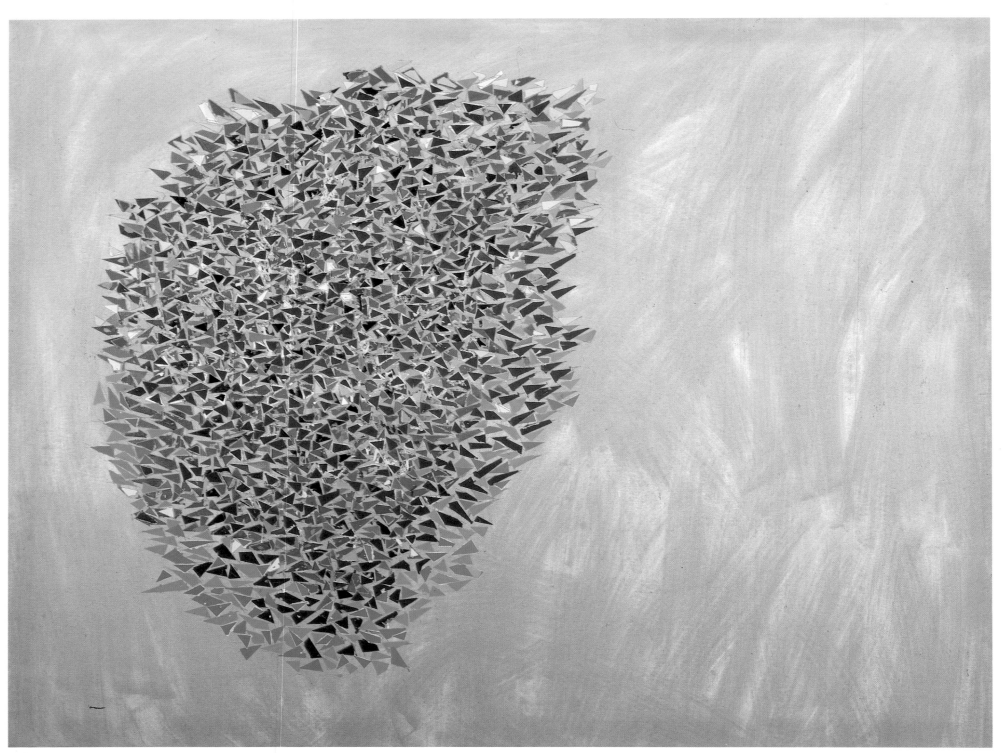

203.

204.

two good shows a month out of hundreds. Then I was asked if I would like to do articles about several artists. The first one was "Franz Kline Paints a Picture." I talked to him and wrote the article; then I did one about Jackson Pollock.

B: The Pollock article has become a rather famous piece. Everyone who writes about the Abstract Expressionists mentions it. I have read it several times; it's beautifully done. The reader has a feeling that he is right there in the studio with Pollock.

G: Thank you. I did a few of those, but gradually my paintings began to sell better and I stopped doing the other things.

B: You taught, too, though, didn't you?

G: While I was working on my masters degree at NYU, I did some part-time teaching there. Then I taught one summer at Cornell University and another at Skowhegan, up in Maine. But I found teaching very tiring. It's tiring to try to paint and teach because you're so involved in art all the time. It's like nothing else exists, and I don't think that's good.

B: When did you feel that you were actually supporting yourself with the sale of your paintings?

G: I would say maybe the last twenty years or so.

B: Is it ever a little frightening to think that sales of paintings might suddenly stop?

G: Oh yes. Somebody asked me once: "Do you think when you sell a painting that it will be the last one that's going to sell?" I think that every time! But they seem to keep selling, and I hope they continue to sell well.

B: I'd like to explore your art education a little.

G: It started, I guess, with Mr. Walter Long. I was painting on my own, and Mr. Long, who was head of the Museum in Auburn near my home town, somehow saw my work and thought I should be encouraged. I took a couple of courses with him, and then he said: "Let me see if I can help you get a scholarship at Syracuse University." He took my paintings there and the faculty awarded me a partial scholarship. I studied at Syracuse for four years, starting with drawing and charcoal drawing during the first year, and mainly painting

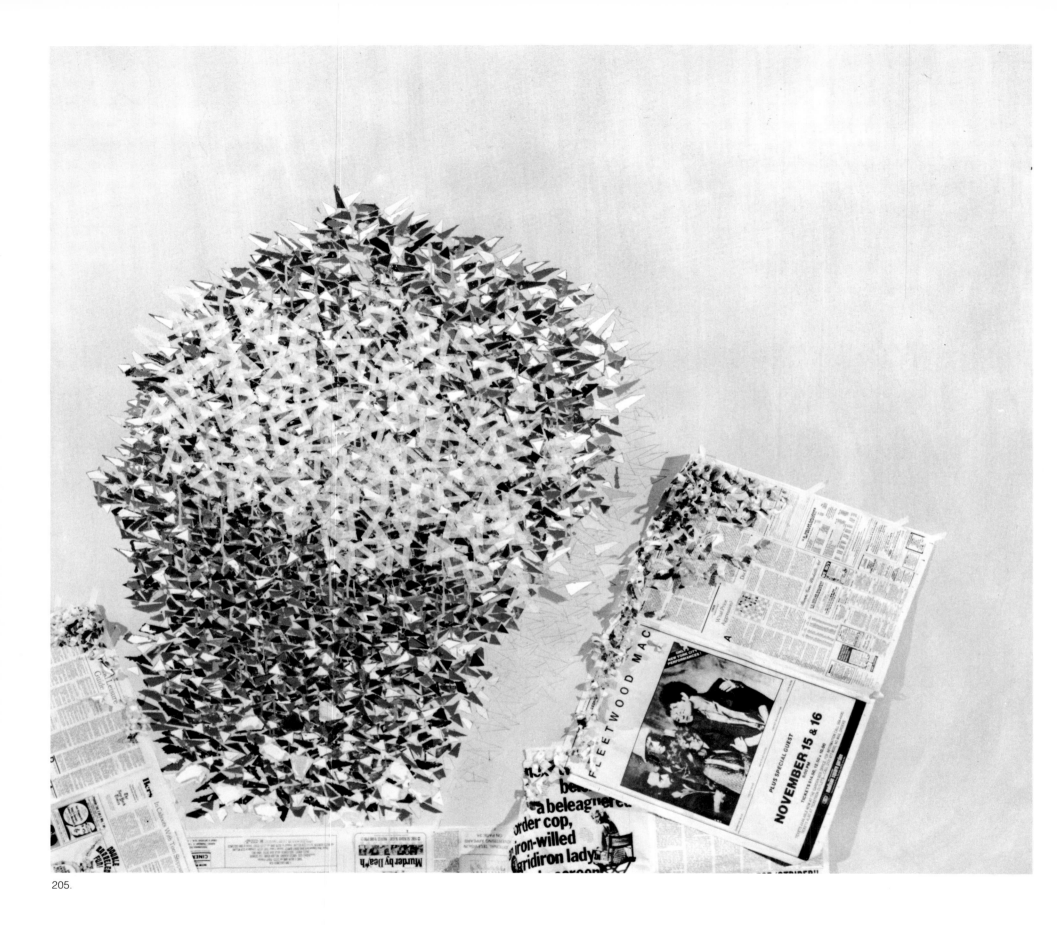

205.

205. *Gray Color Mass* (in progress, 1979)
Acrylic and oil on canvas, 72 x 72"
206–8. Robert Goodnough at his Barrow Street studio, 1979

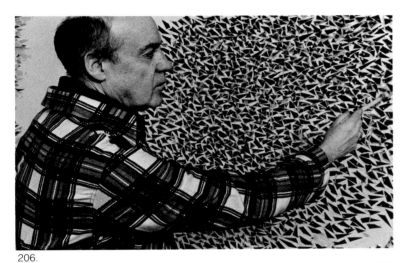

206.

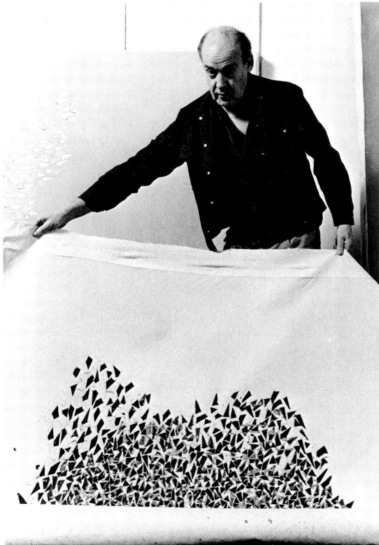

207.

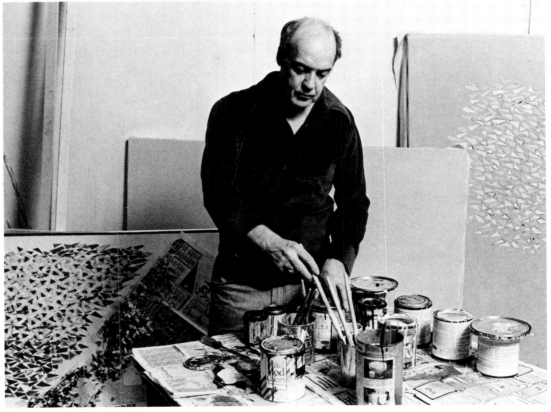

208.

209. *Double Group*, 1979
Acrylic and oil on canvas, 24 x 60"
The Merryman Collection, Stanford,
California
210. *Dark Blue Shapes*, 1979
Acrylic and oil on canvas, 84 x 144"
211. Art critic Clement Greenberg

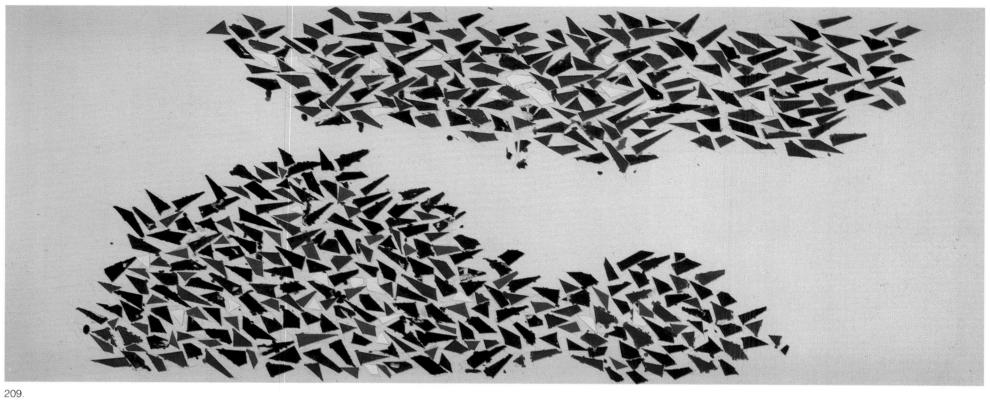

209.

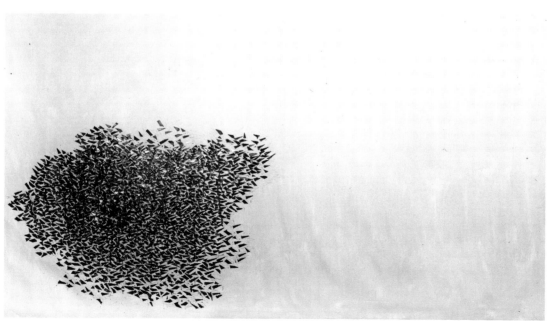

210.

211.

the second year. The third and fourth years were devoted almost entirely to painting—primarily portraits and traditional realism. I finished college and went into the army.

B: Where did you go after the war?

G: The first person I studied with was Amédée Ozenfant in New York. I stayed with him for about one year and then I studied with Hans Hofmann during a summer in Provincetown. Later, I took some classes at The New School for Social Research, but these were mainly courses in philosophy, not painting. And, of course, I got a masters degree in art education at New York University.

B: Some well-known people—Tony Smith, for example—had quite an influence on your life.

G: I met Tony Smith at NYU while he was teaching there. And a group of us would often meet after class because he was a great conversationalist and philosopher about art. We would spend hours together—Tony, myself, George Franklin, Hans Noë, and Tony Louvis. There was a whole group of people. We probably spent too much time talking. But we did learn a lot. Tony Smith was an extremely intelligent man, one of the few individuals I know who could talk well about art—he and Clem Greenberg. Actually, people like Tony Smith and Greenberg helped my education more than the schools did, I believe. Hans Noë and I still discuss art and architecture.

B: How much of an influence was Clem Greenberg on you? He apparently has been a tremendously positive force in the lives of many artists.

G: He has certainly been very encouraging to me and a strong infuence, too.

B: In what ways?

G: Clem is very decisive and very clear about what he likes. He doesn't fool around. If he likes an artist's work, he likes it. And, if he doesn't like it, he says so. He doesn't put an artist's things down, especially. It's just that a person is well aware of what he likes.

B: You know, I find Clem fascinating because so many people pursue him for opinions and statements about their work.

212. *Untitled*, 1979–80
Serigraph, 22 x 34"
Issued in a limited edition of 100,
printed by John Campione
213. *Blue Shapes: Homage to Harry
N. Abrams*, 1979–80
Acrylic and oil on canvas, 80 x 152"
Abrams Family Collection, New York

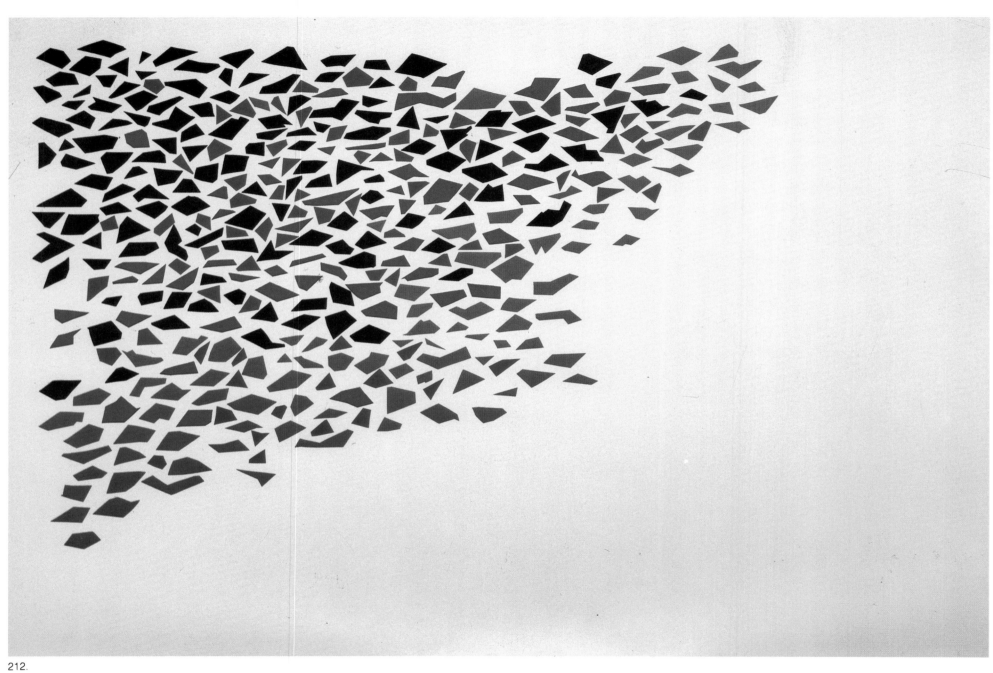

212.

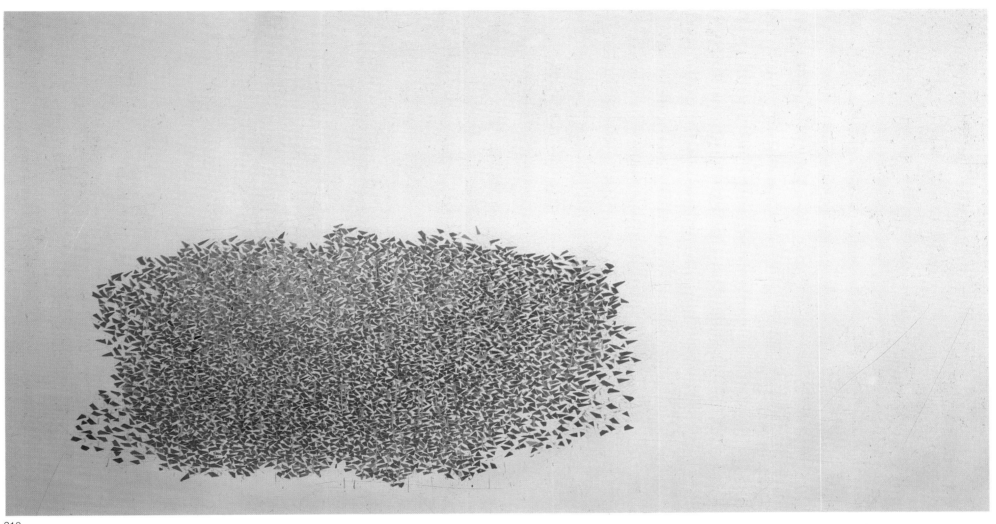

213.

Yet, in spite of the problems that might present to him, Clem tries hard to be diplomatic. He's an extraordinarily nice person. And the situation he finds himself in, even today, as it relates to artists young and old, has to be extremely difficult.

G: I think he's very considerate of people, but he's very tough, too. He doesn't treat art in terms of the person who creates it; he takes art on its own, as a good in itself, regardless of who did it. The fact that it was painted by a certain person doesn't mean that much to him. He looks at a painting in terms of its quality and whether or not it is a good painting. He will take a painting by Pollock or someone else and say it's terrible if he thinks it is terrible. He's a very courageous critic; not only that, he has a sure and rare sense of what is good. The art world owes a great debt to him.

214. *Tan, Blue, White*, 1978–80
Acrylic and oil on canvas, 64 x 78″
Collection Mr. and Mrs. Thad T. Hut-
cheson, Jr., Houston, Texas
215. *Color Mass on Gray*, 1979–80
Acrylic and oil on canvas, 52 x 66″

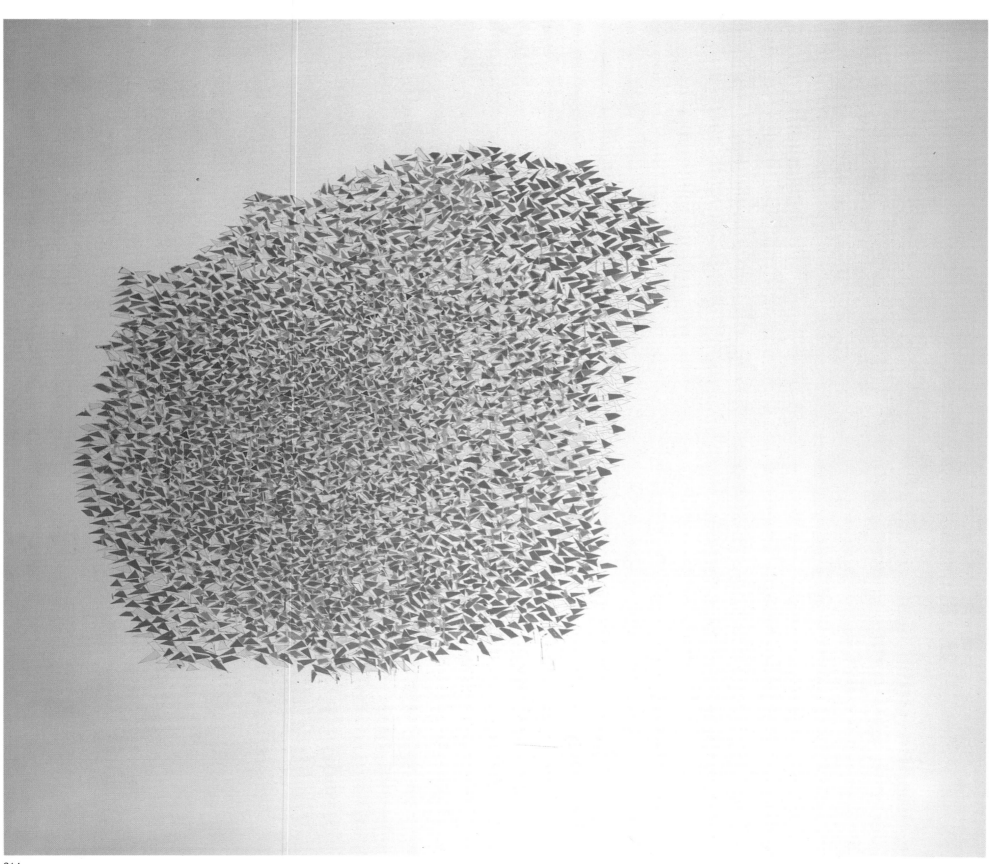

214.

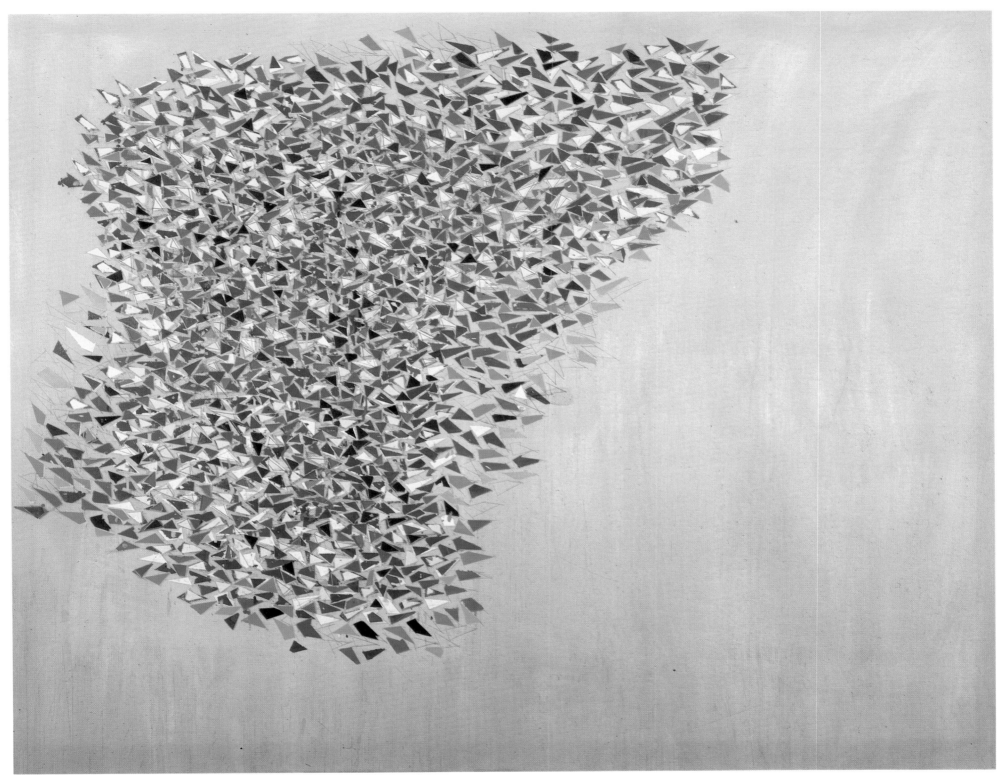

215.

216. A wood and paper design for a swimming pool in the home of William F. Buckley, Jr., 1979–80
217. Jacuzzi in the home of William F. Buckley, Jr.
Ceramic, approximately 8 x 7'

DEVELOPMENT OF A POOL

William F. Buckley, Jr.

My memory usually serves in such matters but not—and this is interesting—in respect to Robert Goodnough. Years ago he floated into my consciousness much as his canvases do. Although the image is weary, it is appropriate to say that he came in on little cat feet. The encounter was at once artistic and personal. Suddenly we were friends, and suddenly I discovered his art. And from the beginning I found the two inseparable. There was something in the art —a tenderness, a diffidence, a quiet sense of authority— that made it alluring, even as its creator was such.

Long ago, but not far away because I have lived in the same house since 1952, I thought of doing an indoor swimming pool. I think I was most intensely stimulated in this direction when I visited that famous hotch-potch in San Simeon. Of all its discrete wonders (and agglomerate repulsiveness) I was struck most by the indoor swimming pool. It hadn't been completed during the lifetime of Mr. Hearst, and, if memory serves, was even when I saw it not entirely finished. It was Pompeian: basically black mosaic decorated by golden dolphins that achieved an extraordinary sprightliness in the artist's rendering, as if they were in constant motion. The effect is very beautiful. The pool is very large, much larger than the average outdoor pool. Such dimensions were way beyond my reach, but the idea came to me that if and when I endeavored a pool, it would have to be mosaic.

Many years went by before I called architect Tom Hume and whispered to him my fugitive thoughts. Tom cast a measured eye on the building, and in due course came up with an astonishing proposal. He could, he said, put in a pool running the length of our terrace. The machinery for it would need to find room in what I brazenly call my "atelier," and the terrace itself would need to be widened. The swimming area would be thirty feet long, eight feet wide, four and one-half feet deep. Ascending the stairs of the pool, one would come to the entrance level, about twelve feet square,

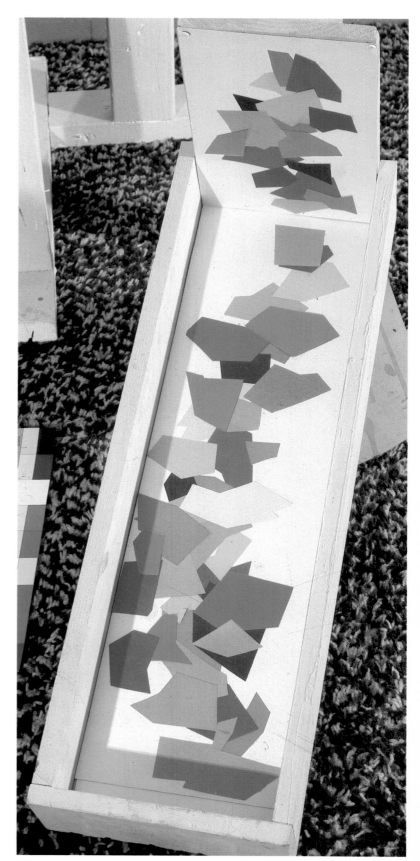

pool, and walk toward you, lapping up to the edge. Then, as though a distillate dropped from the main design, something for the jacuzzi. I stared at the four designs, executed on cardboard, about eighteen inches long, rising six inches, with a little sixteen square-inch section for the jacuzzi. Each was different from the others, though three were in a category of solid colors, while the fourth gave us the famous Goodnough leaf effect. The colors desired by the artist were represented by the colored paper pasted on the cardboard, cut in the shapes he visualized. I did not have the imagination to know what would come of it all, but I had faith that something extraordinary would, and I made my selection. It is, in my judgment and that of others, the most spectacularly beautiful little baggnio in the world.

Four sets of dimmer-lights illuminate the pool. The first comprises eight lights, not visible to the human eye, that shine down the vertical far side of the interior. Underwater, three lights give any desired intensity. Overhead are four lights, shining down on the all-marble walk-in surface; two more are located over the jacuzzi. Shading those lights accentuates whatever you wish in the miraculous sequence of shapes and colors, insinuating their way over thousands of little stones selected by the artist. The eye hardly distinguishes the mosaic that lies underwater from the one rising above it. The circulation pumps provide just a shimmer of water activity, enough to give a special liquidity to the design. A year later I decided (after consulting with Bob) to place mirrors on the ceiling, so that now, sitting on the sofa, you have the Goodnough mosaic going right around you, 360 degrees. At the opposite end of the pool, above the jacuzzi, hang the four compositions from Goodnough; anyone is free to say to himself that he would have selected this design, or that one. On the left is an exquisite iron-on-marble sculptural design by Reed Armstrong—six winged angels climbing an infinitely long ladder, as if trying to reach those exquisite highs that Robert Goodnough's magic eye visualizes whenever he brings paints to canvas, or closes his eyes and thinks mosaic.

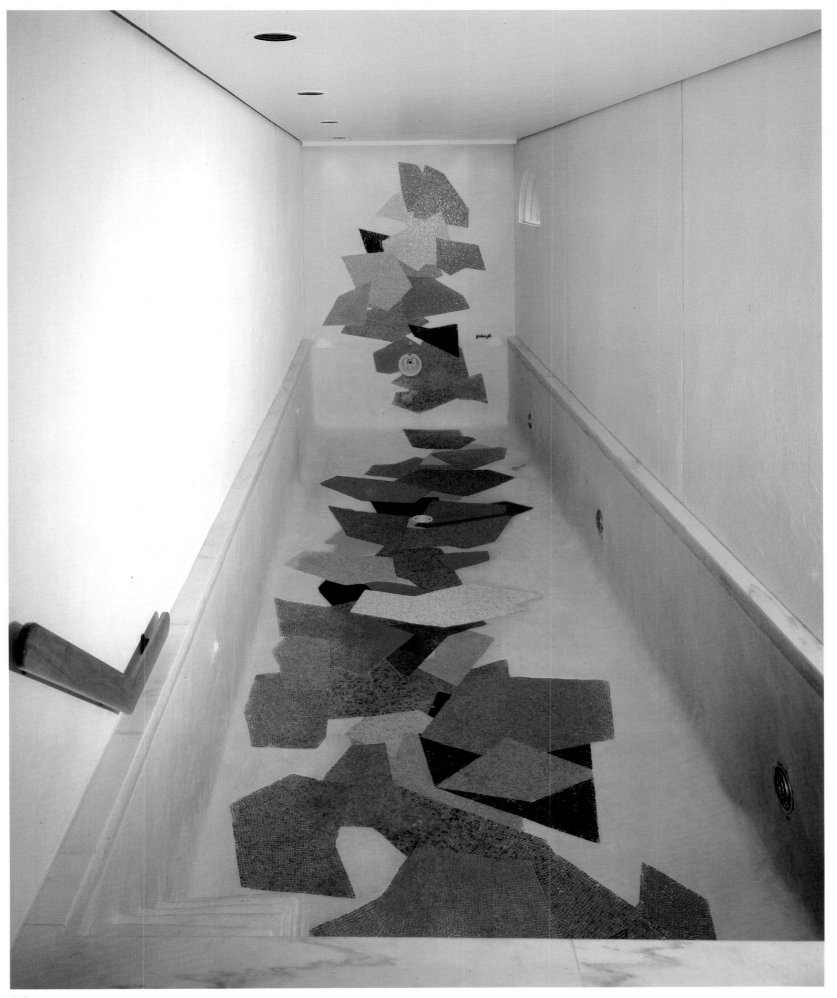

219. *Collage with Red.* 1980
Acrylic and canvas on wood. 24 x 24"
220. Robert Goodnough at work in
his studio. 1980
221. *Bright Colors on Red.* in prog-
ress. 1980
Acrylic and oil on canvas 40 x 60"

B: How would you contrast Amédée Ozenfant and Hans Hofmann?

G: Well, Ozenfant was disciplined, and Hofmann, in a manner of speaking, worked toward freeing you up. So I think they balanced each other.

B: Were you a little awed by Ozenfant? Were students afraid of him? What kind of person was he?

G: Oh, you could be a little afraid of him because he was very strict. You had to try for discipline in your work. If you didn't, he would be down on you. He usually wanted you to paint three coats; the painting would be done in three coats. First, you'd paint one coat, let it dry, put on a second coat, let that dry, and then put on a third coat. This was pretty much a principle that you had to go by. Whereas with Hof-

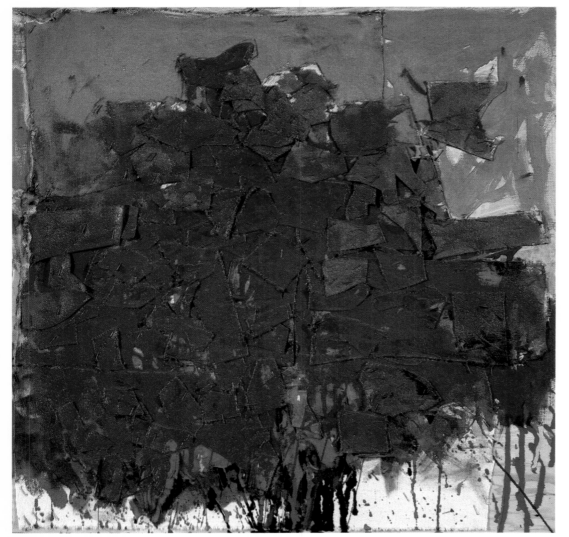

219.

220.

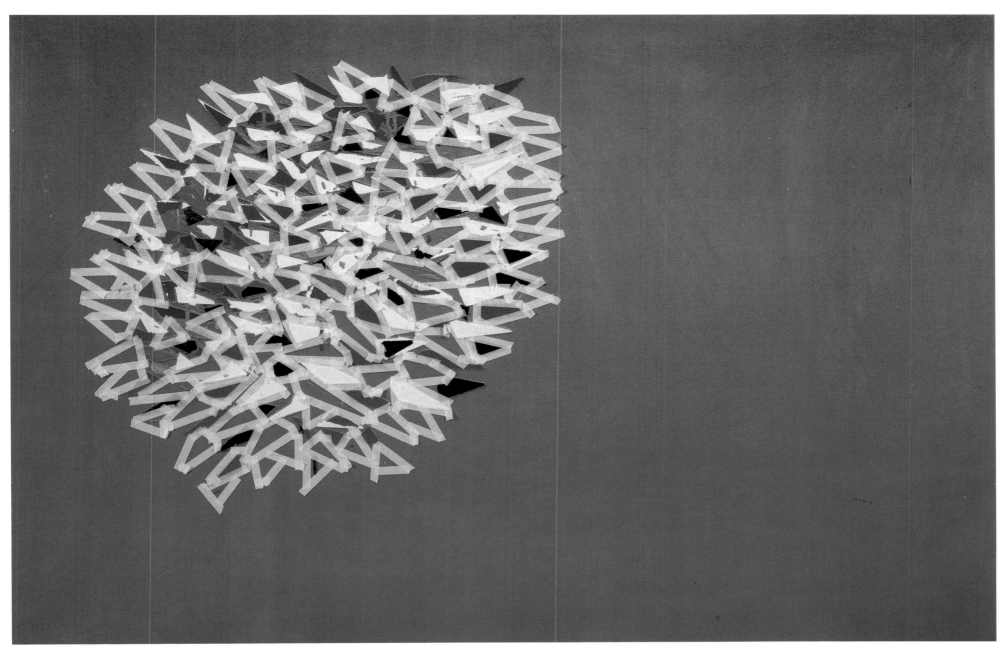

221.

222. *Blue-Gray Mass*, 1980
Acrylic and oil on canvas, 48 x 72"
Collection Mark D. Greenberg, New
York
223. *White Mass*, 1979–80
Acrylic and oil on canvas, 68 x 84"

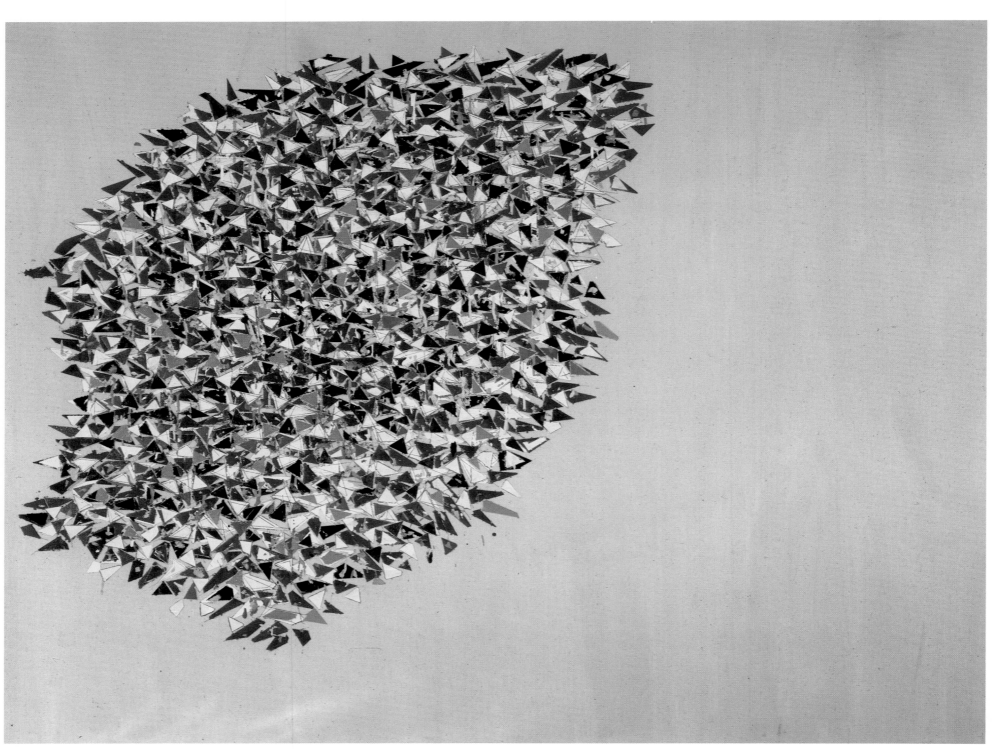

222.

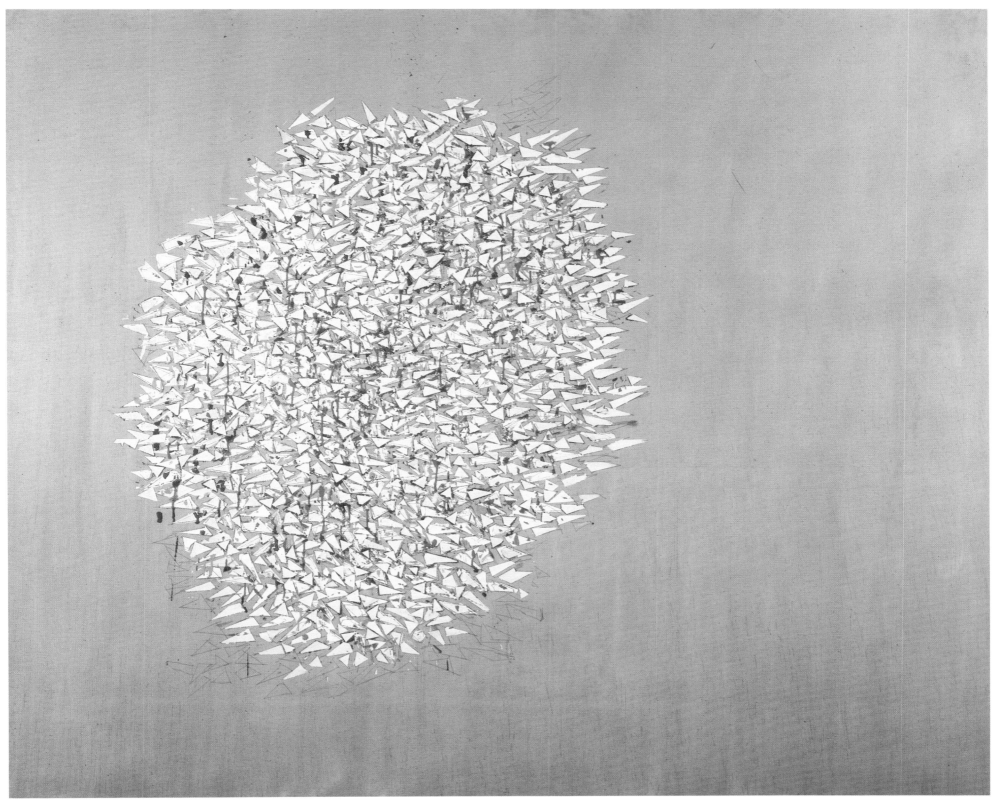

223.

224. *Blue Cluster,* 1978
Acrylic and oil on canvas, 44 x 60"
225. *Shaped Canvas,* 1980
Acrylic and oil on canvas, 84 x 21"
226. *Red,* 1979
Acrylic and oil on canvas, 36 x 36"

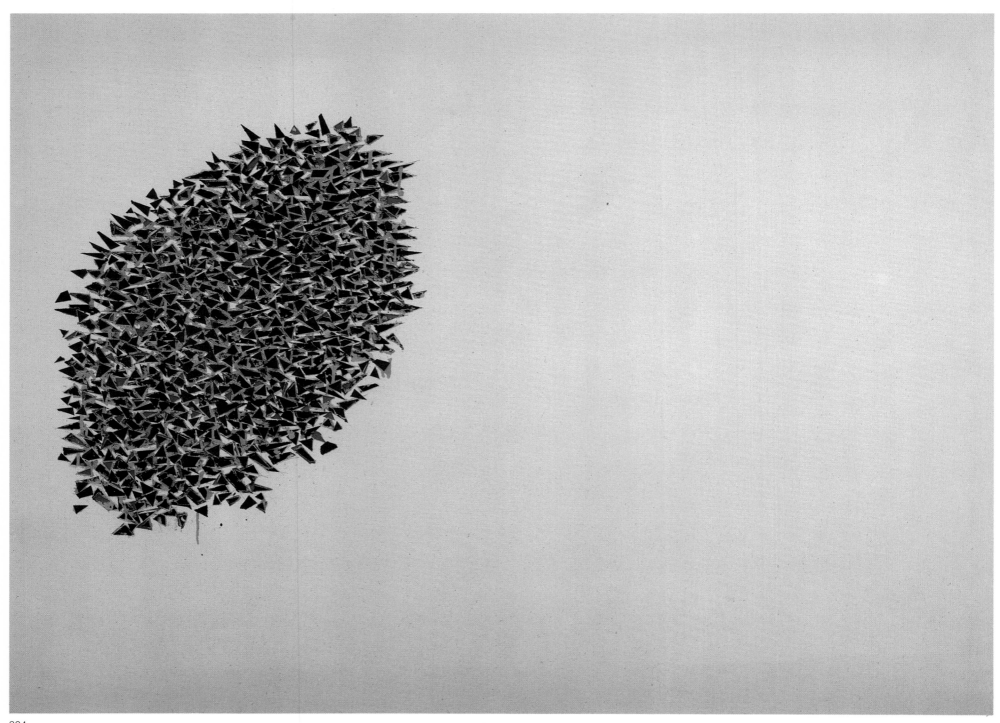

224.

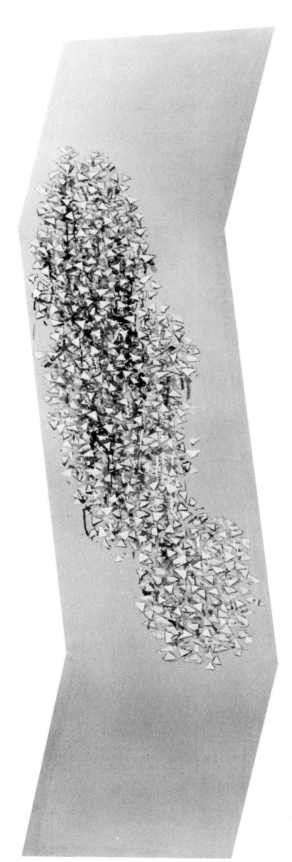

mann, if you were working on, say, a charcoal drawing, and he didn't like it, he would take a chamois and wipe it out. He didn't treat art as precious.

B: Was there more camaraderie in Hofmann's classes than in Ozenfant's?

G: Yes. Both were strong personalities. In Ozenfant's class everyone was quiet—nobody talked. It was a disciplined atmosphere. Hofmann's classes were much freer. But I think either one can be overdone. To me, the classes balanced each other.

B: Can you see their respective influences in your own work today?

G: In a certain sense, I think it's apparent in the work.

B: In terms of the apparent carelessness and the drips, that sort of thing, you reflect Hofmann's feeling that a painting is not too precious. On the other hand, you often put four coats of paint on the shapes you create, so there is a certain disciplined, clean, pristine quality about your canvases, and a contrast within the painting itself.

G: I think Ozenfant started the Purist School. That was es-

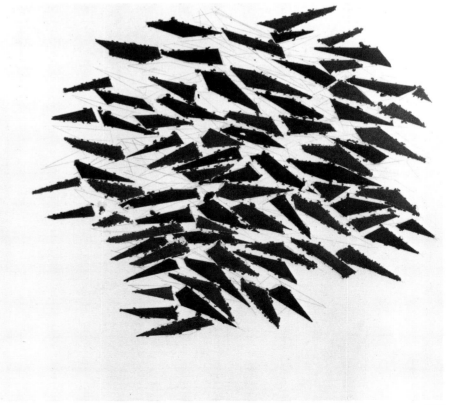

227. *Pastel, White, Pale Blue*, 1981
Acrylic and oil on canvas, 48 x 64"
228. *Color, White, Yellow-Tan*, 1981
Acrylic and oil on canvas, 50 x 64"

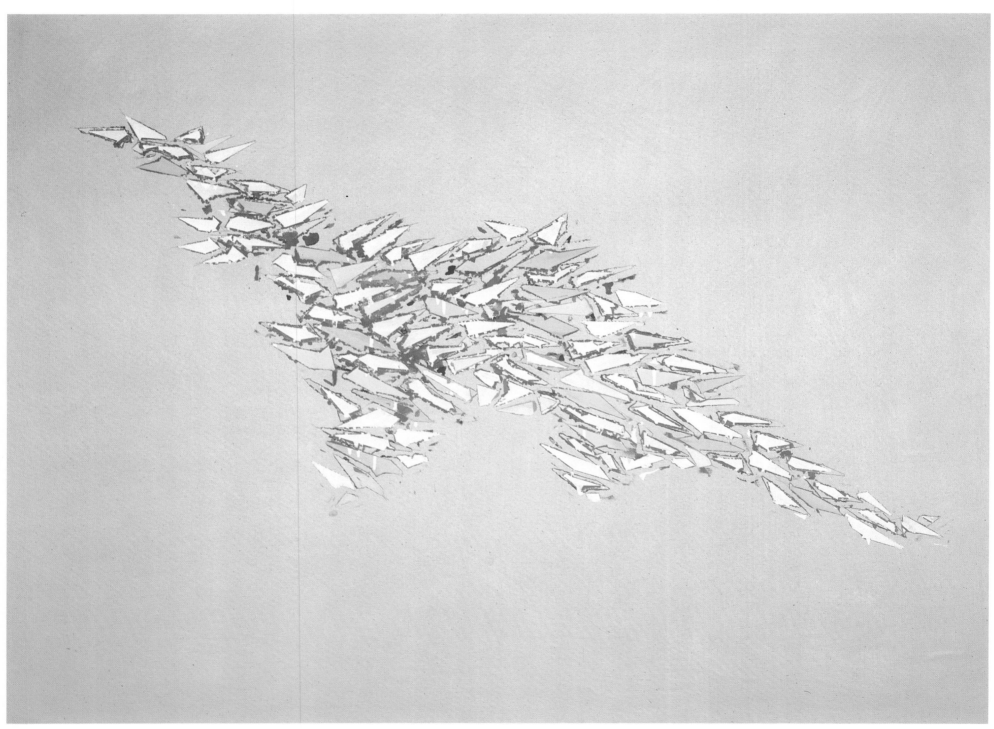

227.

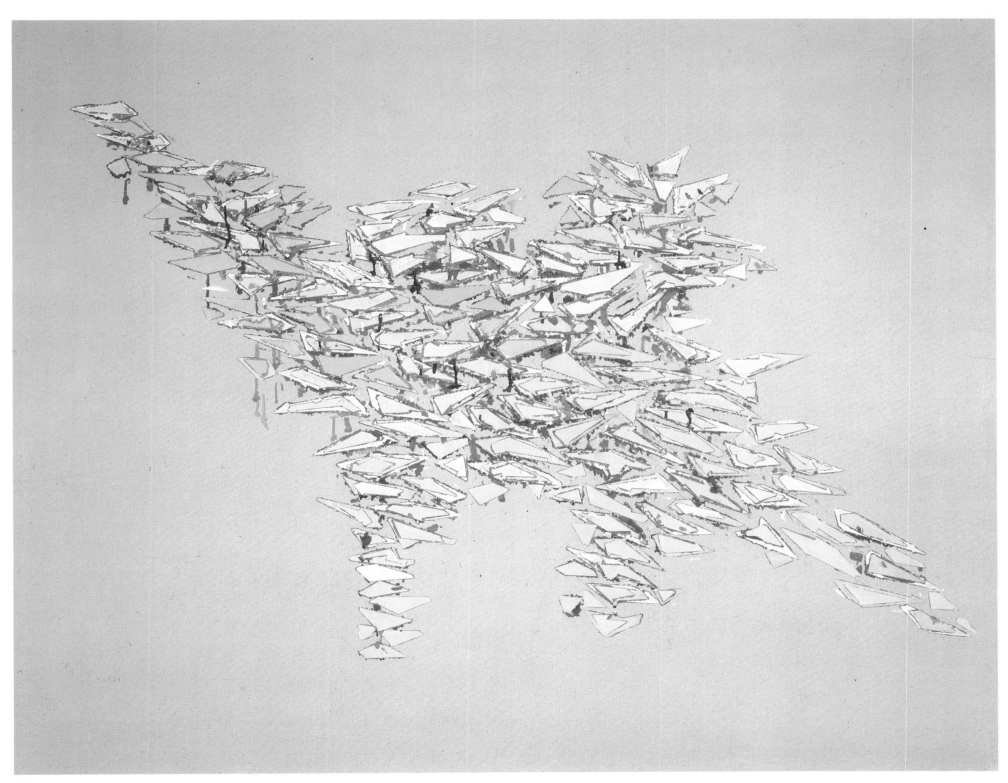

228.

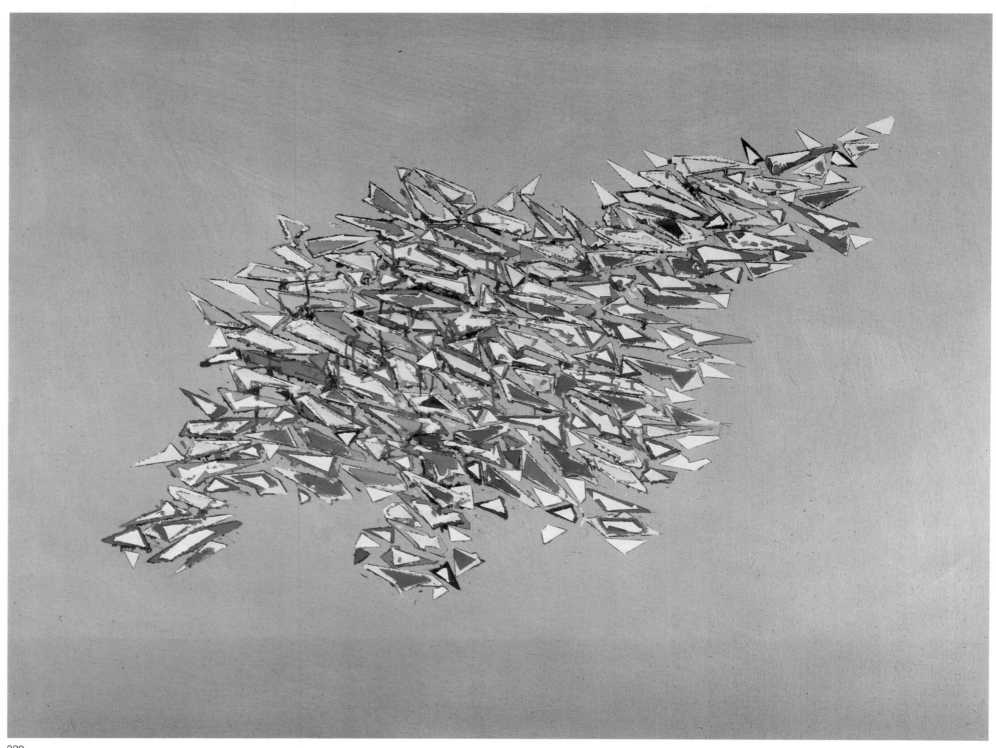

229.

229. *Colors on Gray.* 1981
Acrylic and oil on canvas, 48 x 64"

sentially it. There was a kind of pure quality about the work you would do for Ozenfant. I suppose some of that shows in my work, but in itself, that would not be enough.

B: One of the things that has always fascinated me, and I am certain it must intrigue others, too, is that over the years (I guess I have known you for seventeen or eighteen years) you've moved numerous times. What is there in your nature that has caused you to move your studio so often?

G: It is probably a kind of restlessness. Moving to a new place gives me a new start, a change that would show up in my work. It helps me to avoid settling into a rut where I might work in just one direction. Also, maybe my paintings were selling better. I had a little more money coming in, so I was able to afford larger studios.

B: Strange as it may seem, some of the confusion that goes along with moving—the refurbishing of the new studio, the activity of the workmen, that sort of thing—is apparently something you enjoy.

G: Yes. I like things going on. Maybe, if I were not an artist, I would be a contractor or something like that. I enjoy fixing up a place; I really do.

B: I have always been amused whenever I've visited your current Barrow Street studio. One month the ceiling would be lower, three weeks later the ceiling would be higher and the walls closer together or further apart. Then, of course, one area or another would be partitioned. It always struck me as an amazing situation. Everybody kids you about it, but it has worked well for you.

G: I think that I create a studio in much the same way I create a collage—by moving things around.

B: That's a good analogy.

G: At times George Mero, my handyman around here, probably gets a little impatient with me—putting in walls one day and taking them out the next. But now I believe that I have arrived at a suitable solution, because I haven't changed my studio for several years.

B: That gives me a perfect lead into something else we should discuss: Part of the answer appears to be that you

227

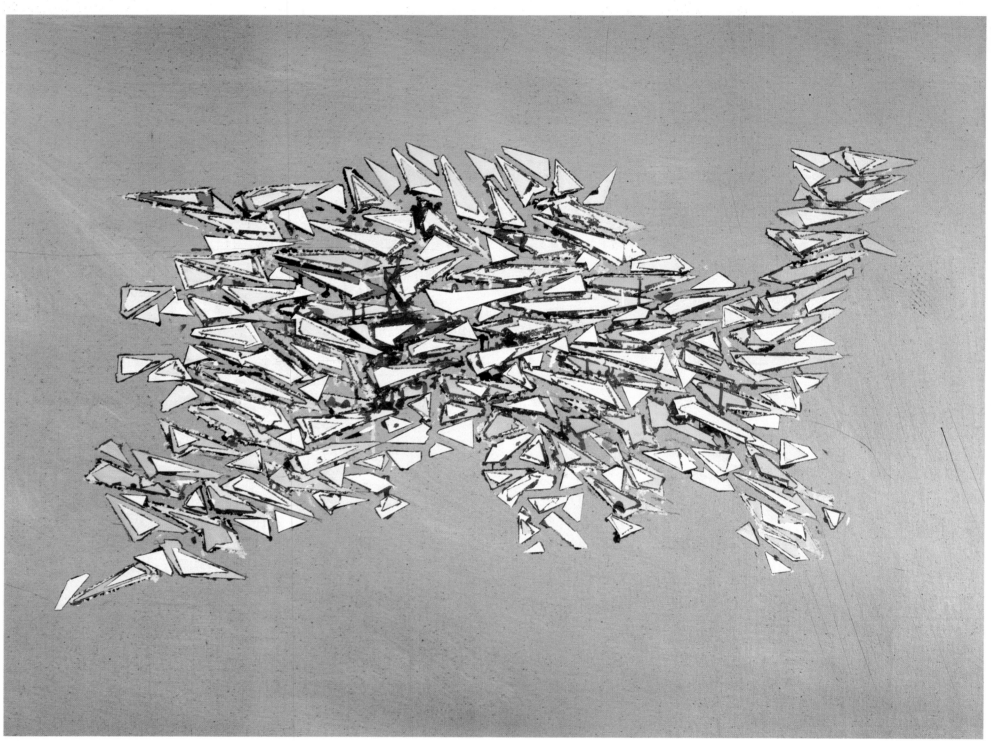

230.

230. *Color, Gray, Color*, 1981
Acrylic and oil on canvas, 42 x 54"
231. *Blue, Gray, White*, 1981
Acrylic and oil on canvas, 42 x 52"

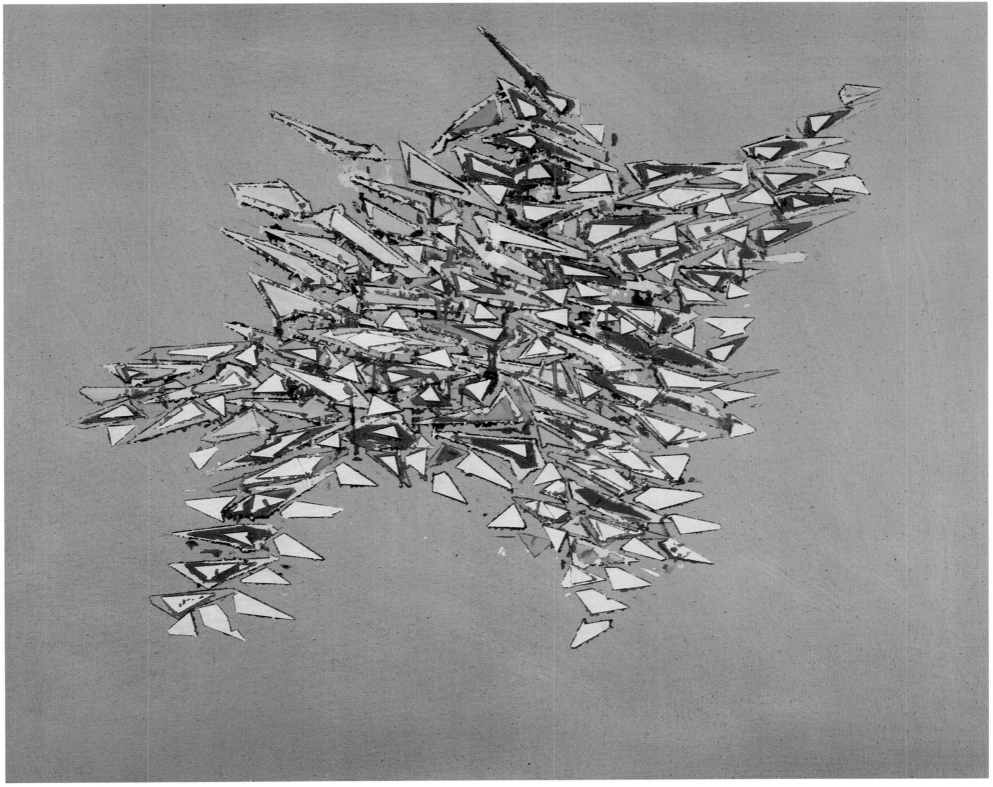

231.

232. Robert Goodnough, wearing a hat given him by André Emmerich, at the entrance to his Christopher Street studio, 1973
233. Robert Goodnough at work in his Christopher Street studio, 1972
234. Robert Goodnough in his Christopher Street studio, 1972

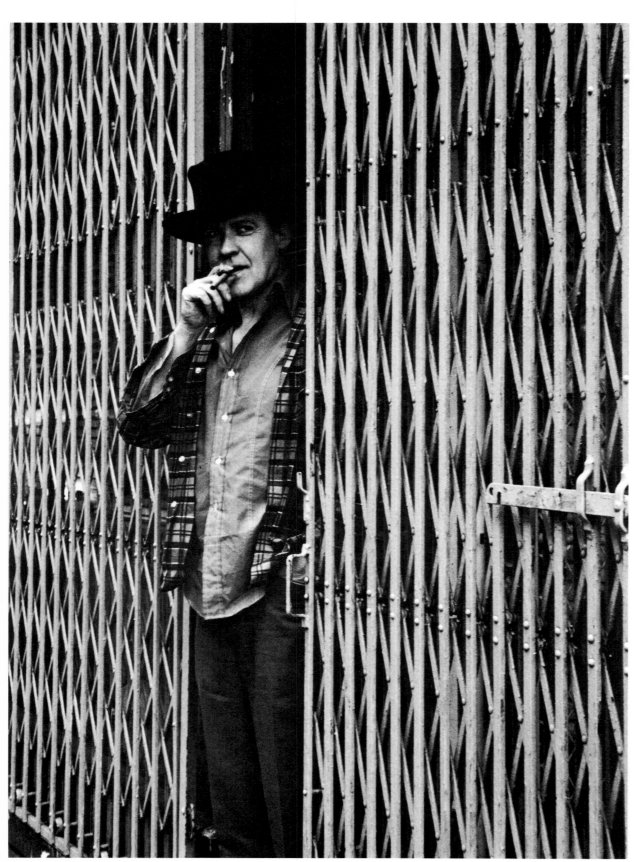

232.

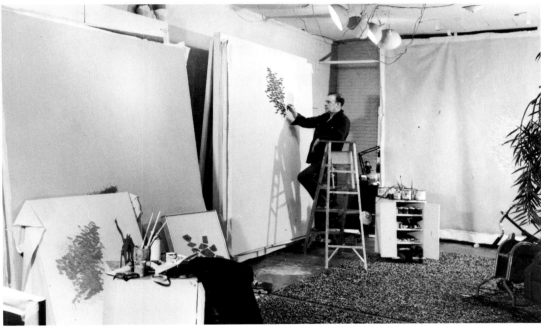

233.

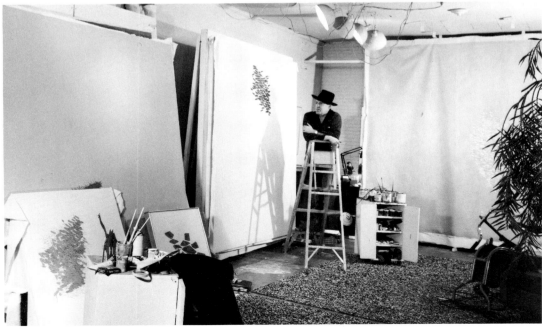

234.

have gotten married. You have a family to think about and care for—your lovely wife Emiko and your baby daughter, Kathleen.

G: Yes.

B: How has marriage affected your life and work? It must have presented you with quite a challenge. It has certainly changed your lifestyle.

G: In a way, but it's not as big a change as I thought it would be. My schedule is somewhat different. I don't stay up as late at night as I used to.

B: You used to stay up until 4 a.m. and sleep until noon!

G: Today I work about the same amount of time as I did before, except for the period when the baby was just a few days old. Being up every three hours made me a little tired, and it was a little difficult to work then. But we've gotten back on schedule and my work patterns are pretty much the same as they were in the past. I think marriage has been a solidifying force for me. It gives me something very strong to live for; I'm doing something for somebody besides myself. It's a very worthwhile thing for me.

B: Let's get back to your work. We've discussed the art world and other things that have influenced your work, so why don't you briefly summarize the manner in which your work has changed between the time you became a professional artist in the late 1940s and now.

G: In recent years my work has followed a single kind of direction. In the 1940s and 1950s, however, I was trying many different approaches, many different directions, and numerous new ideas.So I think I now have achieved consistency in my painting. But the search was important too—the search for direction. Mainly, it was a progression toward quality, which is really the important thing for an artist. You find a direction—your own personal direction—then you try to improve upon it. That's what I think is happening.

B: So you define your work as a constant striving toward improvement and quality.

G: Not in a repetitive sense. There has to be something there, a kind of a ''life force'' or something that gives life to a

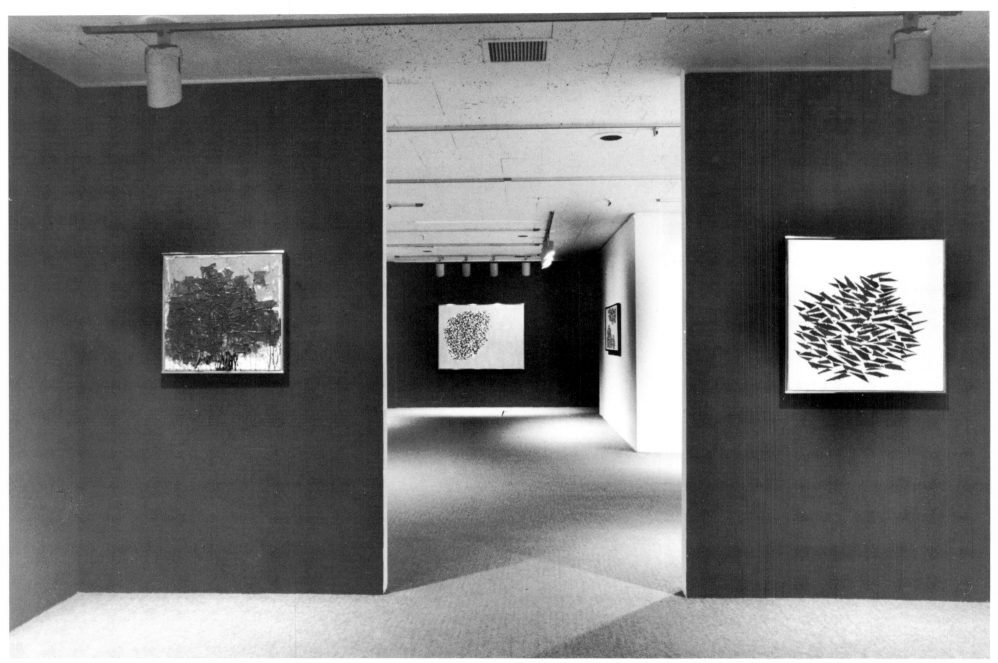

235.

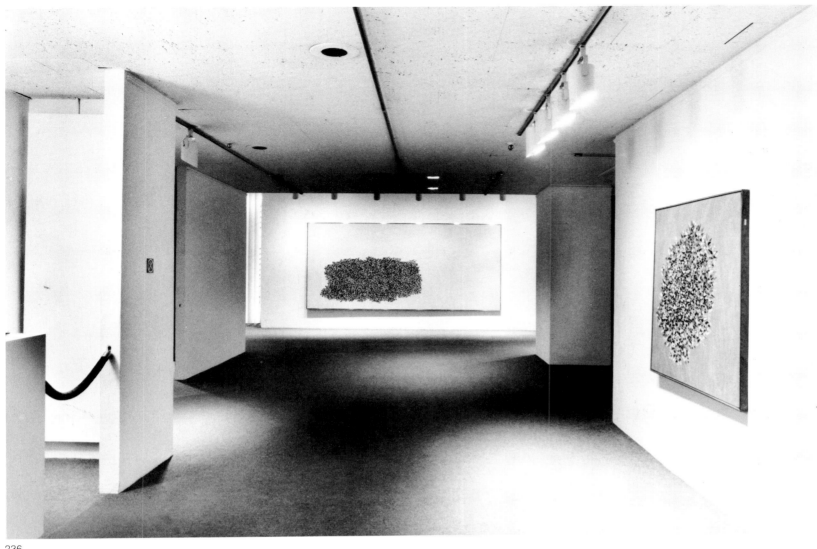

236.

237.

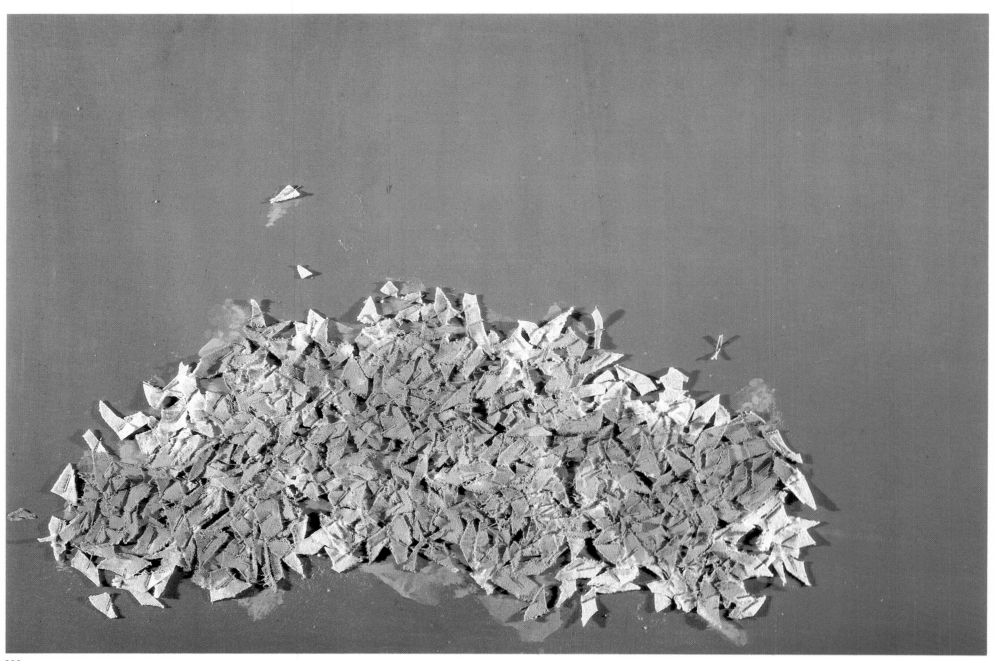

238.

picture. I think that's always different. You develop your own language and say what you have to say in that language. I think I've pretty much found a language. Each picture says something different. Quality deals not only with that language, but with what you're saying with your language. It's difficult to try to explain the idea of quality.

B: There is always a thread of consistency throughout the work. One painting relates to another, even though, to the layman, some of the early paintings might appear entirely different from the kind of work you are doing now.

G: The later paintings developed out of the early ones. You can see that the shapes I use now are inherent in the things I did before. They have been isolated and separated, and the figures have disappeared, but the shapes that made up the figures still remain the same. And the three-dimentional quality is pretty much gone. It has been replaced by a two-dimensional expression, although many people tell me that they see a background, or whatever you want to call it. I just see my paintings as flat surfaces with shapes on them. I see flat shapes and flat colors on a flat canvas.

B: What you're saying then is that the clusters of shapes in your paintings do not float in space. They are not three-dimensional shapes; they are just colors on a surface. Are you surprised when people tell you the clusters of shapes look like confetti, or pieces of paper, or a flock of birds flying? Those are some of the interpretations people have given to your work.

G: It doesn't surprise me because I've heard it many times. They are just reading things into the work. The shapes are simply not fish or birds or anything else. They are just shapes on a canvas—nothing more.

B: You've often told me that it's much like listening to beautiful music; the notes have no particular meaning, but the composition, the orchestration, and the sound are intriguing.

G: To me, the shapes are something like musical notes. It's almost as if the color shapes were sounds. They appeal to you in the same sense that musical sounds do. You don't relate the sounds to something you've heard before, and in

239. *Collage Painting #3*, 1981
Painted canvas on wood, 16 x 24"
240. *Collage Painting #4*, 1981
Painted canvas on wood, 16 x 24"

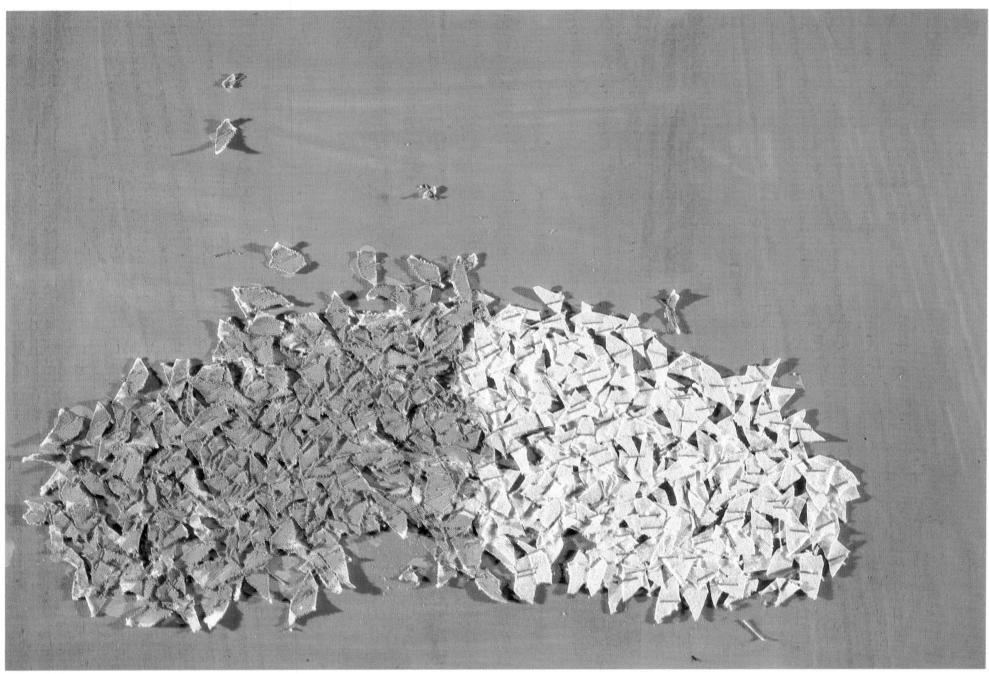

239.

236

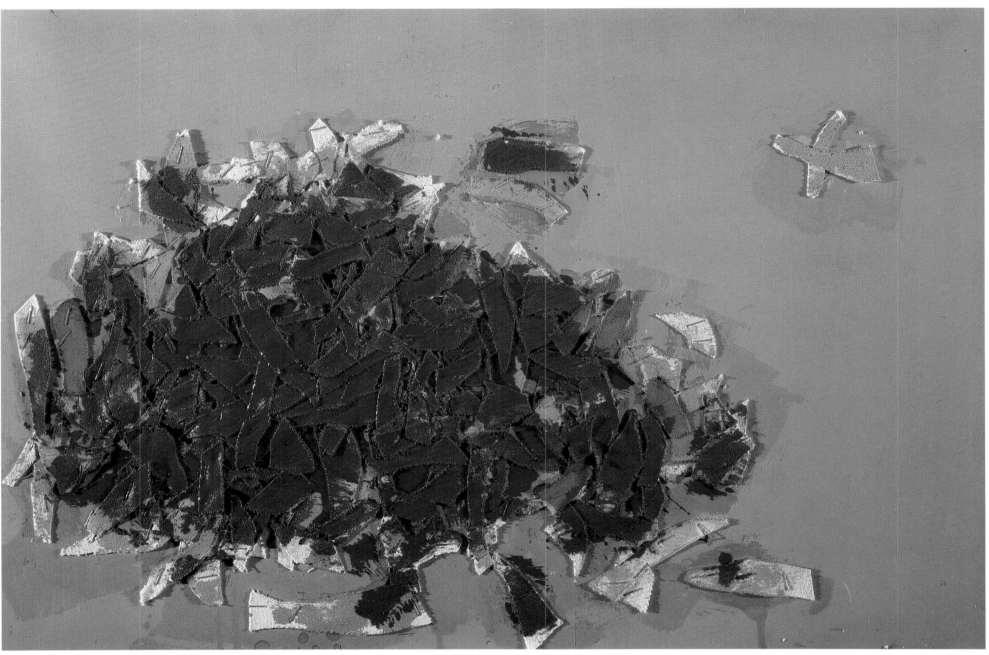

240.

the same way, the shapes in my paintings should not be related to anything outside of themselves. They are just part of a composition on canvas. It's the same as a musical composition; so it does relate to music. Bach's harpsichord music has a certain kind of fragile delicacy, and sometimes I try to get that light, fragile feeling in a painting.

B: Do you see an Oriental quality in your work?

G: Yes, I do. Orientals use space, shapes on a space, or shapes relating to a space. They often use large areas of almost empty space. But I don't consciously try to create an Oriental effect. It's just something that happens. I've never consciously tried for it.

B: You are essentially a painter of beauty. Most of your paintings are quite pleasing. Unlike the English painter Fran-

241. *Collage Painting #5*, 1981
Painted canvas on wood, 16 x 24″
242. *Collage Painting #8*, 1981
Painted canvas on wood, 16 x 24″

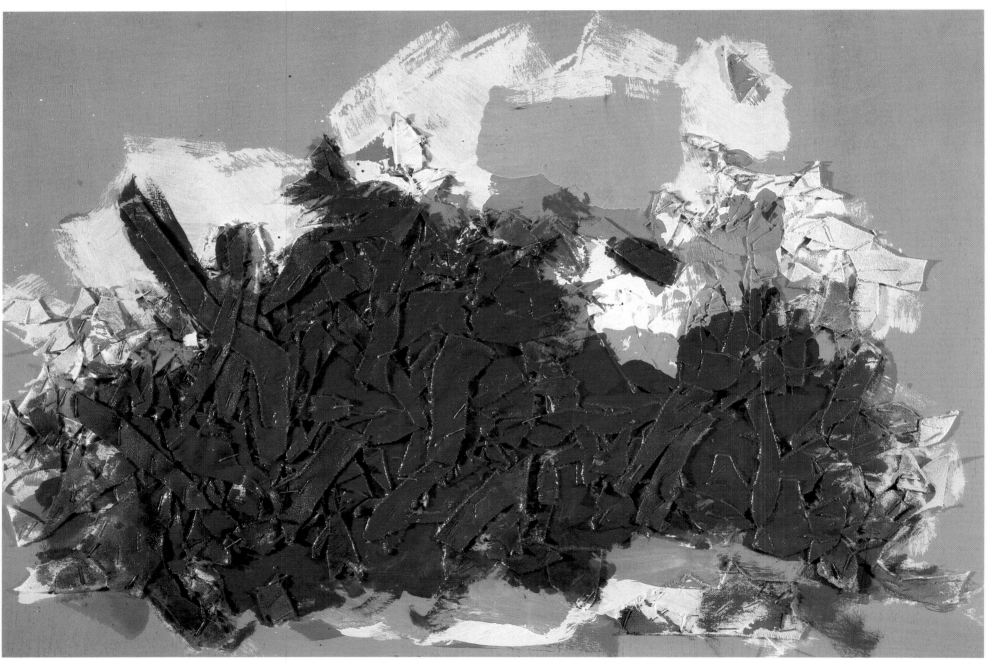

241.

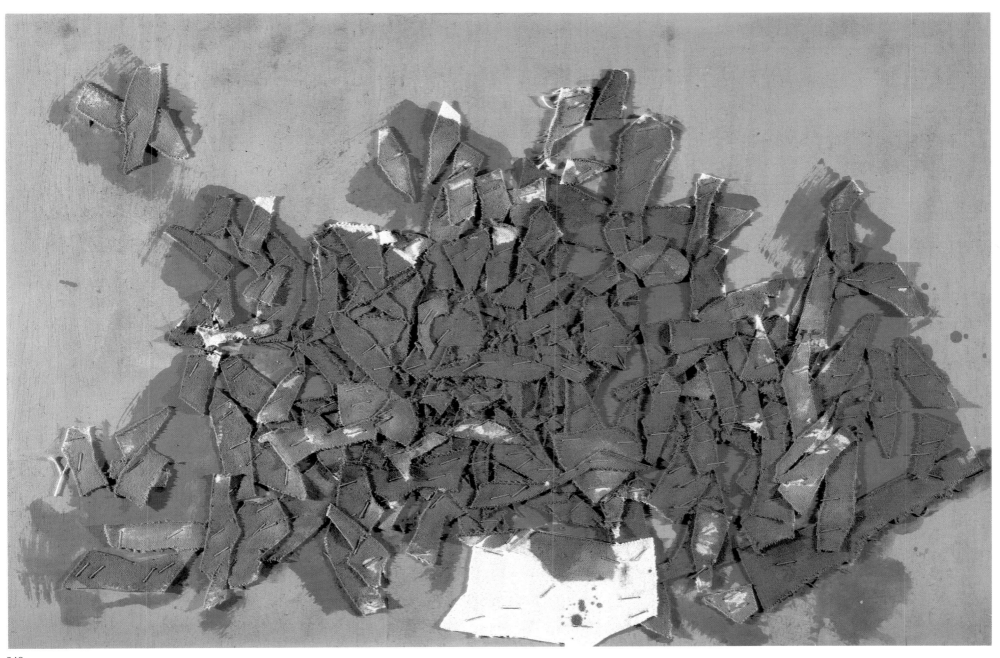

242.

243.

243. Robert Goodnough and his wife, Emiko
244. Robert Goodnough's wife, Emiko, and daughter, Kathleen, 1981

cis Bacon, for example, whose paintings are grotesque, a person does not see anything objectionable in your work. It is generally pleasing to most people.

G: I don't really try for beauty or for the grotesque either, for that matter. I just try for a certain expression on a canvas, and it seldom leans toward the grotesque. To me, my painting is more of an intellectual exercise designed to attain as much emotion as possible, but not the kind of emotion that relates to grotesque ideas or beautiful ideas. I think the world of painting is a world in itself. It is an entirely different world.

B: During the past year or two you have reached, in my opinion, another pivotal point in your career. You have been doing a great deal of experimenting. The consistency is still there, yet I see you reaching out, trying to move in different directions. It has to have been a struggle for you.

G: Yes. I think every good artist goes through phases and probably I'm approaching a new phase. I don't know how much different my work will be from what I've been doing, whether it will be completely different or not. Probably the work I've been doing during the past few years could be termed as leaning toward lyrical. Now I think I'm trying to reach for a little more intensity, although I don't know what the word for it would be. I guess we will just have to see where it takes me.

244.

NOTES

1. Clement Greenberg to Martin H. Bush, January 19, 1973.
2. From an interview with Walter Long, Auburn, New York, March 20, 1980.
3. Robert Goodnough, unpublished manuscript of a poem, n.d.
4. Robert Goodnough, "Subject Matter of the Artists," an unpublished manuscript completed in 1950, 1.
5. Elaine de Kooning, "Hans Hofmann Paints a Picture," *Art News* (February, 1950), 40.
6. Robert Goodnough, "Subject Matter of the Artists," an unpublished manuscript completed in 1950, 34.
7. *Ibid.*, 35.
8. *Ibid.*, 36.
9. *Ibid.*, 18.
10. *Ibid.*, 34.
11. *Ibid.*, 40.
12. *Ibid.*, 43.
13. *Ibid.*, 45.
14. *Ibid.*, 52.
15. *Ibid.*, 51.
16. *Ibid.*, 39.
17. *Ibid.*
18. *Ibid.*, 20–21.
19. Robert Goodnough, "Pollock Paints a Picture," *Art News* (May, 1951), 39–40.
20. *Ibid.*
21. Barbara Guest and B. H. Friedman, *Goodnough* (Paris: Pocket Museum, Editions Georges Fall, 1962), 24.
22. "Is Today's Artist With or Against the Past?" *Art News* (Summer, 1958), 42.
23. *Ibid.*
24. Irving Sandler, *The New York School: The Painters and Sculptors of the Fifties* (New York: Harper & Row, 1978), 116.
25. Robert Goodnough, "Statement," *It Is* (Spring, 1958), 46.

CHRONOLOGY

1946 Settled in New York City to pursue a career in art; studied at the Amédée Ozenfant School of Fine Arts.

1947 Visited Provincetown, Massachusetts, for the summer and studied with Hans Hofmann. Met artists Alfred Leslie, Larry Rivers, and critic Clement Greenberg.

1947 Enrolled at New York University; obtained master's degree three years later.

1948 Member of "The Club," a group dedicated to furthering abstract art. Met Tony Smith, Willem de Kooning, Adolph Gottlieb, Barnett Newman, Ad Reinhardt, Mark Rothko, and others (until 1949).

1949 Student at New School for Social Research.

1950 Exhibited in "New Talent" show at Kootz Gallery, organized by Clement Greenberg and Meyer Schapiro; also included were Franz Kline, Larry Rivers, Alfred Leslie, and others. Instructor at New York University (until 1953). Editorial associate, *Art News* magazine (until 1954).

1952 First major one-person exhibition at Tibor de Nagy Gallery; collage and animal motifs began to interest him.

1953 Joined faculty of Fieldston School, Riverdale, New York.

1954 Began series of sculptured constructions; notably dinosaurs, human figures, and birds.

1960 Faculty (summer), Cornell University, Ithaca, New York.

1962 Awarded $2,000 Garret Purchase Prize, Art Institute of Chicago Annual, The Art Institute of Chicago, Chicago, Illinois.

1962 Book about him published: *Goodnough*, by Barbara Guest and B. H. Friedman. Paris: Editions Georges Fall.

1966 Awarded $5,000 National Council on the Arts grant.

1967 Commissioned to do 32 x 9' painting, *Form In Motion*, for the Manufacturers Hanover Trust office on Fifth Avenue at 57th Street, New York City.

1969 One-person exhibition at Whitney Museum of American Art, New York City, of twelve serigraphs: *One, Two, Three (An Homage to Pablo Casals)*.

1969 Faculty, Skowhegan Art School, Skowhegan, Maine.

1970 Work chosen for exhibition in the United States Pavilion at the Venice Biennale, Venice, Italy.

1971 Awarded $3,000 Prize by the National Institute of Arts and Letters, New York City.

1972 First one-person exhibition at André Emmerich Gallery.

1972 Awarded John Simon Guggenheim Memorial Foundation Fellowship.

1974 One-person exhibition at Everson Museum of Art in Syracuse, New York.

1975 Completed mural 100 feet long, in Cor-ten steel, for Shawmut Bank of Boston, Boston, Massachusetts.

1976 First one-person exhibition at Knoedler Contemporary Art, Inc.

1978 One-person exhibition at Edwin A. Ulrich Museum of Art, Wichita State University, Wichita, Kansas.

1980 Married Emiko Oshikiri.

LIST OF PLATES

Note: Numbers in italic indicate a color plate.

1–3. Robert Goodnough
4. Robert Goodnough
5. Two Figures, 1947
6. Provincetown Landscape, 1947
7. Provincetown Landscape, 1947
8. Collage, 1953
9. Jackson Pollock
10. Clock, Counter Clock, 1952
11. Abstract, 1951
12. Collage, 1953
13. Abstract, 1955
14. Standing Figure: Cowboy, 1954
15. Dinosaurs, 1953
16. Dinosaur, 1952
17. Seated Figure, 1955
18. Composition, 1955
19. Five Greek Figures, 1956
20. Bird, 1956
21. Seated Figure with Gray, 1956–57
22. Reclining Nude, 1957
23. The Frontiersman, 1958
24. Girl in Red, 1958
25. The Flood, 1958
26. Movement of Horses, 1959
27. Centaur, 1958
28. Laocoon, 1958
29. Abstract, 1959
30. Ulysses Abstract, 1959
31. The Spartan, 1959
32. Pan, 1959
33. Laocoon II, 1959
34. Summer, 1959–60
35. Carnival II, 1960
36. Figure, 1960
37. Dinosaur, 1960
38. Vertical, 1960
39. Motorcycle, 1959
40. Picnic, 1960
41. The Bather, 1960
42. Collage, 1960
43. Figure Group: Abduction, 1960
44. The Beach, 1961
45. Country Dance, 1960–61
46. Pan, 1961
47. Three Nudes, 1961
48. Seven, 1961
49. One, 1961
50. Abstraction, 1961–62
51. Collage, 1960

52. Color Collage, 1961
53. Landscape with Figures, 1961
54. Seated Horse, 1961
55. Abduction XI, 1961
56. Ulysses, 1961–62
57. OGO, 1962
58. Drawing #2, 1962
59. Abstraction X, 1963
60. Figure Abstraction, 1963
61. The Boat Trip, 1962
62. Moonlight Sail, 1962
63. Circle in Reds, 1962
64. Robert Goodnough
65. Running Horses, 1963
66. Abstraction, 1962–63
67. Battle of the Sexes, 1963
68. Devils in a Boat, 1963
69. Circle P, 1963
70. Circle in Gray, 1963
71. Man with a Hat, 1963
72. Abstraction, 1963–64
73. Adventure II, 1963
74. Excursion, 1963–64
75. Abstraction, 1964
76. Fragment II, 1964
77. Fragment I, 1964
78. Robert Goodnough's Bleeker Street studio
79. Rectangles II, 1964
80. Rectangles III, 1964
81. Figure with a Green Hat, 1964
82. Robert Goodnough
83. Man with a Hat, 1964
84. Robert Goodnough
85. Fragment IV, 1964
86. Abstraction, 1964
87. Bomb II, 1965
88. Abstract Colors, 1965
89. Devil, 1964–65
90. Red, Blue, and Gray, 1965
91. Tattered and Torn, 1965
92. Untitled, 1965
93. Standing Figure, 1965
94. Black Herring Bone, 1965
95. Red, Black, Blue, 1965
96. Floating Verticals, 1965
97. Chevrons, 1965
98. Rectangular 3, 1965
99. Blue Stairs, 1965
100. V-Shapes, 1965
101. Triangle, 1966

102. Red, Blue Curves, 1966
103. Wood Construction, 1965
104. Color Wheel, 1965
105. Motion Form, 1966
106. Blue and Brown Collage, 1966
107. Prisms II, 1966
108. Prometheus, 1966
109. Abstract Development, 1966
110. Eleven, 1966
111. Blue and Orange II, 1967
112. Bright Colors, 1967
113. Robert Goodnough
114. Vietnam, 1967
115. Struggle, 1968
116. Red and Blue Movement, 1968
117. One Two Three: A Homage to Pablo Casals, 1968
118. Form in Motion, 1967
119. Form in Motion, in progress
120. Robert Goodnough and assistant working on Form in Motion
121. Form in Motion, installed
122. Color Development, 1968
123. III C, 1968
124. Anghiari II, 1968
125. IXL, 1969
126. Bird, 1969
127. Collage Red, Blue, 1969
128. Robert Goodnough
129. Dinosaurs under construction
130. Horizontal Development, 1969
131. Victory of Anghiari, 1969
132. Theme Variations (Blue), 1969–70
133. Red and Blue Abstraction, 1970
134. Sculpture Blue, 1970
135. Green Gray, 1969–70
136. Collage on Gray, I, 1971
137. Collage Study, 1971
138. Green Color Statement, 1971
139. Color Collage, 1971
140. Color Collage on Gray, II, 1971
141. Colors, 1971
142. Pastel Collage, 1971
143. Red, Blue, Ochre, 1972
144. Multi-Color, 1972
145. Development with Red, 1972
146. Colors with Tan, 1972
147. Slate Gray Statement, 1972
148. Quiet Development, 1972
149. Yellow with Dark Blue, 1972
150. Collage with Black, 1972
151. Gray Statement, 1972

152. *Brick Red with Yellow*, 1972
153. Yellow, Green, Gray, 1972
154. White Reach, 1972
155. *Abstract*, 1972–73
156. *Red, Yellow, Green, Gray*, 1973
157. *Colors on Off-White*, 1973
158. Pink and Blue, 1974
159. Orange, 1973
160. *Blue Lift*, 1973
161. *Colors on Pink*, 1973
162. *Colors on Green*, 1973
163. *Collage Study*, 1974
164. *Red on Gray*, 1973–74
165. *Gray Edge*, 1974
166. *Development with Colors*, 1974
167. *Brown and Gray*, 1974
168. *Colors on Green and Orange*, 1975
169. *Abstraction*, 1975
170. *Red, Blue, Pale Yellow*, 1975
171. *Colors on Gold-Tan*, 1975
172. *Colors on Pink*, 1975
173. *Colors on Tan-Gray*, 1975
174. *Blue*, 1975
175. Mural under construction at Shawmut Bank of Boston
176 and 177. Mural installed at Shawmut Bank of Boston
178. *Blue Expansion*, 1975–76
179. *Color Gray*, 1976
180. *Colors on Gray*, 1976
181. Mostly Mozart Festival poster, 1976
182. Installation at Watson/de Nagy Gallery
183. *Collage with Blue*, 1977
184. *Colors on Maroon*, 1977
185. *Cluster Variables*, 1978
186. *Colors on Purple-Red*, 1977
187. *Blue, Red, White, Gray*, 1978
188. *Blue*, 1978
189. *Bright Variables*, 1978
190. *Bright Colors on Blue-Gray*, 1978
191. *Color Shapes*, 1978
192. *Red, Blue, White*, 1978
193. *Pastel Shapes*, 1978
194. *Color Variables*, 1978
195. *Black, White, Red, Gray*, 1978
196 and 197. Installation at Edwin A. Ulrich Museum of Art
198. *Collage Tapestry I*, 1978–79
199. *Collage Tapestry II*, 1978–79
200. *Blue Mass*, 1978–79
201. *Color Mass on Gray*, 1979
202. *Color Shapes on Gray*, 1979
203. *Color Mass on Blue*, 1979

204. Professor Walter K. Long
205. Gray Color Mass, 1979
206-8. Robert Goodnough
209. Double Group, 1979
210. Dark Blue Shapes, 1979
211. Clement Greenberg
212. *Untitled*, 1979–80
213. Blue Shapes: Homage to Harry N. Abrams, 1979–80
214. Tan, Blue, White, 1978–80
215. Color Mass on Gray, 1979–80
216. Design for a swimming pool in the home of William F. Buckley, Jr.
217. Jacuzzi in the home of William F. Buckley, Jr.
218. Swimming pool in the home of William F. Buckley, Jr.
219. Collage with Red, 1980
220. Robert Goodnough
221. Bright Colors on Red, 1977–80
222. Blue-Gray Mass, 1980
223. White Mass, 1979–80
224. Blue Cluster, 1978
225. Shaped Canvas, 1980
226. Red, 1979
227. Pastel, White, Pale Blue, 1981
228. Color, White, Yellow-Tan, 1981
229. Colors on Gray, 1981
230. Color, Gray, Color, 1981
231. Blue, Gray, White. 1981
232–34. Robert Goodnough
235 and 236. Installation at the André Emmerich Gallery
237. André Emmerich and Ken Moffett
238. Collage Painting #2, 1981
239. Collage Painting #3, 1981
240. Collage Painting #4, 1981
241. Collage Painting #5, 1981
242. Collage Painting #8, 1981
243. Robert Goodnough and his wife, Emiko
244. Robert Goodnough's wife, Emiko, and daughter, Kathleen

SELECTED BIBLIOGRAPHY

Writings by Robert Goodnough

"About Painting." *Art and Literature: An International Review.* (Autumn, 1965), 119–127.

"Baizerman Makes a Sculpture." *Art News.* (March, 1952), 40–43.

"David Hare Makes a Sculpture." *Art News.* (March, 1956), 46–49.

"Franz Kline Paints a Picture." *Art News.* (December, 1952), 36–39.

"Goodnough." *Art USA Now.* Nordness, Lee (ed.) and Weller, Allen S. (text.) Lucerne: C. J. Bucher, Ltd., 1962. 11, 317. (Statement by Goodnough, 317.)

"Herbert Ferber Makes a Sculpture." *Art News.* (November, 1952), 40–43.

"Jackson Pollock Paints a Picture." *Art News.* (May, 1951), 38–41.

"Rev ws and Previews: Seymour Lipton." *Art News.* (October, 1950).

"Statement." *It Is* (Spring, 1958), 19.

"The Artist." *Robert Goodnough: Recent Paintings.* New York: Syracuse University Lubin House Gallery, 1972. (Brochure catalog of exhibition, statement by Goodnough, 4–5.)

"Two Postscripts." *Artforum.* (September, 1965), 32.

Books and General References

Baur, John I. H. *Nature in Abstraction.* New York: The Macmillan Company, for the Whitney Museum of American Art, 1958, 83.

Blesh, Rudi. *Modern Art, USA: Man—Rebellion—Conquest 1900–1956.* New York: Alfred A. Knopf, 1956, 51.

Cummings, Paul. *Dictionary of Contemporary American Artists.* New York: St. Martin's Press, 1968, 129–130.

Friedman, B. H. (ed.) *School of New York: Some Younger Artists.* New York and London: Grove Press and Evergreen Books, 1959. "Robert Goodnough" by Barbara Guest, 18–23.

Goodrich, Lloyd and Baur, John I. H. *American Art of Our Century.* New York: Whitney Museum of American Art, 1961, 201.

Goodrich, Lloyd and Baur, John I. H. *American Art of the 20th Century.* London: Thames and Hudson, 1962, 201.

Guest, Barbara and Friedman, B. H. *Goodnough.* Paris: Editions Georges Fall, 1962.

Janis, Harriet and Blesh, Rudi. *Collage: Personalities—Concepts—Techniques.* Philadelphia and New York: Chilton Company, 1962, 67.

Kultermann, Udo. *The New Painting.* New York, Washington: Frederick A. Praeger, 1969, 182.

Nordness, Lee (ed.) and Weller, Allen S. (text.) *Art USA Now.* Lucerne: C. J. Bucher, Ltd., 1962, 11, "Goodnough," by Roland F. Pease, Jr. 316–319.

Rose, Barbara. *American Painting: The 20th Century.* Lausanne, Geneva, Paris: Skira, 1969, 11, 97.

Sandler, Irving. *The New York School: The Painters and Sculptors of the Fifties.* New York: Harper & Row, 1978, 116–121.

Sandler, Irving. *The Triumph of American Painting: A History of Abstract Expressionism.* New York, Washington: Praeger Publishers, 1970, 216.

Seuphor, Michel. *Dictionary of Abstract Painting: With a History of Abstract Painting.* New York: Paris Book Center, 1957, 181.

Shipley, James R. and Weller, Allen S. *Contemporary American Painting and Sculpture 1969*. Urbana, Chicago, and London: University of Illinois Press, 1969, 97.

Articles and Critiques
(Signed and initialed articles, listed alphabetically by author)

Adrian, Dennis. "New York: Robert Goodnough." *Artforum*. (May, 1966), 50.

Ashton, Dore. "Art." *Arts & Architecture*. (March, 1960), 35.

Ashton, Dore. "Art." *Arts & Architecture*. (May, 1962), 7.

Ashton, Dore. "Art: Paintings by Robert Goodnough." *The New York Times*. (January 6, 1959).

Ashton, Dore. "Recent Exhibition at the Tibor de Nagy Gallery." *Arts & Architecture*. (March, 1961), 6.

Ashton, Dore. "Robert Goodnough." *Art Digest*. (November 15, 1952), 23.

Ashton, Dore. "Robert Goodnough." *Studio International*. (July 1, 1962), 8.

Ashton, Dore. "Robert Goodnough at the Tibor de Nagy Gallery." *Studio International*. (June, 1968), 322.

Bates, Catherine. "Getting Up to Date." *The Montreal Star Entertainments*. (November 10, 1973).

Battcock, Gregory. "Robert Goodnough." *Arts Magazine*. (May, 1968), 67.

Bell, Jane. "Robert Goodnough." *Arts Review*. (January, 1975).

Benedikt, Michael. "Robert Goodnough." *Art News*. (March, 1965), 12.

Blakeston, Oswell. "Robert Goodnough." *The Arts Review*. (November 8, 1969), 23.

Borden, Lizzi. "Robert Goodnough." *Artforum*. (April, 1972), 85.

Bourdon, David. "What's Goodnough Celebrating?" *The Village Voice*. (March 8, 1976).

Brach, Paul. "Robert Goodnough." *Art Digest*. (February 1, 1952), 18.

Brumer, Miriam. "Robert Goodnough." *Arts Magazine*. (May, 1969), 63.

Brumer, Miriam. "Goodnough at Tibor de Nagy." *Arts Magazine*. (March, 1970), 62.

Burton, Scott. "Robert Goodnough." *Art News*. (March, 1966), 14.

Burton, Scott. "Robert Goodnough." *Art News*. (Summer, 1968), 15.

Bush, Martin H. "An Interview with Robert Goodnough." *Arts Magazine*. (February, 1979), 136–141.

Bush, Martin H. "Goodnough." *Art International*. (March, 1974), 32–35, 53–54.

Butler, Barbara. "Brach, Goldberg, Goodnough, Mitchell." *Arts Magazine*. (June, 1956), 48–49.

Butler, Susan. "Goodnough Paintings Intelligent, Sophisticated." *Houston Chronicle*. (April 26, 1974).

Campbell, Lawrence. "Robert Goodnough." *Art News*. (May, 1955), 48.

Campbell, Lawrence. "Robert Goodnough." *Art News*. (April 1, 1970), 21.

Clark, Susan. "Some Art Worth Seeing." *The Buffalo Evening News/Gusto*. (January 13, 1978).

Collier, Alberta. "Robert Goodnough Show Opens Today." *The Times-Picayune*, New Orleans. (January 12, 1969).

Conrad, Barnaby III. "Robert Goodnough." *Art World*. (February, 1977), 6.

Crossley, Mimi. "Review Art." *The Houston Post*. (March 11, 1977).

Crossley, Mimi. "Walk in Painting." *The Houston Post*. (September, 1976).

Curtis, Charlotte. "Artists Visit Their Friends at Chase Manhattan." *The New York Times*. (April 18, 1969).

De Montebello, Philippe. "Two Contemporary Paintings." *The Museum of Fine Arts, Houston: Bulletin*. (June, 1970), 47–48.

Devree, Howard. "To Help Artists." *The New York Times*. (June 14, 1959).

Divver, Barbara. "Autumn Exhibitions." *Harcus Krakow Gallery Newsletter*. (Autumn, 1978).

Donohoe, Victoria. "Paintings, Prints 'Let Loose' by Goodnough." *The Philadelphia Inquirer*. (June 9, 1978).

Driver, Morley. "Robert Goodnough, a Name Predicted for Greatness." *The Detroit News*. (March 6, 1966).

Drysdale, Susan. "Abstract 'artmaking' in the '70's." *The Christian Science Monitor*. (April 24, 1972), 9–10.

Faulkner, Joseph W. "Goodnough's Spirited Art Stirs Up Thoughts of the New York School." *Chicago Tribune*. (March 15, 1964).

Findlater, Richard. "Visions of Serenity, Carefully Crafted." *Detroit Free Press*. (January 13, 1974).

Forge, Andrew. "Know-how." *New Statesman*. (August 28, 1964), 294.

Frachman, Noel. "Robert Goodnough." *Arts Magazine*. (April, 1977).

Fried, Alexander. "Art on the Dark and Bright Sides." *San Francisco Examiner*. (April, 1976).

Genauer, Emily. *New York Post*. (February 28, 1976).

Glueck, Grace. "Into the Mainstream, Everybody." *The New York Times*. (June 15, 1969).

Glueck, Grace. "Kootz Is Closing Art Gallery; Will Write About His Career." *The New York Times*. (April 8, 1966).

Glueck, Grace. "Names of Artists in Biennale Released." *The New York Times*. (July 9, 1970).

Glueck, Grace. "Previews." *Art In America*. (January, 1972), 41.

Glueck, Grace. "Reviews." *Art In America*. (January–February, 1972), 37–41.

Glueck, Grace. "Venice—Off With the Show." *The New York Times*. (October 4, 1970).

Goldin, Amy. "Robert Goodnough." *Arts Magazine*. (May, 1966), 65.

Gollin, Jane. "Robert Goodnough." *Art News*. (Summer, 1969), 14.

Gordon, Alastair. "The New Vision Centre." *The Connoisseur*. (September, 1964), 50.

Gray, Cleve. "New Venture—The Hilton Hotel Collection." *Art In America*. (April, 1963), 124.

Guest, Barbara. "Blue Stairs: Poem." *Art In America*. (October, 1965), 47–48.

Hakanson, Joy. "Goodnough and Yunkers." *The Detroit News*. (March 13, 1966).

Hakanson, Joy. "The Art World." *The Detroit News* (November 23, 1969).

Hakanson, Joy. "Robert Goodnough." *Detroit Free Press*. (January 13, 1974).

Harithas, James. "Notes on Goodnough's New Paintings." *Art Spectrum*. (February, 1975), 24.

Hartranft, Ann. "Goodnough Has Top Show at Everson." *Syracuse Herald Journal*. (January 12, 1975).

Hess, Thomas B. "United States Paintings: Some Recent Directions." *Art News Annual*. (1956), 17.

Hughes, Robert. "Abstract Energy." *Observer*. London. (August 23, 1964).

Judd, Donald. "Robert Goodnough." *Arts Magazine*. (February, 1961), 53.

Judd, Donald. "Robert Goodnough." *Arts Magazine*. (May, 1962), 98.

Kachur, Lewis. "Robert Goodnough Paintings Waddington II." *Arts Review*. (March 4, 1975).

Kind, Joshua. "One-Man Shows in Chicago." *Art News*. (May, 1964), 21.

Klinger, Betty. "Artist Goodnough." *The Citizen*. (July 4, 1976).

Kramer, Hilton. "Robert Goodnough." *The New York Times*. (March 28, 1970).

Kramer, Hilton. "Robert Goodnough." *The New York Times*. (February 5, 1972).

Kramer, Hilton. "The Return of 'Handmade' Painting." *The New York Times*. (April, 1972).

Kramer, Hilton. "Robert Goodnough." *The New York Times*. (March 6, 1976).

LaFarge, Henry A. "Robert Goodnough." *Art News*. (November, 1950), 47.

Langsner, Jules. "Everts, Jawlensky, Goodnough." *Art News*. (Summer, 1960), 56.

Marshal, W. Neil. *Arts Magazine*. (1978).

Marshal, W. Neil. "Robert Goodnough: More Than Easel Painting." *Arts Magazine*. (September, 1975).

Mayer, Ralph. "Robert Goodnough." *Art Digest*. (March 15, 1954), 19.

McDonald, Robert. "Robert Goodnough's Paintings." *San Francisco Examiner*. (October 9, 1976).

Moffett, Kenworth. "Notes on Goodnough's Recent Work." *Art International*. (October 20, 1970), 54–56.

Morris, George N. "Nova Gallery Stages Goodnough Exhibit." *Worcester Daily Telegram*. (April 17, 1961).

Moser, Charlotte. "Variations of Goodnough's Theme are Refreshingly Open, Direct." *Houston Chronicle*. (November 30, 1975).

Moser, Charlotte. "Glow of Authority." *Houston Chronicle*. (January 21, 1979).

Muck, Gordon. "Art Views and News." *Syracuse Post-Standard*. (December 23, 1974).

Munsterberg, Hugo. "Robert Goodnough." *Arts Magazine*. (January, 1960), 49.

Myers, John Bernard. "The Perils of Hindsight." *Art Forum*. (October, 1980), 29–31.

Myers, John Bernard. "What Is a Subject?" *Art Journal*. (Spring, 1977), 41.

O'Doherty, Brian. "O! Say Can You See." *Newsweek*. (January 11, 1965), 78.

O'Hara, Frank. "Goodnough Gazed on Euclid Bare." *Art News*. (March, 1954), 18, 64.

Pease, Roland F., Jr. "Robert Goodnough." *Metro 9*. (April, 1962), 57–61.

Perry, Art. "Abstractions a Mixed Bag." *The Province*, Toronto, Canada. (September 16, 1975).

Porter, Fairfield. "Robert Goodnough." *Art News*. (February, 1952), 42.

Porter, Fairfield. "Robert Goodnough." *Art News*. (November, 1952), 45.

Porter, Fairfield. "Robert Goodnough." *Art News*. (January, 1959), 10.

Preston, Stuart. "Contemporary Cross-Currents." *The New York Times*. (January 15, 1961).

Purdie, James. "The Sixties' Rebels are Building Anew." *The Globe and Mail*, Toronto, Canada. (October 18, 1975).

Raynor, Vivien. "Robert Goodnough." *Arts Magazine*. (May, 1963), 107–108.

Raynor, Vivien. "Robert Goodnough." *Arts Magazine*. (March, 1964), 67.

Raynor, Vivien. "Robert Goodnough." *Arts Magazine*. (May–June, 1965), 56–57.

Rose, Barbara. "Abstract Painting Now, 'Refiners.'" *Vogue*. (July, 1970), 34.

Rose, Barbara. "The Second Generation: Academy and Breakthrough." *Artforum*. (September, 1965), 53–63.

Rosenberg, Harold. "The American Action Painters." *Art News*. (December, 1952), 22–23, 48–50.

Rosenberg, Harold. "The Art World." *The New Yorker*. (August 26, 1967), 90.

Rosenblum, Robert. *Arts Magazine*. (February, 1956), 53.

Russell, John. "London Art." *The Sunday Times*, London. (August 23, 1964).

S. T. "Robert Goodnough." *Arts Magazine*. (January, 1969), 54–55.

Sandler, Irving H. "Robert Goodnough." *Art News*. (January, 1960), 12.

Sandler, Irving H. "Robert Goodnough." *Art News*. (January, 1961), 11.

Sandler, Irving H. "Robert Goodnough." *Art News*. (April, 1963), 12.

Sawin, Martica. "Robert Goodnough." *Art Digest*. (May 15, 1955), 29.

Schuyler, James. "Is There an American Print Revival? New York." *Art News*. (January, 1962), 36–37.

Schuyler, James. "Robert Goodnough." *Art News*. (January, 1956), 51.

Steinberg, Leo. "Contemporary Group of New York Painters at Stable Gallery." *Arts Magazine*. (January, 1956), 46–48.

Swenson, G. R. "Robert Goodnough." *Art News*. (March, 1962), 12.

Swenson, G. R. "Robert Goodnough." *Art News*. (February, 1964), 8.

Tyler, Parker. "Robert Goodnough." *Art News*. (March, 1957), 8.

Tyler, Parker. "Is Today's Artist With or Against the Past?" *Art News*. (June, 1958), 42.

Tyler, Parker. "Robert Goodnough." *Art News*. (January, 1958), 16.

Wasserman, Emily. "New York: Robert Goodnough." *Artforum*. (May, 1970), 78–79.

Wasserman, Emily. "Robert Goodnough." *Artforum*. (Summer, 1968), 55–56.

Young, Vernon. "Robert Goodnough." *Arts Magazine*. (May, 1957), 51.

Articles and Critiques

(Unsigned articles listed chronologically)

"Robert Goodnough." *Magazine of Art*. (October, 1952), 258–259.

"As He Pleases." *Newsweek*. (March 19, 1962), 116.

"The Best of the Best." *Time*. (July 6, 1962) 48–49.

Art International. (April, 1964), 56.

"Eleven Paintings, Collage by Goodnough, To Go On Display January 18 at Reed." *Portland Oregonian*. (January 15, 1967).

"University Gallery Seeks Contributions for Purchase of Painting Count Down." *St. Paul Dispatch*. (February 22, 1967).

"Rita Marin Executes Designs in Yarn for Artists." *Handweaver & Craftsman*. (Winter, 1967), 14–15.

"Goodnough Exhibit." *The Times-Picayune*, New Orleans. (January 19, 1969).

"Artist Gives Work to Museum; Show Remains to May 12." *Citizen Advertiser*. Auburn (May, 1969).

"Robert Goodnough Exhibit." *The Times-Picayune*, New Orleans. (November 8, 1970).

"Fourth National Mini Bank Opens." *Wichita Eagle Beacon*. (July 15, 1974).

"Robert Goodnough." *The New York Times*. (October, 1974).

"Robert Goodnough." *The New York Times*. (November 2, 1974).

"Painted—Poetry at Everson." *Citizen Advertiser*, Auburn, New York. (January, 1975).

"Exhibit of Goodnough Paintings at Everson." *The Moravia Republican-Register*. (January, 1975).

"Galerie André Emmerich." *Neue Zürcher Zeitung*, Zurich, Switzerland. (January 11, 1975).

"Zürcher Galerienspiegel." *Basler Nachrichten*. (January 29, 1975).

"Reizvolle Kontraste." *Schweiz Handles-Zeitung*, Zurich, Switzerland. (February, 1975).

"Hochmodern und Archaisch Alt." *Badener Tagblatt*. (February 4, 1975).

"Zurich." *Artequia*. (April, 1975).

"Gifts From New Yorkers Add to WSU's Collection." *Wichita Eagle Beacon*. (November 12, 1978).

Exhibition Catalogs and Brochures

Bush, Martin H. *Goodnough*. Houston: Watson/de Nagy & Company, 1978. (Brochure of exhibition of paintings, January 13–February 10, 1979).

Bush, Martin H. and Moffett, Kenworth. *Goodnough*. Wichita: Ulrich Museum of Art, Wichita State University, 1973.

Bush, Martin H. *Robert Goodnough*. New York: André Emmerich Gallery, 1980. (Brochure of exhibition of paintings, March 15–April 2, 1980).

"Business Buys American Art," New York: Whitney Museum of American Art, 1960. (Third Loan Exhibition by the Friends of the Whitney Museum of American Art, March 17–April 24, 1960), 21.

Collages by American Artists. Muncie: Art Gallery, Ball State University, 1971. (Catalog of an exhibition held at the Art Gallery, Ball State University, October, 1971), 29–30.

Enders, Gaetana. *Eighteen Contemporary Masters*. Ottawa, Canada. United States Embassy, 1977. (Brochure of exhibition of paintings, November, 1977).

Friedman, B. H. *Goodnough*. Los Angeles: Dwan Gallery, 1960. (Brochure catalog of exhibition of paintings, January 7–February 3, 1962).

Goodnough. Houston. Watson/de Nagy & Company, 1979. (Brochure of exhibition held at the Watson/de Nagy Company, January 13–February 10, 1979).

Robert Goodnough. Zurich. Galerie André Emmerich, 1975. (Brochure of exhibition held at the Galerie André Emmerich, January 11–February 15, 1975).

Highlights of the 1969–70 Art Season. Ridgefield: The Aldrich Museum of Contemporary Art, 1970. (Catalog of an exhibition held at the Aldrich Museum of Contemporary Art, June 21–September 13, 1970).

Lauck, Anthony. *Looking Backward from Robert Goodnough*. South Bend: University of Notre Dame. 1967. (Brochure catalog of an exhibition held at the Art Gallery, University of Notre Dame, April 30–August 1, 1967).

Meyers, John Bernard. *One Two Three: (An Homage to Pablo Casals), Twelve Serigraphs by Robert Goodnough*. San Juan: Galeria Colibri, 1969. (Brochure).

Moffett, Kenworth. *Abstract Painting in the 70's: A Selection*. Boston: Museum of Fine Arts, Boston, April 14–May 21, 1972, 20–21.

Robert Goodnough. New York: Syracuse University Lubin House Gallery, 1972. (Brochure catalog of exhibition of paintings, October 24–November 17, 1972).

Robert Goodnough. London: Axiom Gallery, 1969. (Brochure of exhibition, October 9–November 1, 1969).

Robert Goodnough. Detroit: Gertrude Kasle Gallery, 1972. (Brochure of exhibition of paintings, February 26–March 23, 1972).

Robert Goodnough. New York: André Emmerich Gallery, 1972. (Brochure of exhibition of paintings, January 29–February 16, 1972).

Robert Goodnough: Recent Paintings. Detroit: Gertrude Kasle Gallery, 1972. (Brochure of exhibition of paintings, February 26–March 23, 1972).

Seitz, William C. *The Art of Assemblage*. New York: The Museum of Modern Art, 1961.

Steinberg, Leo. *The New York School: Second Generation*. New York: The Jewish Museum, 1957. (Catalog of an exhibition held at The Jewish Museum, March 10–April 18, 1957).

Williams, Ben F. *American Paintings Since 1900 from the Permanent Collection*. Raleigh: North Carolina Museum of Art. 1967. (Catalog of paintings in the exhibition, April 1–23, 1967), 14.

PUBLIC COLLECTIONS

Albright-Knox Art Gallery, Buffalo, New York
Andrew Dickson White Museum of Art, Cornell University, Ithaca, New York
Art Institute of Chicago, Chicago, Illinois
Art Gallery, University of Notre Dame, South Bend, Indiana
Baltimore Museum of Art, Baltimore, Maryland
Birmingham Museum of Art, Birmingham, Alabama
Cayuga Museum of History and Art, Auburn, New York
Ciba-Geigy Chemical Corporation, Ardsley, New York
Corcoran Gallery of Art, Washington, District of Columbia
Edwin A. Ulrich Museum of Art, Wichita State University, Wichita, Kansas
Griffith Art Center, St. Lawrence University, Canton, New York
Hirshhorn Museum and Sculpture Garden, Washington, District of Columbia
Kresge Art Center Gallery, Michigan State University, East Lansing, Michigan
Manufacturers Hanover Trust, New York City
Memorial Art Gallery of the University of Rochester, Rochester, New York
Museum of Fine Arts, Boston, Massachusetts
Museum of Fine Arts, Houston, Texas
Museum of Art, Rhode Island School of Design, Providence, Rhode Island
Museum of Twentieth Century Art, Vienna, Austria
National Museum of American Art, Washington, District of Columbia
New York University Art Collection, New York City
Newark Museum, Newark, New Jersey
North Carolina Museum of Art, Raleigh, North Carolina
Owens-Corning Fiberglas Corporation, Toledo, Ohio
Portland Museum of Art, Portland, Maine
Purdue University, Lafayette, Indiana
Rose Art Museum, Brandeis University, Waltham, Massachusetts
S. C. Johnson Collection of Contemporary American Art, Racine, Wisconsin
State University of New York, Cortland, New York
Syracuse University Art Gallery, Syracuse, New York
The Aldrich Museum of Contemporary Art, Ridgefield, Connecticut
The Chase Manhattan Bank, New York City
The Metropolitan Museum of Art, New York City
The Museum of Modern Art, New York City
The Solomon R. Guggenheim Museum, New York City
University Art Museum, University of California, Berkeley, California
University Gallery, University of Minnesota, Minneapolis, Minnesota
Virginia Museum of Fine Arts, Richmond, Virginia
Wadsworth Atheneum, Hartford, Connecticut
Weatherspoon Art Gallery, University of North Carolina, Greensboro, North Carolina
Whitney Museum of American Art, New York City
Wichita Art Museum, Wichita, Kansas

ONE-PERSON EXHIBITIONS

1980 André Emmerich Gallery, New York City
1979 Watson/de Nagy & Company, Houston, Texas
 Hokin Gallery, Chicago, Illinois
 Hokin Gallery, Palm Beach, Florida
 Klonaridis Inc., Toronto, Canada
1978 Douglas Drake Gallery
 Edwin A. Ulrich Museum of Art, Wichita State University, Wichita, Kansas
 Fontana Gallery, Narberth, Pennsylvania
 Harcus Krakow Gallery, Boston, Massachusetts
 Hokin Gallery, Chicago, Illinois
 Lee Hoffman Gallery, Birmingham, Michigan
 Nina Freudenheim Gallery, Buffalo, New York
1977 David Mirvish Gallery, Toronto, Canada
 M. Knoedler & Company, New York City
 Watson/de Nagy & Company, Houston, Texas
1976 Douglas Drake Gallery, Kansas City, Missouri
 Harcus Krakow Gallery, Boston, Massachusetts
 Knoedler Contemporary Art, New York City
 Waddington Galleries II, London, England
 Watson/de Nagy Gallery, Houston, Texas
 William Sawyer Gallery, San Francisco, California
1975 André Emmerich Gallery, New York City
 David Mirvish Gallery, Toronto, Canada
 Gallerie André Emmerich, Zurich, Switzerland
 Harcus Krakow Rosen Sonnabend Gallery, Boston, Massachusetts
 Ulysses Gallery, Vienna, Austria
 Watson/de Nagy Gallery, Houston, Texas
1974 André Emmerich Gallery, New York City
 David Mirvish Gallery, Toronto, Canada
 Everson Museum of Art, Syracuse, New York
 Gertrude Kasle Gallery, Detroit, Michigan
 Harcus Krakow Gallery, Boston, Massachusetts
 Tibor de Nagy Gallery, Houston, Texas
1973 André Emmerich Gallery, New York City
 Gallerie Ulysses, Vienna, Austria
1972 André Emmerich Gallery, New York City
 Gertrude Kasle Gallery, Detroit, Michigan
 Harcus Krakow Gallery, Boston, Massachusetts
 Nicholas Wilder Gallery, Los Angeles, California
 Syracuse University Lubin House Gallery, New York City
1970 Galerie Simonne Stern, New Orleans, Louisiana
 J. Kasmin Limited, London, England
 Tibor de Nagy Gallery, New York City
1969 Albright-Knox Art Gallery, Buffalo, New York*
 Axiom Gallery, London, England
 Cayuga Museum of History and Art, Auburn, New York
 Galeria Colibri, San Juan, Puerto Rico*
 Galerie Simonne Stern, New Orleans, Louisiana
 Gertrude Kasle Gallery, Detroit, Michigan
 Tibor de Nagy Gallery, New York City
 Whitney Museum of American Art, New York City

1968 Tibor de Nagy Gallery, New York City
1967 Art Gallery, University of Notre Dame, South Bend, Indiana
 Reed College, Portland, Oregon
 Tibor de Nagy Gallery, New York City
1966 Gertrude Kasle Gallery, Detroit, Michigan
 Tibor de Nagy Gallery, New York City
1965 Tibor de Nagy Gallery, New York City
1964 Art Gallery, University of Minnesota, Minneapolis, Minnesota
 Art Gallery, University of Notre Dame, South Bend, Indiana
 Arts Club of Chicago, Chicago, Illinois
 New Vision Centre Gallery, London, England
 Tibor de Nagy Gallery, New York City
 USIS Gallery, American Embassy, London, England
1963 James Goodman Gallery, Buffalo, New York
 Tibor de Nagy Gallery, New York City
1962 Dwan Gallery, Los Angeles, California
 Tibor de Nagy Gallery, New York City
1961 Art Institute of Chicago, Chicago, Illinois
 Dwan Gallery, Los Angeles, California
 The Nova Galleries, Boston, Massachusetts
 Tibor de Nagy Gallery, New York City
1960 Art Institute of Chicago, Chicago, Illinois
 Dwan Gallery, Los Angeles, California
 Ellison Gallery, Fort Worth, Texas
 Jefferson Place Gallery, Washington, District of Columbia
 Tibor de Nagy Gallery, New York City
1959 Dwan Gallery, Los Angeles, California
 Tibor de Nagy Gallery, New York City
1958 Tibor de Nagy Gallery, New York City
1957 Tibor de Nagy Gallery, New York City
1956 Art Museum, Rhode Island School of Design, Providence, Rhode
 Island
 Tibor de Nagy Gallery, New York City
1955 Tibor de Nagy Gallery, New York City
1954 Tibor de Nagy Gallery, New York City
1953 Tibor de Nagy Gallery, New York City
1952 Tibor de Nagy Gallery, New York City**
1950 Wittenborn Gallery, New York City

*One, Two Three: (An Homage to Pablo Casals), Twelve Serigraphs.

**Two exhibitions were held at the Tibor de Nagy Gallery: one in February,
 the other in November.

GROUP EXHIBITIONS

1980 "A Permanent Heritage–Major Works from the Museum Collection," The Museum of Fine Arts, Houston, Texas

"Art From Houston Corporations I," Institute for the Arts, Rice University, Houston, Texas

"L'Amérique aux Indépendents," Grand Palais, Paris, France

1979 "Alumni Artists' Exhibition/1979," Joe and Emily Lowe Art Gallery, Syracuse, New York

"Group Show," Watson/de Nagy & Company, Houston, Texas

1978 Douglas Drake Gallery, Kansas City, Missouri

Grey Art Gallery, New York University, New York City

"Group Show," Watson/de Nagy & Company, Houston, Texas

Meredith Long and Company, Houston, Texas

1977 Contemporary Arts Museum, Houston, Texas

"Eighteen Contemporary Masters," United States Embassy, Ottawa, Canada

"Group Show," Watson/de Nagy & Company, Houston, Texas

"Selections from the Lawrence H. Bloedel Bequest, and related works from the Permanent Collection of the Whitney Museum of American Art," Whitney Museum, New York City

Southern Methodist University Meadows Museum, Dallas, Texas

The Aldrich Museum of Contemporary Art, Ridgefield, Connecticut

1976 Chrysler Museum, Norfolk, Virginia

"40 Years of American Collage," St. Peter's College Art Gallery, Jersey City, New Jersey

1975 "El Lenguaje del Color," Museo de Bellas Artes, Caracas, Venezuela

"Group Show—Gallery Artists," Knoedler Contemporary Art, New York City

"Group Show," The Museum of Fine Arts, Houston, Texas

"Large-Scale Paintings," André Emmerich Gallery, New York City

"Paintings By Robert Goodnough and Thomas Downing," Douglas Drake Gallery, Kansas City, Kansas

"25th Anniversary Exhibition," Tibor de Nagy Gallery, New York City

1974 "Paintings by Robert Goodnough and Sculpture by Ken Greenleaf," Tibor de Nagy Gallery, Houston, Texas

1973 "Group Exhibition," André Emmerich Gallery, New York City

"Ten Years Ago. . .an exhibition of paintings from 1964," David Mirvish Gallery, Toronto, Canada

1972 "American Tapestries," Modern Master Tapestries, New York City

"Modern Tapestries," Pace Gallery, New York City

"Works On Paper," Tibor de Nagy Gallery, New York City

1971 "Collages By American Artists," Art Gallery, Ball State University, Muncie, Indiana

"Group Exhibition," André Emmerich Gallery, New York City

American Academy of Arts and Letters, New York City

1970 "American Painting," Virginia Museum of Fine Arts, Richmond, Virginia

"Bannard, Goodnough, Grooms," John Bernard Myers Gallery, New York City

"Highlights of the 1969–1970 Art Season," The Aldrich Museum of Contemporary Art, Ridgefield, Connecticut

"Twentieth Anniversary Show," Tibor de Nagy Gallery, New York City

"Venice International Biennial Exhibition of Art," United States Pavilion, Venice, Italy

1969 "Contemporary American Painting and Sculpture 1969," Krannert Art Museum, University of Illinois, Champaign, Illinois

"Painting and Sculpture Today," Indianapolis Museum of Art, Indianapolis, Indiana

1967 Kunstnernes Hus, Oslo, Norway

Museum Voor Staden En Lande, Groningen, The Netherlands

"Thirtieth Biennial Exhibition of Contemporary American Paintings," Corcoran Gallery of Art, Washington, District of Columbia

"Wall Hangings," Pepsi-Cola Building, New York City

"American Paintings Since 1900 from the Permanent Collection," North Carolina Museum of Art, Raleigh, North Carolina

Amos Andersen Gallery, Helsinki, Finland

Court Gallery, Copenhagen, Denmark

1966 Boymans-Van Beuningen Museum, Rotterdam, The Netherlands

"Current Trends in American Art," Westmoreland County Museum of Art, Greensburg, Pennsylvania

Foley Art College, Stourbridge, Worcestershire, England

Midland Group Gallery, Nottingham, England

"Tapestries and Rugs by Contemporary Painters and Sculptors," The Museum of Modern Art, New York City (traveling exhibition)

1965 "American Collages," The Museum of Modern Art, New York City

"Annual Exhibition of Contemporary American Painting," Whitney Museum of American Art, New York City

"A Decade of Drawings: 1955—1965," Whitney Museum of American Art, New York City

"Banners," André Emmerich Gallery, New York City

"Northeastern Regional Exhibition of Art Across America," Institute of Contemporary Art, Boston, Massachusetts

"One Hundred Contemporary American Drawings," Museum of Art, University of Michigan, Ann Arbor, Michigan

"The Art Collection Exhibit," Tougaloo College, Tougaloo, Mississippi

1964 "Annual Exhibition of American Painting and Sculpture," Academy of Fine Art, Philadelphia, Pennsylvania

"Larry Aldrich Collection," Krannert Art Museum, University of Illinois, Champaign, Illinois

National Institute of Arts and Letters, New York City

New York World's Fair Art Gallery, New York City

"The Friends Collect," Whitney Museum of American Art, New York City

1963 "Annual Exhibition of Contemporary American Painting," Whitney Museum of American Art, New York City

"Hans Hofmann and His Students," The Museum of Modern Art, New York City (traveling exhibition, 1963–1965)

"International Selection," The Dayton Art Institute, Dayton, Ohio

"The Hilton Hotel Collection," The New York Hilton, New York City

"Twenty-eighth Biennial Exhibition of Contemporary American Painting," Corcoran Gallery of Art, Washington, District of Columbia

"Two Modern Collectors: Susan Morse Hilles, Richard Brown Baker," Yale Art Gallery, Yale University, New Haven, Connecticut

1962 "Annual Exhibition of Contemporary American Painting," Whitney Museum of American Art, New York City

"Art of Assemblage," Dallas Museum of Fine Arts, Dallas, Texas

"Art of Assemblage," San Francisco Museum of Art, San Francisco, California

"Sixty-fifth American Exhibition," Art Institute of Chicago, Chicago, Illinois

"The S. C. Johnson Collection of Contemporary American Art," Milwaukee Art Center, Milwaukee, Wisconsin (traveling exhibition)

1961 "Annual Exhibition of Contemporary American Painting," Whitney Museum of American Art, New York City

"Contemporary Paintings from 1960–61 New York Gallery Shows," Yale University Art Gallery, Yale University, New Haven, Connecticut

"VIIème Exposition Internationale de Tunisie," Tunis, Tunisia

1960 "Business Buys American Art," Whitney Museum of American Art, New York City

"Sixty American Painters: Abstract Expressionist Painting of the Fifties," Walker Art Center, Minneapolis, Minnesota

"The Aldrich Collection," The American Federation of Arts, traveling exhibition, October, 1960—April, 1962: Philbrook Art Center, Tulsa, Oklahoma; Dallas Museum of Fine Arts, Dallas, Texas; Municipal Gallery, Los Angeles, California; San Francisco Museum of Art, San Francisco, California; Seattle Art Museum, Seattle, Washington; The Arts Club of Chicago, Chicago, Illinois; The Baltimore Museum of Art, Baltimore, Maryland; Albany Institute of History and Art, Albany, New York; Allentown Art Museum, Allentown, Pennsylvania; Tucson Art Center, Tucson, Arizona; City Art Museum of St. Louis, St. Louis, Missouri

1959 "Project I," Whitney Museum of American Art, New York City

1958 "Nature in Abstraction," Whitney Museum of American Art, New York City

"Walter Bareiss Collection," The Museum of Modern Art, New York City

1957 "American Paintings: 1945–1957," Minneapolis Institute of Arts,
 Minneapolis, Minnesota
 "Annual Exhibition of Contemporary American Painting," Whitney
 Museum of American Art, New York City
 "The Fourth International Art Exhibition," The Museum of Modern
 Art, New York City
 "The New York School: Second Generation," The Jewish Muse-
 um, New York City
1956 "Annual Exhibition of Contemporary American Painting," Whitney
 Museum of American Art, New York City
 "Contemporary New York Painters," Stable Gallery, New York City
 "Four Painters," Sidney Janis Gallery, New York City
1952 "Paris Vanguard Exhibition," Paris, France
1951 Tibor de Nagy Gallery, New York City
1950 "New Talent," Kootz Gallery, New York City

INDEX

Aarons, George, 18

Abduction paintings, 103, 107

Abduction XI, 107

Abrams, Harry, 187

Abstract art, 8, 12, 14, 19, 26, 50, 61, 75, 88, 94, 103, 110, 179. *See also* Abstract Expressionism

Abstract Expressionism, 11, 12, 14, 36, 41, 44, 46, 49, 55, 58, 61–62, 65, 78, 82, 92, 103, 110, 117, 164, 166, 173, 179. *See also* Action painting, First-generation Abstract Expressionists; Second-generation Abstract Expressionists; New York School

Abstract Horse, 103

Acrylic paint, 143–44

Action painting, 41, 82. *See also* Abstract Expressionism

"American Action Painters, The," 82

American Social Realism, 36

American West motifs, 94, 98

Analytic Cubism, 9, 12, 92, 98. *See also* Cubism; Synthetic Cubism

Anderson, Alexandra, 155

Apollonian art, 179

Arp, Jean, 50

Art collections, 184

Artequia, 152

Artforum, 155

Art in America, 112

ARTnews, 73, 78, 82, 92, 100, 107, 108, 111, 198

Art schools, 18, 29, 35, 36, 44, 46, 49, 55, 58. *See also* specific schools, e.g.: Hofmann, Hans; Long, Walter; New York University; Ozenfant, Amédée; Subjects of the Artist School

Artists Club, The, 70

Association, 61–62. *See also* Subconscious

Auburn, New York, 18, 203

Bach, Johann Sebastian, 237

Bacon, Francis, 237–40

Bather, The, 100

Battle of Anghiari, 103

Battle of the Sexes, The, 107–8

Bay of Pigs, 108

Baziotes, William, 41, 44, 50, 55, 58

Benton, Thomas Hart, 36

Bernini, Gianlorenzo, 78

Black Herring Bone, 110

Black Shapes, 111

Blue Mass, 147

Blue Stairs, 110

Boat paintings, 107–8

Boat Trip, The, 107

Bomb II, 110

Braque, Georges, 30, 98

Brooks, James, 41

Brow, George, Rev., 18

Buckley, William F., Jr., 16
Bush, Martin H., 12n, 161, 164, 166, 168, 171, 173, 179, 180, 184, 187, 188, 191, 195, 198, 203, 207, 209, 219, 223, 231, 235, 237, 240
Cage, John, 50
Calamity Jane, 94
Calas, Nicolas, 50
Campbell, Lawrence, 92, 111
"Cebu News," 25
Cézanne, Paul, 58, 98, 108
Chagall, Marc, 195
Chase Manhattan Bank, collection of, 184
Chevrons, 110
Christensen, Dan, 14
Club, The, 70, 168. See also Eighth Street Club, The; Artists Club, The
Collage with Red, 151
Collage, 80, 81, 82, 143, 151. See also Goodnough, Robert: painting technique
Color-field painting, 12. See also Goodnough, Robert: color; mature style
Color Shapes on Gray, 151
Cornell, Joseph, 50
Cornell University, 203
Cortland, New York, 16
Cubism, 12, 30, 81, 88, 92, 94, 98. See also Analytic Cubism; Synthetic Cubism
Curry, John Stewart, 36
Dada, 50
da Vinci, Leonardo, 94, 103
de Kooning, Elaine, 41n, 75
de Kooning, Willem, 9, 41, 55, 62, 65, 70, 161, 164, 166
de Nagy, Tibor, 14, 73
de Niro, Robert, 75
Depression, the, 19
Devils in a Boat, 108
Diaghilev, Sergei Pavlovich, 75
Dinosaur collages, 80, 81, 82, 111
Dinosaurs, 80, 81, 82, 88
Dionysian art, 129
Double Group, 147
Dzubas, Friedel, 75
Egan, Charles, 75
Eighth Street Club, the, 70, 168
Emmerich, André, 187, 188
"Environmental" paintings, 134, 136
Ernst, Jimmy, 50
"Etherealization." See under Goodnough, Robert: painting technique
Everson Museum of Art, 152
Fauves, 30
Ferber, Herbert, 50
Fieldston School, 73, 198

Figurative painting, 14, 41, 94
First-generation Abstract Expressionists, 55, 92. See also Abstract Expressionism; Second-generation Abstract Expressionists
Form in Motion, 110, 111, 123
Forum, the, 171
Foundations of Modern Art, 29
Frankenthaler, Helen, 75
Franklin, George, 73, 198, 207
Friedman, B. H., 75n
The Frontiersman, 98
Galerie André Emmerich, 152, 155
Geometric painting, 14, 88, 90, 107, 108
Georges, Paul, 35
Gide, André, 30
Glarner, Fritz, 50
Glueck, Grace, 112
Gloucester, Massachusetts, 18
Goodnough, Emiko, 14
Goodnough, Harriet, 16, 19
Goodnough house, 16
Goodnough, Joyce, 16
Goodnough, Leo, 16, 18, 19
Goodnough, Paul, 16
Goodnough, Philip, 16
Goodnough, Robert: abstract paintings, 14, 18; Army life, 20, 24, 25, 28, 29, 108, 110, 207; art education, 18, 19, 29, 30, 35, 36, 55, 164, 166, 203, 207, 219–27; artistic influences, 18, 19, 30, 35, 46, 55, 80, 88, 92, 108, 164, 166, 168, 207–9; career development, 73, 75, 78, 80, 81, 103, 107, 184, 203; character, 14, 103, 107; childhood, 16, 18; color, 11, 14, 73, 78, 88, 98, 108, 110, 111–12, 114, 119, 121, 125, 134, 140, 142, 151, 235–37; critical acclaim, 12, 78, 107, 152–55; cubist paintings, 12; distinctive characteristics of his work, 8–10, 11, 12, 14, 18, 78, 81, 82, 88, 92, 94, 98, 100, 103, 107, 108, 152, 158; early influences, 16, 18; early painting activity, 24, 25; family, 14, 16, 19, 24; ideas on his work, 16, 28, 49–50, 70, 73, 80, 81, 87, 88, 92, 98, 108, 140, 147–52, 231–40; in New York City, 28, 29, 35, 161; mature style, 9, 12, 92, 98, 100, 111–12, 114, 117, 119, 125, 134, 136, 140, 144, 151, 158; other work experience, 73, 198; painting technique, 18, 19, 24, 73, 80, 81, 88, 90, 94, 98, 103, 110, 121, 125, 134, 140, 142, 143–44, 147, 151, 219; physical description, 14; poetry, 24–25; sources of imagery, 80, 81, 88, 94, 98, 100, 103, 107, 108, 134, 136, 158, 237–40; teaching, 70, 73, 198, 203; white-on-white paintings, 111–12, 114, 119, 121, 125; writings on art, 55, 58–61, 62, 65, 68, 69, 198, 203
Gorky, Arshile, 10
Gottlieb, Adolph, 41, 55, 61–62
Grant, Gordon, 18
Gray Color Statement, 125
Greenberg, Clement, 8–10, 12, 35, 73, 75, 92, 166, 179, 207–9
Guest, Barbara, 75n

Guston, Philip, 41
Haagen, Don, 30
Hare, David, 44
Hartigan, Grace, 73, 75
Hartranft, Ann, 152
Hess, George, 19
Hofmann, Hans, 9, 30, 35, 44, 207, 219–23
Horse paintings, 103
Hulsenbeck, Richard, 50
Iglehart, Robert, 49
Kahn, Wolf, 35
Kandinsky, Wassily, 173
Kline, Franz, 41, 70, 73, 161, 164, 203
Kootz Gallery, 73
Kootz, Sam, 73, 75
Koppleman, Hy, 29
Kramer, Hilton, 112, 114
Krasner, Lee, 41, 75
Landscape painting, 41
Laocoon, 94
Le Corbusier, 30
Leslie, Alfred, 35, 73, 75
Long, Walter, Prof., 18, 19, 203
Louvis, Tony, 207
Ma Jolie, 98
Manet, Edouard, 8–9
Manufacturers Hanover Trust office commission, 110–11
Matisse, Henri, 26, 30, 78, 87, 164
Michelangelo, 8
Miró, Joan, 30, 107, 171–73, 195
Modern Artists in America, 55
Mondrian, Piet, 26, 30, 92, 98, 103, 108, 114, 173
Moore, Henry, 195
Moravia, New York, 16, 28
Motherwell, Robert, 41, 44, 46, 49, 55, 58, 61, 155, 164, 195
Movement of Horses B, 103
Mozart, Wolfgang Amadeus, 65
Muck, Gordon, 152
Munsterberg, Hugo, 100
Museum of Natural History, 80
Myers, John Bernard, 73, 155
Neptune mural, 24
Nevelson, Louise, 195
Newman, Barnett, 8, 9, 41, 44, 58, 65, 119, 155, 171, 179
Newman, Muriel Kallis Steinberg, collection of, 9
New School for Social Research, 207
Newsweek, 107
New Talent exhibition, 73
New York School, 36, 92, 166, 168, 173. *See also* Abstract Expression-
 ism

New York School: The Painters and Sculptors, The, 92
New York Times, The, 112–14
New York University, 36, 49, 55, 70, 166
Noë, Hans, 207
Noland, Kenneth, 14, 75, 195
Non-objective painting, 61
Number 8, 78, 80
Number 4 (Pegasus), 78
Odysseus, 92
O'Hara, Frank, 92
Oil paint, 143
O'Keeffe, Georgia, 195
Olitski, Jules, 195
Oriental quality. *See under* Goodnough, Robert: sources of imagery
Owasco Lake, 16
Ozenfant, Amédée, 29, 30, 35, 207, 219, 223, 227
Ozenfant School of Fine Art. *See* Ozenfant, Amédée
Painting techniques (general), 24, 35, 61, 69, 94
Pan, 92
Parsons, Betty, 75
Pegasus. See Number 4
PepsiCo Collection, 184
Picasso, Pablo, 26, 30, 87, 92, 98, 164, 168
Picnic, 98
Pollock, Jackson, 8–10, 41, 49, 50, 58, 65, 69, 75, 82, 92, 161, 164, 166,
 171, 173, 179, 191, 203, 209
Pop Art, 180
Porter, Fairfield, 75, 78
Porter, Katherine Anne, 107
Portraits, 24
Pousette-Dart, Richard, 41
Prager, Sam, 30
Provincetown, Massachusetts, 30, 207
Purist Movement, 29, 223–27
Rape of the Daughters of Leucippus, 103, 107
Rectangles II, 108
Red, Blue, Ochre, 140
Regionalism, 36
Reinhardt, Ad, 41, 50, 55, 70
Rembrandt, 87
Rivers, Larry, 35, 49, 73, 75
Rose, Leatrice, 75
Rosenberg, Harold, 50, 82, 166
Rothko, Mark, 9, 41, 44, 50, 58, 65, 119, 155, 164, 171
Rubens, Peter Paul, 87, 98, 100, 103
Salk, Dr. Lee, 16
Sandler, Irving, 92, 108
Schapiro, Meyer, 73
School of Paris, 36
Seated Figure with Gray, 92

Seated Horse, 103
Second-generation Abstract Expressionists, 11, 12, 14
Ship of Fools, 107
Skowhegan, 203
Smith, Tony, 49, 75, 82, 171, 207
Soutine, Chaim, 81
Stamos, Theodore, 41
Steiner, Michael, 14
Still, Clyfford, 41, 119, 164, 171
Studio 35, 30, 44, 49, 50, 55
Subconscious, 41, 117–19
Subject Matter of the Artists, 55
Subjects of the Artist School, 44, 46, 55, 58
Summer III, 98
Surrealism, 75
Swenson, G. R., 107
Sydney and Frances Lewis Foundation Collection, 184
Synthetic Cubism, 92, 94. *See also* Analytic Cubism; Cubism
Syracuse Herald-Journal, 152
Syracuse Post-Standard, 152
Syracuse University, 18, 19, 164, 203
Thieme, Anthony, 18
Thoreau, Henry David, 98
Tibor de Nagy Gallery, 14, 75, 78, 80, 100, 107, 187
Time magazine, 26
Tomlin, Bradley Walker, 41
Toy Fair, 90
Urban environment, 46, 88–90, 98
van Gogh, Vincent, 81
Variations: Medium, 136, 140
Vicente, Esteban, 73
Vietnam, 108
Vietnam series, 108, 110
Vietnam War, 108, 110
View, 75
V-Shapes, 110
Warhol, Andy, 195
White, 111
White on White, 111
White-on-white paintings, 111–12, 114, 119, 121, 125
Whitney Museum of American Art, 92–94
Wittenborn, George, 73
Wood, Grant, 18, 36
Woodruff, Helen, 49
World War II, 20, 28, 29, 36, 173, 207
Yellow, Green, Gray, 147
YMCA, 198